Moving Pictures, Still Lives

Moving Pictures, Still Lives

FILM, NEW MEDIA, AND
THE LATE TWENTIETH CENTURY

James Tweedie

OXFORD
UNIVERSITY PRESS

OXFORD

UNIVERSITY PRESS

Oxford University Press is a department of the University of Oxford. It furthers
the University's objective of excellence in research, scholarship, and education
by publishing worldwide. Oxford is a registered trade mark of Oxford University
Press in the UK and certain other countries.

Published in the United States of America by Oxford University Press
198 Madison Avenue, New York, NY 10016, United States of America.

Library of Congress Cataloging-in-Publication Data
Names: Tweedie, James, 1969– author.
Title: Moving pictures, still lives : film, new media, and the late twentieth
century / James Tweedie.
Description: New York : Oxford University Press, 2018.
Identifiers: LCCN 2017050040| ISBN 9780190873882 (pbk.) |
ISBN 9780190873875 (hardcover) | ISBN 9780190873912 (Oxford scholarly online)
Subjects: LCSH: Painting and motion pictures. | Motion pictures—Aesthetics.
Classification: LCC PN1995.25 .T94 2018 | DDC 791.43/657—dc23
LC record available at https://lccn.loc.gov/2017050040

1 3 5 7 9 8 6 4 2

Paperback printed by WebCom, Inc., Canada
Hardback printed by Bridgeport National Bindery, Inc., United States of America

{ CONTENTS }

{ ILLUSTRATIONS }

{ ACKNOWLEDGMENTS }

This book began as my doctoral dissertation at the University of Iowa, where I studied under the guidance of Dudley Andrew and Garrett Stewart. This project would have been impossible without their generosity and inspiration. I am extremely grateful to the members of my dissertation and examination committees—Corey Creekmur, Ashley Dawson, Cheryl Herr, Rob Latham, and Louis-Georges Schwartz—and to the faculty and staff who advised and assisted me during my graduate studies. Many of the ideas in this book first took shape in a fantastic graduate seminar on postmodern cinema taught by Angelo Restivo and a provocative seminar and lecture series on the "visual turn" in film studies organized by Dudley Andrew. Many thanks to the other graduate students—including Jay Beck, Mike Meneghetti, Gerald Sim, and Prakash Younger—who made Iowa City such a vital environment for the study of film and media. The project benefited at its early stages from a Ballard-Seashore Fellowship from the Graduate College at Iowa. In its later stages it received valuable support from the Royalty Research Fund of the University of Washington (UW) and the Society of Scholars at UW's Simpson Center for the Humanities. I owe a particular debt of gratitude to the executive director of the Simpson Center, Kathy Woodward, for cultivating a vibrant intellectual community at UW and providing direct and indirect support for this and many other projects in the humanities. I wrote much of the earliest draft of this manuscript while living in Beijing, where late afternoons with Li Ningning were a joyous escape from the difficulties and isolation of writing, and then in New Haven, Connecticut, where the Yale Center for International and Area Studies provided a remarkable intellectual environment and wonderful role models, guides, and companions, including Vilashini Cooppan, Joshua Goldstein, Michael Holquist, Susie Jie Young Kim, Patricia Pessar, Eileen Walsh, and Eric Worby. In the ensuing years, while teaching at UW, I have been sustained by the collegial conversations and friendship of a group of faculty members, staff, and students in cinema and media studies, including Eric Ames, Jennifer Bean, Yomi Braester, Tamara Cooper, Gordana Crnkovic, Marcia Feinstein-Tobey, Stephen Groening, Justin Jesty, Monika Kaup, Sudhir Mahadevan, Leigh Mercer, Yuko Mera, Andy Nestingen, Albert Sbragia, Cynthia Steele, and Shawn Wong. Vikram Prakash drew my attention to the work of Alexander McQueen and opened up a new perspective on heritage culture. My department chairs—Ames, Steele, Mícéál Vaughan, and Gary Handwerk—helped me

strike a balance between research and the everyday demands of teaching and service at a large public university, and my own advisees—Fabrizio Cilento, Yuta Kaminishi, Sarah Ross, and Andrea Schmidt—remind me that there is still so much exciting new work to be done in the field. Thanks also to Norm Hirschy and Lauralee Yeary from Oxford University Press for welcoming me back to OUP and guiding the project through to publication, to Felshiya Bach and the team at Newgen for their flawless management of the production process, and to four of the most generous and insightful reviewers imaginable. Most important, I would like to thank my family, especially my parents, my sisters and brother, my nieces and nephews, my wife, Sasha, and my children, Lino and Zola. They are the reason I view the past as a source of inspiration and look forward to the future with hope and confidence. Finally, I dedicate this book to my grandmother, Lena Liantonio Trotti, who formed some of my most enduring memories from the late twentieth century and who lived a history that I will always struggle to redeem.

A slightly abbreviated version of Chapter 3 appeared in *October*. An earlier version of Chapter 6 appeared in *Cinema Journal*. Excerpts from Chapters 4 and 5 appeared in *Screen* and *SubStance*.

Introduction

THE ARCHAEOMODERN TURN

Historical materialism wishes to retain that image of the past which unexpectedly appears to man singled out by history at a moment of danger. The danger affects both the content of the tradition and its receivers. The same threat hangs over both: that of becoming a tool of the ruling classes. In every era the attempt must be made anew to wrest tradition away from a conformism that is about to overpower it.

—WALTER BENJAMIN, *"THESES ON THE PHILOSOPHY OF HISTORY"*[1]

The Old Medium of Film

Cinema was defined by its illusions. In the earliest public performances and subsequent theories of film, the actualities of the Lumière brothers and the supernatural special effects of Georges Méliès gestured toward two possible paths for cinema. Filmmakers could dedicate themselves to the representation of the world outside the theater, and their images could shock and move audiences because of a compelling resemblance to reality. Or, as in the work of the cinematic magician Méliès, films could flaunt their difference from reality and use images as a platform for fanciful plots and the creative reconstruction of space and time. The dominant strands of film theory have maintained an allegiance to one of these illusions and their seemingly incompatible visions of modernity: film is a modern medium, they suggest, because it uses the technological innovation of the movie camera to present a more accurate vision of the world than other arts limited by the hand and eye of the artist; or film is modern precisely because it takes liberties with reality and reshapes the world through editing or miraculous special effects. But what happens to cinema and decades of theory when film is no longer a paragon of modernity? How do the various realisms branching off from André Bazin or Siegfried Kracauer adapt to an age when other media offer equally compelling illusions of reality, some in immersive virtual formats? What becomes of a century of film theory when the whimsical and thrilling tricks of Méliès appear commonplace, digital effects are everywhere in contemporary cinema, and even apparently

live-action pictures can feature computer-generated imagery in almost every shot? Are the theoretical accounts of cinematic modernism attributed to Walter Benjamin compatible with the current moment, when the revolutionary cinematic shocks that once reverberated in the audience have grown familiar, even comforting? One premise of this book is that the intellectual tradition of film theory needs to reorient itself, not under the influence of these illusions but with the awareness that cinema is now an old medium, a phenomenon of the past more than the future, a form of art and entertainment as closely linked to painting or literature as the now-pervasive digital media that have become the dominant mode of communication in the twenty-first century.

Operating under the illusion that cinema always has been a phenomenon of modernity, film artists, critics, and theorists have usually emphasized the horizon visible in front of them rather than the one receding behind. Critics at the beginning of the twentieth century situated cinema at the vanguard of the arts and highlighted its unparalleled potential for entertaining mass audiences, realizing political revolution, or revealing untapped capacities for thought. The other horizon—the tradition of art, entertainment, and science that film emerged from, challenged, or abandoned—has attracted less attention from filmmakers and critics. Notable exceptions include the influential recent accounts of early cinema that adopt a retrospective gaze and locate film within the traditions of fairground entertainment or vaudeville that predated the invention of the medium. They emphasize the radical modernism of this "cinema of attractions" and its abandonment or domestication in subsequent movies dedicated primarily to storytelling rather than visceral excitement and thrill rides.[2] Cinema was modern from the very beginning, these accounts suggest, but its most innovative forms were sidelined or submerged in the development of more mainstream narrative entertainment, only to be rediscovered in the digital age, with the CGI blockbuster's "reloaded" cinema of attractions.[3] The current tendency to fold cinema into the broader category of "media" further accentuates the future horizon, with film reframed as a precursor to or component of the contemporary digital environment that has been "remediated" or translated into code and reconstituted on the screen.[4] The aging and diminution of cinema are even more evident now that digital production and exhibition have almost completely replaced old-fashioned celluloid. In an age of media convergence, cinema is merely one of many prominent examples of the thoroughgoing transformation of previously distinct media into subsets of the digital. This book will explore a moment in the late twentieth century when filmmakers and theorists began to reimagine cinema as an old medium and a repository of unrealized modern aspirations. In that period the capacity for innovation was intertwined with a creative exploration of the past, as artists and critics reframed modernity as a historical rather than a contemporary or futuristic phenomenon. With these seemingly contradictory tendencies activated all at once, the past was deployed as both an obstacle to change and a

paradoxical source of renewal. Adapting a phrase from Jacques Rancière, I call this at once antiquated and innovative moment the "archaeomodern turn."[5]

Although displays of special effects drove science fiction films and techno-thrillers to the top of the box-office charts and the vanguard of new entertainment technology, the late twentieth century was also an exceptionally retrospective period in cinema. Film played an essential role in the cultural environment of what Pierre Nora called the "era of commemoration." Through heritage films and less conventional takes on history, filmmakers in the 1980s and 1990s contributed to the period's urgent debates about cultural memory. By the turn of the millennium, the technical dimension of cultural memory moved to the foreground, with the digital archive joining the more familiar domain of libraries and other institutions charged with preserving the material manifestations of a particular community: its books, art, documents, and other traces of the past. The promise of a universal archive and infinite digital memory developed alongside new technologies for digitization, storage, retrieval, and surveillance. As the era of commemoration waned, debates about collective identity began to revolve around the technical components of memory. Once the purview of specialists restoring damaged sculptures in museum basements or wiping away centuries of soot from frescoes and paintings, preservation became the responsibility of a new cohort of technicians with expertise in engineering rather than art history or archaeology. One of the most profound transformations experienced in the late twentieth century was the transition from one regime of memory to another, from a past embodied in venerated objects and monuments to digital archives and databases and their more ethereal conception of memory stored on faraway servers or in "the cloud."[6] If cinema in the early twentieth century was often characterized as a vehicle of modernization, and even, in the more radical writings of Benjamin, a force of annihilation, by the end of the century it became a site of ambivalence or resistance against a digital future in the making. As Laura Mulvey argues, at the time of its centennial in 1995, "the cinema seemed to age," but rather than simply "reaching the end of its era," it also sparked a new "compulsion to look backwards, to pause and make a gesture to delay the combined forces of politics, economics and technology."[7] To speak of film in the twenty-first century is to invoke the specter of cinematheques and museums of the moving image rather than the most vibrant and popular trends in contemporary culture. But cinema in the late twentieth century also provided the last glimpse of a waning modern era and a preview of an emerging digital civilization. This book returns to the moment that marks the end of the century of cinema and the beginning of the digital age. It also revisits a group of at once rebellious and retrospective films that linger at the margins of the art film canon but address some of the period's key themes, including its archaeological quest for the modern past and its fascination with archaic modernities. If the films of the late twentieth century never experienced the canonization that

almost immediately greeted Italian neorealist cinema of the 1940s or the new waves and new cinemas from the 1950s to the 1980s, this book hopes to reframe and rediscover the virtues and limitations of movies created during the crucial moment between the fading modernity crystallized in cinema and the ascendant new media visible in the offing.

Film and History in the Late Twentieth Century

During the period immediately after the worldwide political turmoil of the 1960s and the establishment of a fledgling system of globalization, historical narratives enjoyed a period of extraordinary popularity and prestige in Europe and the United States. Recalling the cultural environment in France in the mid-1970s, Jacques Revel wrote, "Historians had acquired a new intellectual and moral authority, as any number of signs attested: the proliferation of historical best-sellers and historical lists in publishers' catalogs; the diversification of historians' contributions, other than books and articles, in the press, on television, and in the movies; the constant presence of historians in public debates largely outside their professional competence. All these signs point to an almost miraculous convergence of scholarly history with a society ready to appropriate the works of the scholars."[8] But instead of propelling or navigating this phenomenon, these newly acclaimed historical texts and experts flowed into a wave of commemoration that overwhelmed and subsumed them. Rather than celebrate the heyday of their discipline, French historians quickly grew wary of a cultural moment characterized by what Nietzsche called a "certain excess of history," a "historical fever" transmitted far beyond the field of scholarly historiography.[9] By 1980, *l'année du patrimoine* in France, the national past was omnipresent due to extraordinary efforts undertaken to ensure its preservation and continuation.[10] The state constructed new repositories for the national patrimony or adapted existing structures in accordance with this retrospective mood, including the Opéra à la Bastille, Bibliothèque de France, and Musée d'Orsay. Puy du Fou, a privately owned historical theme park in the Pays de la Loire region, was launched in 1977 and evolved into the second biggest theme attraction in France (after Disneyland Paris). Its signature "Cinéscénie" depicts several centuries of local history through the narrative of a family and a light and fireworks show set against the backdrop of a restored chateau. Films also gravitated toward historical subjects, with directors borrowing material from historians and literary sources, as in *Le Retour de Martin Guerre* (1984) and a flood of literary adaptations for the screen. According to Revel, this fascination with the past across various academic, artistic, and popular domains resulted primarily from the confusions of the time, as an old country with a deep-seated and painstakingly cultivated belief in its universal mission confronted the reality of contemporary decline. In this retrospective environment, the

"present was uncertain, the future opaque; the past became a safe place in which to invest. The result was a broad change in social attitudes toward the past, a transformation of what might be called the 'regime of historicity.' What people now wanted from history was no longer lessons, precedents, or ways of understanding the present but, rather, a refuge against the uncertainties of the moment. History became an exotic realm, a retrospective utopia that planted its flag in the soil of an absolute elsewhere."[11] No longer in the vanguard of "making history," readers, museum visitors, and film spectators voraciously consumed historical artifacts that often alluded to an illusory golden age, and through these texts and images, the past lingered on like an obsession.

Nora suggests that the wave of revivals and restorations in late twentieth-century Europe was a consequence of the "acceleration of history" during a period of rapid modernization that disrupted the "equilibrium between the present and the past."[12] The destruction of "milieux de mémoire," or "settings in which memory is a real part of everyday existence," marked the vanishing of a communal history and inspired a newfound fascination with an imagined heritage and its promised continuity with a familiar past.[13] At the outset of his *lieux de mémoire* series, Nora argued that the antidote to this nostalgic strain was to expose commemoration itself to the gaze of "critical history," thereby demystifying the civic rituals and public spaces that helped constitute de Gaulle's imaginary homeland, "a certain idea of France." By the publication of the final volume of Nora's series, however, this critical history had been waylaid by nostalgia, as the term *lieux de mémoire* entered the popular lexicon with a positive valence, as a symbol associated with a particular community because of the passage of time and the accumulation of stories.[14] Nora wrote that the "work was intended, by virtue of its conception, method, and even title, to be a counter-commemorative type of history, but commemoration has overtaken it."[15] Memory "today exercises such a powerful hold on our minds," he observed, "that commemorative bulimia has all but consumed all efforts to control it."[16] *La France profonde*, the Impressionist landscape, the regional identity of Marcel Pagnol, lazy weekends in the countryside depicted by Auguste Renoir and wild nights in the Parisian demimonde of Toulouse-Lautrec: the more these receded from the experience of contemporary life and vanished under ideological and economic constraints (if they were ever accessible at all), the more attractive they became in the meanderings of nostalgia. As Nora wrote, "Though lost, that world remained present somehow, giving rise to an odd sense of alienation from a society that by sinking into opacity had regained its mystery and appeal, dropping out of the continuity of history in order to live in the discontinuity of memory."[17] Graffiti in May 1968 had urged the demonstrators to rid society of an intractable past by sending "De Gaulle au Musée."[18] But two decades later a different dynamic dominated the interchange between a society and the institutions charged alternately with preserving history and performing its last rites. Writing of the Louvre after

its recent renovation and expansion, Jean-Pierre Babelon underscored the museum's contemporary mission: "to preserve the 'masterpieces' of human creation from a devouring process of 'consumption' that could, if allowed to go on unchecked, swallow them up altogether."[19] But Babelon also wrangled with the dangers inherent in the consecration of monuments to the past under the influence of an accelerating history and an increasingly commemorative culture: "how," he asked, "does one preserve the city, which is continually giving ground to the expanding museum?"[20]

The outbreak of heritage culture erupted with equal intensity in Britain, where some museums commemorated working-class identity or industrial modernity and others took up residence in the decaying country estates inhabited for generations by the aristocracy. The era nurtured both the Wigan Pier Heritage Centre, which recalled and capitalized on George Orwell's leftist reportage, and the cult of Castle Howard, the television setting of *Brideshead Revisited* (1981). With inspiration provided by numerous published eulogies for a "heritage in danger," and with incentives contained in the National Heritage Acts of 1980 and 1983, historical preservation developed into a robust industry, complete with its own dedicated press.[21] Under the aegis of those laws and the National Trust, financially unviable aristocratic estates were transformed into public-private partnerships supported by an array of incentives and subsidies. This impulse to preserve also produced the commemorative building boom that resulted in a museum opening nearly every week during the 1980s. So explosive and pervasive was this commemorative economy that a museum director warned, in a variation on the refrain voiced in much of western Europe, "You can't project that sort of rate of growth much further before the whole country becomes one big open air museum, and you just join it as you get off at Heathrow."[22] The permissive auspices of nostalgia became a refuge from the present and future, and an expansive national past supplied material for a museum without walls contiguous with the country itself. Theodor Adorno wrote that the "German word, *'museal'* ['*museumlike*'], has unpleasant overtones. It describes objects to which the observer no longer has a vital relationship and which are in the process of dying. . . . Museum and mausoleum are connected by more than phonetic association. Museums are like the family sepulchres of works of art."[23] While the establishment of heritage museums revealed a powerful impulse to preserve during Britain's late twentieth century, those same institutions also displayed a "mausolean" conception of the past and announced the end of history viewed as a dynamic and vital process. The urge to commemorate was also tacit acknowledgment that something had already died.

The excesses of England's heritage industry motivated a voluminous and thoughtful secondary literature, beginning with Patrick Wright's seminal 1985 memoir of his return to an "old country" in the throes of Thatcherite conservatism, and continuing with the work of Robert Hewison and Kevin

Walsh. Wright's *On Living in an Old Country* diagnosed an identity crisis festering during the nation's "era of decline," and he framed heritage culture as a response to those conditions, as an escapist fantasy couched as a return to "roots," a desire for refuge "in an imperial, pre-industrial and often pre-democratic past."[24] According to Wright, "This sense of history as entropic decline has gathered momentum in the sharpening of the British crisis. National Heritage is the backward glance taken from the edge of a vividly imagined abyss, and it accompanies a sense that history is foreclosed."[25] Like later critics of the phenomenon, Wright situated the burgeoning discourse of heritage in contemporary Britain within the context of worldwide economic crises in the early 1970s, citing the heritage phenomenon as a local response to globalization and, more specifically, to Britain's diminishing role in new transnational systems. Similar concerns motivated Eric Hobsbawm and Terence Ranger's nearly contemporaneous inquiry into the "invention of tradition," as well as Raphael Samuel's work on patriotism and on Britain's "national fictions" and "theatres of memory."[26] Paul Gilroy's *The Black Atlantic* (1993) responded to this revival of a nationalist framework by exploring both the modern "counterculture" that developed in the movement of the African diaspora between England, the United States, and the Caribbean, and the effort under way in the early 1990s to reconsolidate identity within national boundaries. "Is this impulse towards cultural protectionism," he asked, "the most cruel trick which the west can play upon its dissident affiliates?"[27] Elaborating on the correlation between heritage culture and the process of globalization, James Clifford and David Harvey traced the connections between this problematic return to roots and the disruptions created by "flexible accumulation" and expanded routes of international trade and travel.[28] Harvey placed this phenomenon in a historical context, "as part of a history of successive waves of time-space compression generated out of the pressures of capital accumulation with its perpetual search to annihilate space through time and reduce turnover time."[29] Heritage culture reemerged with a vengeance during this era of time-space compression because it served as a local palliative to the conditions of postmodernity. For Harvey, "The assertion of any place-bound identity has to rest at some point on the motivational power of tradition. It is difficult, however, to maintain any sense of historical continuity in the face of all the flux and ephemerality of flexible accumulation. The irony is that tradition is now often preserved by being commodified and marketed as such. The search for roots ends up at worst being produced and marketed as an image, as a simulacrum or pastiche."[30] In Harvey's account the surge of commemorative culture visible in particular national contexts should be viewed as interconnected phenomena, as a series of local variations on a global theme, as distinct nodes in a network of heritage movements that arise as an upshot of globalization.

Although local or national customs remained the centerpiece of commemorative culture, the heritage phenomenon assumed global proportions

in the late twentieth century. As Nora wrote in 1992, "Over the past ten or twenty years many countries have in one way or another been subjected to similar tidal waves of memory. Some have witnessed a compulsive return of a repressed past, while others have searched for 'roots' or a 'national heritage.' There has been a bedlam of commemorations, a mushrooming of museums, and a revitalization of tradition in all its forms. No era has ever been as much a prisoner of its memory, as subject to its empire and its law."[31] In 2001, from the retrospective position provided by the turn of the millennium, Svetlana Boym remarked that the "twentieth century began with a futuristic utopia and ended with nostalgia," and she observed that the forward march of modernity often produced countervailing results: "progress didn't cure nostalgia but exacerbated it," while "globalization encouraged stronger local attachments."[32] Although she drew examples primarily from Eastern Europe, Boym viewed millennial nostalgia as a phenomenon best understood from the vantage point of the globe. She wrote, "In counterpoint to our fascination with cyberspace and the virtual global village, there is a no less global epidemic of nostalgia, an affective yearning for a community with a collective memory, a longing for continuity in a fragmented world. Nostalgia inevitably reappears as a defense mechanism in a time of accelerated rhythms of life and historical upheavals."[33] Nostalgia is a "historical emotion" that flows against the grain of time, drifting backward while the machinery of modern life rushes in the opposite direction.[34] Viewed not as a series of disconnected examples but as a global phenomenon, nostalgia became a key analytical category toward the end of the century because it expressed a profound dissatisfaction with the narratives of progress that had long rationalized the project of modernization. For Boym nostalgia was a symptom of the ailments of the late twentieth century, and it provided a necessary counterweight to narratives that envisioned the march toward a modern utopia or a global village without considering the enduring appeal of nostalgic fantasies of return.

Although American mythology usually foregrounds the nation's newness and innovation, heritage culture also thrived in the United States in the late twentieth century. The American version of this replenished zeal for the past was personified in the figure of Ken Burns, the documentarian whose multipart films, *The Civil War* (1990), *Baseball* (1994), and *Jazz* (2001), were significant media events and reinvented the previously stodgy genre of the public television documentary for a mass audience. In movie theaters, the Academy Award–winning *Chariots of Fire* (Hugh Hudson, 1982) was a box-office hit throughout the United States and one of Ronald Reagan's favorite films. A range of European and American heritage films followed in its footsteps, transporting nostalgia to the big screen. Historians from across the ideological, geographical, and historical spectrum—from Doris Kearns Goodwin to Howard Zinn, from David McCullough to Stephen Ambrose and Shelby Foote—became best-selling authors and minor celebrities, supplying a steady

stream of popular narratives about the past. As Sean Wilentz argued, the "rage for historical fiction" and the "revival . . . of popular history as passive nostalgic spectacle" resulted in a more sentimental vision of the past, an "America made easy."[35] Public intellectuals like Daniel Bell and Allan Bloom spun their critiques of contemporary American culture around the still center of a timeless tradition. The essential function of the humanities, argued Bloom, is "interpreting and transmitting old books, preserving what we call tradition, in a democratic order where tradition is not privileged."[36] The word "tradition" appeared like a mantra throughout the work of Bell and Bloom, almost like the magical solution to every problem, though this quasi-official culture somehow emerged from their accounts as an endangered category under threat from the "democratic order." Writing in 1976, Bell asked, "Who today defends tradition?"[37] But the 1980s and 1990s would witness the reestablishment of state and private institutions dedicated to the defense of that tradition, an excess of commemoration that rivaled anything in Europe at the time. Right-wing nationalists in the twenty-first century would later promise to "Make America Great Again," with "again" and its promise of restoration the key variable in that formula. Adopting its strategy from an old playbook and updating it for the age of social media, this movement gestured backward to an idealized but unspecified era in American history, toward a mythical and therefore infinitely malleable heritage that could serve its irredentist plans for the future.

This long-standing preoccupation with European-American heritage was also a key component of broader debates about the role of western culture courses on college campuses in the late twentieth century. While heritage culture provided a conduit for familiar and entrenched historical narratives, the rise of multiculturalism encouraged the exploration of America's non-European roots in both the foundational history of indigenous nations and centuries of migration from Africa, Asia, and Latin America. Arguments about heritage were again fraught with political significance, as they gestured back toward radically different genealogies and resolved into seemingly incompatible futures. Like Gilroy, Michael Hanchard viewed the experience of the African diaspora as an alternative to Eurocentric heritage culture at the end of the century and as the foundation of an "Afro-Modernity."[38] He noted the central role of "historical narrative" in the constitution of this vision of the future, as he constructed an at once archaeological and prospective account of the "future past," of a diaspora that views tradition and modernity not as conceptual opposites but as the integrated foundations of a "transnational 'imagined community.'"[39] The American variation on the global commemorative boom of the late twentieth centuries assumed the form of both the conservative defense of a hegemonic heritage and an archaeological approach to modernity that searched for alternatives in the "future past."

For many critics the heritage film, a product of both the multiplex and the manor house, best exemplified the affective appeal, the political pitfalls,

and the scope of late twentieth-century commemorative culture. Like the preserved estates that encapsulated an aristocratic past, television serials like *Brideshead Revisited* and films like *Chariots of Fire* transformed the national past into a charming retreat, a resplendent time capsule restored for the screen and displayed in sumptuous images. In this work the screen became a conduit for history reduced to "a vast collection of images," and for a pageant characterized by high production values and conspicuous quality.[40] As Andrew Higson argued, the insistent visual register of the heritage film can gloss over the contradictions exposed in its narrative and (as in the case of *Chariots of Fire*, for example) eventually reinforce the regressive version of nationalism that it otherwise renders problematic.[41] In the late twentieth century, literary adaptations became a staple of the heritage film repertoire. Kenneth Branagh's forays into popular Shakespeare, film's newfound interest in the Victorian age, and the cinematic vogue of Jane Austen and Henry James attested to the persistence of another eminently and increasingly marketable form of heritage: the literary canon.[42] In whatever form the heritage film was conspicuously literary in its preoccupations, with "literary" signifying an institutionalized form of literature reminiscent of F. R. Leavis and his plea "for continuity" with the grand tradition of English letters.[43] The heritage film became a mode of academic art in the tradition of Alberti and Reynolds, and this prestige has been affirmed by the official arbiters of cinematic value, including the Ministry of Culture in France and the Academy in the United States. In the 1980s and 1990s, movies with a historical setting won half of the Césars for best film in France and fifteen out of twenty Oscars for Best Picture, including at least five located in Britain. Making a lavish film about the past is the surest path to the awards podium in the present, especially if the film borrows the aura of the literary canon.[44]

The opening sequences of heritage films and television serials often distill the formula down to its essential features, revealing the literary source, the estate, and a museumlike display of period objects. The Merchant-Ivory adaptation of *A Room with a View* (James Ivory, 1985) features credits that evoke the frontispiece of an illuminated manuscript (accompanied by a London Philharmonic Orchestra performance of Puccini) and conspicuous "chapter" breaks on screen that foreground its origins in E. M. Forster's novel. The film also follows its main characters on a standardized grand tour of Italian museums, with art objects on display for both their English beholders and the viewer of the film. A tale of class conflict and youthful rebellion, the film is wrapped in the trappings of literary and artistic heritage. In *Howard's End* (1992), another Merchant-Ivory adaptation of Forster, the literary source is linked to the enduring physical presence of the house and the fields surrounding it, with Emma Thompson strolling through grass and trees that appear at once vibrant with the life that once unfolded there and threatened by historical change. The recent success of *Downton Abbey* (2010–2016), a BBC production

that achieved record ratings in the United States on the PBS anthology series Masterpiece, hints at the longevity of this formula and the underlying fascination with aristocratic heritage. In that series the estate once again occupies the center of visual attention, from the credit sequence focused on bells, candles, and other period objects to the ubiquitous presence of the eponymous house and grounds. In heritage cinema and television, the inherently abstract and ideological concept of tradition is endowed with insistently material forms, as the manor house transforms the language of a source novel and a vague sense of history into a physical structure, into imposing buildings and gardens that loom over the narrative but remain haunted by their own vulnerability, by their status as icons of a bygone era. As Peter Greenaway remarked in 1991, "Photography of the country house is almost a sub-genre, appealing to a much scrambled notion of nostalgia, snobbery and fantasy of a pre-electric rural idyll that has provided much work for many cameramen, inside and outside of the cinema."[45] Such films and programs often ramify into related industries, as when *Chariots of Fire* spawned a craze for Edwardian fashions and designers like Ralph Lauren and Laura Ashley organized their brands around the enduring appeal of English heritage. They also provide indirect advertising for "cultural tourism," the transformation of cultural artifacts and a whole way of life into an exhibit, or, in Guy Debord's less charitable words, as "the chance to go and see what has been made trite."[46] For Fredric Jameson and others these heritage films (or, as Jameson calls them, "nostalgia films") are another symptom of the postmodern condition and the highbrow counterparts of the more stylized, youth-oriented multiplex film or *cinéma du look* of the 1980s.[47] They are historical allusions deployed in the process of forgetting. In theories of late twentieth-century cinema the relationship between the present and its past is figured either as an act of desertion—"let the dead bury their dead," in Marx's aphorism—or as an antiquarian obsession, in which "the tradition of the dead generations weighs like a nightmare on the brain of the living."[48]

One fundamental problem motivating this book is the inadequacy of much critical theory when faced with the totality of these intimately connected phenomena in the late twentieth century: a postmodern culture of dislocation and erasure; a vehement defense of entrenched traditions; and artistic experiments that reject the dichotomy between tradition and modernity and instead construct an archaeomodern cinema in the zone between. Too often the attendant critical debates devolved into fruitless arguments between celebrants of a forward-looking postmodernity and apologists for an oppressive tradition, or, seen from the reverse angle, between an ahistorical culture of consumption and a neglected historical real. These debates are best exemplified in the long-running dispute between Jameson, whose critique of postmodern consumer society remains the most influential (and, to me, persuasive) cultural theory of the late twentieth century, and Linda Hutcheon, whose celebration of postmodern "historiographic metafiction" was the most prominent alternative.[49]

Paul Ricoeur outlines the dilemma that plagues those purporting to begin anew, unencumbered by the burdens of history, and those who derive sustenance from roots in an always problematic and traumatic past. The question, writes Ricoeur, is "how to become modern and to return to sources; how to revive an old, dormant civilization and take part in universal civilization."[50] For all the rhetoric of innovation and rebirth that characterizes the discourses of modernity and postmodernity, the power of late twentieth-century art and theory often derives from a paradoxical return to disavowed sources, from a dynamic of repudiation and redemption. Michel de Certeau writes that "a relation of indebtedness and rejection" structures any return to the past, as the very act of preservation—the writing, painting, or cinematic reconstruction of history—attests to the ultimately unbridgeable divide between the present and a past accessible only through a "discourse of separation."[51] "An equally telling fact," de Certeau adds, "is that relations to tradition change. The 'return to origins' always states the contrary of what it believes, at least in the sense that it presupposes a *distancing* in respect to a past . . . and a will to *recover* what, in one fashion or another, seems lost in a received language. In this way the 'return to origins' is always a modernism as well."[52] The works of art and philosophy that inspire this book are remarkable not because of a reflexive veneration of tradition but because they recognize that a return to origins can also be a form of modernism, that the past is a record of flux and transition, and that preservation is imperative in order to counter the history of the victors with a contrary tale of unfamiliar origins and unrealized promise. The following pages will introduce two narratives and theories of late twentieth-century visual culture: one focused on a revival of interest in the baroque and its centuries-old vision of modernity, the other on media archaeology and its attempt to reframe distant history through the lens of modern media technology. To think about the late twentieth century as a mannerist or neobaroque age or to situate new media in "deep time" is to reject both the relentlessly commemorative and the precociously postmodern frames that shaped critical discourse at the end of the last century. These are two examples of the late twentieth century's turn toward an archaeomodern conception of history, heritage, and media.

The Baroque Present

The return of "mannerism" and the "baroque" in the anachronistic context of the late twentieth century offered an alternative to both the rejection and the stifling embrace of the past, to postmodernism imagined as a vehicle of eradication as well as its foil in the heritage industry. This connection between the early modern era and the late twentieth century was crucial to the enterprise of critical theory, as, almost like an apparition, the baroque wandered in and out

of criticism and philosophy from the 1970s to the 1990s. As Timothy Hampton wrote in a 1991 issue of *Yale French Studies* devoted to "Baroque Topographies," "The Baroque has shadowed ghostlike around much recent thought. One need only point out the importance for poststructuralist criticism, theory and historiography of analyses concerned with historical structures and texts traditionally labeled Baroque. Michel Foucault's influential work on early seventeenth-century models of representation and on seventeenth-century institutions of normalization, Walter Benjamin's often mentioned but rarely studied thesis on the German Baroque *Trauerspiel*, and Michel de Certeau's studies of mystical discourse, to name only the most famous, all suggest the importance of the Baroque in both the genesis of modernity and the critical vocabulary of what has come to be called postmodernism."[53] Hampton's list could be extended to include Christine Buci-Glucksmann's feminist appropriation of Benjamin and the baroque, Martin Jay's writing on the "baroque ocular regime," and Gilles Deleuze's study of Leibniz and his baroque philosophy.[54] More recently, the work of Lois Parkinson Zamora and Monika Kaup has underscored the connection between the baroque and contemporary postcolonial theory, as the "New World" adopted the uncontrollable exuberance of the baroque and used it toward radically different ends.[55] And Iain Chambers argues for the centrality of the baroque to a reconfigured cultural studies because engagement with baroque art and theory helps construct a truly "interdisciplinary space" informed by "diverse protocols" and attuned to "supplements," "remainders," and the "movements of boundaries."[56] This baroque revival helps clarify the linkages between the diverse projects of these critics and theorists. For Benjamin, historical materialism should "blast open the continuum of history" and "seize hold of a memory as it flashes up at a moment of danger."[57] Benjamin underscores the urgency of this project: "For every image of the past that is not recognized by the present as one of its own concerns threatens to disappear irretrievably."[58] With Benjamin serving as one of its most influential guides, cultural theory in the late twentieth century recognized the baroque as "one of its own concerns."

Each of these thinkers developed a personal, idiosyncratic vision of the period's art and history, but in each case the baroque served a similar function: it embodied a modern past and invoked a trace of modernity resistant to the tradition that enveloped and threatened to consume it. In *The Possession at Loudun* (1970) and *The Mystic Fable* (1982), de Certeau celebrates the baroque mystics who "took leave of the medieval universe" and "moved into the modern period."[59] Sixteenth- and seventeenth-century mysticism signaled for de Certeau the possibility of movement and variation within the most conservative and deeply rooted traditions rather than submission to received wisdom: "Behind the various religious conducts or convictions, the possibility was created of *making* these figures into something else and of *using* them to serve different strategies—a possibility whose equivalent can be seen during

the same era, in the more flexible fields of writing or aesthetics, with the art (baroque or rhetorical) of treating and rearranging inherited images or ideas in order to obtain new effects from them."[60] And for Benjamin, whose revenant featured so prominently in critical theory from the late twentieth century, the baroque mourning play exemplified his philosophy of history as both a record of wanton destruction and possibilities preserved in a state of ruin. The baroque *Trauerspiel*'s allegorical images and portents of modernity reemerged in Benjamin's later writings on Baudelaire and Surrealism, in his "Theses on the Philosophy of History," and more recently in the "revival of allegory" in contemporary art criticism. The resonance of each of these theorists derives from their ability to write about the past not through the anchoring metaphor of roots; not through deceptive assertions of a break; not as a "good example" exhibiting a set of virtues to be emulated by posterity; not as a moment on a historicist timeline, with the present merely the culmination of a march toward modernity initiated in the baroque era; and not as an antiquarian lament that today's culture suffers because of its departure from a glorious golden age. Instead they review a past littered with ruined and buried possibilities, each overcome but not extinguished by a tradition that too often substitutes a justification of the conquerors for history itself. The idiosyncratic baroques of Benjamin, de Certeau, and Deleuze pry open the space between that official narrative and history. They mark the excess that tradition can never assimilate and reveal a struggle for modernity held in abeyance. This book is concerned with the atavistic orientation of art and theory often framed under the rubric of postmodernism, and with artists and thinkers from the late twentieth century who invoked a modernity with a sense of history and the promise buried in the modern past.

This insinuation of the baroque into theory is paralleled by the emergence of a neobaroque visual culture in various realms—from cinema to painting, from literature to drama—in the late twentieth century. The art historian Stephen Calloway identified a "great Baroque revival" in the art, architecture, dance, and furniture and fashion design of the 1980s and 1990s, and Omar Calabrese described the neobaroque as the "sign of the times."[61] This fascination with things baroque and mannerist also colored film theory and criticism in the 1980s, including the critics at *Cahiers du Cinéma*, who devoted a special issue to "cinema in a time of mannerism," as well as Raphaël Bassan, who chronicled the emergence of the French "néobaroques."[62] In the most compelling accounts of recent German cinema—especially Eric L. Santner's *Stranded Objects*—Benjamin's writing on baroque allegory became an interface between German history and recent directors, especially the films of Hans Jürgen Syberberg.[63] In Spanish cinema Mary Hivnor identified a "baroque equation" operating in both the most ostentatious and the most reserved films, from the works of Pedro Almodóvar and José Luis Guerín to the cinematic paintings of Victor Erice.[64] These directors "curiously revive something of the baroque

philosophy and concerns of the Spanish theater of the seventeenth century."[65] In Britain this discussion likewise focused on cinema, including the films of Peter Greenaway, Sally Potter, and, especially, Derek Jarman, whose work, wrote Simon Field, best exemplified that "gradual, scattered but undeniable emergence of what might be described as 'mannerist' cinema" characterized by "a 'theatrical' mise-en-scene, the use of tableaux, hyperbolic lighting effects, [and] quotation from painting."[66] Timothy Murray and Angela Ndalianis have identified a baroque aesthetic model in digital culture and the contemporary Hollywood blockbuster, suggesting that the baroque has migrated from the deep recesses of history, the archive, and the museum to multiplex theaters and handheld screens.[67] Lev Manovich describes the stylistic excesses of the music video as a "Mannerist stage of cinema," while Belén Vidal views a "mannerist aesthetic" in period and costume dramas popular at the turn of the millennium.[68] Serge Daney used the term "mannerist" to describe the films of a wide range of directors in the late twentieth century, from Francis Ford Coppola, Brian De Palma, and Jim Jarmusch to Dario Argento and Wim Wenders.[69] These filmmakers helped define a distinct era in film history, according to Daney, who rejected the term "classical" when applied to cinema and instead identified three major periods: "pioneers, moderns and mannerists."[70] And in his preface to a collection of Daney's reviews and essays, Deleuze identified the concept of mannerism as one of Daney's major contributions to contemporary film criticism and described the period's mannerist films as "a tense, convulsive form of cinema that leans, as it tries to turn round, on the very system that seeks to control or replace it," an aesthetic that abandons the modernist make-it-new mentality and instead reveals an "image slipping across preexisting, presupposed images."[71] Mannerist and baroque cinema announced the end of a logic of ruptures and breaks and instead launched into an archaeological project that pursued the radical ambitions of modernism by other means.

Although some invocations of mannerism and the baroque use the terms interchangeably with perceived synonyms like "ornate," or in more derogatory contexts, "flashy" and "superficial," this expansive critical literature on the neobaroque hints at a connection, however tenuous, between the culture commonly called postmodern and the historical baroque. If that choice of terminology invites charges of anachronism, these artists and critics suggest that historicism, or history constructed as a continuum of successive events, should be countered by an "erroneous" history of revenance and reemergence. Deleuze writes that the baroque recurs because it remains a productive antidote to the most hackneyed models of return. It provides a tool to analyze and describe cultural phenomena that might otherwise remain unnoticed, and it continues to generate more events, producing "fold after fold: if the Baroque can be stretched beyond its precise historical limits, it appears to us that it is always by virtue of this criterion."[72] The nature of that bond remains ambiguous. It becomes concrete in the contemporary engagement with historical figures

from the baroque era (in Deleuze's return to Leibniz, or Jarman's film about Caravaggio) and the resurgence of strategies often associated with baroque art (in the revival of a particular mode of allegory and the tableau vivant). But more crucial and revealing in the context of this book is the desire to recover the baroque, and, conversely, to unearth and redeem a modern past submerged beneath more dominant narratives of historical development or the continuity of tradition. Foucault suggests that we "should totally and absolutely suspect anything that claims to be a return" because "there is in fact no such thing as a return. History, and the meticulous interest applied to history, is certainly one of the best defenses against this theme of the return."[73] But as Hal Foster writes, "The question of historical returns is old in art history; indeed, in the form of the renaissance of classical antiquity, it is foundational."[74] The key problem is reimagining a process of return usually envisioned as either imitation or absolute rejection. In both content and form, that foundational return—with its implicit narrative of classical triumph, then tragic degradation, then rediscovery and preservation of a timeless ideal—continues to structure the writing of cultural history, but other models of return contradict the formulas that focus on either rupture or restoration. Perhaps, as Foucault argues, "what is found at the historical beginning of things is not the inviolable identity of their origin; it is the dissension of other things. It is disparity."[75] If the classical aspires to a return to an idealized heritage and if modernism alludes to a dynamic of departure rather than restoration, then the neobaroque signals a return to origins marked by dissension and disparity. "Historical analogies are never more than suggestive," writes Perry Anderson. "But there are occasions where they may be more fruitful than predictions."[76] To invoke mannerism, the baroque, and an archaeological dimension of modern media is to launch a deviation into the past rather than a return to origins.

If terms like "mannerism" and "baroque" sound anachronistic in a late twentieth-century context, they are merely the latest in a long succession of transhistorical categories littered throughout the history of visual culture. This belated mannerism and the neobaroque were preceded by innumerable references to "classicism," "neoclassicism," and "modernism" wandering untethered throughout writings in art history, literary criticism, and film studies. Raymond Williams notes that the word "modern" was used in contradistinction to "ancient" before the Renaissance and entered common usage by the late sixteenth century.[77] "Modernism" and its variants emerged by the seventeenth century, bestowing on the condition and effects of "modernity" a name that would endure for nearly four hundred years.[78] While this etymology alludes to a long history of European modernity, most cultural historians (Stephen Kern, for example) locate the advent of the modern in the altered notions of time and space ushered in by technological inventions straddling the turn of the century.[79] Twentieth-century modernity therefore marks a distinctive break with the sense of the modern that preceded it, and that

difference is intimately linked with technological change. Michael Fried traces a longer chronology of the modern in art, arguing in 1965 that "a dialectic of modernism has been at work in the visual arts for more than a century now."[80] Similar art historical narratives posit Baudelaire's *Les Fleurs du mal* (1857) and the *Le Peintre de la vie moderne* (1863) or Manet's Le *Déjeuner sur l'herbe* (1863) as the transformative moments that inaugurated a modernist era. But such a consensus is achieved only by excluding countless dissenters and by ignoring the ubiquitous outlying references to modernity that attenuate this timeline to the breaking point.

The confusions of the modern are nowhere more evident than in film studies, a discipline characterized by incessant borrowing from critical vocabularies with origins in often distant periods in the European past, and a discipline through which the language of "modernity" and "modernism" wanders incessantly.[81] Jameson's essay delineating various periods in the history of cinema unfolds through a series of provocative anachronisms, as both silent and sound cinema recapitulate the history of literature (from realism to modernism to postmodernism) but at different historical moments, thereby sundering any connection between each style and the social milieu that produced it.[82] Jameson elsewhere elaborates at length on the specific social history of modernist literature, but that argument falls to the wayside as his chronological account of film history retraces the same progression followed by European literature, with cinematic modernism originating in postwar Italian neorealism, nearly a century after Baudelaire or Manet ushered in its literary and artistic precursors. The argument undergoes a further complication when Jameson suggests that silent and sound films progress through these periods separately, with the avant-gardes of the 1970s becoming a postmodernity for the silents, whose chronicle then falls out of sync with a surpassing sound cinema.[83] Two theories of history operate and alternate in Jameson's periodization of cinema: first, within each medium, a relatively conventional series of styles, one succeeding the next in linear fashion; and second, across the divide between media and between silent and sound film, a history in which the same terms reappear at different moments, folding back and forth across chaotic timelines and maps, verging on a model of artistic eternal return but never resolving neatly into regular cycles.[84] A significant "error" thus underlies Jameson's sweeping and ongoing history of cinema. But equally significant is the prevalence of this meandering modernity, in Jameson's work and elsewhere, so that the study of cinema and media is often organized around an implicit narrative of survival and redemption. Jameson's call to "always historicize" confronts the challenge posed by film and media to the practice of historiography, as critics encounter work that fits awkwardly within the periodizing categories borrowed from other arts. Underlying Jameson's account of film history lies a more archaeological model in which we never quite arrive at a terminal postmodernity and seemingly outdated or forgotten forms return, as though from the dead.

Despite invaluable and painstaking efforts to identify their roots in specific phenomena at the turn of our century, the words "modern" and "modernism" also attest to another history and resist efforts to identify them exclusively with "our times." While Jacques Derrida asserts that cubist collage enacts a disruption of language crucial to the experience and understanding of modernity, and although that decentering "is no doubt part of the totality of an era, our own," he maintains that process "has always already begun to proclaim itself."[85] When they appear in seemingly antiquated contexts—in Arnold Hauser's treatise on mannerism or in Jean Rousset's study of a French baroque that "proclaims itself innovative and modernist"—references to modernism still possess the power to startle through their seeming anachronism.[86] In "A Berlin Childhood around 1900" Benjamin writes of the linguistic power inherent in the untimely intimation, as déjà vu calls us "unexpectedly into the cool sepulcher of the past," and its unnamed counterpart lures us into the future through the vehicle of a seemingly misplaced word. Such a word "makes us pull up short, like a muff that someone has forgotten in our room. Just as the latter points us to a stranger who was on the premises, so there are words or pauses pointing us to that invisible stranger—the future—which forgot them at our place."[87] Like artifacts from the future, the many variations on the word "modern" confront us with the limits of a model that defines the history of the twentieth century, or the era since Baudelaire or Manet, primarily through its departures from the past. This etymological history suggests, as Clement Greenberg insisted in 1961, that "Modernism has never meant anything like a break with the past. It may mean a devolution, an unraveling of anterior tradition, but it also means its continuation. Modernist art develops out of the past without gap or break."[88] For Stephen Melville, writing in 1981, "one of the essential facts of the modern, now newly visible, is that from within it the relation between the practice of an enterprise and its past has always already become problematic: modernism has always already invaded the history and tradition from which it would distinguish itself, and so is capable of finding itself wherever it looks within that history."[89] Melville writes that "'Postmodernism' means, if it means anything, something about the way in which modernism must inevitably come to see in itself its own allegory (and so also something like its own failure, its nonidentity with itself—but these then would be the terms of its power and success)."[90] "These are names with time in them," Melville writes.[91] Each possesses its individual history, but each also begins "folding and unfolding works of art and criticism into one another" and pursues a history of retrospection and foresight, borrowing from the past and returning to discover new meanings.[92] The repeated failures to pin down the origins of modernism, the compulsion to abuse the term in a variety of disparate contexts, the seemingly anachronistic allusions within texts that now seem safely ensconced within tradition: these vagabonding modernisms of critical discourse, taken together, indicate both the limitations of conventional

definitions and possibilities for a much longer and less teleological history of modernity. Foucault suggests that to treat modernity as an expanse of time is to commit a category mistake. He argues that modernity is best characterized as an attitude rather than a period, as a concept like the Greek "ethos" rather than "the twentieth century": "And consequently, rather than seeking to distinguish the 'modern era' from the 'premodern' or 'postmodern,' I think it would be more useful to try to find out how the attitude of modernity, ever since its formation, has found itself struggling with attitudes of 'countermodernity.'"[93] Late twentieth-century variations on mannerism and the baroque allude to the longer timeline of an extended, interrupted, and persistent aspiration to modernity, and as the following chapters suggest, cinema at the end of its own historical trajectory became a vehicle for the exploration of both a future beyond film and other possible pasts.

In his last word on the baroque, José Antonio Maravall writes that the "society of the seventeenth century—biting its own tail—revealed the grounds of its own crisis: a process of modernization that was contradictorily set in place to preserve inherited structures. This way of posing the question explains that relationship in the mode of a historical law: if a society in the seventeenth century showed itself to be well adapted to baroque culture, whenever we consider its baroque richer, we shall necessarily discover that such a society's future would also be more closed."[94] The revival of the baroque is one of many revenants that appear in the pages of this book, but it is emblematic of a common strategy that assumes many names and forms in the late twentieth century. This return of and to the baroque suggests that late twentieth-century cinema bears the stigma of belatedness; it implies, in that age-old lament, that there is nothing new under the sun. But asking, with Shakespeare, "whether revolution be the same" does not necessarily deny the possibility of revolution and succumb to fatalistic portents of the end of history. For within Shakespeare's observation lies the possibility of reversal, with repetition becoming the source of revolutionary potential. "In every era," Benjamin writes, "the attempt must be made anew to wrest tradition away from conformism that is about to overpower it."[95] While "there is a kind of transmission that is a catastrophe," he argues, there is also a manner of return that redeems revolutionary possibilities in the past.[96] This book views the archaeomodern art and theory of the late twentieth century as a search for the emancipatory model of return envisioned by Benjamin. Although Maravall's "historical law" predicts a future hemmed in by heritage, Benjamin, de Certeau, and Deleuze imagine different baroques and therefore different futures: the baroque allegory, which redeems a past of liberatory potentials, but only from the ruins of history; baroque mysticism, which bears the most burdensome of traditions on its back, not to uphold an eternal essence, but to preserve a record of boundaries crossed; and the baroque envisioned by Deleuze, an ontology of change, which imagines a past and future always multiplying, ramifying, in motion.

Museums and Time Machines

Developing in tandem with the revival of mannerism and the baroque, media archaeology also explores and hopes to salvage the archaeomodern past. Although it remains an emerging field, the foundational texts of media archaeology date back more than three decades, to the early writing of Friedrich Kittler and Siegfried Zielinski from the 1980s. A product of the Euro-American cultural environment of the late twentieth century rather than the digital one of today, that work shares many fundamental concerns with the heritage industry and its critiques, binding it to other key cultural and intellectual phenomena concerned with the persistence, recovery, and preservation of material culture. Wolfgang Ernst characterizes media archaeology as an "antiquarian" enterprise obsessed with obsolete or dead media, and his work presents an apology for this "media-critical antiquarianism."[97] Ernst is interested in what could be described as "technological heritage," and he traces a lineage back into a modern past of radio transmitters and mainframe computers rather than the legendary time of nations, the "sites of memory" analyzed by Nora, or timeless great books and other masterpieces that over the years acquire the aura of art. The key difference between these intimately related undertakings lies in their distinct approaches to the material objects at the core of their respective projects, with media archaeology developing a radically antihumanist tradition focused on the impact and agency of machines and the heritage industry appealing to one of the most enduring and destructive types of humanism: the myth of an eternal organic community with roots in a fairy-tale past. This antihumanist approach to the past links people like Ernst and Kittler, whose projects are otherwise quite distinct. In its most extreme forms, media archaeology reflects on history and memory without resorting to human reference points at all, and the excesses of heritage culture reveal why, in the context of the 1980s, that seemed like an attractive and empowering prospect.

Perhaps the most influential and field-defining of these studies, Kittler's *Discourse Networks, 1800/1900* (originally published in 1985) and *Gramophone, Film, Typewriter* (originally published in 1986), established inscription or recording systems and their characteristic mechanical objects as the primary materials for historical analysis, displacing textual analysis, hermeneutic strategies, and centuries of painstakingly developed protocols for studying art and literary objects produced with those writing implements and machines. Taking his cue from Foucault, Kittler refuses to engage in the interpretation of documents, focusing instead on the social structures and technological processes that made the production of those documents possible in the first place. Instead of yet another reading of Goethe's *Faust*, Kittler rambles through primers on childhood literacy targeted at mothers, he views literature alongside the government education policies that shaped a generation of readers and writers, and he traces the bureaucratization of university instruction

that made poetry into a state concern. Kittler shifts the ground of his work from the literary canon or specific films as objects of interpretation and instead concentrates on the more fundamental effects of penmanship lessons or the mathematical formulas without which modern recording devices like the gramophone would have been inconceivable. Anticommemorative in the extreme, Kittler's work seeks to avoid the pitfalls of nostalgia by rejecting humanistic narratives and counternarratives, by focusing on the most basic facts of literature, cinema, and other media: the letters on the page and the pedagogical practices that make them legible as poetry, or the engineering and hardware underlying the production of sound recordings or film. Embracing the nonnarrative and increasingly nonhuman logic of systems and machines, he constructs an archaeology in which those "discourse networks" or inscription systems rather than human actors are the key motors of history. The revolutionary effect of modern storage devices like the phonograph or cinematograph lies, first, in their capacity to escape the "alphabetic monopoly" and record sound and visual data from distinct realms of the sensorium and, second, in their disregard for the touchstone of human experience.[98] Within the discourse network of 1900, Kittler argues, "memory is taken from people and delegated to a material organization of discourse."[99] Collective memory and individual genius, he suggests, should be replaced in discussions of heritage and cultural canons by more fundamental inscription technology, "random generators," and storage. The digital revolution, Kittler maintained late in his career, has only accelerated the potential for machinic production that ignores human reference points altogether.

But Kittler's writing is misunderstood if viewed primarily as a forward-looking prefiguration of the digital age. Geoffrey Winthrop-Young and others have pointed out that one of the key targets of Kittler's critique is the *Bildung* tradition, which dramatizes the inculcation of an intellectual and cultural heritage in the presumably unformed subject.[100] Kittler also targets the Heimat narrative, which, as Alexandra Ludewig argues in *Screening Nostalgia*, experienced a revival in the late twentieth century.[101] Much of his work revolves around the concept of Heimat, especially in his essay on nostalgia for and the imaginary destruction of homelands in Friedrich Schiller, Heinrich von Kleist, and Thomas Pynchon, with the last offering a glimpse of a world where technology has replaced the nationalist frame altogether.[102] The revolution in media technology initiated around the turn of the twentieth century made possible a rebellion against the Bildung tradition and its status as a quasi-official hermeneutic lens onto history, as well as a rejection of what Alon Confino calls Germany's "culture of remembrance."[103] In one of his many formulations of this key argument, Kittler writes, "What the technological media record is their own opposition to the state and school."[104] While he provides an overly deterministic account of the invention and popularization of recording and replay devices like the phonograph or cinematograph, those excesses are the

strongest indicator of the desire that motivates his overall project and propels this most calculating of thinkers into flights of fancy. Some countervailing force must oppose the mindless inculcation of tradition and the repetition of the past, and for Kittler that force is media technology allied in the intellectual sphere with a broader methodological change that replaces the usually retrospective concept of tradition with the ostensibly forward-looking category of media.

In an autobiographical note on his own intellectual history, Zielinski writes that his monumental study of *Deep Time of the Media* was sparked toward the end of the 1980s, while working on *Audiovisions*, his previous book about the ends of cinema and television, both "entr'actes" in the long history of media. He writes that during that initial period of research, his "intention was to make cinema and television comprehensible as two particular media events and structures whose hegemonial power is historically limited. At the time of writing, there were already hectic signs heralding a technological and cultural transition centered on the digital and computers."[105] Zielinski then characteristically transitions from a focus on the information society and screen culture in the 1990s to his research on their precursors over the longue durée of media technology: the sixteenth- and seventeenth-century manuscripts yoked together in his analysis with the digital revolution.[106] Zielinski's "deep time" is another form of anticommemorative history, with short-circuits constantly disrupting the chronological flow and centuries-old devices staking the most convincing claims to modernity. His most crucial move, one copied and critiqued in more recent studies, is to sweep virtually every form of cultural production into the boundless umbrella category of "media" and to view these "variants" as precursors of modern and contemporary digital forms, what we usually think of when we think of "media." Bruno Latour has famously argued that "we have never been modern"; Zielinski maintains, to the contrary, that we have always been on the cusp of modernity, that narratives of progress point the vector of development in the wrong direction, that we need to venture into neglected domains of history to rediscover a modernity thwarted by official repression.[107] For Zielinski this terminological and conceptual move challenges the more conventional opposition between tradition and modernity by rediscovering and reframing archaic, obscure, obsolete cultural technologies and images as incipiently modern forms. On the one hand there is an official, amply chronicled heritage; then there is the alternative history that almost magically opens up to the scholar or artist who comes seeking media rather than the conventional categories associated with the arts and technologies of the distant past. Media archaeology has from the outset been concerned with the problematic status of a technological vanguard that ages almost instantaneously, and from the vantage point of that archaic, ruined condition it discovers a repository of cultural and political potential.

Ernst emphasizes this relationship between media archaeology, history, and cultural memory when he notes that his initiation into the field proceeded from his relatively conventional training as a historian. That training resulted in a profound frustration with the narrative conventions of historical writing and a series of influential encounters with the critiques of historiography produced by Foucault in *The Archaeology of Knowledge* and Hayden White in *Metahistory*.[108] Ernst's media archaeology begins by confronting the problematic status of a history of modernity, especially the accelerated history of technological revolutions and the futuristic objects that linger on awkwardly as relics of the past. In a further extension of the pun on "roots" and "routes," on the late twentieth-century dialectic of return to local origins and departure into global networks, Ernst suggests that going "*back to roots* (which is the archive), to the beginnings" should be balanced by a return to the "mathematical *square root*, as a constitutive force in algorithmic, technomathematical media."[109] If globalization and the perceived decline of the nation-state and local traditions provided one horizon for the impulse to return to sources, Ernst, writing one to two decades after the early work of Kittler and Zielinski, presents the development of digital media as another factor in the compulsion to restore, preserve, and even mythologize the past. One motivation of Ernst's project is the challenge of digital or technomathematical media to practices of memory and the reinvention of "historical imagination in the age of new media."[110] "Although the stability of memory and tradition was formerly guaranteed by the printed text," Ernst writes, "dynamic hypertexts—the textual form of the Internet—will turn memory itself into an ephemeral *passing* drama."[111] While the excesses of commemoration became a widespread concern in the 1980s, memory remains a pressing cultural and philosophical problem for Ernst because of threats posed not only by the enduring mythologies of heritage but also by the mechanisms of digital and algorithmic processing. Media devices equip their users with, to use Ernst's words, "time machines" that carry forward into the future the cultural and mathematical logic, the systems of thought, even the utopian aspirations that produced them. But in doing so, they also introduced radically reconfigured models of time and memory, with reusable short-term memory operating in contrast to more venerable and enduring institutions like the archive or museum. Constantly updating and erasing memory have become the necessary preconditions for the longer-term storage of information in the digital era. If the late twentieth century experienced a commemorative overload sparked by the perceived decline of the nation-state and its cultural traditions, by the turn of the millennium, a new, technologically inflected paradigm of memory eventually ascended into a position of hegemony. The recent transformation of the word "curation" reflects this broader shift, as a task previously associated with heritage institutions and the organization of cultural memory has morphed into the more managerial role of combating information overload. Alain Resnais

framed the Bibliothèque nationale de France as the product of a collective desire to amass "toute la mémoire du monde" in his eponymous 1957 documentary, even if that quixotic aspiration to total knowledge and, ultimately, "happiness," remained an unattainable goal. With digital technology promising to eliminate many of the physical and logistical constraints on the state-managed library, archive, or museum, those repositories of cultural tradition have become equal partners with private caretakers of memory whose goal is the preservation of a usable past. No longer housed in imposing physical structures designed to accentuate their own monumentality, a digital avatar of that tradition is at once instantly accessible and out of sight and mind, stored in server farms, many dotting the otherwise rural landscapes fetishized in the heritage cinema of the 1980s and 1990s. The late twentieth-century problems of tradition and memory, like so many objects of intense social debate in our age, found a technological "solution" better characterized as a form of displacement or substitution: the digitization of everything. Overtaken by history and especially the digital revolution, Nora's "era of commemoration" ended not with a bang but with a whimper.

Here we encounter a dilemma anticipated by Kittler, whose key concept of the "discourse network" suggests that interpretive frameworks and strategies are historical and material practices and that we fail to capture the truly revolutionary or threatening potential of an emerging social and cultural situation if we adhere to the intellectual framework inherited from a previous situation, if we remain products of a centuries-old Bildung tradition rather than observers of the present. Kittler frames this as a parable about the dangers of sentimentality and what he views as the still dominant position of old-fashioned hermeneutics within the German academy. But with the acceleration of history in the second half of the twentieth century, we may find that even the most compelling arguments from the 1980s have outlived the crisis they addressed and now find themselves in a radically reengineered environment where we outsource more quintessentially human activities like memory to our technological extensions. Digital media and computer technology no longer subvert the heritage phenomenon; they have become objects with their own heritage institutions like the Living Computer Museum in Seattle or the Computer History Museum in Mountain View. Ernst's own archival projects and collections of obsolete hardware could be viewed within this vein of technonostalgia. But Kittler was always the most intellectually compelling and confounding of the German media theorists because of the insistently antihumanist strain in his work almost from the beginning. Is an argument against Kittler's technological turn just another nostalgic attempt to revive an outdated form of humanism? What falls between the sentimental culture of commemoration and Kittler's radical celebration of the cold logic of machines and systems? What Kittler overlooks, however, is the ambivalence of the technology he embraces. The media revolution he locates in 1900 was always both

humanist and antihumanist and both nostalgic and anticommemorative. Cinema has always been a mechanism of preservation and destruction, a sepulcher for relics and superstitions from the past and one of history's most powerful cultural innovations. No longer fixated on the future horizon, the cinema of the late twentieth century reinvented itself as an archaeomodern medium, as the product of those contradictory legacies and illusions.

What changed in the late twentieth century and what remains pertinent now is the awareness that the media that energized the discourse network of 1900 are no longer the vehicles of modernization celebrated by Benjamin and in altered but consonant terms by Kittler. Drawing on the work of Stanley Cavell, D. N. Rodowick argues that cinema was defined by a range of automatisms—"forms, conventions, or genres that arise creatively out of the existing materials and material conditions of given art practices" and "serve as potential materials or forms for future practices"—especially the mechanized process that restores movement to still images and the causal relationship between the recorded image and the light that enters the camera lens.[112] Although film has always been in part a technological marvel, the automatisms that shaped cinema were not exclusively the product of modern machinery. The retrospective glance of cinema in the late twentieth century focused instead on the conventions and underexplored creative potential at the intersection of moving images and painting, printing, and other media whose history has not been defined so exclusively through their relationship to modernity. That archaeomodern turn marks the late twentieth century as a distinct period in the history of media, a moment energized by the desire for an anticommemorative conception of memory and a refusal of the purely technological solutions that would become hegemonic in the twenty-first. The confounding digital experiments of Peter Greenaway or Agnès Varda are best understood as an attempt to link emerging digital technology and a humanist tradition of artistic production, not as the last gasp of heritage but as an attempt to invent a third term that lies outside the false dichotomy of tradition and modernity that remains a powerful framing device in cinema and media. In their work painting returns as an inspiration and conceptual basis for the future practice of making movies.

The technological and cultural transformations of the intervening years, especially the ubiquitous presence of digital media, challenge the original assumptions of the project initiated several decades ago by Kittler, Zielinski, and others, and later adapted by Ernst. With digital or technomathematical culture now in the ascendance and memory reinvented as a computational and ephemeral phenomenon subject to regular erasure, the antihumanist gestures of Kittler and Ernst have become perfectly consistent with the dominant political and economic forces of our time. Media archaeology is like heritage culture viewed through the looking glass, a nostalgia for a bygone modernity rather than the aristocratic splendor of *Brideshead Revisited* or *Downton Abbey*. Between the inception of this field in the 1980s and today, the

world that motivated the media-archaeological gaze has itself passed through the looking glass, and the compelling late twentieth-century problems centered on heritage and the national past—the invocation of an organic community, the relationship between heritage institutions and state power, and the reinforcement of long-standing patterns of gender, racial, national, and linguistic exclusion—exist alongside the twenty-first-century problems of precarious storage protocols, data archiving, and surveillance. What seemed like a solution or at least a compelling response to a profound cultural problem in late twentieth-century Europe has itself become a new problem. The parallel development of media archaeology and heritage culture allows us to view the transition between these two conceptions of memory, rootedness, and belonging: from national archives to cloud storage, from the bright sunlit uplands of heritage cinema to Google Street View, from place-bound identities to geotargeting in social media. The archaeomodern cinema of the late twentieth century emerges during the brief transitional moment in between.

Archaeomodern Images

On the frontispiece and in the introductory remarks of *Les Mots and les choses* (1966), Foucault submits Velázquez's *Las Meninas* (1656) as Exhibit A in his overview of the classical mode of representation, an episteme that, according to Foucault's periodization, extends from the late sixteenth century into the nineteenth.[113] *Las Meninas*, he argues, delineates the system of classical representation itself and provides "the definition of the space it opens up to us."[114] Proceeding from Foucault's virtuoso analysis (and often adding a soupçon of Lacan) critics have adopted *Las Meninas* as a blueprint of the structures of classical representation and a theoretical model for the relationship between images and the viewing subject. In these hands the painting becomes an illustration of the traps strewn throughout every picture, and its moments of liberation open onto yet more traps, as the viewer wanders among a strictly limited series of subject positions: viewer, artist, sovereign. An orchestration of imbricated fantasies, the model of classical representation dangles a promise of privilege and mastery before the spectator, beckoning the subject to exchange the absent real for a normalized illusion of plenitude. In one of innumerable examples of this gloss on Foucault, Jean-Pierre Oudart writes, "The spectator, excluded from the representation, is involved in it in a phantasmatic way: he is now inscribed as a subject by a compositional arrangement which will proceed to mask its theatrical origins ever more effectively, in a figurative system which will present its effects of the real as effects of optical reality (reflections, light and shade, discontinuity of planes, etc.) which are the traces of the inscription of the subject in the form of a lack."[115] In Foucault's historical writings, the era of Velázquez ushers in modern modes of discipline and incarceration,

resulting in a political climate described by Maravall, Hauser, and others wary of the ministrations of the period's "guided culture." Foucault's study of *Las Meninas* has buttressed that argument, as the mode of classical representation constrains the viewer in ways consistent with the era's other disciplinary interventions.

The shortcoming of Foucault's essay lies in the primary and ultimate importance bestowed by fiat on the system of Albertian perspective. Although it toys with the disorienting possibilities of the movement initiated by the painting, although it considers in detail the baroque instability of *Las Meninas*, the essay finally situates Velázquez at the farthest verge of—but still safely within—a classical paradigm. While the bulk of the essay responds to an emblematic image of the artist struggling against the confines of the classical, Foucault reverts in the last instance to what Svetlana Alpers calls a "determinate and determining notion of classical representation."[116] The genius of the essay lies, however, in those lengthy descriptions of the painting's "subtle system of feints," its continuous "oscillation" among various subject positions, the endless "cycle" leading the gaze from the objects of representation to the craftsman's tools, from pictured bodies to painted reflections, from the inside of the frame to the unbounded world outside.[117] Those movements expose the obsolescence of the classical representational system, its inadequacy when charged with representing simultaneous and shifting identities that haunt a single, fixed point before the canvas. In a transposition of the practice of anamorphosis, the painting registers the instability of the artist, sitter, and spectator rather than the contortions of its content viewed from shifting perspectives. While Foucault writes of variations sacrificed to an illusion of truth, the painting also illustrates what Deleuze calls "the truth of a variation."[118] In his study of the baroque fold, Deleuze writes, "The point of view is not what varies with the subject, at least in the first instance; it is, to the contrary, the condition in which an eventual subject apprehends a variation (metamorphosis), or: something = x (anamorphosis). . . . It is not a variation of truth according to the subject, but the condition in which the truth of a variation appears to the subject. This is the very idea of Baroque perspective."[119] This variable and fluctuating perspective allows Velazquez to "[rule] at the threshold of . . . two incompatible visibilities."[120] While Foucault's analysis foregrounds the act of misrecognition (*méconnaissance*) that establishes a position of spectatorial privilege, his itinerary through the painting plots a trajectory of mutually incompatible recognitions, a series of impossible identities that threaten the concept of identity itself and any system predicated on the singularity of the viewing subject. Apropos of *Las Meninas*, John Searle writes, "In the classical conception there is a connection between what is painted and the possibility of painting it, for the whole conception of art as imitation was a conception of the artist producing an imitation of what he saw."[121] But in *Las Meninas* "what we see never resides in what we say," as difference intercedes between the seen

and its representation on canvas or in the many narratives conceived as keys to the goings-on during this immortalized moment in the court of Philip IV.[122] Confronted with the limits of the classical, the painting gestures toward the invisible, the impossible, or, to use the Leibnizian term dear to Deleuze, the "incompossible." It rejects the fixed perspective and hierarchically rendered space Aristotle authorizes as the basis of representation, and it occupies the very cracks papered over in that system. It is art predicated on its own instability; it is a canvas "distorted, diverted and torn from its centre."[123]

Foucault's essay on *Las Meninas* ultimately curbs the process of folding initiated in the painting, as it reestablishes the ruling authority reflected in that mirror on the rear wall. At that privileged position in the paradigm of classical perspective—the crucial site where the orthogonals converge—a mirror becomes the index of truth to authorize a reassuringly final perspective on the image. Like a photograph or cinematic still, that mirror fixes a particular moment, mummifying regal bodies, imposing constancy on a scene where movement once reigned. Yet Foucault's essay places an extraordinary and unbearable burden on that mirror. In his analysis, at that single point of convergence, artist, subject, and spectator likewise congregate, realizing a virtually "theological" transformation through "the unity of this trinity and the trinity of this unity."[124] As Joel Snyder and Ted Cohen point out, insofar as it assumes the coincidence of that mirror and the vanishing point in one-point perspective, Foucault's argument rests on a technical error: he misidentifies the point where the orthogonals come together, displacing it from its actual position—the figure, usually identified as the queen's attendant, standing in the doorway—to the mirror.[125] But notwithstanding this important objection, Foucault's insistence on the classical foundations of *Las Meninas* also vanishes in that enchanted glass. That framed surface on the back wall can reinforce the unity of artist, viewer, and ruler only by violating the physical and optical laws that classical conventions hope to duplicate, and only by transforming that mirror into a device that records or projects images from another time instead of reflecting the scene immediately before it. It reins in the elusive movements of the painting only by pretending that the enduring image in the mirror, this persistent reflection, is the most natural of phenomena. On that mirror—the device that becomes for Benjamin and other early theorists of cinema "an anticipatory fore-form of the modern media"—an untimely and prophetic object is overlain.[126] In the most paradoxical of his many analogies for the cinematic screen, Bazin writes, "It is false to say that the screen is incapable of putting us 'in the presence of' the actor. It does so in the same way as a mirror—one must agree that the mirror relays the presence of the person reflected in it—but it is a mirror with a delayed reflection, the tin foil of which retains the image."[127] Like the mirror at the heart of *Las Meninas*, Bazin's impossible tinfoil becomes a supernatural medium: it records a world and projects its afterimage; it reflects reality but only after violating the

fundamental optical principles of the mirror, whose images are by definition dependent on the continued presence of an identical subject and spectator. In the case of *Las Meninas* that reflection is also a recorded and projected image with its own reality.[128] If "the heart of the paradox presented by the Meninas is in that mirror," then that incongruity is constructed around not only the identity of the beholder or sitter or artist, but also the bizarre, anachronistic, photographic or proto-cinematic glass that captures and projects the image of a vanished subject who once stood before it.[129] Perhaps for this reason critics have long commented on the eerie effects produced by *Las Meninas* as it transforms viewers into "spiritualistic mediums who complain that they are being disturbed by 'presences.'"[130] Those haunting presences include the baroque challenge to the classical system of representation and the anticipation of new media—the photographic and the cinematic—within the baroque. Through its constitutive paradox, its confounding of physics, Bazin's mirror betrays the limits of a naïve conception of cinematic realism and the classical representational paradigm. Foucault's magical mirror also transforms *Las Meninas* into an object of media archaeological excavation and a premonition of the theoretical problems that film and media studies have revolved around for over a century. In an essay devoted to Freud's "magical writing pad" and its relation to media theory, Thomas Elsaesser argues that Freudian psychoanalysis was concerned at the most fundamental level with memory and that the *Wunderblock* was an imaginary solution to the concrete problem of preservation during a period of modernization and sensory overload. In Freud's implicit and incipient theory of media technology, "an apparatus, considered as archive or memory, needs to differentiate clearly and separate the transmission function (mirror or feedback) from the storage function (memory or 'forgetting')."[131] Foucault's reading of *Las Meninas* hinges on the undecidable status of the mirror that seems alternately to transmit images and to store them. On the back wall of the royal palace, in a painting that allegorizes the process of painting and representation, that key point in the image, a location that belongs at once to the baroque and a modern media environment, becomes what Ernst calls a "media-archaeological short circuit."[132]

The conceptual categories of art history and media studies collapse in these haunted mirrors, and in place of those paradigms we see images that are at once visions of the past and technological marvels, momentarily still but unstable and unsettling, archaeological and modern. *Las Meninas* invokes and eradicates familiar ways of seeing and knowing, but alongside the spectacle of royal glorification and formal pyrotechnics, it also presents an allegory of the archaeomodern. Foucault's virtuoso account of *Las Meninas* views it as a cinematic painting, a canvas that gestures toward both modern representational technology and the tradition of royal display, a work of art that weaves together seemingly incompatible temporalities and systems of representation. Written at the end of a long artistic sequence dominated by mechanical media,

Moving Pictures, Still Lives is also the story of cinematic paintings that conjure up delayed reflections and set frozen images in motion. Looking at the history of cinema in retrospect and at the digital revolution in anticipation, the films and theory of the late twentieth century linger at the threshold between two ways of seeing, between the powerful illusions that inspired the century of cinema and the digital fantasies of today.

The Cinema of Painters

This book unfolds over two sections, beginning with theory and ending with images. The first section revisits three of the most influential figures in film and media theory during the late twentieth century. First, it considers the belated recognition and canonization of Benjamin's writing on cinema and the resonance of his analysis of film's revolutionary potential almost a half century after its publication. The first chapter links Benjamin's writing on the baroque mourning play to the revival of allegory in the late twentieth century and argues that his often-overlooked meditations on allegory and ruins provide a more relevant theory of the old medium of film than his more renowned essay on cinema and mechanical reproduction. The second chapter engages with the monumental cinema books of Deleuze from the 1980s, which, despite their innovations and idiosyncrasies, are also products of their time and grapple with the late twentieth century's characteristic concern with history, memory, and belatedness. This chapter seeks to historicize his work and consider the implications of his status as a latecomer in the long tradition of film theory. Chapter 3 engages with the immensely important but neglected work of Serge Daney, especially his meditations on the act of watching films on television. Daney suggested that he was looking at cinema and the century in the "rear-view mirror," and his work examines the implications of the aging of the quintessential modern art and its passage into a new era of media proliferation and saturation. Rather than view these three influential theorists as spokespeople for the revolutionary modernity of the medium, this section rereads them as eleventh-hour philosophers of cinema who reconsider the history of film only after acknowledging that it failed to live up to the promises made by its most forceful advocates in the early twentieth century. It reframes their work on film as a mourning play for revolutions past and a means of reviving the possibilities of the modern age (and its paradigmatic medium, cinema) during periods of political and cultural retrenchment.

The second part of the manuscript, titled "The Cinema of Painters," is structured around a series of interactions among media, filmmakers, and national traditions. It examines the work of late twentieth-century filmmakers who systematically deployed strategies normally associated with other visual media or art forms, especially painting. Theories of new media often emphasize

the "painterly" aspects of digital production, as when Manovich argues that the "manual construction of images in digital cinema represents a return to nineteenth century pre-cinematic practices, when images were hand-painted and hand-animated."[133] In the digital age, cinema has become a "sub-genre of painting."[134] The films of the late twentieth century adopted a very different model of painting that focused not on the palette repurposed as a metaphor for the digital toolkit but on the canvas reimagined as a short-circuit in the flow of cinema, a site where the "dialectical relationship between old and new media" produces what Mulvey calls an "aesthetic of delay."[135] The directors in this cinema of painters reject the standard models of film as a storytelling medium or vehicle for special effects and instead fill the frame with a succession of tableaux vivants, still lifes, illuminated manuscripts, and landscapes. They view painterly devices, the canvas, and the frame not through the lens of nostalgia but as portals to earlier conceptions of modernity, including the mannerist and baroque age. They also merge the history of painting with the centuries-long prehistory of mechanical and digital media, calling into question the familiar narratives of rupture and revolution used to characterize modern times. Viewed collectively, the cinema of painters removes cinema from its habitual position as the paragon of modernity and positions it within the long history of archaic art forms that linger on after their original moment of power or promise. Individual chapters focus on the use of the tableau vivant in the films of Jean-Luc Godard and Derek Jarman (chapter 4), the cinematic still lifes of Alain Cavalier and Terence Davies (chapter 5), the animated and illustrated books on display in the work of Peter Greenaway (chapter 6), and the approach to landscape cinematography in a series of films and digital documentaries—*Vagabond* (1985), *The Gleaners and I* (2000), and *The Beaches of Agnès* (2008)—by one of the first (and one of the last) great directors of the French New Wave, Agnès Varda (chapter 7). Through her images and her observations in voice-over, Varda conceives of a new role for the filmmaker in the late twentieth century: the gleaner who returns to a virtually abandoned landscape and rediscovers both the waste and the vast profusion left behind at the end.

Theory and the Modern Past

The Hauntology of the Cinematic Image

WALTER BENJAMIN, MODERN MEDIA,
AND THE MOURNING PLAY

The spirit world is ahistorical. To it the *Trauerspiel* consigns its dead.

—WALTER BENJAMIN, *THE ORIGIN OF GERMAN TRAGIC DRAMA*[1]

Contemporary critical theory has been swarming with ghosts. These hauntings have proliferated because, after several decades of apocalyptic rhetoric prophesying a series of decisive ends—of the nation, history, art, cinema, and many others—the same artistic and intellectual traditions have yet to bury even the long departed. To the spirit world they consign their dead. And like the ghost in *Hamlet*—the apotheosis of the baroque *Trauerspiel*, according to Walter Benjamin—those specters return, bearing obscure petitions from an ahistorical beyond, demanding justice in the material world, provoking a violent clash of history and its aftermath. With no proper space or temporality, the ghost exists in an enigmatic state on the verge of both reanimation and vanishing. Neither past nor present, neither here nor there, it lingers on.

The following chapter is concerned not with the contemporary specter in all its forms, but with the prominent strand of film and media studies that views cinema as an old, dying medium even as it writes about the lingering presence of that medium and its afterlife in the digital age. I focus in particular on the work of Benjamin, who developed the most influential account of cinema's relationship to modernity and whose work endures in contemporary media theory, despite the vast difference between the revolutionary shock of early cinema and today's ecology of omnipresent images. Benjamin has for decades exerted a profound influence on film theory and art history, primarily through his famous "Artwork" essay from 1936, which was widely dismissed and drastically reedited by his colleagues at the Frankfurt School and which found an avid readership in the turbulent political climate of the time. The essay was rediscovered by Marxist critics in the 1970s but only ascended to its current canonical status in the 1980s. Benjamin's essay on the potential of early cinema finally found its mass, global audience in the late twentieth century. At the same time, another, more recent Benjamin revival in critical theory has

reawakened interest in a wider array of his work, including his writings on baroque allegory, which have contributed to the reassessment of allegorical tendencies in postmodern art and criticism. If Benjamin has projected a much more imposing presence over the past three decades than during his lifetime, what does this spectral figure say to or even demand of contemporary critics?

During this return of and to Benjamin, invocations of his work have been founded on the tacit assertion that the elements of European modernity foremost in his mind—the shocks occasioned by new technologies of image reproduction, modernity's assault on tradition, and the relation of the image to history—have migrated to the center of recent cultural debates. Mobilizations of his writing therefore imply that an underlying continuity links the modern condition described by Benjamin and our own. Also implicit in this scenario is what Richard Wolin calls the "danger of overidentification," which threatens to muddle the historical particularities of the early twentieth century and the late, including the distinction between mechanical and digital reproduction.[2] As Irving Wohlfarth wrote in the early 1990s, "The relation between Benjamin's now and ours is one of intense closeness and distance—not the emphatic closeness or the safe distance which form the two sides of the historicist coin."[3] One limitation of the Benjamin revival is therefore the inverse relationship between the intensity of his writing and the familiarity and safety that inevitably accompany the accrual of academic authority. For Shoshana Felman the best response to the volumes of recent work on Benjamin is yet another revenant of Benjamin, the one who writes in praise of the listener, "the silent one," "the unappropriated source of meaning."[4] Unable to reconcile that tribute to silence with the commotion his thought has atavistically produced, Felman writes that "the task of criticism today is not to drown Benjamin's texts in an ever growing noise but to return Benjamin to his silence."[5] The "critically repetitive mechanical reproduction of his work" overwhelms the untransmittable "instances of silence" less amenable to the aims of criticism.[6] Like Felman herself, anyone writing about Benjamin today must consider the enervating effects of reflexive repetition, while also recognizing the potential danger of concluding that the rest is silence, of failing to understand the provenance and urgency of this hue and cry.

With Felman's admonitions in mind, we should also consider the possibility that Benjamin's writings have reemerged so often in recent critical theory not because their meaning has been exhausted or appropriated but because the Benjamin revival remains tentative and incomplete, despite the long litany of books, essays, and citations. Nowhere has the resurgence of Benjamin been more fitful and erratic, more beset by this disquieting mix of noise and silence, than in the field of film and media studies, where his foundational influence is everywhere displayed, but often at the expense of other, less clamorous versions of Benjamin. To the extent that Benjamin's legacy has been skewed toward the positions advocated in the "Artwork" essay—a masterful theory of

modernity that nevertheless has exerted a domineering and disproportionate influence in the study of cinema and modern visual culture—it devolves too easily into a defense of modernist eradication and a denigration of whatever lingers on. The "Artwork" essay commends the radical disruption of tradition made possible by modern technologies of reproduction, including the cinematic apparatus.[7] But after celebrating the machine's capacity to shatter the illusion of perpetual continuity that leaves the present mired in tradition, and after silencing that history, the essay never posits an alternative historicity to stem the forgetting of the past. A very particular spirit of Benjamin, glimpsed at the height of his "liquidationist" phase, has become an indispensable arbiter for those seeking to understand images reproduced through technical means and outside the aura of art.[8] Through his halting, constantly fluctuating, faceted approach to the fundamental problematic of modernity—the necessity of revolution and the danger of eradication—Benjamin adopts various incompatible perspectives on a predicament faced by artists and critics from his time onward. Are modern technologies of reproduction forces of destruction aligned with broader manifestations of industrial and mechanical modernity? Or, as theorists like André Bazin suggest, do they participate in age-old rituals of preservation, like twentieth-century versions of the sarcophagus? To advocate for the positions canonically attributed to Benjamin ignores the paradoxes that haunt his work and succumbs to what Fredric Jameson calls the "false problem of the antithesis between humanism (respect for the past) and nihilism (end of history, disappearance of the past)."[9]

Miriam Hansen revised this standard account of Benjamin by returning to the second draft of the "Artwork" essay and jettisoning the third, "multiply compromised" version edited under the influence of Adorno.[10] While this third draft (the one included in *Illuminations*, the familiar English translation of selected Benjamin essays) distributes the entire field of cultural production into a series of neat binary oppositions, Hansen spies in the earlier typescript a different Benjamin obsessed not with liquidation but with play in its multiple manifestations, with *Spiel* defined variously as "game," "performance," "gamble," and "play."[11] In her exhaustive treatment of the various forms of play considered in Benjamin's writing on cinema, Hansen counters the conventional wisdom that situates Benjamin securely on one side of a false dichotomy between tradition and modernity. But because it attempts to replace the lifeless and mechanistic Benjamin with his alternately playful and calculating double, Hansen's essay leaps past his writings on other arts and media that neither portend catastrophe nor create a "space for play." Most noticeably, the essay begins by "bracketing . . . another sense of *Spiel* associated with dramatic art, the noun that forms part of the composite term *Trauerspiel*, literally play of mourning."[12] The following chapter engages directly with this other, less ludic, more traumatic understanding of *Spiel* and its implications for film and media studies. The theory of cinema proclaimed in Benjamin's latest version of the "Artwork"

essay was always a quixotic attempt to revive utopian ambitions left unrealized long before its publication in 1936, and his theory of art in the age of its mechanical reproducibility also requires a theory of mourning for the emancipated future glimpsed there in passing. At the moment when the aspirations of early cinema yield to the retrospective gaze of history and media archaeology, a mourning play unfolds.

What follows is an attempt to unsettle a canonical account in film and critical studies by returning to the ideas that haunt Benjamin's better-known "Artwork" essay, especially the theory of allegory developed in his study of the baroque *Trauerspiel*, then elaborated and modified in his last writings. Viewing media history as a mourning play, as a suspended spectacle rather than a tale of technological triumph or a tragedy marching toward resolution, this chapter is an exercise in reading the silences and erasures in Benjamin's film theory and in the thinkers conventionally viewed as his intellectual antagonists, including Bazin. While Benjamin's study of the baroque mourning play advocates "an uncompromisingly radical modernist aesthetic in all but name," it also prefigures his writings on the philosophy of history, positing allegory as a force simultaneously of destruction and preservation, as a spectral strategy in which the departed both persist and attest to their own demise.[13] What survives in this account is not the liquidationist Benjamin or the technological determinist who emerges from reductive accounts of his work, but a philosopher who remains attuned to what modern art transmits through the din of mechanical reproduction. This Benjamin is concerned not only with the machinery circulating through city streets or projecting a displaced world on a flickering screen but also with the histories and traditions that linger on in the wake of modernization. Jacques Rancière identifies an "archaeomodern turn" in Benjamin's late work, which rejects a straightforward transition from the "not yet" of prehistory to the "too early" of the modern and the postmodern, and instead takes "one turn *more*."[14] In some of his earliest and latest writing, especially in his study of the *Trauerspiel* and his unfinished Arcades Project, the archaeomodern Benjamin explores this imbrication of the past and future and offers his most compelling insights for the study of modern media. Mechanically reproducible media are both repositories of the past and the machinery that drives historical transformation. They are at once forces of preservation and technological devices like any other. They exist in an ambiguous temporal state between the return to the past and the anticipation of the future. They are archaeomodern. Incorporating Benjamin's work into the study of modern and contemporary media leads us back to his fragile, haunted histories of modernity and his idiosyncratic tales of vanishing and return. Or, as Andreas Gryphius writes in his apology for the ghostly incarnations appearing on the baroque stage, that era's peculiar variation on the *deus ex machina*, "If anyone should find it odd that we do not bring forth a god from

the machine, like the ancients, but rather a spirit from the grave, then let him consider what has occasionally been written about ghosts."[15]

Haunted Screens

Cinema and media studies has been the intellectual field most haunted by ghosts. As Jeffrey Sconce points out, from the nineteenth century onward new communications technology has been at once estranged and domesticated through the language of spectrality, with dead machines responsible for creating an aura of "liveness" and presence.[16] Friedrich Kittler detects a similar level of superstition in the early reception of telephones that somehow managed to combine the dead with the living, "steel with flesh": "Wherever phones are ringing, a ghost resides in the receiver."[17] Recent writing on the "deep time of the media" and "zombie media" (a variation on the theme of spectrality, with the zombie more alive than dead and the ghost more dead than alive) suggests that communications technology often marks the threshold between modernity and the never entirely obsolete past. For this reason, Jussi Parikka describes media archaeology as a "Benjaminian" project designed to revive the unrealized aspirations of discarded and seemingly forgotten media technologies.[18] Moving images and recorded sound have been the principal inspirations for this haunted history and theory of media, but the same spirit has also guided writing on photography, as the medium's mechanical recording of reality reveals both the phantasmatic presence and traumatic absence of the subject visible in the image. The photograph bestows a second life on the past, but it wavers precariously between a document of original vitality and an occasion for mourning the absent figures and worlds that seem so close at hand. Commentators have long remarked on this aspect of the medium, as Roland Barthes, for example, writes that the photograph is "the living image of a dead thing," and photography itself is "a kind of primitive theater, a kind of *Tableau Vivant*, a figuration of the motionless and made-up face beneath which we see the dead."[19] Eduardo Cadava extends Benjamin's observation that in the *Trauerspiel* "the dead become ghosts," applying it to the similarly enclosed and stilled space of the photographic image: "The return of what was once there takes the form of a haunting. . . . The possibility of the photographic image requires that there be such things as ghosts and phantoms."[20] This history of haunted images dates back to the earliest days of photography, which from the outset combined the most advanced technology of reproduction and the most archaic conception of a spirit world. And it continued into the age of cinema and beyond, establishing a logic of persistence that belies the assumption that the introduction of new media technology signals the end of the line for rickety old contraptions and their outmoded superstitions. As

Kittler writes, "Ghosts, a.k.a. media, cannot die at all. Where one stops, another somewhere begins."[21]

Although the creation story of cinema usually leads back to the practical scientific pursuits of Thomas Edison and the Lumière brothers, film theory has often ventured into the spirit world. Bazin's influential essay on the origins of cinematic realism, "The Ontology of the Photographic Image," begins with a cryptic remark about the psychological factors motivating artistic production. "If the plastic arts were put under psychoanalysis," he writes, "the practice of embalming the dead might turn out to be a fundamental factor in their creation. The process might reveal that at the origin of painting and sculpture there lies a mummy complex."[22] Bazin argues that cinema sustains this calling, this ability and obligation to preserve, even more powerfully than its predecessors because, as a neutral, mechanized instrument, the camera can record reality with greater fidelity to its object. In a mythic "total cinema," modern artists and audiences would realize, at long last, this desire for perfect preservation. Although Bazin's "mummy complex" was for decades one of the most maligned concepts in film theory, on the most general level it does describe a peculiar, ghostly power of plastic arts: home movies and family photographs, documentary footage from the archives, and films from bygone eras all possess an undeniable capacity to inspire affective responses, resulting ultimately in nostalgia or keen pangs of loss that frustrate the clinical or hackneyed or merely inadequate designations used to characterize those responses in retrospect. To belittle Bazin's "mummy complex" ignores one fundamental personal and social function of art in people's everyday lives. Because archives of images can also uphold the traditions that allow communities to survive the threats and assaults of history, that process of preservation also links these arts to historiography. Of course, films also manipulate those same responses, as, for example, historical films can exploit the appearance of a perfectly mummified past in order to bolster an already widespread understanding of history. As countless critics of Bazin have emphasized, the cinematic apparatus is never used neutrally in a real-world environment and only particularly valuable bodies and objects are deemed worthy of mummification.

This critique notwithstanding, Bazin's numerous interlocutors have paid far less attention to the most bizarre aspect of the impossible scenario imagined at the outset of this essay: rather than administer psychoanalysis to the usual suspects—a human being or, in the realm of cultural criticism, a fictional character or an author accessible mainly through a text—Bazin places the chimerical bodies and psyches of the media themselves on the analyst's couch in order to discover some posited primal desire. The traditional arts and modern media speak about their own aspirations and the motivations of the people who invented and practiced them. Although Bazin alludes to popular impressions of Luxor and amateur Egyptology, his absurd animated canvases, sculptures, and cameras also recall the dancing and speaking table of Marx's

Capital. In a striking moment of quickening and ventriloquism Marx compels the table, a repository of labor and human desire, to tell the story of its production and reveal the social relations embroiled in that process.[23] Bazin likewise asks various arts, again imagined as repositories of labor and desire, to unveil the psyche of the species responsible for their creation. Both scenarios—the anthropomorphic rhetorical gesture, followed by an unanswerable question, followed by a presupposed, speculative answer—betray a sense of desperation, an implacable desire to found an argument on the essential but hidden nature of things. The desperation underlying Bazin's argument becomes more poignant when his context is taken into account. In the middle and aftermath of World War II, with the tragic effects of aestheticized violence and politics virtually inescapable in Europe, Bazin's cool and quasi-scientific appeal to a neutral apparatus obscures a frantic attempt to salvage a decimated communitarian spirit through cinema, with movies helping to organize a world in the throes of rebuilding by projecting a shared reality for everyone to use as the foundation of that reconstruction. Despite his arguments for a timeless, realist essence of cinema and its sister arts, Bazin's theories were also local and historical, as he advocated a cinema bent on revealing the interconnectedness of audiences whose residual faith in that unity had been shattered beyond repair. In this sense, Bazin's theory of cinematic realism was an untimely meditation on a devastated world, on the ruined spaces and societies that would eventually become the focus of Gilles Deleuze's account of cinema after the war. In the process of imagining a realist essence of the medium, Bazin resuscitates and transforms an anachronistic conception of cinema: the filmed image is the thing itself, he asserts, and this truth has been evident since the advent of the medium. Bazin inserts that mythological tale of origins into the history of all the plastic arts, and his talking statues and pictures, like Marx's animated and ventriloquized table, are the products of a desire for the preservation and recognition of reality at the core of artistic creation and especially modern reproduction. More than any longing to embalm the dead, he betrays a utopian wish to preserve an ontological reality against the dangerous illusions of spectacle and to rediscover vanquished communitarian possibilities within the ruins war had already wrought.

But that is not Bazin's last word on the ontology of the photographic image. In his 1951 essay on "Theater and Cinema," Bazin describes cinema as "a mirror with a delayed reflection," as an enigmatic tinfoil that "retains the image."[24] Like reflections in a mirror, the bodies, objects, and spaces that appear on a screen resemble their counterparts in the real world, but they only resurface after an obscure interval of displacement and delay, vanishing and return. The cinema is marked by both realism and revenance. As in the uncanny mirror hanging on the palace wall in *Las Meninas* of Velázquez, a film reveals both material and ghostly forms.[25] And while he began the "Ontology" essay by evoking a "mummy complex," Bazin returned to the essay over a decade later

to add an equally cryptic ending: "On the other hand, of course, cinema is also a language," with "language" becoming the figure for the analysis and dissection performed on reality, for the medium's capacity to rupture an ostensibly continuous unfolding of time and space, for the already absent referent of cinema.[26] In a moment of rhetorical legerdemain, Bazin shifted to "the other hand" the disruptions and disunity that haunted his conception of cinematic realism. Later generations of theorists would seize on that gesture and write of a cinema structured like a language, using that analytical tool to deconstruct standardized and cynically false illusions of unity rather than to construct a hopeful illusion. As he resurrected a myth of total cinema, Bazin also maintained a penchant for paradox, for the abrupt gesture that confounds his theory of realist cinema's unity of time and space with an equal and opposite logic of the fragment. But that critical gesture, that specter of a cinema characterized by disruption and dislocation, was always irrupting within Bazin's understanding of filmic ontology. Bazin's argument from ontology is predicated not only on the capacity of cinema to record the material world present before the camera but also on the reality of ghosts.

Based primarily on his "Artwork" essay, Benjamin has often been characterized in film and visual studies as the antithesis of Bazin, as an advocate for certain aesthetic and political avant-gardes, and as an apologist for the obliteration left in their wake. Benjamin's belated manifesto for a radical modernism argues that the machinery of mechanical reproduction initiates a profound break with age-old modes of representation and reception, destroying the "aura" that binds art to tradition and puncturing the quasi-religious, cultic shroud that isolates art from history. Benjamin and Bazin therefore attribute diametrically opposed functions to the modern machinery of reproduction: for Benjamin cinema operates as a force of disruption within the history of art, shocking the viewer into an estranged relationship to images and the tradition they embody; for Bazin the invention of cinema marks a further evolution of painting and photography into a more realist medium because it records a direct imprint of the world and upholds the possibility of an integral vision of time and space. But, like Bazin's untimely essay on the ontology of the photographic image, Benjamin's "Artwork" essay was anachronistic long before its publication, as it argued for cinema's inherent radicalism despite overwhelming evidence of its potential co-optation. At the time of the "Artwork" essay cinema had already transitioned from the most innovative cultural phenomenon of the machine age to the beleaguered avant-garde of a failed revolution. Hansen characterizes Benjamin's shifting relationship to the medium, especially his celebration of Soviet montage and his critique of the actuality of institutionalized cinema in the 1930s, as "tactical belatedness."[27] Far from diminishing the force of the essay, however, the "belated moment of the Artwork Essay only enhances the utopian modality of its statements, shifting the emphasis from a definition of what film *is* to its failed opportunities

and unrealized promises."[28] Like Bazin's "Ontology" essay, Benjamin's theory of cinema posits a mechanical essence of the medium and confronts the contradictions inherent in that faith in technological deliverance.

Although Benjamin's vindication of the shocks of modernity has become his canonized position in film theory, challenges to that position surface throughout his writing, in the "Artwork" essay and elsewhere. What contradicts this enthusiastic defense of the techniques of mechanical reproduction? What haunts Benjamin's modernity? Like Bazin, Benjamin puts modern media on the couch to confront their apparitions, especially in his elusive concept of the "optical unconscious," which endows the arts of mechanical recording with a power of accidental and incidental preservation just after identifying their more fundamental tendency toward destruction. Benjamin's "Artwork" essay, the epitome of his "liquidationist" mode, is haunted by the fear that the eradication wrought by modern technology will result inevitably in the loss of unrealized utopian possibilities. And his work as a whole reveals its own variations on the "mummy complex," with the storyteller and the ragpicker becoming unlikely forces of preservation. Over the course of his career and sometimes within the space of a single essay, Benjamin the arch-modernist also develops an idiosyncratic repertoire of survival strategies.[29] The Brechtian Benjamin, who embraces the radical disruptions wrought by mechanical reproduction and celebrates their capacity to dislodge the restraints of inherited ideology, coexists tenuously with the Benjamin who remains equally concerned with obsolete or esoteric elements of tradition, with an almost forgotten history that retains the capacity to displace received wisdom about the past.

Benjamin's thought wanders between the terms of this dialectic, embracing the possibilities of mechanical reproduction and then attacking the myth of progress inherent in many conceptions of modernity, welcoming a mechanized emancipation from oppressive traditions and then lamenting the lost potential harbored in obscure reaches of the past and destroyed by the blunt instruments of modernity. He oscillates between a desire to recover traditions on the verge of oblivion and an abiding disgust at the ways tradition is habitually preserved and submissively venerated. In the "Artwork" essay, written in the context of the rise of the Nazi Party in Germany, all appeals to tradition are tainted with the threat of fascism, whose aestheticized politics constantly invokes an enduring organic community, upholding the promise of return, establishing an ersatz continuity amidst precipitous social and technological change.[30] But Benjamin's work is also plagued by the fear that modernism's quest for absolute novelty is neither realizable nor desirable: some elements of the past will persist because of their instrumental value to the powerful and to the institutions charged with perpetuating an official history; others will vanish into oblivion, leveling history into a complacent and unthreatening expanse of heritage. "From what are phenomena rescued?" he asks. "Not just or not so much from the ill-repute and contempt into which they've fallen,

but from the catastrophe when a certain form of transmission often presents them in terms of their 'value as heritage.' "[31] In his philosophical précis for the "Arcades Project," Benjamin writes, "There is a kind of transmission that is a catastrophe," and mythologies of the uniform organic community glorify that tragedy of continuation.[32] Benjamin diagnoses beneath the conspicuous new façades of modernity an equally insistent cycle of recurrence. As Wolin argues, he "uncovers a mythical compulsion to repeat under the guise of 'modernization.' "[33] For Benjamin tragedy and *Trauerspiel* represent two approaches to the crises of modernity: the former responds through mythical invocations of an enduring tradition, bestowing meaning on the present by affirming its continuity with the past; the latter mourns amidst the ruins looming over the stage, concrete manifestations of the demolition of mythic structures and the suspension of time. The baroque mourning play rejects the palliative or restorative function of tragedy and disrupts the ultimately catastrophic process of retreat into the "always-the-same," the mythical permanence that obscures the "time of the now."[34] Jürgen Habermas suggests that "cultural goods are spoils that the ruling elite carries in its triumphal parade," and Benjamin directs his critique at the cultural objects perpetually on parade and the waymarks that guide this process of repetition.[35] And Benjamin praises writers like Kafka, whose work is valuable precisely because it "presents a sickness of tradition."[36] Benjamin embarks on a salvage operation oriented toward the neglected traditions under threat of extinction and the "now-times" lying dormant within musty vaults of institutionalized culture.

Even during his most radical phase Benjamin suggests that tradition may maintain some atavistic value, especially when reduced from a state of captivating grandeur to a less exalted condition, from a monumental spectacle to a state of stillness or ruin. At such moments of depredation, tradition emerges from its mythological façade and exposes the "jags and crags" that provide a "handhold" and allow us to "move beyond" it.[37] As Hansen argues, the "Artwork" essay embraces mechanical reproduction primarily for its destructive capacity, but it therefore abandons the still-potent spheres of aesthetics, tradition, and, ultimately, history to conservative or reactionary politics.[38] And while Benjamin's "Artwork" essay betrays a fascination with the possibilities of excessive speed, as in his enthusiasm for the "shocks" ushered into modern art by the advent of moving pictures, his writing often favors the opposite extreme, with the photographic image representing the possibility of a history arrested within or wrested from the mechanical motion of modernity. For Benjamin the photograph offers not the misguided promise of an artificial and potentially destructive myth of progress, but an opportunity to contemplate "dialectics at a standstill."[39] The stillness inherent in Benjamin's conception of history and his critique of capitalist modernity also characterizes his early study of the German baroque *Trauerspiel*, which stages history through a procession of arrested images. As Cadava argues, photography and the baroque

stage are closely related in their representation of a momentarily halted history: "Like the stage setting that in Benjamin's *Trauerspiel* book names the spatial enclosing and freezing of history, photography names a process that, seizing and tearing an image from its context, works to immobilize the flow of history. This is why, following the exigency of the fragment or thesis, photography can be said to be another name for the arrest that Benjamin identifies with the moment of revolution. Although Marx identifies revolutions as the 'locomotives of world history,' Benjamin suggests that 'perhaps it is completely otherwise. Perhaps revolutions are, in this train of traveling generations, the reach for the emergency brake.'"[40] Photography's capacity for suspension, interruption, and interference informs Benjamin's approach to the writing of history and criticism, endowing his aphoristic prose style with a quality that Susan Sontag describes as "freeze-frame Baroque."[41] And the idiosyncratic formal experiments that appear throughout his writing—the thesis or fragment, the montage of quotations, the travelogue composed of impressions strung tenuously together—adapt the structure of the *Trauerspiel* book's often unsettling and enigmatic mosaic of quotations. That style itself mimics the appearance of the baroque stage viewed by Adorno as a space dedicated to the "enclosing and freezing of history" within single images, to the "spellbinding, philosophical gesture that freezes the animate."[42] This freeze-frame baroque is the philosophical and aesthetic foundation of Benjamin's theory of history because it opens onto a past frozen in time and outside both a hegemonic heritage and the devastation of modernity.

As Adorno points out, however, these states of stillness and speed coexist in a complex relationship because extreme immobility can serve as a platform for the most elusive velocities. Reviewing Benjamin's *One-Way Street* (1928), Adorno remarks that the book's stuttering, fragmentary style, its halting presentation of "dialectics at a standstill," is paradoxically charged with setting "thinking in motion." Adorno then extends this observation to the whole of Benjamin's work, arguing that "one only understands Benjamin correctly when one senses behind every one of his sentences the sudden reversal of utmost movement into something static, indeed into the 'static' idea (*Vorstellung*) of the movement itself."[43] Nothing exemplifies this migration between extremes more markedly than his simultaneous fascination with the shocks of modernity and the stillness inherent in the photograph. Benjamin's writing on the *Trauerspiel* anticipates these alternating forces of flight and rest, as it highlights the dramatic conclusion that crescendos into a conflict between exodus and arrest: "Again and again, in Shakespeare, in Calderón, battles fill the last act, and kings, princes, attendants, and followers 'enter, fleeing.' The moment in which they become visible to spectators brings them to a standstill. The flight of the *dramatis personae* is arrested by the stage. Their entry into the visual field of nonparticipating and truly impartial persons allows the harassed to draw breath, bathes them in new air. The appearance on stage of those who

enter 'fleeing' takes from this its hidden meaning. Our reading of this formula is imbued with expectation of a place, a light, a footlight glare, in which our flight through life may be likewise sheltered in the presence of onlooking strangers."[44] Benjamin's "Artwork" essay imagines a theory of cinema in which the bodies and machines projected onto the silver screen "enter, fleeing," with the dynamic and revolutionary force of mechanically reproducible images. But like the photograph, the thesis, the montage of quotations, and the *Trauerspiel*, cinema can also stage furious movements in order to arrest them, to engineer a hiatus whose radical difference from the action proper transforms the theater into a "shelter" and launches the "onlooking strangers" into new movements of thought. Although Benjamin's precise mode of revolutionary praxis changes at various moments of his career, his most enduring method, which structures both the early *Trauerspiel* book and the late "Theses on the Philosophy of History," is to reverse the inertia of both the past and modernity: tradition is subjected to the shocks of mechanized art, and modernity is conceived as a series of arrested images, each envisioned "at a standstill." While the "Artwork" essay is framed primarily as an assault on an oppressive tradition, while cinema is viewed initially as an onslaught of destabilizing images, art and history move at other velocities elsewhere in Benjamin's writing.

After withdrawing his *Habilitationsschrift* on the baroque *Trauerspiel*, Benjamin composed a parable to serve as its preface. This unpublished and extremely caustic tale was designed to settle old scores with the academy, but it also introduces the peculiar logic governing the book, which, like the parable, maintains an unsteady balance between past and present, stillness and shock. The preface adapts the familiar fairy tale of "Sleeping Beauty," but it discards the better-known aspects of the story and instead seizes on a seemingly irrelevant embellishment involving a palace cook and his scullery boy. In the version of the story collected by the brothers Grimm, a scorned fairy godmother vows to exact revenge on a newborn princess and prophesies that the girl will fall into a state of eternal slumber when pricked by a spinning wheel. At the moment when that prophecy comes true, the entire kingdom screeches to an abrupt halt, and everything—including the hand of a cook about to box the ears of his headstrong assistant—freezes mid-motion. The kingdom remains paralyzed for a legendary expanse of time, while a dense and thorny hedge surrounds it, thwarting all prospective saviors and suitors. Benjamin departs from standard versions of the tale when he attributes the inevitable revival of Sleeping Beauty not to "the kiss of some Prince Charming," but to the marginal figure of the cook: "The cook it was who awoke her, when he gave the scullery boy a resounding slap that echoed throughout the castle with the pent-up force of so many years."[45] Benjamin then likens his own study of the baroque, a manuscript in suspense after its inhospitable reception, to Sleeping Beauty herself, in her state of uneasy and unsought repose: "A beautiful child lies sleeping behind the thorny hedge of the following pages. Let

no Prince Charming clad in the shining armor of modern scholarship venture too close. For as he embraces his bride, she will bite him. To awaken her, the author has, instead, reserved for himself the role of the cook. Too long has the slap been overdue that is intended to send reverberations through the corridors of academic scholarship. Then this poor truth will also awaken."[46] Although Benjamin cloaks his preface in the guise of an age-old fairy tale, his eccentric take on the "Sleeping Beauty" tale also highlights its peculiar modernity. It elides the familiar protagonists, who remain mired in the always-the-same time of legends and whose revival promises to extend indefinitely the life of the kingdom under the princess and her Prince Charming. Instead Benjamin foregrounds the contemporary moment that interrupts the continuum of mythological time, abruptly transporting these fairy-tale figures out of the interminable temporal expanses of yore. The story of a slap that shocks and awakens, this preface is a harbinger of ideas pursued in the "Artwork" essay and after, as that blow constitutes an assault on the imagined continuity of history, much like modern representational technology destroys the aura connecting the work of art to its fantastic origins at some point in the immeasurably distant past.

While the irony of Benjamin's presentation lies in his choice of a fairy tale to deliver his own blow to an academy still beholden to its own conventions, still caught in its own scholarly slumber, the parable hinges on the cook's swinging, then suspended hand. If everything in the kingdom stops and starts according to the cues provided by the prince and princess, then the cook's slap remains an anomaly, a long-arrested gesture that suddenly disrupts a mythological time frame and alludes to other movements initiated against the grain of the story and out of time. Benjamin's preface implies that this otherwise traditional tale contains an incipient rebellion, in the startling, spectral movements left unrecorded in other versions of the story. The anomalous action that ruptures the continuum of history can equal the provocative power of the machinery of modern reproduction, like the cinematic or photographic apparatus. As in this parable, Benjamin's literary and cultural inquiries, from the *Trauerspiel* study to the Arcades Project, were charged with "liberat[ing] the enormous energies of history that are bound up in the 'once upon a time' of classical historiography. The history that showed things 'as they really were' was the strongest narcotic of the century."[47] The ultimately fatal failing of historicism, he suggests, is the tendency to patch up a chronological continuum and therefore shield the present from the blows capable of awakening the slumbering subject of history. In a particularly fervent denunciation of historicism, Benjamin writes that "historicism gives the 'eternal' image of the past," while "historical materialism leaves it to others to be drained by the whore called 'Once upon a time' in historicism's bordello."[48] For Benjamin, historicism affords access only to a passive, enervated past that continues on as usual, with time merely creeping along and history serving as a tool of

commemoration. The shortcoming of the heritage model also lies in its sopo-
rific effect on an audience, for, as Wohlfarth asks, "Isn't commemoration an-
other way of putting them to sleep?"[49] Benjamin envisions this metaphorical
awakening not as a coming to consciousness within history but as an altered
understanding of history itself. Or, as Rancière argues, "Benjamin preceded us
in thinking that the awakening from the nineteenth century was also an awak-
ening from the nineteenth century's conception of the awakening."[50] "The ordi-
nary awakening," writes Rancière, "is the awakening to the heritage," a revival
that remains futile because it happens "too early" and never overcomes the
constraints of an inherited order.[51] The "archaeomodern turn" in Benjamin's
thought asserts that becoming modern first entails a return to an incipient but
unrealized modernity in the past, that awakening from sleep also requires a
heightened awareness of the dream through which the subject has slumbered
for so long. In Benjamin's conception the *Trauerspiel*, like the writing of his-
tory, becomes an "exhumation of lost (or murdered) possibilities": "This is rev-
olution not as binding the not-yet-gained future, but as redemption of the lost
past; revolution not as mortgaging the living, but manumitting the dead."[52]
In the séance parlors of critical theory in the late twentieth century, we also
witnessed a revolution against the liquidationist excesses of postmodernism
and the soporifics of commemoration. The revival of Benjamin in that period
provided another intellectual and aesthetic model that proceeded not through
obliteration or restoration but through the redemption of overlooked details
and spectral gestures whose time had finally come.

History, Allegory, and Mourning

Like the slap that awakens the kingdom in "Sleeping Beauty," allegory serves
in the *Trauerspiel* and in Benjamin's criticism as the shock that provokes a
clash between the now and the seemingly stable past. More than just an in-
terpretation of the forgotten masterpieces of baroque drama, *The Origin of
German Tragic Drama* foregrounds the correspondences between the literary
genre of the *Trauerspiel* and allegory. That emphasis is especially prominent
in Benjamin's synopses of the book, which point toward two related recovery
operations: first, of the literary reputation of the baroque mourning play; and,
second, of "the philosophical significance of a vanished and misunderstood
form of art: allegory."[53] As Craig Owens points out, the decline of allegory
coincided with the rise of history painting in the late eighteenth century, when
both were enlisted in the service of political patrons and devolved into didac-
ticism.[54] This trajectory of decline reached its nadir when modernism branded
both allegory and history painting as anachronistic relics insufficiently attuned
to the urgent obligations of art charged with making it new.[55] But because it
initiates a movement between coupled texts and images, allegory often entails

epistemological reflection on the nature of looking and reading, with the referent always absent and separate, accessible only through layers of interceding texts and images. Rather than represent reality, allegory inserts a supplement, a rhetorical surplus that underscores the discrepancy between the real and the word or image. Benjamin's baroque emerges as a response to the mystifications of classical art and philosophy: to its illusions of naturalness and to the destruction wrought by those illusions in the physical world. Benjamin suggests that "by its very essence classicism was not permitted to behold the lack of freedom, the imperfection, the collapse of the physical, beautiful, nature. But beneath its extravagant pomp, this is precisely what baroque allegory proclaims, with unprecedented emphasis. A deep-rooted intuition of the problematic character of art . . . emerges as a reaction to its self-confidence at the time of the Renaissance."[56] Because it disrupts the process of interpretation, allegorical criticism is always fraught with the danger of arbitrariness, but that threat exists in a productive tension with the critical dimension of allegory, which provokes the dissipation of meaning and asserts that our perspective on the totality is always partial, restricted, finite. For this reason, its characteristic strategy is fragmentation, and its emblematic images, the ruin and the corpse. "Allegories are," writes Benjamin, "in the realm of thoughts, what ruins are in the realm of things."[57]

As both a critic and writer Benjamin was continually fascinated by allegory in its ancient and modern manifestations. While the *Trauerspiel* book approaches allegory as an object of theoretical inquiry, *One Way Street* (1928) and the embryonic Arcades Project put that theory into practice, contemplating then exemplifying the line from Baudelaire that inspired Benjamin: "All becomes allegory."[58] Because destruction and decay often instigate a retreat into the comforting totality of myth, allegory serves a remedial function by treating that ruined world as an object to be redeemed in itself. His study of the baroque played a crucial role in the development of his philosophy of history, for, as Susan Buck-Morss writes, "It was the Baroque poets who demonstrated to Benjamin that the 'failed material' of his own historical era could be 'elevated to the position of allegory.' What made this so valuable for a dialectical presentation of modernity was that allegory and myth were 'antithetical.' Indeed, allegory was the 'antidote' to myth."[59] Buck-Morss emphasizes the importance of allegory not only to Benjamin's aesthetic sensibility but also to his politics, and not only during his study of the baroque, but throughout his career. She writes that when he "conceived of the Arcades project, there is no doubt that he was self-consciously reviving allegorical techniques. Dialectical images are a modern form of emblematics. But whereas the Baroque dramas were melancholy reflections on the inevitability of decay and disintegration, in the *Passagen-Werk* the devaluation of (new) nature and its status as ruin becomes instructive politically. The debris of industrial culture teaches us not the necessity of submitting to historical catastrophe, but the fragility of the

social order that tells us this catastrophe is necessary. The crumbling of the monuments that were built to signify the immortality of civilization becomes proof, rather, of its transiency. And the fleetingness of temporal power does not cause sadness; it informs political practice."[60] Thus, while allegory appears initially as the theoretical core of Benjamin's writing on the baroque *Trauerspiel*, it winds implicitly or explicitly through most of his career, from his most obviously Marxist work produced under the influence of Brecht, to his most "messianic" writings. As Hansen argues, this transformation of baroque allegory into a tool of modern criticism is also evident in Benjamin's analysis of Charlie Chaplin, whose possession by the machinery of modernity allegorizes the relationship between humanity and those machines.[61] The "Artwork" essay likewise treats cinematic devices allegorically, as the fragmentation of reality and accumulation of rubble become emblematic of the destruction enacted in modern times and its fallout for humanity.[62] Benjamin's attempt to rediscover the protomodernity of a centuries-old aesthetic and the historical origins of even the most dynamic culture hinges on his theory of allegory.

To students of postmodern art and theory, Benjamin's analysis of baroque allegory and the revival of allegory in Baudelaire will sound eerily familiar. Although the terms of postmodern discourse shift and mutate and possess their own precise historicity, the late twentieth century also witnessed a revival of the "allegorical impulse" in the arts and theory.[63] In these recent examples the artist or critic responds to the exigencies of contemporary culture—to the proliferation of spectacular images, to a crisis in literary and art historiography, to a despoiling modernization and the problem of preservation through heritage—by adapting the allegorical process modeled in the baroque *Trauerspiel* and theorized by Benjamin. Just as Benjamin focused on the possibilities inherent even in the ruinous modernity of the early twentieth century, his study of baroque allegory—the equivalent in the realm of ideas to the ruin in the realm of things—recalls the critical and utopian potential of allegory in modern times and sets the stage for its vigorous afterlife in the waning years of the twentieth century. The belated arrival of the ghost of Benjamin in film and media theory signals the violent collision of the past and postmodernity, tradition and its repercussions, history and allegory.

Initially a force of interference, disruption, and fragmentation, allegory also becomes a force of redemption, because, as Adorno writes, Benjamin retained a "conception of the fragment as a philosophical form that—precisely because it is fractured and incomplete—retains something of the force of the universal that evaporates in all-inclusive projects."[64] In the fundamental paradox governing his approach to philosophy and cultural criticism, the fragmentation enacted by allegory allows a concealed utopian potential to emerge from the wreckage of history, just as allegory's counterparts in the realm of things, the ruins strewn in the wake of progress, also become a site of preservation. In his meditation on Central Park, Benjamin writes, "That which is touched by

the allegorical intention is torn from the context of life's interconnections: it is simultaneously shattered and conserved. Allegory attaches itself to the rubble (*Trümmer*). It offers the image of transfixed unrest."[65] Simultaneously petrified and preserved, the subject of allegory is shocked into and sheltered in its newly stilled state, and, like the slap-happy cook who escapes a fate prescribed by myth, allegory wields the force of change precisely because it swings against the grain of progress, against the illusory advancement that conceals a cumbersome, "always-the-same" reality. The violence of allegory lies in the display of a fractured world, but the ruins of history serve as a repository of transcendent moments and emancipation. They contain the "now-times" obscured by myth. If, as Benjamin suggests, the fact that "things 'just go on' *is* the catastrophe," redemption must seek out the "the small fissure in the ongoing catastrophe."[66] The difference between the apocalyptic and the messianic is found within those minute fissures and the ghosts that continue to haunt them.

As he began research for his Habilitation on the baroque *Trauerspiel*, Benjamin also composed several radio plays for Germany's state-run broadcasting corporation, though the last of these was scrapped by the station in 1933, as the political climate deteriorated. That final radio play, *Lichtenberg*, is a blend of science fiction and hagiography, and it tells an at once catastrophic and messianic story of a scientist whose research attracts the attention of enlightened admirers on the moon while being greeted with indifference in Germany. Based on the life of the renowned physicist and astronomer Georg Christoph Lichtenberg, the play telescopes the present and the future, as the members of the "Moon Committee for Earth Research" explore his public and private life through technologies of observation barely imaginable even in the most effervescent celebrations of modern media, including the work of Dziga Vertov or Benjamin's "Artwork" essay. The fanciful devices introduced in *Lichtenberg* offer futuristic refinements of the cinematic apparatus: the "spectrophone" allows the moon creatures to see and hear anything happening on earth; the "parlamonium" transforms the most boring dialogue into pleasant background music more consistent with the moon's harmonious ambient sound; and the "oneiroscope" affords direct access to human dreams. Like the cinema itself, these three distinct devices present reality as though viewed through a surveillance camera, reduce it to the mellifluous diversions of mood music, and delve into something like the "optical unconscious." In his everyday life Lichtenberg struggles to advance scientific knowledge, even when his work receives little recognition and his private affairs provoke scorn; in his dreams Lichtenberg imagines the total destruction of the planet in images even more apocalyptic than the ruined landscape viewed through the rearward glance of Benjamin's "angel of history." By the end of the play Lichtenberg becomes the sole exception to the fatalistic rule pronounced by one earth researcher—that the "last few millennia have not shown a single case in which a human being has amounted to anything"—but only because he, too, shares this fundamental

pessimism about the future of human civilization.[67] Benjamin's play seeks to preserve for posterity the example of Lichtenberg, most notably his critique of the insularity and parochialism of German intellectual life, an attack launched in language that resembles Benjamin's own "Sleeping Beauty" parable aimed at the academic institutions that would reject his *Habilitationsschrift*. But it presents that criticism within a clearly allegorical context in which both the centrality of human concerns and the existence of the planet itself are thrown into doubt. Lichtenberg's dreams predict a cataclysmic future and the "spectrophone" offers glimpses and echoes of human beings in the process of becoming ghosts, not only because they are etherealized through the media but also because they are incapable of viewing their everyday existence alongside the nightmarish future envisioned by the "oneiroscope," because they are unable to construct an allegory that confronts the real world with its at once horrific and utopian dreamscape. A baroque mourning play adapted to the radio and the new media environment of the first half of the twentieth century, *Lichtenberg* is an allegory that combines two of Benjamin's enduring concerns: the folly of an Enlightenment conception of progress and the revolutionary possibilities of modern media. But in this case those media are at once speculative and spectral, as they dwell beyond the present moment (and Earth itself) and recall a past when cultural and social conventions stifled truly radical thought. Neither mere reality nor mere entertainment nor the unconscious laid bare, modern media like cinema are a crystallization of the possibilities alluded to in Benjamin's *Lichtenberg*. They are ghostly technologies where the lifelike figures on-screen or vibrant voices over the airwaves are also phantoms wandering between past and future and bearing witness to the failure of their grandest aspirations in time.

Specters of Cinema

Jacques Derrida was often characterized as an apocalyptic writer, as the architect of a potentially nihilistic critique of the western philosophical tradition. Two of the most prominent casualties of a Derridean analysis of film would be theorists like Bazin, who upholds the capacity of the photographic image to bestow presence on objects recorded in another space and time, and Benjamin, who affirms the messianic power of both obscure reaches of tradition and the apparatus of mechanical reproduction. Written in 1993, Derrida's *Specters of Marx* reflected a significant turning point in his thinking, as it combined the Heideggerian assault on the metaphysical core of Western philosophy with a fervent attempt to salvage a concept of justice from that onslaught. And like the change in orientation and emphasis announced in that book, a return to Benjamin could help salvage a sense of justice and a utopian promise in film and media theories that often appear naïve and outmoded

when confronted with a deconstructive critique or more empirical and sociological strategies.

Specters of Marx continues to apply the methodology that structures Derrida's previous work: intensive close readings of canonical literature and philosophy, what Jameson calls a "parasitical activity" that receives its sustenance from the past but simultaneously introduces radical difference into inherited understandings of those texts.[68] It also highlights the metaphysics of presence that emerged at crucial moments in Marx, especially in the dancing tables used to lend solidity to the mystical concept of use-value. Derrida's analysis centers on Marx's repeated invocations of spirits, his departure from materialist discourse, and his reliance on a ghostly rhetoric at crucial moments of *Capital* and the "The Manifesto of the Communist Party" (1848). Derrida writes, "Marx does not like ghosts any more than his adversaries do. He does not want to believe in them. But he thinks of nothing else. He believes rather in what is supposed to distinguish them from actual reality, living effectivity. He believes he can oppose them, like life to death, like vain appearances of the simulacrum to real presence. He believes enough in the dividing line of this opposition to want to denounce, chase away, or exorcise the specters but by means of critical analysis and not by some counter-magic. But how to distinguish between the analysis that denounces magic and the counter-magic that it still risks being?"[69] Although we are often obliged to bear witness to, amend, or rebel against what we inherit, we also "inherit the very thing that allows us to bear witness to it."[70] That paradox—with revolt a force of preservation, and preservation a source of revolutionary energy—structures Derrida's simultaneous return both to Marx and to deconstruction in its own wake.

Behind the depredations of deconstruction lies the amorphous but necessary concept of "justice," "the undeconstructible condition of any deconstruction," but also "a condition that is itself *in deconstruction*," a condition inherent in but also subject to the process of deconstruction.[71] Derrida emphasizes that deconstruction must always be performed in the pursuit of justice; otherwise, how can we know whether deconstruction itself is a worthwhile undertaking, how can a historical real survive this hypercritique of rhetoric, and how can deconstruction resist the threatening devolution into banal and vacuous nihilism? Jameson, among others, identifies this recuperation of justice as a shift from an "apocalyptic" to a "messianic" phase in Derrida's writing and argues that *Specters* reminds us retrospectively of the "subterranean Utopianism" and "weak messianic" strains running throughout its author's work.[72] Derrida recalls that he coined the term "deconstruction" while translating a constellation of phrases in Heidegger that had been approximated alternately by "destruction" and "retrieval." If deconstruction was reduced over the years primarily to the former activity, it became an insistent force of retrieval in the late phase of Derrida's career. With the perspective afforded by three decades of hindsight, he suggests that his work has always pursued this utopian goal, and

"deconstruction has never had any sense or interest, in my view at least, except as a radicalization, which is to say also *in the tradition* of a certain Marxism, in a certain *spirit of Marxism*."[73] Best exemplified in Benjamin's work, that spirit also appears in Blanchot's challenge to scientific Marxism and departs most noticeably from the Althusserian reinterpretation of Marx, which attempts to disengage Marxist thought from a "messianic eschatology."[74] Derrida's purpose is to disentangle the theological from the messianic: "Can one conceive an atheological heritage of the messianic?" he asks, adding that "a heritage is never natural," for "one can inherit more than once, in different places and at different times."[75] In *Specters of Marx* Derrida's tacit and "unnatural" inheritance is the messianic Marxism of Benjamin. Derrida asserts some crucial differences between his own text and the work of Benjamin, but Jameson detects in *Specters of Marx* the "emergence of Benjaminian constellations in Derrida's work."[76] Benjamin "offers the supreme example of the intellectual committed to revolutionary values in a world in which revolution cannot be expected to happen," but he also provides a model, in his *Trauerspiel* book and elsewhere, for reviving a latent potential amidst physical decay and philosophical exhaustion.[77] Derrida's return to Marx, which bears the subtitle "The State of the Debt, the Work of Mourning, and the New International," envisions the "end of history" predicted at the close of the millennium as a mourning play and adopts a characteristically Benjaminian strategy to "*bear witness*" to this crisis.[78] This engagement with the legacy of Benjamin distinguishes *Specters of Marx* from Derrida's earlier writings and initiates a "future-oriented," "active" phase in his career.[79] The motivating forces behind *Specters of Marx*—the popularity of Francis Fukuyama's "end of history" thesis and its definitive pronouncement of the death of Marxism, the more general vogue of apocalyptic tones in western philosophy, the ossification of a "spirit of deconstruction" into a dogma in its own right—compelled Derrida to revisit the teleology of his own thought and reconsider the messianic spirit of Benjamin. Derrida's study attempts to sustain a utopian strain of Marxism during "trough years" like the 1980s and 1990s, when the "triumph of the West, of the Western *idea*" left competing ideals in a state of morbidity.[80]

For the tutor text in this engagement between Marxism and deconstruction and between the "end of history" and what remains, Derrida chose *Hamlet*, the emblematic baroque *Trauerspiel* and a story in which justice hinges on the enigmatic testimony of a ghost. With the times "out of joint," a spirit returns from the grave, compelling just action based on a peculiar, spectral form of evidence.[81] That ghost becomes the crux of Derrida's *Hamlet* because the drama of contemplation and deferral puzzles over this enigmatic testimony and the ontological status of the ghost itself. Derrida extends and makes explicit the Shakespearean undertones of Heidegger's essay on "The Anaximander Fragment," in which a meditation on the possibility of justice in a time "out of joint" depends on a crucial and habitually mistranslated phrase in

Anaximander: the more common formula of "giving justice" becomes giving shape to "whatever lingers awhile in presence."[82] Derrida's dual obsession with the just and the ghostly reveals the ramifications of this modified translation, especially the linguistic connections between justice and the ambiguous ontology of "whatever lingers." In Derrida's reading *Hamlet* presents the allegorical pursuit of justice predicated on "the irreducible excess of a disjointure or an anachrony," an excess that adopts the form of a ghost.[83] Hamlet mourns his loss and his belatedness; he curses the destiny that forces him to bear witness to an unspeakable crime; he is reduced to inaction by the exhaustion of all means available to realize justice; he wages an ongoing struggle against the prescriptions of revenge tragedy, which necessitate heroic action under circumstances that seem to foreclose such heroism. Taking their cues from the specter of his father, Hamlet's deliberations locate the text more precisely within the category of mourning play theorized by Benjamin, who lashes out at the "irrelevance of the absurd concept of tragedy which has been used to judge these works" and whose impertinence "ought to have been clear long ago."[84] Rather than set the world right through a return to myth (the characteristic strategy of classical tragedy), Hamlet rejects the temptations of mythology and seizes on the possibilities inherent in a world out of joint. *Hamlet's* "problem of problems" cannot be resolved by leaping into action and restoring order, so the play instead revolves around the potential for justice in things that linger and traces left behind.

Underlying Derrida's *Specters* is a theory of the emergence of a historically new media environment where the ontological guarantee at the core of Bazin's work or the revolutionary aspirations of Benjamin's "Artwork" essay seem like hopeless anachronisms. Derrida develops a theory of hauntology attuned to these new phenomena, to "the new speed of *apparition* . . . of the simulacrum, the synthetic or prosthetic image, and the virtual event, cyberspace and surveillance."[85] He writes of specters that exist at the borders of a solid, foundational world and a hauntology that hovers at the margins of the ontological argument in Bazin and other realist film theory. Derrida confronts Marxist analysis with the limits of pure ontology because spectacular images disseminate with increased speed and range, because they are subject to new forms of manipulation, and because those images increasingly constitute the stuff of reality and define our relationship to the past. The mediation of images creates a spectralized reality, one that "does not belong to ontology."[86] Confronted with the advent of these conditions in the 1960s, Guy Debord envisioned a dystopian society of the spectacle, with images divorced from materiality and history. Derrida's revision instead detects a society of the specter, a world characterized initially by the loss lamented by Debord, then by the revenant, by a vague but insistent entity that returns and plots a trajectory back into the past. If ontology is concerned with and depends on the continued presence of its subjects, Derrida responds with the countervailing concept of "hauntology,"

with the representation of, in Warren Montag's gloss, "what persists beyond the end, beyond death, of what was never alive enough to die, never present enough to become absent."[87] Hauntology reflects the ambiguous, liminal status of something whose ontology remains obscure because one can never decide whether or not it "responds to a name and corresponds to an essence."[88] Like the simulacrum, the specter appears immaterial and exists primarily as a copy; it *begins by coming back*."[89] But the specter also insinuates a new understanding of origins into the process of return because it couples return and revolt, confronting an essential reality with its "paradoxical phenomenality," its furtively invisible visibility, its nonsensuous sensuousness.[90] The specter exists at the threshold between two regimes of visibility, vacillating between a perceptible object and "what one thinks one sees," or what one projects onto "an imaginary screen."[91] Because of its paradoxical status, the revenant compels its witness to rethink the return as a special category of event, existing outside the conventions of linear narrative, and exploding the binary model that posits, on one side, the effective, actual, present, and on the other, the ideal or nonpresent.[92] The ghost attests to the actuality of the absent, the invisible, and the lost. The ghost's return becomes a torturous reiteration of the past, but it also channels what Deleuze calls the joyful and "terrible power" that can accompany repetition, with the play of gestures unfolding "before organised bodies, with masks before faces, with spectres and phantoms before characters."[93]

When trying to describe the status of these emblems of repetition and loss, Derrida veers most closely toward Benjamin's writings on the power of the ruin and its artistic counterpart, allegory. *Specters of Marx* signals the revival of allegory in the work of Derrida. When he asserts, for example, that hauntology involves a "*double interpretation*" and "concurrent readings," he echoes the writings on allegory advanced by Benjamin and extended by Owens, in particular the assertion that allegory occurs "whenever one text is doubled by another."[94] What Derrida's ghosts ultimately embody is the coincidence of the incontrovertibly real—a precondition of justice, he argues—and the allegorical. While Marx tries to distinguish actual reality from the "vain appearance of the simulacrum," "a world cleansed of spectrality is precisely ontology itself, a world of pure presence, of immediate density, of things without a past: for Derrida, an impossible and noxious nostalgia."[95] With philosophers and political pundits bandying about proclamations of the "end of history" in the late twentieth century, specters and allegories became vehicles for the survival of history. The most recent manifestation of the end of history thesis founded its own logic of late capitalism on a revamped nostalgia for pure presence, on its own attempt to relieve reality of its ghosts. "Postmodernity," Jameson suggests, presupposes a "present that has already triumphantly exorcised all of its ghosts and believes itself to be without a past and without spectrality," and it imagines the culmination of history through the ascension of late capitalism to

pure ontology, "the pure presence of the world-market system freed from all the errors of human history and of previous social formations, including the ghost of Marx himself."[96] The specter assumes a form denied it in the course of history and in its quasi-official afterlife in museums or official versions of the national past. Hauntology is in Derrida's philosophy what allegory is in the arts and what ruins are in the realm of things: an allusion to the inaccessible totality and a recognition of the fragments that remain. It concentrates on these manifestations from the past and hopes to decipher their auguries for the future. Or, as Benjamin writes, "Ghosts, like the profoundly significant allegories, are manifestations from the realm of mourning; they have an affinity for mourners, for those who ponder over signs and over the future."[97]

Of course, Derrida is not literally holding a séance and placing his faith in salvation visited on us by ghosts. But as critics contended throughout his career, Derrida's incantatory critiques can carry deconstruction to the verge of nihilism, where the end of history is enacted by different, deconstructive means. Antonio Negri, among others, suggests that Derrida is merely responding to Marx's occasional invocation of specters by seeing ghosts everywhere, reducing everything to the status of the specter, and resigning himself to an enfeebled, entirely negative reaction to the ontology he critiques. Negri insists that this "ghostly reality," accurately observed by Derrida, "forms an ontology in which we're enveloped."[98] Those new conditions should become the subject of Marxist analysis, he contends, but Derrida "remains prisoner of an ineffectual and exhausted definition of ontology," the very ontology he critiques.[99] Derrida's detailed response to his critics announces his agreement with Negri's analysis of the altered conditions of a spectral reality ("I agree, agree about everything with the exception of one word"), but his mistrust of that one word—"ontology"—signals his departure from a tradition.[100] He writes that Negri's embrace of ontology as a point of reference "cedes to what I think is the most problematic aspect of Marx, namely, the unrestrained, classical, traditional . . . desire to conjure away any and all spectrality so as to recover the *full, concrete reality* of the process of genesis hidden *behind the specter's mask*."[101] Derrida's goal is not to deny the existence of reality, history, and their attendant possibility of justice, but to alter the modes of inquiry and representation that too often conjure up an illusion of fullness, totality, and depth. For this reason, Derrida's implicit engagement with Benjamin is particularly significant because his invocation of ghosts, his claim that the specter returns in an impatient quest for redemption, his assault on a classical mode of analysis, his mistrust of the totalizing and mythologizing gestures upholding that tradition, his advertisement of his recent writings as a "work of mourning": all of these situate Derrida's hauntology within the tradition inherited, sustained, and altered by Benjamin. In *Specters of Marx* Derrida recognizes that the struggle for the future begins by rescuing deconstruction from an enervating and depoliticizing version of itself that had taken hold in the late twentieth

century. Or, as Benjamin writes, the goal of historical materialism is "to wrest tradition away from a conformism that is about to overpower it," but "only that historian will have the gift of fanning the spark of hope in the past who is firmly convinced that *even the dead* will not be safe from the enemy if he wins. And this enemy has not ceased to be victorious."[102]

What position does cinema occupy in this story of ghosts that haunt new media and the discourses that surround them? As Laura Mulvey argued in her reflection on the centenary of the medium, "Certainly, the cinema is inhabited increasingly by spectres."[103] Once a privileged site for the celebration of modern life and now an old medium, cinema became a vehicle for the mourning of the modern past. For most of the twentieth century film assumed its quasi-official position as an emblematic modern art form, with a phalanx of filmmakers and theorists, including Benjamin, demonstrating precisely how cinema contributed to the construction of global modernity. But the recent history of film studies suggests that the discipline has been pulled in two directions: toward the domain of tradition, with the medium reframed not at the vanguard of the future, but as a phenomenon whose heyday has receded into the past, a modern institution whose revolutionary dynamism is now a phenomenon of history; and toward digital and convergence culture, where the four screens exist alongside each other and film is the oldest and often the least dynamic of these new media. In academia, media and screen studies now occupy the vaguely subversive position once claimed by cinema, and these hybrid disciplines concentrate less on film than the rapidly proliferating modes of participation and spectatorship that characterize our current media environment, on the video games and text messaging now almost certainly absorbing dozens or hundreds or people within a short radius of the reader of this book. Somewhere outside the framework of tradition and modernity lies the screen capable of switching among these various functions and adapting to new ones, bouncing between SMS in newly invented ad hoc languages and hastily captured and discarded images, or displaying several windows simultaneously for the alternately rapt and wandering eye. Ghosts haunted the screens and media theories of the late twentieth century because historical and technological transformations have made us "ontologically restless," to borrow Stanley Cavell's phrase about the impact of photography and the implication that the photographic image affords access to "things themselves" rather than mere representations. Derrida's concept of hauntology identifies the peculiar spectrality of the digital age and the anxiety provoked by the collapse of one set of illusions, including the promise of access to "things themselves," and the ascension of another regime of the image. In 2000 Stephen Prince wrote, "Before there was cinema. Now, and in the future, there is software."[104] "Hauntology" alludes to both the creative possibilities and the dangers inherent in this transition to an image-making process organized around software and the ubiquitous screen, a formation more attuned to simulation, manipulation, and

surveillance. In these new conditions the waning promise of photographic realism returns in the ontologically restless form of a ghost. At the same time, as the discipline of film studies undergoes the transition to this new environment, equally important intellectual work focuses on the many failed revolutions that litter the history of the modern media: early cinema before the emergence of classical narrative and editing paradigms; the boisterous and boosterish avant-gardes of the 1920s; the high and low margins of classical cinema; and the filmmakers who continue to claim the mantle of innovation, even as critics and industry analysts foresee the end of cinema.[105] While conventional research traditions guide the return to archived prints from the earliest days of the medium, film and media studies has become an archaeological field dedicated to newness now relegated to the past, with the overarching theoretical framework often supplied by Benjamin, the theorist of failed revolutions. If Benjamin's most notable direct contribution to film theory has been the "Artwork" essay and its account of modernist annihilation, scholars and artists in the late twentieth century have returned to another Benjamin concerned above all with the question of mourning, preservation, and survival. To study film in its paradoxical contemporary state—as a modern past, a tradition of modernity—is to mourn the loss of its utopian ambitions and unrealized promises and to confront the haunting presence of ghosts.

The purpose of mourning, writes Derrida, is to "ontologize remains," and the theories of cinema devised by Bazin and Benjamin sought to reanimate the images and spaces that constituted the modernity of their times.[106] As the already anachronistic title of his most famous essay suggests, Bazin's meditations on the essence of cinema reveal not a philosophy of cinema itself but a retrospective reflection on the ontology of the photographic image. His aspiration for cinema is the sustenance and extension of photography's original promise through a new medium capable of recording movement and duration as well as the static imprint of reality. Bazin's "myth of total cinema" both amplifies the medium's utility and displays his nostalgia for the historical possibilities that once accompanied the mechanical recording of the world. But this "myth" remains haunted by the apocalyptic possibilities championed at times by Benjamin, because if film mummifies and preserves reality, it also becomes an index of the ruins wrought all around it, of the reality of partial cinema. Benjamin, writing in the guise of a forward-looking essay about the future after mechanically reproducible images, focuses instead on the faded promise of early cinema. His prophecies about the disruptive force of new technologies evoke an already-archaic world where those technologies have not yet been incorporated into and co-opted by capitalist modernity. Both Bazin and Benjamin write from a condition of mourning for a technology they once hoped would deliver on its dual promises of unity and agitation. But both habitually subdue and conceal an allegory of cinema that emerges hesitantly in Bazin's paradoxes and intermittently when Benjamin invokes archaic forms

of art before the advent of modern techniques of reproduction. Both obscure what Garrett Stewart calls the "the *passing away* that precedes all *coming to be* in cinema's spectral presence, each instant of imaging the ghost of its own foremath."[107] The cinema they conjure up as a force for unveiling a hidden totality or eradicating beautiful illusions is also part of a political and economic system whose own labyrinthine myths prevent any medium from delivering on such bold promises. But because of their retrospective orientation and despite their nostalgia, their seemingly ahistorical comments on the essence of cinema imagine a history of the medium through the strategies described by Michel de Certeau: they "proliferate about a loss" and make "readable an absence that has multiplied the productions of desire."[108] The philosophy and the history of cinema converge at this site of absence.[109] The past of a medium that helped construct twentieth-century modernity is accessible not through a theory of its essence or the channels of history proper, but through a hauntology of the cinematic image. Watching a film compels us to scour the frames of films past for what failed to materialize and what history failed to preserve. The canonical works in the European or American traditions persist not only as venerated works of art but also as the ruins of those traditions. "A masterpiece," writes Derrida, "always moves . . . in the manner of a ghost."[110] This is especially true of cinematic masterpieces in the new millennium, when film has become a "posthumous object" in search of an afterlife in emerging digital platforms.[111] In an era when the attention economy and the product cycles of technology promise something new at every turn, cinema provides at once the prehistory of that illusion, a record of the deferrals and fiascos that ensued, and an archaeomodern vision that awaits redemption in the future. This haunted theory of film turns away from the god in the cinematic machine and its contemporary digital avatars. Instead it revisits the glorious happenings on the silver screen and gazes backward at the revolutionary modernity that was projected in theaters for over a century. It hopes to redeem the modern promise that captured imaginations around the world, the ghosts that flickered on screens throughout the twentieth century, and the images that were never alive enough to die but too real to forget.

Time's Arrow, Time's Bow

DELEUZE IN THE BAROQUE AGE OF CINEMA

While Walter Benjamin aspired to a philosophy of history that would lay bare the obligations, burdens, and possibilities buried in the past, Gilles Deleuze spent the first decades of his professional life denigrating and repudiating history. In his collaborative work with Félix Guattari, he contends that the transmission of history is always contaminated by its institutional associations, so "history is made only by those who oppose history (not by those who insert themselves into it, or even reshape it)."[1] To their critics the work of Deleuze and Guattari is doomed by this aversion to history: it exemplifies a cosmopolitan restlessness that valorizes displacement while disregarding the concrete realities that make migration either an aspiration, a necessity, or an ordeal. By not "doing history" Deleuze and Guattari neglect the dangers inherent in the forgetting or denial of the past and revel in the artificial bliss of an abstract and rhetorical dynamism fueled by the whims of desire.[2] That criticism stings in part because of its disquieting proximity to the truth, especially in their most cavalier paeans to schizophrenia and a nomadic existence. But the force of that critique is limited because of its selective reading of their work and its failure to engage adequately with the late career of Deleuze, in particular the period in the 1980s when he worked apart from Guattari and began focusing intensively on cinema. Even in his midlife collaborations with Guattari, the polemical and provocative language obscures the fact that they never question the existence and importance of historical reality but instead challenge a sluggish and stationary conception of history viewed from the perspective of the conquerors and the institutions created in their honor. In that sense, they echo the lessons of Benjamin, who praised heretics and mystics for refusing the temptations of orthodoxy and instead preserving fragments of tradition through their voices and gestures, as well as the objects around them. These marginal subjects of history revived a "tradition by carrying it on their backs, instead of simply administering it in a sedentary way."[3] Because they followed

their faith on those peregrinations, they were at once the most theological and modern subjects. Deleuze and Guattari admired the historical examples of figures who carried tradition on their backs while remaining in motion. Any indictment of Deleuze and Guattari must also consider the consequences of a sedentary history and the value of the initial act of displacement that uproots, estranges, and reimagines the past.

If Deleuze and Guattari begin by repudiating history as habitually practiced, their writing then pursues the inimical ideal known at various moments in their work as "antihistory," the "transhistorical," and "the opposite of history." A truly critical history would be a countervailing force opposing its institutional counterparts; it would reject the stratified and unyielding power that they attribute to the "state apparatus" by interfering with the impulse to rediscover and reinforce our roots in the past. "There is no act of creation that is not transhistorical," they write.[4] Creation is ushered in not by history, but by the "Untimely," by the "innocence of becoming," by "forgetting as opposed to memory."[5] Rejecting the fixity of history, they instead pursue a nomadology devoted to more transient subjects. "History," they write, "is always written from the sedentary point of view and the name of a unitary State apparatus. . . . What is lacking is a Nomadology, the opposite of a history."[6] Writing against the increasingly widespread fascination with memory in the humanistic disciplines and the conflation of their two intellectual antagonists in the phrase "historical memory," Deleuze and Guattari champion work that remains defiantly "antimemory" by opposing the transience of "becoming" to the rootedness of memory. "*Becoming is an antimemory*," they argue, because "memories always have a reterritorialization function" that returns to the deadening comforts of habit.[7] If the repudiation of history is one of the inaugural gestures of Deleuze and Guattari's writing, their idiosyncratic project provokes a number of daunting questions, none more puzzling than this: what does the past look like to those who emphatically reject the practice of history and renounce the power of memory? This chapter will explore the crucial changes in Deleuze's response to that question in his key work from the 1980s and 1990s, especially his cinema books, his study of baroque philosophy and aesthetics, and the meditations on an emerging "control society" produced at the end of his life.

Deleuze's rejection of history was always paradoxical because he combined it with a simultaneous return to sources from the European philosophical and literary canon and because his opposition to history was never accompanied by its seemingly inevitable complement: a wholesale valorization of the new and the modern. Alongside the more eclectic and peripatetic tomes written with Guattari stand a series of monographs devoted to his quirky pantheon of philosophers and writers, most of them identified in the titles of the books. Bergson, Kant, Nietzsche, Proust, and Spinoza not only provide the content of the eponymous studies by Deleuze, but they also draw him back toward a certain intellectual tradition, even as he pursues a mode of thinking outside the

constraints imposed by this patrimony. His task is to shake the domineering presence of inherited habits of thought, but among his most important tools is that seemingly omnipresent tradition. Why does the "opposite of a history" emerge from ideas and practices lodged deep in the past? Is there a tradition that opposes the institutionalizing tendencies of history and resists the rooted-ness of memory? Deleuze's writing in the 1980s, especially his work on cinema and on Leibniz and the baroque, is philosophy rooted in that tradition of de-racination. Writing beyond the limits of the new history practiced by the likes of Carlo Ginzburg, Michel Foucault, and others, Deleuze approaches the past not to construct a narrative leading up to the present day, not to indulge in the consoling play of recognitions, but to discover vestiges of the untimely past that remain incompatible with history proper. The ambition of Deleuze's study of Leibniz and the baroque is to consider that flight from history as an object of (anti)historical inquiry, as an enterprise with its own elusive past. The inti-mately related goal of his cinema books is to draw together two seemingly in-compatible functions of cinema and their divergent theoretical traditions: first, the conception of cinema as a mnemonic machine that preserves the past and enhances the relatively feeble human power of recollection; and, second, its foundational links to a radical modernism constructed on the ruins of history.

This retrospective reconception of cinematic modernism only crystallized during the 1980s, when Deleuze combined his lifelong interest in nomadic departures and his relatively belated fascination with recollection and return. This tendency is especially prominent in his cinema books, which complicate the habitual association of movement with progress toward the future and re-turn as a retracing of steps back into the past. Instead, Deleuze's cinema books situate post–World War II cinema and the time-image within a makeshift tra-dition of antihistorical arts that return to neglected moments of dynamism that never evolved into a position of dominance or hegemony. The first generation of filmmakers and audiences was fascinated by the possibilities of representing movement and by the mechanical apparatus itself, and, like other theorists, Deleuze rightly locates the invention of cinema within a larger narrative of modern machines and media. In devoting his second book to the time-image, Deleuze suggests that the movement-image was the invention of a particular cultural and intellectual moment that reveled in the vertiginous rush of life at the turn of the twentieth century. The time-image, on the other hand, is the product of a retrospective mood, a phenomenon of recollection rather than eradication. The time-image is a sign of the baroque age of cinema, of the medium's transition from a tool of radical modernization to an aging medium. This antiquarian vision of cinema underscores Deleuze's imbrication in the key cultural concerns of the late twentieth century, even as he emphatically rejects the standard responses to the obsolescence of a modern social and cul-tural project, including revivalism and a fantasy of perfect preservation. By the time Deleuze wrote his books on the movement- and time-images, cinema's

status as the paradigmatic modern medium had already been consigned to history. Instead of rehearsing that narrative and reliving the glorious early days of cinema as a rebuke to the present, Deleuze turned familiar debates about cinematic modernity on their head: recollection, he suggests, can be an act of radical modernism, an act as fraught with political potential and danger as the first cinematic experiments that sought to leave history in their wake. Images of thought lurching into motion, Deleuze's work aspires to the condition of moving pictures, but rather than a modernist version of the movies transfixed by their rush into the future, his late-life meditations are organized around the process of return: to Bergson's modern past and, deeper in time, to the baroque.

Deleuze and the Baroque

As Brian Massumi points out, the "pragmatics" and "schizoanalysis" proposed by Deleuze and Guattari in their "Capitalism and Schizophrenia" books have been prefigured by Spinoza's "ethics," Nietzsche's "gay science," Artaud's "crowned anarchy," Blanchot's "space of literature," and Foucault's "outside thought," all of which aim at a thorough reappraisal of the prevailing structures of western thought.[8] Deleuze later adds Leibniz's "fold" and cinematic philosophy to that lexicon. While he engages with some of the most exalted figures in the European canon, Deleuze argues that his purpose in returning to a grand tradition is not to recapitulate received wisdom, but to read those masterworks otherwise, causing them to give birth to a monster that their authors could not possibly have imagined. Instead of incorporating the marginal Deleuzo-Guattarian canon into a dominant philosophical tradition, they render that tradition monstrous, accentuating the contortions and distortions through which it maintains intellectual purity and highlighting the passages when another science or mode of thought insinuates itself into those exclusive structures. In such moments aesthetics can sustain philosophy, for the desire to tease a system of thought from the rantings of Artaud must also be reciprocated in an anarchistic approach to the crowning achievements of philosophy, including the likes of Kant and Hegel. Rather than establish philosophy as a metadiscourse charged with adjudicating disputes among less august subjects, Deleuze's writing continually dethrones philosophy by introducing the aesthetic, the political, and the cinematic into its rarefied chambers. The result is a tradition that appears uncannily modern, a tradition in motion, often in spite of itself. Arguing that modernity is characterized above all by its fascination with movement, Foucault writes that "being modern does not lie in recognizing and accepting this perpetual movement; on the contrary, it lies in adopting a certain attitude with respect to this movement; and this deliberate, difficult attitude consists in recapturing something eternal that is

not beyond the present instant, not behind it, but within it."[9] Over the course of his work Deleuze repeatedly invokes a past that endures because of its tendency toward movement and change, the dominant concerns of his earlier career with Guattari. *The Fold* (1988) displays the contradictory tendencies in Deleuze's work: his celebration of chaos and eccentric motion and his quixotic pursuit of an abiding unity made possible by that upheaval. And if, as Deleuze asserts, "we all remain Leibnizian," we remain heirs to both of those eccentric and holistic traditions, to the movement of modernity and the momentary arrest of the monad.[10]

Deleuze aligns his study of Leibniz and the baroque fold with innumerable accounts of the baroque as an aesthetic and a historical era characterized by its belatedness and by extremes of change and stasis, by extravagant and shifting spectacles that coexisted with a profusion of extraordinary still lifes by masters of the genre.[11] One point of convergence between the various definitions of the baroque—as the style of the late sixteenth and seventeenth centuries, or the "high baroque" of 1630, or a recurring aspect of European modernity, or the "historical structure" that produced such an aesthetic—lies in the shared belief that the baroque is a culture of excess and extremes, in both the political and artistic domains. In words that could characterize both these dimensions of the baroque, José Antonio Maravall writes that the products of the period ranged from "exuberance" to "severe simplicity" and that to "appear baroque, the use of one or the other required the fulfillment of no more than one condition: that in both cases abundance or simplicity take place in the extreme."[12] Michel de Certeau's study of sixteenth- and seventeenth-century mysticism identifies in the writings and public displays of mystics and heretics an attempt to occupy the excluded extremes of religious discourse, to counteract dogmatism through paradoxical combinations of "withdrawal" and "virtuosity," "rapture and rhetoric."[13] Benjamin's study of the baroque *Trauerspiel* seizes on a similar tendency, arguing that the "baroque apotheosis . . . is accomplished in the movement between extremes," especially between an excessive speed that anticipates the mechanized shocks of early cinema and the stillness that foreshadows the arrested moments of photography.[14]

For Deleuze the fold is the material form of extravagant motion. Its precise contours remain elusive, as it crops up in various geographical regions, historical eras, artistic practices, and academic disciplines, without regard to established protocols of scholarly inquiry. Rather than begin with specific examples, Deleuze first defines the fold as an attitude toward fluidity and movement, then explores the infinitely varied substances that reveal undulating folds or "pleats of matter." As Dorothea Olkowski argues, Deleuze observes the "reality of temporal and spatial change on a pragmatic level" and responds by positing an "abstract but fluid ontology."[15] Like a category-busting entry in Borges's "Chinese Dictionary," the fold both destroys familiar concepts and constructs new links between normally unrelated fields, assuming recognizable shapes,

dissolving into evanescent abstractions, and returning in another guise. Deleuze's book on the baroque lists the material traits of the phenomenon and notes their appearance in the natural world and the work of Leibniz. The fold manifests itself in the labyrinth, then the undulating sheaves of paper in a book cracked open, then the development of an egg cell into an organism, then the vessels running through the leaves of plants and trees, "two never being exactly alike because of their veins or folds."[16] Deleuze and Guattari's "Capitalism and Schizophrenia" books ascribe a range of characteristics to the rhizome: connection, as "any point of a rhizome can be connected to any other, and must be"; heterogeneity; multiplicity; the indefinite article, where the expansiveness of "some" replaces the finitude of "the"; asignifying rupture; cartography and decalcomania, or resistance to "any structural or generative principle."[17] Deleuze and Guattari take as axiomatic the reality of this incessant flux, for *"you will never find a homogeneous system that is not still already affected by a regulated, continuous, immanent process of variation."*[18] All of these traits reappear in *The Fold* as the protean qualities of a baroque aesthetic. The fold is a path traced through a rhizome, a network defined by "variation, expansion, conquest, capture, offshoots."[19] The incessant change and amplification visible in the fold is the primary contribution of the baroque, writes Deleuze, for "the Baroque invents the infinite work or process. The problem is not how to finish a fold, but how to continue it, to have it go through the ceiling, how to bring it to infinity."[20] Deleuze's baroque philosophy is tantalized by the spectacle of extreme movement and the possibility of continuous variation, as he develops a formal counterpart to his earlier vocabulary of "decoded flows," "lines of flight," "nomadism," and "deterritorialization," all of which reveal the instability inherent in social structures and the natural world. The fold is an aesthetic attuned to this reality of mutability and variation.

The Fold refashions Deleuze's long-standing interest in the vagaries of movement as a pursuit of linkages, a process of complication, implication, and explication. He initially conceives of the accumulation of "unsubsumable singularities in terms of a logic of series," a course of thought governed by the principle of extension, but as Timothy S. Murphy argues, he "ultimately arrives at a logic of folding" and the principle of connection and assemblage.[21] Because of this multiplicity and connectivity, crossing between genres and media—ekphrasis and intermediality—becomes the characteristic mode of baroque art, bringing "together architects, painters, musicians, poets, and philosophers."[22] Maravall argues that in Spanish baroque writers like Calderón and Lope de Vega the "topos *ut pictura poesis* would find its fullest meaning . . . and become most widely diffused."[23] In the baroque labyrinth poems produced on the Iberian peninsula, this migration across media constructs a montage of visual and verbal elements, with the poem always shifting between a graphic or calligraphic object and a text, between visual and verbal paradigms.[24] And in the German baroque the emblem, "a montage of visual image and linguistic sign,"

would become a serious mode of expression, forcing the viewer to "read, like a picture puzzle, what things 'mean.'"[25] In the *Trauerspiel*, writes Benjamin, citing Carl Horst, allegory's purpose is "always to reveal a 'crossing of the borders of a different mode,' an advance of the plastic arts into the territory of the 'rhetorical' arts."[26] According to Deleuze these "combinations of the visible and the legible make up 'emblems' or allegories dear to the Baroque sensibility. We are always referred to a new kind of correspondence or mutual expression, an *entr'expression*, fold after fold."[27] The baroque is therefore an art of impurity and amalgamation, and it displays an affinity for what Rosalind Krauss calls the "post-medium condition" rather than the search for the essence of a particular medium, the characteristic pursuit of high modernism as formulated by Clement Greenberg or Michael Fried.[28] An art of adulteration, the baroque welcomes translation, a carriage across a threshold that transforms the original. The fold is not only a provisional form assumed by moving objects but form itself in motion.

The baroque celebration of impurity extends from the aesthetic to the philosophical spheres, where Leibniz and Spinoza devise a philosophy based not on timeless concepts but the movement from principle to principle. Elaborating on José Ortega y Gasset's observation, Deleuze writes, "On the one hand, Leibniz loves principles, and he is probably the only philosopher who invents them endlessly. He invents them with pleasure and enthusiasm, and he brandishes them like swords. But on the other hand, he plays with principles, multiplies formulas, varies their relations, and incessantly wants to 'prove' them as if, loving them too much, his respect for them were lacking."[29] That lack of "respect," an insolence shared by both Leibniz and Deleuze, results in a flood of new principles that inundates and overwhelms, but it also becomes a source of innovation, as they refuse to resort out of habit to well-worn concepts. Deleuze's description and celebration of the meanderings of the fold resolve into an apology for the equally eccentric career of Leibniz, into what Tom Conley calls "a plea for Leibniz."[30] It then plots an escape from aesthetic and philosophical routines, redirecting a tradition that finds itself in a rut, *un mauvais pli*. Within his readings of European philosophy, Deleuze discovers in Leibniz a *dérive* in the sense the Situationist International applied to their ramblings throughout Paris: Leibniz leads away from a habitual route, into a deviation, off the beaten path.

Leibniz exemplifies a philosophical tendency that Deleuze describes as "mannerism," or the tendency to divorce manners from an essence that precedes them. Leibniz accentuates those manners, attending to the predicates as well as the subjects, uprooting and unsettling the forms from which those manners emanate. Deleuze writes that "the world is predication itself, manners being the particular predicates, and the subject, what goes from one predicate to another as if from one aspect of the world to another. The coupling *basis-manners* disenfranchises form or essence: Leibniz makes it the mark

of his philosophy."[31] Baroque allegory contributes to this separation of form and essence because the allegorical image initiates a series of associations, its meaning accessible only through an open-ended process of decoding. In allegory, Deleuze writes, "*Basic images* tend to break their frames, form a continuous fresco, and join broader cycles . . . because the pictured form . . . is never an essence or an attribute, as in a symbol, but an event, which is thus related to a history or to a series."[32] Deleuze and Leibniz oppose manners to attributes, celebrating the movement from one predicate to another rather than the subject's claims to ownership and authority over those traits. The familiar critique of "essentialism" undergoes a subtle revision first in *A Thousand Plateaus* and again in *The Fold*, as the model of essences becomes odious not only because it envelops the subject in unsuitable inherited forms, but also because the essential subject inevitably constrains the predicate, limiting the extent to which it can unfold into new possibilities and thereby effect change in the subject itself. Deleuze and Guattari write that "there has always been a struggle in language between the verb *être* (to be) and the conjunction *et* (and) between *est* and *et*. . . . It is only in appearance that these two terms are in accord and combine, for the first acts in language as a constant and forms the diatonic scale of language, while the second places everything in variation, constituting the lines of a generalized chromaticism."[33] Nonstandard speech, including the rambling accumulation of manners joined loosely by "and," can act as a "tensor," or a means of facilitating the movement through several coordinate systems. Deleuze and Guattari write, "The atypical expression constitutes a cutting edge of deterritorialization of language, it plays the role of *tensor*; in other words, it causes language to tend toward the limit of its elements, forms, or notions, toward a near side or a beyond of language. The tensor effects a kind of transitivization of the phrase, causing the last term to react upon the preceding term, back through the entire chain. It assures an intensive and chromatic treatment of language. An expression as simple as AND . . . can play the role of tensor for all of language. In this sense, AND is less a conjunction than the atypical expression of all the possible conjunctions it places in continuous variation."[34] If nonstandard speech opens onto new modes of thought, the accumulation of words like "and" can reimagine the previous terms in the sequence and promote the amplification of folds and the proliferation of manners.

To the extent that Deleuze's own writing operates according to a consistent pattern of aesthetic principles, that style is best described in his study of Leibniz and the baroque. Deleuze's prose, with its penchant for rambling sentences and the neologism's "atypical expression," operates under an imperative of perpetual movement, jettisoning old terminology as soon as it grows stagnant and dogmatic.[35] Gregory Flaxman describes the rhetorical or literary aspiration of Deleuze as the creation of a "style commensurate to the power of the false."[36] The exuberant style of Deleuze and Guattari, as well as their "barbarous or

shocking" language, reveals a desire to flee from the confines of philosophy by adopting a new rhetoric or transplanting inherited terms into an unexpected context.[37] The Deleuzian sentence also displays its own variation on Leibniz's "Baroque grammar," which resists the tendency to endow the subject with proprietary rights over the predicate. Deleuze writes, "*Leibnizian inclusion is based upon a scheme of subject-verb-object that since antiquity resists the scheme of attribution.* Here we have a Baroque grammar in which the predicate is above all a relation and an event, and not an attribute. . . . Predication is not an attribution. The predicate is the 'execution of travel,' an act, a movement, a change, and not the state of travel. The predicate *is the proposition itself.*"[38] This baroque grammar permeates Deleuze's work, down to the level of sentence construction and verbal invention, which reflect this compulsion to fold and refold, to initiate and sustain movement. In this sense, Deleuze is a baroque or mannerist philosopher whose style leaps from one neologism or concept to the next in a process that prioritizes creation rather than repetition of core principles.

In the later writings of Deleuze and Guattari, including the revision that *A Thousand Plateaus* performs on *Anti-Oedipus*, a model based on the valorization of movement yields to the orchestration of intensities, visualized in moments of extreme mobility and stillness: "It is a question not of organization but of composition; not of development or differentiation but of movement and rest, speed and slowness."[39] The orchestration of movements in art and literature is intimately related to the new political movements envisioned in Deleuze and Guattari as the simultaneous destruction of systems based on representation and self-identity and the formation of aggregations based on strategic coalitions. These movements, "becomings, in other words," gesture beyond the politics of identity in which the subject figures into prescribed categories.[40] As is their usual procedure, Deleuze and Guattari borrow and transform the concept of *haecceity*—a term central to Leibniz's writing—for these variable degrees of mobility, and distinguish between this individuation based on motion and the conventional categories of subjectivity and objecthood. They write, "There is a mode of individuation very different from that of a person, subject, thing, or substance. We reserve the name *haecceity* for it. A season, a winter, a summer, an hour, a date have a perfect individuality lacking nothing, even though this individuality is different from that of a thing or a subject. They are haecceities in the sense that they consist entirely of relations of movement and rest between molecules and particles, capacities to affect and be affected."[41] Artists in the Deleuzo-Guattarian canon—including Franz Kafka, Samuel Beckett, John Cage, Ghérasim Luca, Nathalie Sarraute, and Jean-Luc Godard—are characterized above all by their orchestration of movement and rest "between the extreme slownesses and vertiginous speeds of geology and astronomy."[42] According to Deleuze and Guattari, "The essential thing is that each of these authors has his own procedure of variation,

his own widened chromaticism, his own mad production of speeds and intervals."[43] Deleuze and Guattari detect these forces of escape and moments of arrest throughout their mosaic of plateaus. They celebrate Cage, for example, for whom "silence as sonorous rest also marks the absolute state of movement."[44] Or Godard, who "effectively carries the fixed plane of cinema to this state where forms dissolve, and all that subsists are tiny variations of speed between movements in composition."[45] Although they also champion Pierre Boulez and Francis Bacon and various practitioners of "minor literature," Deleuze and Guattari often privilege photography and cinema as the paradigmatic examples and conceptual "thresholds" of their philosophy of stasis and movement. They liken the philosophy of movement to the observation of "huge Japanese wrestlers whose advance is too slow or whose holds are too fast to see, so that what embraces are less the wrestlers than the infinite slowness of the wait (what is going to happen?) and the infinite speed of the result (what happened?). What we must do is reach the photographic or cinematic threshold; but in relation to the photograph, movement and affect once again took refuge above and below. When Kierkegaard adopts the marvelous motto, 'I look only at the movements,' he is acting astonishingly like a precursor of the cinema, multiplying versions of a love scenario . . . according to variable speeds and slownesses."[46] Taken together, Deleuze's cinema books also orchestrate extreme forms of speed and stillness, with the movement-image the cinematic contribution to the age-old ambition "to look only at the movements," and the time-image a means of exploring the potential of a cinema where everything is possible because nothing happens.

Deleuze and Guattari's writings on nomadology and the baroque have been criticized for their occasional reliance on the tropes of "old anthropology," their penchant for perplexing neologisms, their tendency to tinker with incompletely understood disciplines, and their apparent obliviousness to the relatively stable structures of the world through which they wander.[47] What if, as Paul Virilio maintains, the production of intense speed is neither the prerogative of the artist nor a means of resistance, but instead the result of technologies of representation and reproduction themselves and therefore merely announces humanity's submission to their fiat?[48] Do Deleuze and Guattari merely celebrate an illusion of novelty and the endless recirculation of images, and do they therefore revel in their capitulation to the logic of late capitalism? Deleuze's solo writings begin playfully and lightly, often overflying the systems that bring a temporary and protean but nevertheless real order to this "chaosmos."[49] But he and Guattari warn repeatedly that a liberatory line of flight always contains the danger of fascism.[50] In the most nuanced moments of A Thousand Plateaus, the ecstatic tone remains, but it coexists with a note of circumspection. That book introduces the possibility of suspension within what Gregory Bateson calls a "plateau" of consciousness, an interval rather than a fixed and finite state, a "region of intensities."[51] Such admonitions serve

as an important brake on the movements initiated throughout their work, and they underscore the ultimately unrealizable status of the nomadic ideal. They write, "If the nomad can be called the Deterritorialized par excellence, it is precisely because there is no reterritorialization *afterward* as with the migrant, or upon *something else* as with the sedentary (the sedentary's relation with the earth is mediatized by something else, a property regime, a State apparatus)."[52] Nearly everything, however, faces the possibility of a "reterritorialization *afterward*," even the texts most resistant to normalization: even "Kleist and Artaud themselves have ended up becoming monuments, inspiring a model to be copied—a model far more insidious than the others—for the artificial stammerings and innumerable tracings that claim to be their equal."[53] With these examples in mind, *A Thousand Plateaus* concludes with a warning, as the authors emphasize the limitations of the model developed over their preceding collaboration, with deterritorialized, "smooth" spaces always under threat of reterritorialization and "striation." They write, "Movements, speed and slowness, are sometimes enough to reconstruct a smooth space. Of course, smooth spaces are not in themselves liberatory. But the struggle is changed or displaced in them, and life reconstitutes its stakes, confronts new obstacles, invents new paces, switches adversaries. Never believe that a smooth space will suffice to save us."[54]

Despite its very real limitations—its antagonistic relationship to history and geography, its proliferating dualisms (arboreal and rhizomatic, movement-image and time-image, classical and baroque)—Deleuze's thought must also be considered within the context of what it does, what it displaces, and what it departs from. Deleuze and Guattari are therefore unapologetic about their refusal to write geography or history and their linguistic experimentation. They write, "It is not a question of this or that place on earth, or of a given moment in history, still less of this or that category of thought. It is a question of a model that is perpetually in construction or collapsing, and of a process that is perpetually prolonging itself, breaking off and starting up again. No, this is not a new or different dualism. . . . We invoke one dualism only in order to challenge another. We employ a dualism of models only in order to challenge another. We employ a dualism of models only in order to arrive at a process that challenges all models. Each time, mental correctives are necessary to undo the dualisms we had no wish to construct but through which we pass. Arrive at the magic formula we all seek—PLURALISM = MONISM—via all the dualisms that are the enemy, an entirely necessary enemy, the furniture we are forever rearranging."[55] Deleuze and Guattari emphasize that their theoretical undertaking never involves the spontaneous generation of concepts; instead it discards obsolete principles, uproots entrenched ideologies, shifts inherited "furniture," in the hope of provoking a new and emancipatory mutation from within that forbidding legacy.

In his book on the baroque Deleuze elaborates on and responds to the well-founded concerns raised in his earlier work, as Leibniz's monadology forms a necessary complement to any equal and opposite nomadology. If, as Deleuze writes, "closure is the condition of being for the world," the baroque's dispersive impulse jeopardizes at every fold the search for a stable totality and therefore verges on the "unmappable" postmodern system theorized by Fredric Jameson.[56] While Jameson repeatedly laments the reversals that confound contemporary approaches to the totality, he also harks back to the baroque philosophers embraced by Deleuze for a model of this elusive system. In *The Geopolitical Aesthetic*, Jameson hails a baroque prototype of cognitive mapping then experiencing a revival through Deleuze.[57] He writes about the ongoing cartographic effort in recent European thought engaged in "mapping its own geographical future: nowhere so luminously as in Deleuze's return to Leibniz, where the monadology offers a more substantial philosophical solution than all the various current ideologies of pluralism."[58] The model of the monad remains suggestive for Jameson and crucial throughout the work of Deleuze because it envisions a totality that does not compromise the integrity of each fragment or force it to submit to an imposed unity. In *Proust and Signs* (1972) Deleuze provides his clearest description of the quandary later addressed in *The Fold*: "Once again, the problem of the work of art is the problem of a unity and a totality that would be neither logical nor organic, that is, neither presupposed by the parts as a lost unity or a fragmented totality nor formed or prefigured by them in the course of a logical development or of an organic evolution."[59] For Deleuze this totality will always be impossible to construct because it consists of fragmented parts with tenuous and contingent rather than necessary or essential connections; it is not transcendent. But he also searches for a way to account for its peculiar existence. He writes, "For it is the character and nature of the parts or fragments to exclude the Logos both as logical unity and as organic totality. But there is, there must be a unity that is the unity *of* this very multiplicity, a whole that is the whole *of* just these fragments: a One and a Whole that would not be the principle but, on the contrary, 'the effect' of the multiplicity and of its disconnected parts. One and Whole that would function as effect, effect of machines, instead of as principles."[60] Leibniz's monad is a model of singularity and totality that envisions the multiple as a necessary condition for the whole and the whole as a constellation of singular moments. Using a geographical metaphor to describe the monad's quasi-cartographic function, Deleuze writes, "As an individual unit each monad includes the whole series; hence it conveys the entire world, but does not express it *without expressing more clearly a small region of the world, a 'subdivision,' a borough of the city, a finite sequence.* Two souls do not have the same order, but neither do they have the same sequence or the same clear or enlightened region."[61] The monadology imagines a subject that straddles two noncontiguous, "incompossible" worlds and whose juxtaposition seems to rest

on a category mistake that allows the specificity of the local to mingle with the abstractions of the totality.

In formal terms Deleuze and Leibniz contrast the monad first to the more pervasive models of art or history as a "window" opening onto the world or the past, and then to equally reductive models that posit art as a mirror raised before nature. Deleuze's writing on the monad has enormous ramifications for theories of painting, photography, and cinema, the media most often envisioned as windows and mirrors, and for historical representation, which often functions as a "window onto the social and cultural concerns of an era" or a "mirror of the past."[62] As Dudley Andrew argues, film theory is habitually divided into two schools dating from the advent of the medium and extending into the present day: occupying one side, theorists like André Bazin, for whom the window often provides the basic analogy to the screen; and, on the other, Sergei Eisenstein and Rudolf Arnheim, who imagine the film as a frame, focusing on certain objects and events, while relegating others to the margins of the picture or excluding them altogether.[63] Both models continue to guide and constrain contemporary theories of the image, for, as Victor Burgin writes, "the perspectivist's 'window on the world,' and proscenium arch, remain the habitual frames of our representations—even in television. But such means of circumscribing the *mise-en-scène* appear out of their time; dislocated survivors from another time, a sort of nostalgia."[64] The most radical trends in film theory during the 1970s, especially those associated with the journals *Screen* and *Tel Quel*, assumed that either the structure of classical Hollywood narrative or the cinematic apparatus posed as a window and obscured the inevitable framing process that all representation entails. Jean-Louis Baudry's statement of the problem remains the most explicit, as he adopts Plato's allegory of the cave, with the spectators of the film envisioned as slaves to the images around them because they maintain a naive faith in the reality of the cinematic shadows before them, because they adhere ingenuously to the belief that cinema is a window opening onto a world rather than the motivated projection of potentially misleading images and manufactured desires. Deleuze departs from both Bazin and Eisenstein when he suggests that the screen is neither a window nor a frame, but a monad: a structure with no windows or holes, which serves less as a border for the images projected inside than as a surface upon which a grid of information unfolds. In his formulation the characteristic act of cinema is not framing a view (on the analogy with painting) or projection into dark space (as apparatus theory holds), but the accumulation of movements and "sheets of past." Extending Leibniz's physical analogies for the monad, Deleuze writes, "The painting-window is replaced by tabulation, the grid on which lines, numbers, and changing characters are inscribed."[65] Within this environment, "Leibniz is endlessly drawing up linear and numerical tables. With them he decorates the inner walls of the monad. Folds replace holes."[66]

Deleuze remarks that the monads of Leibniz parallel in the realm of philosophy the camera obscura that appears in his writings on aesthetics: each assaults the barrier between inside and outside, and each seeks to connect the isolated and atomized individual to the totality. The camera obscura has long been invoked—by Bergson, Freud, and, most famously, Marx, while denouncing the illusions produced by the camera obscura of ideology—as a model for the distortion or inversion of reality through intentional or unconscious manipulation.[67] Relying heavily on Leibniz's writing on the camera obscura, Jonathan Crary posits that instrument as the emblematic technique of observation in the seventeenth and eighteenth centuries because it situates the body of the observer within "rigid structures," immobilizing vision within the confines of the chamber's black box. The camera obscura becomes the apotheosis of the baroque era's guided culture, as it establishes "fixed relations of interior/exterior" and imposes a "juridical model" on the observer.[68] While Crary argues that new techniques of observation and social formations introduced in the 1830s and 1840s motivated a "freeing up of vision," an influential strain of film theory views the "camera obscura and cinema as bound up in a single enduring apparatus of political and social power, elaborated over several centuries, that continues to discipline and regulate the status of an observer."[69] But Leibniz and Deleuze imagine the camera obscura as a less technologically determined or coercive phenomenon. The wall, canvas, or screen serves not as a passive receptacle of images but as a structuring force operating under a productive "tension" between the observer and the apparatus. Leibniz writes that "we should have to postulate that there is a screen in this dark room to receive the species, and that it is not uniform but is diversified by folds representing items of innate knowledge; and, what is more, that this screen or membrane, being under tension, has a kind of elasticity or active force, and indeed that it acts (or reacts) in ways which are adapted both to past folds and to new ones."[70] A return to Leibniz provokes nothing less than a total reappraisal of the foundational model of the camera obscura and its interlacing folds from the past and the new.

In cinema Deleuze also observes the traces of change made visible on a "stretched canvas diversified by moving, living folds."[71] In Deleuze's reading of Leibniz, the camera obscura becomes a precursor to a cinema envisioned not only as a machine, but also as a chamber and a surface dedicated to the display of moving images. As Svetlana Alpers writes, "We are so accustomed by now to associating the image cast by the camera obscura with the real look of Dutch painting (and after that with photography) that we tend to forget that this was only one face of the device."[72] Some showmen, she argues, used the machines "to contrive a theatrical presentation" while others deployed the related "magic lantern" for similarly spectacular performances.[73] Historians of the camera obscura also emphasize its status as a proto-cinematic device, arguing that "it's closer to a primitive movie-making apparatus-plus-theater in that the image

projected into the booth or box, completely dependent on the amount of light that it is sucking in via the small opening, is always, in a way, breathing. What drew early enthusiasts to the gizmo, which initially was often trained from a window down onto a street, was the thrill of seeing people move about on a kind of contained screen."[74] A mistrust of the ideological effects of the cinematic apparatus reigned in the corpus of politically inflected texts produced primarily in the 1970s. But beginning in the 1980s Deleuze proposed a countervailing theory of the cinematic image affected but undetermined by that apparatus. Virilio argues that the "field of vision" is "comparable to the ground of an archaeological excavation," and writers like Crary have unearthed the camera obscura, presenting that device as emblematic of a particularly coercive and restrictive paradigm of visual culture.[75] Yet that prototypical device reveals little beyond its capacity for subjugation. In Deleuze's study of Leibniz the revival of the monad is a way of rethinking cinema to recover the peculiar relationship between inside and outside, stasis and movement, past and future, embodied in the camera obscura.

Extreme speed alternating with moments of stillness, the "orchestration of movement and rest," and the artist's "procedure of variation" all make change visible, audible, and readable. For Benjamin these arrangements are crucial not only in the baroque *Trauerspiel* and modernist art, but also in the at once theoretical and concrete concerns of historical materialism. Benjamin writes, "Thinking involves not only the flow of thoughts, but their arrest as well. Where thinking suddenly stops in a configuration pregnant with tensions, it gives that configuration a shock, by which it crystallizes into a monad. A historical materialist approaches a historical subject only where he encounters it as a monad. In this structure he recognizes the sign of a Messianic cessation of happening, or, put differently, a revolutionary chance in the fight for the oppressed past. . . . As a result of this method the lifework is preserved in this work and at the same time canceled; in the lifework, the era; and in the era, the entire course of history."[76] Benjamin's historical materialist studies not the enduring structure of a constellation but its tensions. A materialist history is a record of that strain, as the monad wavers between visions of specificity and totality. While few would affix the label "historical materialism" to the work of Deleuze, especially given his aversion to history, he operates under that same structuring tension between the stillness of the constellation and the chaos from which it emerges. His nomadology is intoxicated by the possibilities of that change; his monadology contemplates both the constant mutations of the totality and the necessarily limited, momentary, fragmentary instantiations of the whole. Andrew remarks that Jean Mitry's contribution to the debate over the fundamental question "What is cinema?" is the obvious but conceptually difficult conclusion that cinema "oscillates" between its status as a window and a frame, that the medium exists at the nexus between reality and the limited access to reality afforded by the enclosures of art.[77] The monad is a way of

thinking through the tension between aspirations to change and the confines of a particular form or medium.

Deleuze's account of the baroque never resolves into a pure celebration of dynamic, unconstrained movement, a difference of emphasis that marks his development as a thinker from the era of *Anti-Oedipus* to the late twentieth century. As a countervailing force, he introduces a mesh sieve or filter (*crible*), like the screens in open windows or the sifters used to separate gold from the soil or wheat from chaff.[78] As the following section suggests, Deleuze uses this concept of the strainer or sieve as the basis of a theory of the cinematic screen distinct from the transparent and unobstructed window onto reality or the purely opaque and reflective surface that projects fantasies rather than the real world. While the baroque has become synonymous with excess and unbridled formal energy, this vision of chaos and disorder is unthinkable without the patterns rendered momentarily visible on a surface. If media like photography and film have been theorized in accordance with its original promise of radical modernity, another cinema appears to Deleuze during its baroque age, a cinema that is at once as old as Leibniz and as stunning as the earliest films of the Lumière brothers or Georges Méliès, an archaeomodern medium that draws together distant historical periods and seemingly irreconcilable philosophical positions. As he writes in *The Fold*, "Chaos does not exist; it is an abstraction because it is inseparable from a screen that makes something—something rather than nothing—emerge from it. Chaos would be a pure *Many*, a purely disjunctive diversity, while the something is a *One*, not a pregiven unity, but instead the indefinite article that designates a certain singularity. How can the Many become the One? A great screen has to be placed in between them."[79] Deleuze begins his career as a philosopher by asking what the "opposite of a history" might look like, and he celebrates the possibilities inherent in an intellectual nomadism that throws off the constraints imposed by the past. He ends that career by posing an intimately connected question: "What is cinema?" Neither a window nor a frame, cinema is movement within a monad, chaos on a screen.

Cinema Unfolds

Deleuze's cinema books repeatedly advertise their author's own belatedness, his status as a latecomer to the history of film and the long tradition of philosophical writing about cinema. Bergson is the most obvious predecessor and interlocutor for Deleuze, but he also engages with a range of (mostly French) critics and scholars, including Bazin, Christian Metz, and Serge Daney, with the goal of locating himself alongside but apart from existing critical strains that emphasize the realist potential of cinema or develop analogies between film and language. Deleuze's books are revisionist projects designed

to rejuvenate and reorient what he sees as the insightful but ultimately misguided film theory produced before him. Deleuze also rejects the allure of modernity that flashed across screens around the world in the late nineteenth and early twentieth centuries. Instead he alludes to various "deaths" of cinema that have confronted filmmakers since the post–World War II "crisis of the action-image" and that undermined the confidence evident in the first generations of intellectuals interested in film. Writing from a position of weariness and resignation, he notes the absurdity of theories that celebrated the power of cinema to shock spectators into a new political or aesthetic consciousness. "Everyone knows that, if an art necessarily imposed the shock or vibration, the world would have changed long ago, and men would have been thinking for a long time. So this pretension of the cinema, at least among the greatest pioneers, raises a smile today."[80] Worse even than the laughable illusion that cinema could lead directly to a revolution in consciousness are the historical examples when cinema did become an instrument of indoctrination, when the politically charged spectator posited in Benjamin or Eisenstein passed through the looking glass and became "the dummy of every kind of propaganda" and a "fascist man."[81] Although Deleuze suggests that the stakes are lower in mainstream entertainment, he mocks the cruel banality he sees in the mass film culture of his time. "Cinema is dying," he writes, "from its quantitative mediocrity."[82] In the art cinema that occupies most of Deleuze's time and attention, self-reflexive films about film itself merely amount to cinema's "melancholic Hegelian reflections on its own death: having no more stories to tell, it would take itself as its own object and would be able to tell only its own story."[83] But Deleuze continued to write about cinema even after announcing that a particular strand of optimistic and futuristic thought had arrived not at the promised liberation but at a disappointing or even devastating conclusion. Quoting Antonioni, he suggests that "when everything has been said, when the main scene seems over, there is what comes afterwards."[84] Deleuze is a late-arriving philosopher of cinema, whose inquiry begins after the main scene has concluded and during the search for the medium's afterlife. While an atmosphere of decline permeates his writing on film, he also insists that "it is foolish to talk about the death of the cinema because cinema is still at the beginning of its investigations."[85] Introducing the approach to history that would govern his work on Leibniz and the baroque, Deleuze suggests that the century of cinema should be understood not as a sequence that plays out from beginning to end but as a spiral or fold that draws together even the most distant moments in time. While Leibniz makes a couple of explicit cameos in Deleuze's cinema books, Deleuze's simultaneous return to the baroque also colors his meditations on cinema, as he revisits the history of film from a condition of belatedness, locates it within a tradition of ruined projects now relegated to the past, and frames that condition of ruin as a position of vulnerability, openness, and renewal. Rather than produce another celebration

of cinematic modernity or anticipate yet another technological and stylistic rebirth, Deleuze writes an eleventh-hour philosophy of cinema imbued with an understanding of his own position looking back from the end of the twentieth century rather than rushing forward with hope and confidence from the beginning.[86]

While Deleuze stresses the difference between his own philosophy of cinema and a proper history of film, *The Movement-Image* and *The Time-Image* contain regular temporal markers that hint at an implied chronology operating in the background. That immanent history emerges most notably in the structuring divide between the types of images that lend their names to the two volumes and announce a transfer of the "soul of the cinema" from a hegemonic but timeworn form to its faltering and experimental successor.[87] He writes, "Why is the Second World War taken as a break? The fact is that, in Europe, the post-war period has greatly increased the situations which we no longer know how to react to, in spaces which we no longer know how to describe. These were 'any spaces whatever,' deserted but inhabited, disused warehouses, waste ground, cities in the course of demolition or reconstruction. And in these any-spaces-whatever a new race of characters was stirring, kind of mutant: they saw rather than acted, they were seers."[88] In the new cinemas of the post–World War II era, "a new kind of image is born," and in his discussion of the recollection image, he argues that "a whole new sense of subjectivity appears," suggesting that this novelty signals an epoch-making transformation, the arrival of a "new society," rather than a minor alteration in taste or fashion.[89] These allusions to a "break" and a range of "new" phenomena, to situations and subjects that "no longer" exist, and to the origins of this aesthetic innovation in broader social changes suggest that Deleuze was at least tempted to veer into a more historical or sociological analysis, even as he devoted the bulk of his work to the intersection of film and philosophy. Yet this Deleuzian history always assumes a peculiar and unsatisfying form, most noticeably in the seemingly haphazard list of tangentially related occurrences that associate the crisis of the action-image with "many factors which only had their full effect after the war, some of which were social, economic, political, moral and others more internal to art, to literature and to the cinema in particular. We might mention, in no particular order, the war and its consequences, the unsteadiness of the 'American Dream' in all its aspects, the new consciousness of minorities, the rise and inflation of images both in the external world and in people's minds, the influence on the cinema of the new modes of narrative with which literature had experimented, the crisis of Hollywood and its old genres."[90] These occasional lapses into a sketchy cause-effect narrative written in "no particular order" also function as parodies of history in which timelines no longer impose a structure on events and even the most momentous episodes pass by in a phrase before receding into the background of a discussion focused on images and time. Even when Deleuze

presents the matter-of-fact historical background of his argument, he is also writing the opposite of history.

Deleuze's cinema books feature a series of meditations on the limitations of a chronological understanding of the past and its implicit models of development and evolution. Given the seemingly obvious affinities between Bergson's thought and cinema, Deleuze asks why Bergson failed to give the new medium its due. He hints that his predecessor succumbed to the widespread anticinema sentiment in intellectual circles at the turn of the twentieth century and failed to see how movies could crystallize the fledgling concept of the movement-image Bergson had proposed in 1896 in *Matter and Memory*, at the very moment when film pioneers were introducing their inventions to a mass public. "Or," from an alternative perspective, Deleuze asks, "did he fall victim to another illusion which affects everything in its initial stages? We know that things and people are always forced to conceal themselves, have to conceal themselves when they begin. What else could they do? They come into being within a set which no longer includes them and, in order not to be rejected, have to project the characteristics which they retain in common with the set. The essence of a thing never appears at the outset, but in the middle, in the course of its development, when its strength is assured."[91] Underlying this sympathetic critique of Bergson is an unconventional model of development that excuses his oversights as an almost inevitable product of their time, a period when cinema had not yet revealed the "essence" that was present at the outset but would only find an appropriate form with the emergence of a classical style, the European avant-gardes of the teens and twenties, and the new cinemas after World War II. Deleuze unveils a historical paradigm that consists of false starts and delays, of possibilities revealed in a burst then obscured for years or decades. He reimagines philosophy as a return to origins with the goal of uncovering the potential obscured by the passage of time and the widespread acceptance of a flawed narrative that emphasizes evolution and progress. In *The Movement-Image* Deleuze cites Bergson himself as the source of this insight: "As Bergson says, although he had not seen its application to cinema, things are never defined by their primitive state, but by the tendency concealed in this state."[92] In the second volume Nietzsche becomes the inspiration for this untimely model of history: "To use a formula of Nietzsche's, it is never at the beginning that something new, a new art, is able to reveal its essence; what it was from the outset it can reveal only after a detour in its evolution."[93] While Deleuze occasionally deploys the familiar sequential language of birth and death, before and after, old and new, the cinema books also present a meditation on historiography that dispenses with the privilege of beginnings and the gravity of ends and instead explores the creative potential of return.

The key transformation identified by Deleuze and foregrounded in the division of his project into two volumes is the crisis of a cinema organized around

action and the emergence of a "cinema of time."[94] He considers this "a much more important change . . . than the one which happened with the talkie" and upends the conventional scaffolding of events that structure most film histories centered on technological, industrial, or aesthetic revolutions.[95] After a period of uncertainty and experimentation in the first years after the invention of cinema, after the misdirection that confounded Bergson, filmmakers began to understand and exploit the fundamental relationship between movies and movement. Contrary to Bergson's claim that film represents an artificial semblance of motion added to still images extracted from a continuously moving object, Deleuze argues that "cinema does not give us an image to which movement is added, it immediately gives us a movement-image. It does give us a section, but a section which is mobile, not an immobile section + abstract movement."[96] Deleuze relates this to the "modern scientific revolution" that sought knowledge not through the contemplation of "privileged instants" or ideal forms but the more randomized study of the arbitrary block of time, the "any-instant-whatever."[97] This emphasis on the haphazard event could be criticized for flattening a terrain once organized around transcendent artistic achievements, but Deleuze instead highlights the potential of cinema to transform any moment or image, however inconsequential and unassuming, into something exceptional or iconic. He writes, "When one relates movement to any-moment-whatevers, one must be capable of thinking the production of the new, that is, of the remarkable and the singular, at any one of these moments: this is a complete conversion of philosophy. It is what Bergson ultimately aims to do: to give modern science the metaphysic which corresponds to it, which it lacks as one half lacks the other. But can we stop once we have set out on this path? Can we deny that the arts must also go through this conversion or that the cinema is an essential factor in this, and that it has a role to play in the birth and formation of this new thought, this new way of thinking?"[98] Deleuze's philosophy of cinema is founded on the possibilities inherent in "any moment" rather than the primacy of an exemplary instant, or, more precisely, what makes cinema remarkable is the potential singularity of any flash in time.

While any film establishes relationships between the slices of time edited together within the boundaries of a particular movie, it also invokes a "virtual relationship" between the images visible on the screen and an unbound multitude of movements and times, an "infinite set of all images" that "constitutes a kind of plane [plan] of immanence. The image exists in itself, on this plane."[99] The protocols of classical cinema and the various stylistic schools establish parameters and determine which image can follow logically after another, but Deleuze suggests that cinema fulfills its potential only when we realize that any image can become exceptional, open onto any other image, and extend into an infinite plane of possibility. The "cinema of time" jams the automatic responses that governed classical cinema—gunshot, duck and dodge, fire back, run—and features characters who observe an unfamiliar world instead

of acting in one they recognize by force of habit. Deleuze then rewrites the history of cinema to reveal the emergence of the time-image in the most unlikely places, including deep-focus shots where movement into space corresponds with the unfolding of time or the enervated bodies that lay bare a condition of "tiredness and waiting," "even despair."[100] He writes that the "attitude of the body is like a time-image, the one which puts the before and the after in the body, the series of time."[101] These deliberate and unhurried time-images are precursors to the "slow cinema" on display in the film festival circuit in recent years, but they also resist the obvious association between time and the duration of the shot on-screen. Instead, Deleuze suggests that all filmmakers have been experimenting with the fundamental components of movement and time and that the time-image has always been surging from the screen, even in the seemingly inhospitable climate of classical cinema. The innovation of the new cinemas and new waves is therefore framed not as the creation of something from nothing but as an archaeological process aimed at the rediscovery of film's fundamental premises and potential.

In language that recalls his writing on the baroque fold, Deleuze invokes the shape of an arc, spiral, or ellipse to describe a flow of time that deviates from plotted linear paths and invites a leap across space and time from one seemingly distant point to another, like a string connecting the two ends of an archer's bow. In *The Fold* he writes that "*the world is the infinite curve that touches at an infinity of points an infinity of curves*," and his writing on cinema also confronts a world of infinite arabesques, of unspooling reels of celluloid rather than one frame following mechanically after another.[102] If the philosophy of movement for millennia has focused obsessively on the arrow that travels ineluctably forward from one point to another, Deleuze discards the arrow altogether and focuses not on its destination but on its trajectory in flight and the curve of the bow. He evokes this model first in the context of Eisenstein and his opposition to an "organic" paradigm of simple, sequential "genesis and growth" that disregards the potential for revolutionary change. Eisenstein foregrounds the transformative power of passionate intensity rather than orderly, guided progress. The key, writes Deleuze, "is that from one point to another on the spiral one can extend vectors which are like the strings of a bow, or the spans of the twist of a spiral. It is no longer a case of the formation and progression of the oppositions themselves, following the twists of the spiral, but of the transition from one opposite to the other, or rather into the other, along the spans: the leap into the opposite. There is not simply the opposition of earth and water, of the one and the many; there is the transition of the one into the other, and the sudden upsurge of the other out of the one. There is not simply the organic unity of opposites, but the pathetic passage of the opposite into its contrary. There is not simply an organic link between two instants, but a pathetic jump, in which the second instant gains a new power, since the first has passed into it."[103] If Deleuze proposes a history of cinema, it

follows this paradoxical "logic" of pathos, as films and images burst out of a chronological sequence and frustrate ingrained habits of historiography.

The key concepts developed by Deleuze in *The Time-Image* are also founded on the aesthetic principles of the curve or spiral and the events made possible in those departures from a linear form. Like the "attractional calculus" of Eisenstein, the time-image provokes a surge of feeling, but unlike the Soviet ambition of elevating cinema to a "higher power," the postwar art cinema initiates a less purposeful, more meandering movement that disregards the advance of time.[104] Time curves in on itself in the films analyzed in Deleuze's second cinema book, and he renders this phenomenon most vividly in his elaborate definition of the aspect of time made visible in cinematic "chronosigns." These signs consist of, "on the one hand, time as whole, as great circle or spiral, which draws together the set of movement in the universe; on the other, time as interval, which indicates the smallest unit of movement or action. Time as whole, the set of movement in the universe, is the bird which hovers, continually increasing its circle. But the numerical unit of movement is the beating of a wing, the continually diminishing interval between two movements or two actions. Time as interval is the accelerated variable present, and time as whole is the spiral open at both ends, the immensity of past and future. Infinitely dilated, the present would become the whole itself; infinitely contracted, the whole would happen in the interval."[105] Cinema can be revolutionary not only through the explicitly political modes theorized by Eisenstein or Benjamin but also in its capacity to rethink our relationship to time imagined not as a clock ticking forward but as the totality of all moments in the past or future, each accessible to thought from any other moment just as a film could, if freed from the constraints of narrative, combine any two images across the open and liberating space of the interval, in the instantaneous beating of a wing. This would not be the old-fashioned clockwork universe but a cinematic one where the "material universe, the plane of immanence, is the *machine assemblage of movement-images.*"[106] Inspired and anticipated by Bergson's treatise on movement and time, Deleuze envisions "the universe as cinema," as a "metacinema."[107] Deleuze's "cinema of time" would likewise view time as cinema, as an assemblage of moving images from the past, present, and future linked together through spirals and folds rather than a chronological ordering of events.

In the transition between his two cinema books, especially the conclusion of the first volume, Deleuze considers the most common response to the openness in space and time made possible in film and the strategies deployed to impose order on that chaos. He asks "what maintains a set [*ensemble*] in this world without totality or linkage. The answer is simple: what forms the set are *clichés*, and nothing else. Nothing but clichés, clichés everywhere."[108] For Deleuze the cliché represents a pernicious relationship to the past because it involves the habitual extension of prior actions and decisions into the present and future.

Like the flashback in cinema—a device that usually shows the automatic reaction to a trigger and therefore the equivalent of a sensory-motor response in the realm of time and memory—the cliché leads us back to a predetermined moment in time and its prescribed lessons. This reflexive return to the trite and familiar betrays the spirit of indeterminacy, the exposure to both risk and grace, that defines the interval. Deleuze writes, "We have schemata for turning away when it is too unpleasant, for prompting resignation when it is terrible and for assimilating when it is too beautiful. It should be pointed out here that even metaphors are sensory-motor evasions, and furnish us with something to say when we no longer know what to do: they are specific schemata of an affective nature. Now this is what a cliché is. A cliché is a sensory-motor image of the thing. As Bergson says, we do not perceive the thing or the image in its entirety, we always perceive less of it, we perceive only what we are interested in perceiving, or rather what it is in our interest to perceive, by virtue of our economic interests, ideological beliefs and psychological demands. We therefore normally perceive only clichés."[109] In the immediate post–World War II period filmmakers began to escape the regime of the cliché by engineering situations where "our sensory-motor schemata jam or break," allowing "a different type of image [to] appear: a pure optical-sound image, the whole image without metaphor."[110] The freedom to reveal a direct image of time was only one stage in a thoroughgoing transformation of cinema that culminated in an attack on the regime of the cliché. This revolution involved a "triple reversal which defines a beyond of movement. The image had to free itself from sensory-motor links; it had to stop being action-image in order to become a pure optical, sound (and tactile) image. But the latter was not enough: it had to enter into relations with yet other forces, so that it could itself escape from a world of clichés."[111] Deleuze then goes on to define the major subcategories of the time-image through their opposition to the tyranny of the cliché viewed at once as an aesthetic category and a historical one, as a continual return of the past that forecloses a future in the throes of emergence.

As Deleuze explores this fundamental relationship between time and cinema, a topic that has occupied film theory from the debut of the medium, he also implicates himself in the key intellectual and cultural debates of the late twentieth century. In the context of his ongoing struggle against the cliché, Deleuze cites the representation of history as a contested site where filmmakers grapple with competing conceptions of time and memory. He contrasts, for example, "the film of monumental and antiquarian history," which uses stereotypes about the past to assert its authenticity, and the "costume film," where the "fabrics and hangings" serve as "indices of a situation which they disclose" and "the dressmaker, the designer" allows history to materialize in the "habitus," rather than assume the readymade form furnished by our "habits" of historical thinking.[112] He also distinguishes between the undetermined quality of the any-space-whatever and the overdetermined meaning

of a "derived milieu" that is "actualised directly in determinate, geographical, historical and social space-times."[113] Derived milieux are the domain of realism, he suggests, but they are nowhere more coercive than in the historical film that establishes its credentials through a parade of period costumes, objects, and spaces: the powdered wig, the horse and buggy, the country estate, and the other stock references that locate a narrative in past times and places. Deleuze suggests that historical films had to be jostled out of a hackneyed model of historiography in order to rediscover a more emancipated relationship to time. Deleuze also celebrates a mode of cinema that allegorizes the dangers inherent in routinized recapitulation of the past. In Luis Buñuel's *The Exterminating Angel* (1962), for example, the "Angel's guests want to commemorate, that is, to repeat the repetition which has saved them; but in this way they fall back into a repetition which ruins them."[114] Deleuze's cinema books revisit his earlier attempt to write the "opposite of a history" without dipping into a reservoir of clichés awaiting their perpetual rediscovery and ruinous rebirth and without resorting to the unrealized modernist vision of continual revolution and the nomadic variation on the theme developed with Guattari. Writing in the 1980s rather than in Bergson's time or the heyday of neorealism, writing amid the mature formulas of late cinema rather than in the first bloom of its invention or the revivals of the new waves, Deleuze identifies the banality of unshakable conventions as a symptom of the decline or even death of the medium. Viewed from the late twentieth century, cinema had to be liberated from both the accumulated habits of the intervening decades and the recurrent myths of liberation that had become another ruinous repetition.

Confronted with a cinema that once aspired to radical modernism but soon lapsed into cliché, Deleuze again seeks guidance in the observations of Bergson, whose philosophy of time and the image would allow Deleuze to connect, like a bowstring, the two ends of film history: the moment of its invention and the period of its apparent decline. The "memory-image" is the key Bergsonian concept adopted by Deleuze, who renames it the "time-image," describes its qualities and subsets in painstaking detail, and enlists the power of memory against the liquidationist excesses of modernism and the openness of time against the tyranny of the cliché. This transition from "memory" to "time" is crucial for Deleuze, as he abandons the subterranean metaphors of roots or history buried underground and instead describes a temporal plane that includes images from the past, present, and future, each potentially open to links with any other image or time. He writes that "there is no present which is not haunted by a past and a future, by a past which is not reducible to a former present, by a future which does not consist of a present to come. . . . It is characteristic of cinema to seize this past and this future that coexist with the present image. To film what is *before* and what is *after*."[115] Cinema can resort to flashbacks and other shortcuts into a specific memory extracted from the past, but cinema can also reveal that "memory is not in us; it is we who

move in a Being-memory, a world-memory."[116] Deleuze underscores the limitations of any historical model that involves literal or metaphorical "digging" for an artifact in the ground or a memory and returning with this memento to everyday life in the present. He writes, "Just as we perceive things in the place where they are, and have to place ourselves among things in order to perceive them, we go to look for recollection in the place where it is, we have to place ourselves with a leap into the past in general, into these purely virtual images which have been constantly preserved through time."[117] Rather than an eternal return of the same, Deleuze views cinematic time as a "vertical line which unites [the present] at a deep level with its own past, as well as to the past of the other presents, constituting between them all one and the same coexistence, one and the same contemporaneity."[118] The highest aspiration of cinema is not the recovery of a particular past event or memory, but an immersion in the totality of time. Deleuze's career suggests that the full implications of cinema only became visible when the futurism of the early twentieth century and the commemoration of the late had run their separate courses into the dead ends of modernist annihilation or catastrophic return.

The later Deleuze, like so many theorists of cinema and media, is also captivated by ghosts, by entities that escape the mire of the past and persist in an indistinct temporality between the living and the dead. He expresses a fascination with the "characters who return from the land of the dead" in Alain Resnais, and he suggests that from the beginning of his career, "Resnais has considered only one cinematic subject, body or actor, a man returning from the dead."[119] He comments on the "phantoms" in Kafka that "threaten us all the more as they do not come from the past" but instead reside in the techniques of communication.[120] He describes an *archaeological, stratigraphic, tectonic* image that delivers us not to "prehistory . . . but to the deserted layers of our time which bury our own phantoms."[121] And he narrates the history of cinema itself as a tale of unrealized revolutions and the ghosts left in their wake: "It took modern cinema to re-read the whole of cinema as already made up of aberrant movements and false continuity shots. The direct time-image is the phantom which has always haunted the cinema, but it took modern cinema to give a body to this phantom."[122] His book on the time-image provides both a retrospective account of the ghosts roaming throughout his previous volume on cinematic movement and a taxonomy of the many forms this phantom assumed after the war. Deleuze views the time-image as a wraithlike presence that only became intelligible toward the end of a long sequence in film history and theory. Although his two books are structured around a "crisis" and a break, before and after, his account of film history could also be viewed as a tale of spirits, with the figure of the ghost bending chronology and bringing together discrete and distant points on a timeline. Foucault highlights what he calls a "heterochronic" dimension of certain spaces, including the graveyard, which brings together distinct "slices of time," and Deleuze treats film

like a heterochronic phenomenon, a haunted graveyard where the past always threatens to become active and dynamic again.[123] As he traces the paths of phantoms that swoop back and forward in time, Deleuze writes nothing less than a cinematic philosophy of cinema.

Like the ghost, cinema creates folds in time. In *Cinema 2* Deleuze writes, "If feelings are the ages of the world, thought is the non-chronological time which corresponds to them. If feelings are sheets of past, thought, the brain, is the set of non-localizable relations between all these sheets, the continuity which rolls them up and unrolls them like so many lobes, preventing them from halting and becoming fixed in a death-position. . . . This is what happens when the image becomes time-image. The world has become memory, brain, superimposition of ages or lobes, but the brain itself has become conscious-ness, continuation of ages, creation or growth of ever new lobes, re-creation of matter as with styrene. The screen [*l'écran*] itself is the cerebral membrane where immediate and direct confrontations take place between the past and the future, the inside and the outside, at a distance impossible to deter-mine, independent of any fixed point. . . . The image no longer has space and movement as its primary characteristics but topology and time."[124] In his work produced in the 1980s and 1990s, Deleuze presents the fold as a manifesta-tion in the domain of aesthetics of his more abstract models of the brain and the screen.[125] He concludes his book on Leibniz by presenting the sieve as a device that transforms the chaos of pure vitality into folds that both ramify in new directions and maintain their connection to the past, that reinvent themselves before they become rigid, like the death mask or the cliché. In the cinema books the brain is likewise associated with both memory and crea-tion, with the ages and the new, with continuity and fluctuation. The brain is both a screen conventionally conceived as an adaptable surface that can reflect images of almost any form of life and a screen or filter (*crible*) that arranges the chaos of pure creation into sheets of time. In Deleuze's philosophy of cinema "the past which is preserved takes on all the virtues of beginning and begin-ning again: it is what holds in its depths or in its sides the surge of the new reality, the bursting forth of life."[126] In the 1980s, Deleuze's vitalist positions resurfaced most forcefully when he wrote about the endurance of the past and the value of recollection as a source of reinvention. Approaching both his cinema books and the baroque toward the end of his life and at the terminus of the twentieth century, Deleuze observed that cinema had become a baroque phenomenon: it remained tempted by the allure of the new but haunted by its contradictory status as a relic from the modern past. How do we reconcile the claims of radical modernist filmmakers and theorists with the seemingly incompatible vision of cinema as a repository of time? How can the pure in-ventiveness and vitality of cinema be reconciled with the past that also inhabits those images? How can a medium associated from its inception with modern-ization survive into the late twentieth century and beyond, when its futuristic

visions now seem like relics from another age? Rather than veer toward either the promise of newness or the past, cinema would be the great screen placed between them. The cinematic screen is a sievelike surface that both displays information and permits different temporalities to pass through and fold into each other, a site where one image follows after another in a spectacle of relentless innovation and where each of those images also carries forward a persistent and untimely vision from the past. A Deleuzian philosophy unfolds in that gap between the modernity and the memory of cinema.

After Cinema

Despite his allusions to the death of cinema, Deleuze's cinema books display an optimism consistent with his suggestion that this end would also result in a new beginning, including a possible migration of the artistic potential of cinema from celluloid to "electronic" media. He writes that the "question of a crisis of the cinema is often raised—under the pressure of television, then of the electronic image. But the creative capacities of both are inseparable from what the great directors of the cinema contribute to them. Rather like Varese in music, they lay claim to the new materials and means that the future makes possible."[127] Throughout his writings on cinema Deleuze reaches backward into music, painting, or literature and forward into more contemporary media and communications technology for analogies to illustrate his key terms and concepts. The analog of the frame, he argues, "is to be found in an information system rather than a linguistic one" because the frame operates as a "closed system . . . [that] can be considered in relation to the data that it communicates to the spectators."[128] The frame, in other words, is a device best understood through the lens of the "informatic" rather than semiotics.[129] The rise of video or the digital image coincides with a radical shift in aesthetics away from traditions organized around the representation of the human figure and other natural reference points. In the new video formats of the 1980s, "the screen itself, even if it keeps a vertical position by convention, no longer seems to refer to the human posture, like a window or a painting, but rather constitutes a table of information, an opaque surface on which are inscribed 'data,' information replacing nature, and the brain-city, the third eye, replacing the eyes of nature."[130] While the technological dimension of media features less prominently in the work of Deleuze than Benjamin and many other film theorists, this irruption of data, information science, communication, and other forerunners of contemporary digital culture is not entirely uncharacteristic. Throughout the cinema books and especially at the end of *Cinema 2*, he seems to be composing a précis for a third book on the age of technomathematical media that subsequent critics would begin to write.[131]

Once again the philosopher predisposed toward the opposite of history introduces a logic of historical breaks and epoch-making events. In his passages on the great post–World War II film musicals and comedies, he draws an explicit distinction between the reclaimed contraptions that the action revolved around in the heyday of Chaplin, Keaton, and Lloyd and the more abstract objects that emerged in the age of the time-image. Of the films of Jerry Lewis, he writes, "This is no longer the age of the tool or machine, as they appear in the earlier stages, notably in the machines of Keaton that we have described. This is a new age of electronics, and the remote controlled object which substitutes optical and sound signs for sensory-motor ones. It is no longer the machine that goes wrong and goes mad, like the feeding machine in *Modern Times*, it is the cold rationality of the autonomous technical object which reacts on the situation and ravages the set."[132] The incipient digital media of his time would be emblematic of this new category of object for Deleuze and the latest challenge for a philosophy that tries to reconcile the powers of repetition and the desire for emancipation from the cliché. In a long strain of technofuturist literature and theory, a caricature of Deleuze has become the prophet of a network society, though that caricature usually relies heavily on his nomadic thought rather than the work produced in the last decade of his life. In this line of reasoning, the twenty-first century would belatedly realize the destiny prescribed by Foucault and become the Deleuzian century. Deleuze's own analysis of this historically new media environment remained tentative and inconclusive, even as he offered only brief descriptions of the phenomenon appearing on screens around him. He writes, "The electronic image, that is, the tele and video image, the numerical image coming into being, either had to transform cinema or to replace it, to mark its death. We do not claim to be producing an analysis of the new images, which would be beyond our aims, but only to indicate certain effects whose relation to the cinematographic image remains to be determined. The new images no longer have any outside (out-of-field), any more than they are internalized in a whole; rather, they have a right side and a reverse, reversible and non-superimposable, like a power to turn back on themselves. They are the object of a perpetual reorganization, in which a new image can arise from any point whatever of the preceding image."[133] The challenge and the danger of this new category of image would lie precisely in the obsolescence of the brain/screen that retains the past while unfolding into the future. Deleuze maintains that "when the frame or the screen functions as instrument panel, printing or computing table, the image is constantly being cut into another image, being printed through a visible mesh [*trame apparente*], sliding over other images in an 'incessant stream of messages,' and the shot itself is less like an eye than an overloaded brain endlessly absorbing information: it is the brain-information, brain-city couple which replaces that of eye-Nature."[134] In the digital revolution the screen envisioned as a phenomenon of folding and an interface between temporalities would give way to a constantly erased and

updated table of information. For Deleuze this would represent the tragedy of a "modern world . . . in which information replaces nature."[135] For that reason, he concludes his long philosophy of cinema and his brief meditation on the future of the medium with a diversion into data: "The life or the afterlife of cinema depends on its internal struggle with informatics."[136]

Deleuze's concern with the conflict between cinema and data assumes a more politicized form in his "Postscript on the Societies of Control." In the older disciplinary societies analyzed by Foucault, the daily routine involved a series of transitions between one institution and another, "from school to the barracks, from the barracks to the factory."[137] In that environment "one was always starting again."[138] In the societies of control, he argues, "one is never finished with anything."[139] One never transitions out of a particular mode of existence or disciplinary regime because the major social institutions have become "metastable states coexisting in one and the same modulation, like a universal system of deformation."[140] Code is the universal language underlying that system of perpetual information exchange. As in his cinema books, Deleuze suggests that "types of machines are easily matched with each type of society—not that machines are determining, but because they express those social forms capable of generating them and using them."[141] He writes that the "old societies of sovereignty made use of simple machines—levers, pulleys, clocks" and newer disciplinary societies arose alongside "machines involving energy."[142] The comedies of Chaplin, Keaton, and Lloyd staged cinema's most memorable encounters with modern machines—assembly lines arrayed before industrial equipment, cars, trains—and their attendant modes of discipline. "Societies of control," he continues, "operate with machines of a third type, computers."[143] Their energy is no longer concentrated in a particular location like the factory or prison but "dispersive," their power wielded not by bosses but by more abstract and disconnected entities like corporations and shareholders.[144] Deleuze frames these observations as both tentative speculation and an ominous premonition: "What counts is that we are at the beginning of something."[145] Once again, Deleuze's political commentary lapses into the type of historical analysis centered on the transition from the old to the new. This pessimistic anticipation of the beginning of a control society stands in contrast to the idiosyncratic model of time and transitions introduced in his cinema books and his study of the baroque fold. In their commentary on an emerging digital culture, Deleuze's cinema books foreshadow his later observations about a system of control that never turns off, that tracks us everywhere, that recodes everything—the human, the image, language, art, life itself—as data. But Deleuze also suggests that a revival of a more utopian vision of media would result not only from another new beginning but also a return to the archaic worlds of the past.

In writing a philosophy of cinema in the late twentieth century, Deleuze is also writing a radical historiography of cinema that reverses the habitual

understanding of ends and beginnings, obsolescence and renewal. Deleuze makes no distinctions between the potential of the often maligned cinema of the 1980s and the masterpieces of the silent era or the art cinema after World War II. Cinema was as vital in its late twentieth-century condition of ruin as it was during the early days of the Lumière brothers and Méliès or the mature period of the dream factory or the new waves of the post–World War II era. No longer prey to its founding illusions, to the fantasy of revolution guided by art and machines, cinema could become for Deleuze both a repository of those still vibrant dreams and a cold analysis of their collapse. Updating Bazin for a new era, Deleuze's cinema books ask what cinema was at various moments in its history and, more urgently, what it became in the late twentieth century. And his answer is, first, a philosophical one centered on his meticulous taxonomy of images and examples drawn from a stunning range of films from eight decades. But, second, the definition of film in the 1980s could not be separated from the philosophy of time crystallized in cinematic images and at last visible in its baroque age. For Deleuze cinema is no longer a record of modernity, a glimpse of the future lived out in the present, a medium perfectly attuned to its time. Instead, he suggests that the aging utopias of the past can survive into the digital future only if we view the philosophy and films of the late twentieth century as a great screen placed between those two historical eras. A repository of the archaic and the modern, of deep time and rapid movement, that screen is where the revolutionary aspirations of the twentieth century flourished and faded and where audiences from the next century may rediscover the other end of a bow.

Serge Daney, Zapper

CINEMA, TELEVISION, AND
THE PERSISTENCE OF MEDIA

The Rearview Mirror

Just a few weeks before his death in 1992, Serge Daney granted a lengthy interview to Serge Toubiana, his coeditor at *Cahiers du Cinéma* for much of the 1970s. Referring several times to his emaciated appearance and exhaustion during the last stages of his struggle with AIDS, Daney framed this conversation as a farewell to a longtime friend and as a summation of his philosophy of media. He began the interview with these words: "There's an image I really like; it's the rear-view mirror. There's a moment—let's call it aging or dying—when it's better to look in the rear-view mirror."[1] The rearview mirror, he suggested, is where "phantoms" come to meet you.[2] Over a three-decade career, Daney continually invoked this rhetoric of mortality and phantoms, especially when he alluded to the aging, death, and ghostly afterlife of cinema. In a 1977 interview at the Bleecker Street Cinema in New York, he described cinephilia as a "mourning work" made necessary because "something is dead," because only "traces, shadows remain."[3] And he praised a cohort of "filmmakers for whom an image is closer to an inscription on a tombstone than to an advertising poster," an "epitaph" rather than a flashy exhibition of its own vitality. While his work resonates with the spectral language in critical theory at the end of the twentieth century, most notably in Derrida's *Specters of Marx*, the image of the rearview mirror and its retrospective gaze clashes with established accounts of the history of cinema and the theory of media technology that developed alongside it.[4] Emerging film genres from the late nineteenth and early twentieth centuries often metaphorically and literally situated their cameras at the front of rapidly moving vehicles, and through phantom rides and other images linked to locomotion, filmmakers expressed their affinity with motorized movement rather than the natural landscapes and human

settlements they rushed past. As Tom Gunning points out, pictures that featured onrushing trains and trams were among the most popular early films, and they have remained influential in film theory through the oft-repeated but apocryphal tale of audiences racing out of a Lumière brothers' screening for fear of being annihilated by a steel monster bellowing smoke (Figure 3.1).[5] In actuality, Gunning argues, the audience likely stood its ground, experiencing the twin thrills of modern technology: a mobile machine chugging toward them on-screen, and a contraption capable of projecting movement from a box at the center of the theater or café. This foundational myth attests to a desire on the part of film critics to situate cinema at the forefront of the artistic and technological avant-gardes, even when its status was much more ambiguous and the medium could be conscripted into conservative cultural and political causes. This account continued to influence cinema and theory for decades, as in Dziga Vertov's *Man with a Movie Camera* (1929), when the man and camera either ride together on a speeding motorcycle, the operator cranking away furiously, or straddle streetcar and train tracks (Figure 3.2). In the first half-century of cinema, trains, streetcars, and movie cameras often hurtled forward on "parallel tracks," creating phantoms without being haunted by them.[6]

Daney displayed his own fascination with what he called "our reflexes of an automobilo-cinephilic kind," especially in a series of *Libération* pieces published in 1984 and dedicated to "fifty years of star turns for automobiles in cinema."[7] In these vignettes he outlines a historical progression in the relationship between cars and movies, beginning with the "visual exaltation of movement" still prominent in the late silent era. In the Harold Lloyd vehicle *Hot Water* (1924), for example, the car provides "an open observatory from which it is possible to view the world anew," and it complements the "burlesque world" of the 1920s film comedy, a genre that regularly departs from the strictures of narrative economy, just as the zigzagging automobiles on the burlesque screen "are not yet condemned to the single-file line of a regulated highway."[8] In the classical Hollywood studio picture—*Grand Hotel* (1932) is Daney's example—the star system and the auto industry burnish their images together, participating at once in a "rivalry" and a "duet": "The star and the car, impeccable, gleam in unison. The chrome is makeup, the eyes are headlights, the fur coat is an intimation of leather: the identification runs deep."[9] The car no longer drags the comedian down anarchic roads: "It is not made to run on asphalt but to turn on a pedestal."[10] In Robert Aldrich's *Kiss Me Deadly* from 1955, the flashy sports car has transitioned from an object of veneration to an extension of the cinematic apparatus itself: "The camera draws closer, glues itself to the glass, coils itself up on the back seat, films at the height of the windshield wipers. . . . The camera and the car are accomplices."[11] With the actors shouting over the howling engine, the soundtrack a mix of human voices and mechanical noise, the camera becomes the automobile's alter ego

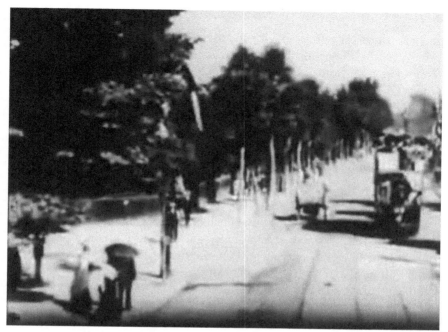

FIGURE 3.1. *Panorama of Ealing from a Moving Tram*

FIGURE 3.2. *The Man with a Movie Camera*

and a collaborator in the violence about to ensue. In this "new scenography," Daney writes, "the windshield acts as a second screen, isolating the head of the protagonists from the background that flows by, pointing them out like targets."[12] The series concludes with two reflections on the age of Europe's economic miracles, the period when "Italian cinema dreams also of white cars that fit in with the architecture of service stations, sunlight, brand new housing projects and all this boom urbanism, Antonionian, showing off amidst pockets of misery."[13] Before continuing to write the dual history of cars and modernity, we "must first see that our time is that of Hertz and Avis. More like rental cars than possessions, more utilitarian than fetishized, they would have a hard time becoming actresses. Just extras."[14] If cars enjoyed a privileged status in Daney's writing and in cinema, if they served as barometers of the evolving relationship between images and industrial modernity, between the emblematic media and machines of the twentieth century, then his late-career shift to the presiding metaphor of the rearview mirror is all the more significant. Once a harbinger of the future, cinema for most of the twentieth century belonged with cars and trains at the forefront of the drive into modernity. In the proliferation of screens and platforms that forms the contemporary image environment, however, cinema, once the star of stars, is now a member of an ensemble cast, if not yet an extra. For Daney, writing in the era of ubiquitous television in the home and traffic jams outside, the promise of modernity that energized early filmmakers and theorists seemed like a quaint anachronism, and the cinema an archive of those antiquated visions of the future.

Daney's awareness of his belated position in the history of cinema became increasingly acute toward the end of his career, as the waves of new cinemas from the 1950s to the '80s yielded to a fundamentally changed artistic and economic landscape, with television and video at the vanguard of an emerging visual field. While some French New Wave directors maintained their enthusiasm for cars, the fundamental premise of film's modernist equation—that cinema is a force of innovation, progress, or even revolution—was difficult to sustain in the post–World War II era (and, given the New Wave obsession with car wrecks, culminating in the dozens of dented and charred auto bodies that litter Jean-Luc Godard's *Weekend* [1967], the directors seemed implicitly to have acknowledged as much). In Daney's revisionist formulation, filmmakers were more akin to Benjamin's angel of history than to the technophile caricatures that often appear in film theory: no longer engineers on a train headed toward a utopian future or practitioners of the most important and lucrative art, they surveyed a ruined landscape with a camera whose reels of celluloid appeared obsolete in the age of TV and video. In the late twentieth century, cinema was no longer the most recent and dynamic art form, a perpetually youthful phenomenon rejuvenated at regular intervals by the next modernist or avant-garde movement; it was, for Daney, already an old medium.

Daney's end-of-life interview compels us to look back at the language of retrospection and belatedness that infiltrated his work from the beginning and became a dominant feature in the 1980s, when he confronted the senescence of cinema rather than its ontology or revolutionary potential. One pivotal moment in Daney's intellectual and professional career was his transition in the early '80s from a film critic at *Cahiers*, the house journal of postwar cinephilia and seat of '70s radicalism, to a wide-ranging media critic at *Libération*, where the demands of daily journalism and the sheer quantity of images circulating on television altered his perspective on cinema and newer media.[15] While the *Cahiers* critics were famous (and sometimes notorious) for watching the same film five, ten, even twenty times, the television critic in the 1980s wrote about images— live newscasts, political debates, talk shows, advertisements—immediately after they disappeared, often without a trace, to be replaced by another event, guest, or product. And with multiple channels and a single television, critics were acutely aware that some programs and singular events escaped their field of vision while being broadcast to a potential audience of millions. Armed with a remote control, they became chroniclers of programs that passed by too quickly to register, even in the rearview mirror. When Daney launched into a remarkable series of essays about watching film on the small screen in 1987, he viewed cinema through the lens provided by television. Whole "channels" of film history were missing, he argued, even though filmmakers had occupied a privileged position on the tracks and highways of modernity. He also insisted on watching television cinematically and therefore atavistically, with the grandiose but unrealized aspirations of cinema present like afterimages on a smaller screen. In watching film and television with the eye of the other, Daney highlighted the persistence and coincidence of media rather than a dynamic of newness and obsolescence, arguing that the era of media ontologies had passed; "specificity," he wrote, is "a word that kills."[16] He was no longer concerned with Bazin's foundational question, "What is cinema?" Instead, Daney asked what cinema *was* and what it had become, viewing the medium retrospectively, from the vantage point of a critic who arrived too late for the most fervent excesses of modernism and cinephilia. Daney's daily practice forced him to reframe movies on a small screen and subject them to the vagaries of the remote control, transforming the critic into a zapper and cinema into the type of phantom that the vehicles of modernity usually left behind.

An Adult Art

Daney began writing about films in the flush of New Wave cinephilia in the 1960s, at the moment when a cohort of young filmmakers, many of them former *Cahiers* critics, chronicled the adventures of the baby-boom generation and the ostensible renewal of French society. The cinema of "papa" was

under assault by François Truffaut and like-minded colleagues, who made Hollywood their own and contrasted it with staid French period dramas and literary adaptations rooted in a "tradition of quality." The cinephile critics insisted on an idiosyncratic mode of reception and hoped that their eccentricity in word and deed would transform the products of a studio assembly line into a series of intimate messages sent from individual directors to the critic occupying his preferred seat in a theater in Paris. One indication of the infectious peculiarity of cinephilia is, as Christian Keathley points out, the astonishing number of people who have commented in print on the color of Cary Grant's socks in the crop-duster sequence of *North by Northwest* (Figure 3.3).[17] The seemingly irrelevant detail, an incongruous dash of taupe on Grant's otherwise impeccable *Mad Men* outfit, became an emblem of radical openness to the possibilities of the cinematic image. Driven by equal parts youthful energy and naïveté, these critics hoped to personalize an industrial art and revive the visceral sensation of seeing moving pictures for the first time.

In this context, with the spirit of rejuvenation in the air, Daney bestowed a surprising and precocious title on his first review: "An Adult Art." Published in a short-lived fanzine edited by Daney and his friend Louis Skorecki, the essay focuses on a classic Hollywood Western—*Rio Bravo* (1959) by Howard Hawks—and views it as a manifestation of the auteur's signature themes rendered visible in the mise-en-scène.[18] This is the characteristic *Cahiers* formula inherited from the days when the young cinephiles marshaled by Truffaut, Godard, Éric Rohmer, and Jacques Rivette sought to reframe cinema as a director's medium and define style as a question of staging before the camera. Daney follows this formula with almost religious

FIGURE 3.3. *North by Northwest*

zeal, as he foregrounds the relationship between characterization and the setting in *Rio Bravo* and throughout the director's career. In its style and attention to a particular class of details, Daney's review reads like an audition for the part of a full-fledged *Cahiers* critic, a role he would assume just two years later. But despite his dedication to an auteurist model and cultivated attention to mise-en-scène, Daney approaches this "adult art" with a different conception of its historical development and his own relationship to tradition. In the context of a review of *Rio Bravo*, of course, the title carries few connotations of pornography or thematic maturity. (Despite the valiant efforts of Angie Dickinson in her breakthrough role, the film is a product of the late Production Code era and appears chaste by all but the most puritanical standards.) Cinema and its subject matter are the adults for Daney, who notes that instead of the dynamic cowboy embodied by John Wayne in *Stagecoach* (John Ford, 1939), the most recent "heroes of Hawks are fifty-somethings and no longer young men."[19] *Rio Bravo*, he writes, is a tale of "regret," and neither its protagonists nor its genre can claim the mantle of newness. The pioneers from his earlier films "have aged, and it's no longer the splendor of the testament that moves us but the nostalgia of the lion grown old."[20] Daney repeatedly displays this obsession with the age of heroes in cinema, including those in front of and behind the camera. Reviewing a related genre picture, he writes, "In 1948, so 37 years ago, Howard Hawks (52 years old at the time) directed for United Artists (a company founded in 1911) one of his rare Westerns, and what's more, in black and white. It's *Red River*. In the lead role, John Wayne rolls his eyes and struts his stuff (he is 41). . . . Loyal to the Hawksian theme of apprenticeship, Hawks asks Montgomery Clift (28 years old) to play the role of 'young' protégé hazed by his seniors. . . . Walter Brennan (54, but he doesn't look it, he looks older) rehearses the role of 'plaintive old maid' from *Rio Bravo* (1958), and the beautiful Joanne Dru (25) plays proudly the role of the woman."[21] Daney concludes with a nod toward the score and its composer, "Dimitri Tiomkin (born in 1899 in Saint Petersburg)."[22] From the beginning of his career, Daney left the impression that classical genre cinema, the playground of the young Turks at *Cahiers*, should always appear in print with its advancing age following immediately in parentheses.

One of Daney's distinctive characteristics throughout his tenure at *Cahiers* was his attention to cinema's accumulated baggage of tradition and convention. He wrote about Sam Peckinpah's *The Wild Bunch* (1969), for example, with its flurries of bullets and indiscriminate killing, as a product of the director's belated relationship to the Western genre as it developed in the 1930s and 1940s. Daney focused first on the extended precredit sequence, a popular practice at the time, and described it as a "veritable trailer" for the film to follow, a concise and economical summary that dooms the feature itself to redundancy. These sequences highlight the futility of the films that follow, and the directors

often unwittingly "show the uselessness of their products" through trailers that promise and reveal too much.[23] Still alluding to an auteurist model of analysis, Daney argued that Peckinpah "wanted to make this uselessness into a personal theme," but only through a form of negation, with the great directors defined by their willful refusal to say anything at all.[24] In the case of Peckinpah, this sense of resignation, this acknowledgment of the vanity of action, even in the most spectacular fight sequences and explosions, was the product of having come "too late." "His problem," Daney wrote, was "that of the preceding generation (that of Huston, of Ray or of Preminger) which, unable to reflect its relation-ship to Hollywood (through a specific manner of making films, money, and ideology), had to convey this incapacity metaphorically through the themes addressed (failure, derision, the entropy of all human enterprise, of all *mise en scène*, etc.)."[25] Likewise, the film portrays its band of cowboys as heroes due to inertia or as a marketing strategy, but it never upholds them as exemplary figures to be admired and emulated. "All the novelty of the films of Peckinpah resides in this slippage of the meaning" of words like "hero," though they also display "nostalgia" for such characters and the actors who once personified them.[26] Allied with their failed heroes on-screen, the directors of Peckinpah's generation bathed the screen in blood and violence, though they realized that this unprecedented cinematic excess was just a more extravagant variation on the same timeworn themes. The aging of cinema was visible everywhere on the screen, from the characters and actors to the mannerist excesses of its genres and styles.

A generation younger than Truffaut and company, Daney identified him-self as a "ciné-fils" rather than a "cinephile," a descendant of a long tradition of filmmaking and criticism rather than a newcomer and innovator, an inheritor of the legacy of cinephilia rather than a founding member of the *Cahiers* circle raised at the cinematheque. He imagined the young boy in Charles Laughton's *Night of the Hunter* (1955)—a prematurely aged and worldweary child who flees with his sister from a relentless psychopath—as "one of my favorite alter egos" and "my 'American' brother."[27] Like Daney and his generation of as-piring cinephiles, Laughton's kids on the run are "amateur children" marked by "gravity" rather than playfulness, especially in comparison with their care-free Hollywood siblings or the baby boomers celebrated in the French popular press of the 1950s and the "young French cinema" of the Nouvelle Vague.[28] If the cinephile attested to the timeless quality of Hollywood cinema and linked those movies (often incoherently) to the youth movement in French film and society, the "ciné-fils" followed cautiously and at a distance, adopting many of the signature obsessions of his predecessors but recognizing manifestations of the aging of cinema rather than its eternal youth.

Daney's rejection of cinema's most cherished myths would become com-monplace at the "red" *Cahiers* of the radical and tumultuous 1970s.[29] His task as coeditor was to salvage the journal from an intellectual impasse and the

devastating collapse of its finances caused by the pursuit of an elusive combination of aesthetic purity and leftist militancy. Over two decades he worked through at least three distinct periods in the history of *Cahiers*, each distinguished by a disavowal of positions the editors had once vigorously evangelized and defended. If early *Cahiers* critics attempted to elevate cinema made by key directors, including classical genre films, to the rank of art, its era of "political modernism" began with a renunciation of all the premises underlying that editorial policy: the very idea of the auteur was a romantic mystification; studio pictures were the vehicles of capitalist and imperialist indoctrination; and the medium itself, with its illusion of reality projected before a passive spectator, was a perfect instantiation of Marx's "camera obscura of ideology."[30] Together with the holdovers at *Cahiers*, Daney continued to produce film criticism despite this profound suspicion of nearly all modes of cinema and precious few examples of the avant-garde alternative they sought. A 1974 review of Barbet Schroeder's *General Idi Amin Dada* condemns the ambiguity of a film that professes to represent the failures of official governance in Uganda but adopts a cinema verité style that leaves the most important historical and political facts unspoken, hides behind "obscurantism," and confirms "dominant prejudices" about postcolonial states doomed either to authoritarianism or anarchy.[31] "What is cinéma-vérité?" he writes. "A metaphysic of the undecideable."[32] To leave the world and its image ambiguous was to acquiesce to the regnant political system and pervasive ideological biases. Even the techniques of leftist filmmaking inherited from the 1960s, including cinema verité, can be "entirely structured by bourgeois ideology," and under those conditions, one "never gets out" and instead remains imprisoned within "a territory that from the outset belongs entirely to the enemy. There is nothing to win by going onto this terrain."[33] Aside from the occasional and outlying review of Jerry Lewis (a structuralist account of *Which Way to the Front?* [1970]) or a brief, fanciful take on *The Blob* (Irvin S. Yeaworth, Jr., 1958) and its allegory of the inevitable conquest of capitalism, Daney avoided the domain of popular culture and mainstream political cinema in the late 1960s and early '70s, choosing to focus instead on experimental films and the act of criticism itself.[34]

Pasolini's formally unclassifiable *Teorema* (1968) receives more favorable treatment from Daney, but even that review emphasizes not the promise of a new beginning but the belatedness of a director and film coming at the "end" of a cinematic tradition. He begins by recounting what rapidly became a truism in radical film criticism of the time: "One understands more and more that a film only ever tells the story of its own creation (filming, preparation, fabrication)."[35] "*Teorema* is a film that almost doesn't exist" because it merely shows the "faces of those who watch it, at the moment they watch."[36] In language that anticipates Giorgio Agamben's invocation of Bartleby and his strategy of dogged refusal, Daney writes of the film's "militant passivity," its provocation disguised behind a strategy of "delay" that withholds essential

information: why the film's "visitor" has arrived, what scheme he intends to hatch, and how the family (imagined as a figure for the audience) should respond to the happenings they witness.[37] The review defends *Teorema* not for maintaining an illusion of neutrality but for acknowledging that there is no escape from the existing political and aesthetic order and no solution to the impasses of their time, let alone the missing and unattainable "theorem" indicated in Pasolini's title. "*Teorema* is not the last film," writes Daney, but it presents a "reflection on the function of the *cinéaste*," who is always aware of his "complicity with the things he denounces."[38] The filmmaker is "condemned to please, even (and always) *for the last time*."[39] A radical conception of film would, in the spirit of Laura Mulvey's work in the 1970s, mark the end of a pleasurable cinema, the end of a sequence that began with the invigorating sensation of speed and energy in the earliest films and continued with a massively popular industrial art.[40] Daney posits the end of cinema as the ultimate goal of engaged filmmakers in the era of political modernism, but even Pasolini's most austere work is condemned to replicate the conditions of its own failure. A truly revolutionary film in Daney's eyes, a film like *The Promised Land* (*La tierra prometida*, 1973) by Miguel Littín of Chile, is merely "snubbed, not seen, not received."[41] This mode of cinema documents the history of real bloodshed and "opposes itself *morally* to the ketchup of cinema" visible in the work of Peckinpah or Claude Sautet.[42] In France, Daney writes, a cinema capable of altering the ideological framework of the viewer remains "purely and simply unseen" or it becomes a "beautiful but useless object" in the eyes of incredulous critics.[43] Instead, what passes for radical cinema in Europe is an endless rehearsal of the end of cinema followed by yet another remake of the last film.

At the end of the 1970s Daney found himself at the stalemate visible in the intensely pessimistic reviews cited above and in dozens of others written throughout the decade: he saw on one side a popular cinema deeply implicated in the depredations of capitalism and imperialism, and, on the other, a niche cinema of committed artists isolated from a public commensurate with the scale of their ambition. Like the binaries that organized so much cultural and theoretical production in the period, this scenario seemed to offer no way out. Daney's ultimate response to this dilemma was foreshadowed in his review of Miloš Forman's *One Flew over the Cuckoo's Nest* (1975). He describes the film as a parable about the right to resist and the necessity of recognizing that power operates through the illusion of its own omnipotence, through its construction of a stage with no apparent exit and therefore no way to build another society somewhere in the wings. Forman's strategy of revolt is to concoct a series of carnivalesque scenes in which the Shakespearean motto "the world is a stage, the stage is a world" becomes the rallying cry for rebels rather than a tool of power.[44] Jack Nicholson's hero, McMurphy, obliterates the distinction between inside and outside, sane and insane; he is a character who, like Forman, "plays with walls."[45] Yet for Daney the film is far from a utopian drama

about the futility of power and the indomitable human will. McMurphy, the clown who overturns the order of the asylum, undergoes a forced lobotomy and faces a lifetime of confinement. Only a form of euthanasia—when "Chief" Bromden suffocates him with a pillow—can release him from this subjugation. Chief, the Native American character played by Will Sampson, is the singular hero who manages to outwit authority by discarding his assigned role, escaping from the asylum's theater of the absurd, and leaving its walls behind. Daney's tenure as editor-in-chief at *Cahiers* began by reckoning with the two exhausted modes of cultural politics that circulated around him in the 1970s: first, the still-dominant mass-media industries that survived the social upheaval of the 1960s; second, the austere political modernisms that remained masters of a small and diminishing niche, trapped in asylums of their own making. In the 1977 interview at Bleecker Street Cinema, he offered an explanation for the stark separation of moving images into silos dedicated exclusively to popular, bourgeois, or political art: "Why divide? The reason, I think, is sociological. The cinema is less and less a popular form of expression and more and more recognized as 'art' by the middle class. Its instructional function has terminated (television has perhaps replaced it). It is seen more and more by an increasingly enlightened petit-bourgeois audience and tends to play the role that theater used to play: a place of prestige, debates, parades."[46] Daney's reformulated response in the mid-1980s was to withdraw gradually from film criticism and concentrate on a younger medium that had not yet acquired the aura of prestige or quality. He decamped over to *Libération*, where he had contributed film reviews for many years, and began to write about moving images characterized by their variety, impermanence, and liveness rather than the perfection of their classical form. He wrote about popular programs that were unlikely to be radical but that almost certainly managed to affect, or even organize, the consciousness of their viewers. After more than eighty years, filmmakers and critics had become enamored of their own walls—between experimental and popular cinema, between engaged and commercial art, between the increasingly esoteric theories of cinema and the mass appeal of the culture industry—and Daney saw television criticism as an opportunity to leave them behind for good. The irony was that he eventually found himself writing about films broadcast on television. TV provided the opportunity to return to cinema viewed not as ideology and capital crystallized in an image but as an archaic art whose future would unfold via new media technologies. For Daney, television was both the new seat of cultural and social power and a cinema without walls.

Zapping the Cinema

Daney's move to *Libération* coincided with a major shift in the status of television as an object of theory and criticism. In France, as elsewhere in the

North Atlantic, movies supplemented original programming and provided a dependable, abundant, and relatively cheap form of content that appealed to executives at new networks faced with no on-air talent, no signature style, and day after day of dead time. After the first public broadcast in 1935, France was served by a single channel until 1963, with a third added in 1972 and three more between 1984 and 1986. Each addition increased the demand for a stable programming supply. *Cahiers* critics were among the first to take television seriously, and the original subtitle of the journal, "*Révue du cinéma et du télécinéma*," reflected the intellectual interest in and fascination with television, especially its convergence with older media like film. One of its founders, Jacques Doniol-Valcroze, believed that "all that is cinema is ours" and that a hybrid telecinema fell securely within its orbit.[47] The other founder, Bazin, wrote frequently about television between 1952 and his death in 1958, focusing on its paradoxical combination of publicity and intimacy.[48] With the normalization of cinephile criticism at *Cahiers*, television began to fall by the wayside or devolve into an object of derision, and in 1955 "*télécinema*" was dropped from the journal's masthead. While critics like Truffaut and Godard expanded the definition of "cinema" by directing their attention toward international films and the B-movies produced on Southern California's Poverty Row, they also narrowed its scope by divorcing it from newer media like television. At that moment, *Cahiers* abandoned a field that would soon be occupied by sociologists and philosophers intrigued and troubled by the social and political power of media. Le Centre d'Études des Communications de Masse (CECMAS), established by Georges Friedmann in 1960, was dedicated to the study of all that fell under the rubric of mass communication: "the press, radio, television, cinema, advertising: this list is obviously not comprehensive."[49] The center's house journal, *Communications*, moved indiscriminately between studies of the cover design of *Paris-Match* to the changing figurations of the hero in New Wave cinema to Edgar Morin's political economy of the culture industry. In this sociological context, both film and television were subsumed by the umbrella category of "communications," and ontological questions about each particular medium receded in importance. This disciplinary paradigm was a potent antidote to the excesses of cinephilia, and social-science methodologies remain a key component of television studies.

By the time Daney began writing for *Libération*, it was no longer possible to apply concepts inherited from film theory to television without also reflecting on the distinct histories of those media. While Daney continued to write regular pieces on the latest films and major festivals, the bread and butter of a critic for a daily newspaper, his work in the early 1980s frequently veered away from such standard fare and engaged with the challenges that television and video posed to filmmakers and critics whose formation began in the heyday of cinephilia. His writing includes scattered moments of telephobia, including premonitions of a postmodern dystopia in which a formerly material world

has been reduced to an insubstantial image; it also includes denunciations of the effect of television, especially TV commercials, on the aesthetics of cinema.[50] At the same time, he suggests that the convergence of old and new media should never provoke a debilitating nostalgia and mistrust of the future. Apropos of Pierre Granier-Deferre's *Une étrange affaire* (1981), he writes, "That a film is an inflated ad bears witness to the deterioration of cinema and the vitality of advertising. Our world (of images and sounds) is changing in a fundamental way, and that's good. Commercials, and this is no longer a secret for anyone, are in general more amusing, more inventive, more precise than features at the cinema. And above all, more honest. A commercial lasts the time is takes to understand what it's selling."[51] Daney also identifies mainstream television as the site where the aesthetic experiments of 1950s cinema were salvaged and embraced after being rejected by filmmakers. Television became a repository of discarded forms, an "archaeology of failure" that recycled and revived the past innovations of theater and cinema.[52] Through his embrace of the most intellectually suspect dimensions of television and his celebration of the small screen as a storehouse of cinematic artifacts, Daney distances himself from both the politicized *Cahiers* line of the 1970s and contemporary variations on the theme: "that there is a slippery slope from the TV to the circus and from there to fascism."[53] "Ten or more years ago" it may have been credible to "speak of the 'media' like fat Molochs, insatiable and perverse . . . but today, in 1983?" he asks. "No," he argues, "we should hold a memorial service for the grand totalitarian scenario of the sixties. . . . We must invent our own fear of the media for the eighties and nineties ourselves."[54] His late twentieth-century anxiety revolves around the concern that cinema will adopt aesthetic norms modeled on the appearance and pacing of television and shut the "two doors" that defined cinema from its inception: a street-level entry that appeals to everyone and opens onto the realm of popular culture; and a hidden portal to an aesthetic and philosophical domain where the most "extravagant things" are possible.[55] He maintains that films (Claude Miller's *Mortelle randonnée* [1983] is his principal example) produced under the influence of television struggle to graft the "'look' of advertising images from the 1980s . . . onto the old fiction machine of the 1950s," and the result "resembles a car on which one only highlights the clutch, the ability to start and restart, without knowing how to use the brakes. The machine is not enough: it needs a driver who knows how to stop it (by making it bump into something real) or who agrees to crash along with it."[56] If television was becoming the platform that "manage[d] the event" in an increasingly mediatized society, cinema could be the "witness to images of the world" and the obstacle that compels images to slow down, if only for a moment, by forcing them to "bump into something real."[57]

In the early 1980s, before reinventing himself as a daily chronicler of happenings on the small screen, Daney devoted several of his most expansive essays and series of articles to television, its idiosyncratic history, and its

relationship to cinema. He wrote, for example, about a long-running pedagog-ical program called *La Caméra explore le temps* (1957–1966), which, on the one hand, represents the old-fashioned and discredited mode of historiography centered on the power and logic of the state. On the other hand, that relatively conservative mandate encounters the constraints and possibilities inherent in television—especially its hypervisibility and vast resources of time, its impera-tive to fill the screen hour after hour—and produces a seemingly incongruous result: as the camera transforms documents into aesthetic objects and lingers on the gestures of actors reenacting history, it ventures as far as possible from the stereotypical educational film that compresses events into the format of classical cinema. Instead, Daney writes, *La Caméra explore le temps* "could have been, at least at the beginning, an avant-garde series" because French television, at once ahead of and behind the times, adopted and institution-alized the most innovative trends in cinema, even as they were abandoned by filmmakers.[58] "Over the course of the fifties," Daney writes, "when French cinema was reduced to a very low level, the nascent television (unaware of its powers, still indifferent to its 'specificity') was synchronized with that which became the most modern in cinema: from the treatment of the voice in Bresson to the expectation before the involuntary gag in Tati."[59] Daney views this standard educational series as an "archaeology of what no longer works in cinema" and a primer not in the national history curriculum but in the interlaced history of media.[60]

A similar theoretical strain guides the various installments of his coverage of the 1984 Olympic Games in Los Angeles, where the sporting events pro-vided a pretext for ABC's experiment in television on an unprecedented scale. On visiting the network's studios, he observed that despite its overwhelming task as the sole global provider of television footage for the Olympics, "ABC nevertheless continues to make some soap operas during the Games. There is something vaguely moving in this survival of the part of TV that still resembles cinema. But nothing would be more erroneous, and in any case un-American, than to imagine some rivalry between cinema and TV. That story is already over. Television has inherited much from cinema."[61] With a crew of 3,500 scattered around the city to provide round-the-clock coverage of simultaneous events, and with commercials and human-interest stories framing occasional outbreaks of rowing or track and field, the Olympic telecast is more decentered and unruly than a film. But in Daney's argument, all of the seemingly incom-patible and divergent components contribute to the same thematic arc, as the makers of the ads and the main attraction "tell us the same thing, each in his fashion, the one with the imperatives of live transmission, the others with commercial messages. They never tell us that all this is beautiful but they insist on convincing us that all this is 'good'. . . So good that one truly goes to sleep with the idea that these Olympic Games are an immense commercial for the human species, only we don't know the sponsor."[62]

A monumental undertaking, ABC's Olympic coverage is best viewed, in Daney's eyes, through the prism of its smallest component, the thirty-second ad. But that exercise is worthwhile only if we understand that an Olympic telecast is an anomalous, endless commercial that withholds the concluding gesture of the brand name. Daney is most critical of contemporary cinema when it mimics the form of television commercials; he is most effusive about television when it seems to revive the promise of cinema. The most productive viewing strategy, he suggests, is to view one medium through the lens of another: to watch cinema with an awareness that the cinephile's theatrical paradise no longer exists and that the commercialization of images has always been the horizon of the film industry; and to watch television "like a film, with a perverse eye."[63] The anachronistic quality of his account of ABC's Olympic coverage lies in the fact that he refuses both the obvious conclusion, that the ultimate sponsor is the network or the International Olympic Committee or the various competing nations, and the postmodern assertion that there is no author or authority to organize the chaotic flux. His writing on television is "perverse" because he insists that a film remains to be seen somewhere in this endless stream of images.

Daney became a television critic well before its legitimation as an academic or theoretical field, and he describes this personal and professional transition as a departure from ingrained habits and into something unknown and invigorating. In his interview with Toubiana, he says, "In leaving *Cahiers* at 35 years old I experienced the most important crisis of my life, with a very strong sense of having wasted my life, of not existing, or of having completely forgotten to live by keeping myself safe in the middle ground."[64] At *Libération*, he discovered "an enormous backlog of writing. All that I should have written in the previous ten years finally came out."[65] His new work was rooted in frustration with both the institutionalized cinephilia inherited from the 1950s and the clear division of territory between radical art and mass communication during the "red" period at *Cahiers*. His writing on television was one of the earliest attempts to theorize what has become a dominant strain in media studies and the culture industries themselves: convergence.[66] In 1974 Raymond Williams published one of the first accounts of the ontology of television, arguing that the "flow" of programming, from news to commercials to drama, not to mention the disruption of hopping from channel to channel, was the defining feature of television and marked a radical departure from the enclosed, relatively uncontaminated form of a movie viewed from beginning to end, in a darkened space, without interruption.[67] Films could appear on television as part of the regular lineup of content, but each individual picture existed alongside an infinite supply of other images that threatened the integrity of the narrative. Although it emerges in fragments, through daily reviews and retrospective interviews, Daney's piecemeal theory of television offers a corrective to the models that develop in accordance with Williams and his alluring vision of an

almost aqueous flow. It questions the historical timeline implicit in Richard Dienst's account of the "outbreak of television" and its assumption that "everything that appears on television somehow becomes essentially televisual."[68] For Daney, what distinguishes the modern moving-image environment is the coincidence of media, with painting, photography, and theater occupying a crucial position in the early years of cinema and film instrumental in the creation of television. D. N. Rodowick attributes "a certain historical attitude toward film to the functioning of broadcast television as a film museum," and one of Daney's primary tasks is to explore this archival dimension of television, though this implies a radical transformation in the concept of the museum, with the desire for preservation and permanence challenged by the new medium's liveness and ephemerality, as well as the impurity of its presentation on the small screen.[69] Despite those undeniable changes, Daney writes, "What I don't believe at all is that when something seems to disappear it is immediately replaced by something else."[70] Like the phantoms that appear in the rearview mirror, cinema continues to haunt the television he watches, day in and day out, until he finds it impossible to engage with television, with its supposed presence and intimacy, without simultaneously thinking about the perfection and staging of cinema.

Dancy's writing about television is a cinephile's account of broadcast media, a theory of the persistence and lingering consequences of images. But if cinema should be framed as an aging medium in the rearview mirror, what happens to cinephilia, that paradoxical, pathological love of cinema that motivated (and often derailed) the *Cahiers* critics of the 1950s? Does cinephilia linger on when faced with the diminishing effects of the small rather than the large screen, the living room rather than the theater, the audience of one or two instead of, in ideal circumstances, the crowd? One of Daney's first theoretical moves in marking the transition from cinema to television is to downplay the importance of many commonly cited distinctions between these two modes of exhibition: the size of the screen does not define television, nor does its occasional liveness. Instead, he argues that television was not really invented until the advent of the remote control; "le zapping" is, for Daney, the definitive act of television spectatorship.[71] In other words, the advent of the medium with one and then a handful of channels was merely a preview, an extended glimpse of coming attractions rather than a realization of the potential of television. The remote control, he suggests, revealed the possibilities present in the technology and its characteristic spaces: zapping continues the evolution of media consumption into a personalized activity, one more subject to the whims of the viewer and, he writes, defiantly and with only a trace of ambivalence, more democratic (and he uses that term even after what he characterizes as the Americanization of French television).[72] Developing a theory of television around this crucial act of zapping, Daney notes, "Zapping is what comes after the editor and before 'the end.'"[73] The primary task of the

zapper, then, is to "deprogram" the television. With its rhythm of presenter followed by a news brief followed by the presenter followed by a serial drama, all with frequent commercial interruptions, the very orchestration of television programs constitutes a form of institutional zapping. Daney describes countless moments of auto-zapping within each television program, as the host of a talk show, for example, shifts from one guest or topic to another, as if tapping on a remote control to transition from, say, an elite politician to an everyday citizen representing a certain cause, thereby puncturing one discourse with another that interrupts and contradicts it. Daney tacitly accepts the argument that television adapts a vaudevillian tradition of mixed entertainment and spurns classical narrative structures. And as he develops zapping into the foundation of his theory of television, he begins to see zapping everywhere. In a lighthearted discussion of one of the traditional metaphors for television, the fishbowl, Daney views fish flitting about the tank as both the "true star" of this literal flow and stand-ins for the spectator surfing from one channel to the next.[74] "Do they zap?" he asks of the fish.[75] Far from a new technology introduced in France in the 1950s, the remote merely activates potentials present in the medium of television long before its invention and inherent in the natural world. We have always been zappers, he suggests.

If zapping has always been with us, can the experience of cinephilia resurface in "telephilia" or "telecinephilia," two terms that Daney mentions without elaboration? Always suspicious of the tendency among intellectuals to dismiss television out of hand, he points out that the oft-heard claim "I rarely watch television nowadays" is usually followed by the synopsis of a gossipy story first told on television and then disseminated through newspapers or word of mouth. Television manages to infiltrate the minds of a cultural elite who insist that they ignore it. He adds that the same is true of stodgy cinephiles and their vociferous opposition to the small screen that ruins great films. He argues that even the most ardent film buffs at *Cahiers* should be equally enthusiastic telephiles because many of the key figures from the B-movie factories celebrated by Godard, Truffaut, and others transitioned en masse to television by the end of the 1950s.[76] The cops and cowboys on television serials are the successors, he suggests, of the hard-boiled detectives and Western heroes who populated the movies churned out by Monogram Pictures, and they have as much claim to be inheritors of the New Wave sensibility as the international art films of the 1960s and '70s. The transition from cinephilia to telephilia would not require a major defection or betrayal; it would follow the path paved by the filmmakers themselves.

When he turns specifically to television programs, Daney's analysis is informed by a cinephile's sensibility and critical protocols, as he often practices a variation on mise-en-scène criticism and compiles a fastidious record of observed details. He discusses the implications of various seating arrangements for guests on a political debate show and the symbolic choreography of bodies

that takes place when the host meanders away from or rejoins the fray. He observes the various styles of taking the stage in news or interview programs, with hosts sometimes emphasizing their equality with the audience or conquering the stage by pacing from one side to the other. He describes the verdant backdrops designed to transform the flexible nonplace of the studio into a semblance of the natural world. And, sounding like a 1950s *Cahiers* critic again, he introduces an element of idiosyncrasy into his discussion of an otherwise wooden political debate between two abysmal candidates: Jean-Marie Le Pen and the Communist Party standard-bearer, André Lajoinie. In an essay titled "The Socks of Lajoinie," Daney writes, "Among the thousand and one reasons to think Lajoinie is useless, there is a secretly inexcusable one that's related to his socks. Socks with circles, gray in a gray setting, communist socks stretched in vain toward the camera, while the owner of the militant feet they adorn, his hands tensed on the arm of his chair and his gaze looking elsewhere, tries to remove his paralyzed body from the drudgery of a debate where he has little hope of succeeding. . . . Lajoinie was betrayed by them (his socks) and by a camera . . . visibly ashamed" of the task at hand.[77] If the cinephile can obsess over the sartorial decisions of Cary Grant, the telephile can conscript the Stalinist socks of Lajoinie into a political allegory, a crystallization of stage-managed politics whose primary weakness is an incapacity to orchestrate everything, to control all aspects of its mise-en-scène, especially the seemingly irrelevant details whose emblem for Daney is Lajoinie's socks. Even in a televised debate between dinosaurs, he suggests, the image opens onto a line of flight. Once again Daney's model of spectatorship, with its politically inflected deprogramming, identifies zapping as the viewer's fundamental activity.

While Daney suggests that the protocols of cinephilia are available to the television viewer, he also glances at the movies in a rearview mirror, watching cinema on television with a conceptual apparatus developed for TV. His anachronistic approach to cinema suggests that the manner of spectatorship and criticism celebrated as cinephilia was always already a form of zapping. Frustrated by the moribund tradition of quality, critics like Truffaut and the Hollywood aficionados at the Cinéma Mac-Mahon zapped the French production system by binging on American studio fare and its déclassé cousins from Poverty Row. Cinephilia is a prototype of zapping, and this love of cinema is animated by a counterintuitive desire for television, a desire that precedes the burgeoning of that medium into a mass cultural and economic phenomenon, a desire for television before television. As the French New Wave unfolded across the 1950s and '60s, televisions featured prominently in the urban landscape and cinematic mise-en-scène. The TV appears as yet another home appliance and reflective surface for self-adoration in Chabrol's *Les Bonnes Femmes* (1960) and as the object of a sociological gaze in Godard's *Masculin féminin* (1966) (Figure 3.4), which frames it as an essential component of consumer culture and a washing machine for images. In *Alphaville* (1965) and Tati's *Playtime* (1967),

FIGURE 3.4. *Masculin féminin*

television has become a crystallization of totalitarian spectacle or the atomization of suburban apartment living. We live within and through media technology, these films suggest, and the arrival of television corresponds perfectly with the reconstruction of Paris according to the logic of information flows and communication. But in the 1980s Daney writes against the grain of this dystopian critique of the culture industry and the society of the spectacle, as he searches for a theory of zapping adequate not only to cinema or television but also to a world reinvented in the image of contemporary media.

At the end of his career Daney stopped writing regularly about television and concentrated again on film and cultural criticism, and his death foreclosed any possibility of discovering an afterlife of TV analogous to the revenant of cinema he experienced on the small screen. He viewed television as both the "end and completion of cinema" and the "preview of something still to come," a future that he would not live to see.[78] But his late texts also question the validity of the linear conception of media history implied in habitual references to the cinematic past, the televisual present, and the future of video (or now digital media). Instead he offers a model of history as a spiral in which transitions are never complete and, as in Deleuze's study of the Baroque fold, old media always implicate themselves in new media, and new media in the old. For Daney, a theory of television can develop in embryonic form in the most passionate devotees of cinema. There are, of course, many possible objections to this association

between cinephilia and television, including some proposed by Daney himself. Most importantly, he argues, cinephilia was predicated on a quasi-religious faith in the uniqueness of the cinematic image. In this sense, cinephilia was another symptom of cinema's transition into an old medium because it adhered to an archaic conception of art, insisted on the singularity of a mass-produced object, and rejected the logic of mechanical reproduction and all it entails. For this reason Daney characterizes "the cinephile [as] the one who, watching a film that has just been released, a contemporary film, already feels the passing, the 'that will have been.'"[79] But he also writes that cinema "prolonged something of the nineteenth century in the twentieth century for a very long time and in a rather unexpected manner."[80] After asking what cinema was, Daney offers both a historical and a theoretical answer. Cinema was a product of the late nineteenth and early twentieth centuries, and the history of the medium is deeply imbricated in that setting: industrialization, urbanization, mass production and consumption, war and devastation on an overwhelming scale. The history of cinema unfolds through the existing images that represent this experience, from the phantom rides and city scenes so popular in early movies to the spectacular blockbusters of the 1970s, but it also circulates around images that are missing, around the vanishing reality that remains absent from discussions focused on the medium's dynamism and modernity.

One of Daney's last meditations on cinema, his essay "The Tracking Shot in *Kapò*," resumes his lifelong fascination with the aging of cinema and the phantoms film left behind. His title alludes to Jacques Rivette's famous *Cahiers* piece "On Abjection," a frontal assault on Gillo Pontecorvo's concentration-camp drama *Kapò* (1960), which Daney always refused to watch. The film culminates in an elaborate escape attempt organized by a young Jewish girl, who dies at the base of the camp wall. In that final sequence the camera tracks toward the fallen victim, played by Emmanuelle Riva, and reframes her face, an inexcusable attempt to beautify horror in the eyes of Rivette: "The man who decides, at that moment, to have a dolly in to tilt up at the body, while taking care to precisely note the hand raised in the angle of its final framing—this man deserves nothing but the most profound contempt."[81] With Rivette's condemnation unshakably in mind, Daney accepts the fundamental premise that, as the *Cahiers* critics asserted in the 1950s and '60s, morality is "a matter of a tracking shot." But Daney also asserts that the moral and aesthetic "adulthood" of cinema arrived not with the classical narrative structures or sound but with the postwar modernism of directors like Resnais in *Night and Fog* (1955), whose meditation on the Shoah reminds us that "the sphere of the visible had ceased to be wholly available: There were gaps and holes, necessary hollows and superfluous plenitude, forever missing images and always defective gazes."[82] If Daney's history of cinema is organized around those flaws, then the most contemptible films are the ones that, in a display of exquisite images or spectacular effects, conjure up an illusion of perfection. He writes

that "cinema exists only to bring back what has already been seen once: well seen, poorly seen, unseen."[83] The great films, he suggests, force us to hark back and, through a combination of memory and imagination, finally discover what we failed or refused to see. Regarded for much of the twentieth century as the artistic counterpart to cars and trains rushing forward in time and space, cinema becomes a spectral medium for Daney, a means of averting our gaze from the promised techno-utopia and viewing history against the flow of time.

As Daney's history of cinema spirals backward toward the nineteenth century, his theory of new media in the late twentieth century constantly folds back in time. In one early review Daney alludes in passing to what he calls "phatic cinema," a reference to Roman Jakobson's observations about a class of speech acts designed to indicate only that the line of communication is open: "Hello?"; "Yes, I'm here."[84] Daney views cinema as a kind of phatic medium that, in the age of liveness and omnipresent image flows, keeps the line of communication to the past open. What Daney's writing about television suggests, finally, is that we view the history of media not only as a succession of innovative technologies and new possibilities but also as the continual production of outdated and archaic forms that linger on long after their apparent demise. Amidst the news broadcasts, live sports, and talk shows that provided a glimpse of the media environment to come, Daney zapped his television and found himself looking at cinema in the rearview mirror.

The Cinema of Painters

The Suspended Spectacle of History

THE TABLEAU VIVANT IN
LATE TWENTIETH-CENTURY CINEMA

The Posthistorical Image

Within its thirty-minute span, Pier Paolo Pasolini's *La ricotta* (1963) (the director's contribution to the *RoGoPaG* omnibus film) oscillates between two incongruous pictures. The first, shot in a primitivizing black and white, recounts the struggles of a starving extra on a film set, the indifference and indulgence of the picture's financial backers, and the director's vacillation between fidelity to a socioeconomic truth embodied in that extra and the commercial demands of the film market. The second, in extravagant color, affords a glimpse of the film being produced through this combination of art, labor, and commerce, focusing on two elaborate tableaux vivants that re-create mannerist masterpieces, beginning with Jacopo Pontormo's *Deposition from the Cross* (1528) and continuing with Rosso Fiorentino's treatment of the same theme (Figure 4.1). The black and white film follows the vicissitudes of the life of that extra, Stracci (or, because of a tendency to gorge on his favorite cheese, "la ricotta"), as he delivers a meager meal to his family, endures insults and abuse from cast and crew, watches the star's pampered dog devour his lunch, savors his few opportunities to eat, and, finally, literally, dies on the cross after the caprices of the star delay his scene, condemning him to an overly long spell strapped to wooden boards just down the hill from a Cinecittà simulation of "Calvary." Yet despite these dire preoccupations with issues of life and death, Stracci's story also borders on comedy through its bizarre juxtapositions of the sacred and the profane, the sacralized world of high art and mundane reality of everyday life. The film's crew, straight out of Fellini, parade around in campy costumes while desecrating their biblical set with their indulgence in pop music and dance. The crown of thorns emerges from a box of dry goods before framing a housing complex in the distance.

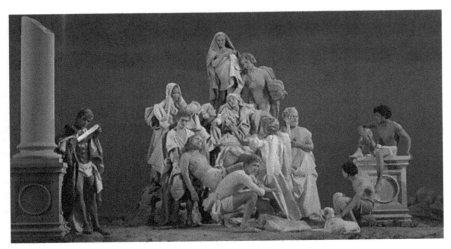

FIGURE 4.1. *La ricotta*

An overflowing, Caravaggesque still life prompts an assistant director's accusation: "Saints, have you eaten the whole of the last supper?" The extra playing Christ talks primarily about partisan politics and considers entry into heaven a reward for proper political beliefs, and Stracci's brief moments of freedom proceed with the jerky and unnaturally rapid movements of a silent film, transforming him from serial victim into Chaplinesque hero. The tableaux also verge on bitter caricatures of their sources, as the soundtrack drifts between contemporary and classical accompaniments, the gathered actors and actresses struggle to maintain elaborate poses before ultimately toppling over, and the assistant director flings comments at inhabitants of an otherwise somber tableau, instructing them to deliver "more rapture, more piety" and warning an actress to lose her "*Comédie-Française* drawl." As Naomi Greene argues, in these tableaux, "Pasolini mocks what he called the 'worst' side of his own art: he greatly exaggerates, and thereby parodies, his 'mannerist' taste for startling contrasts and hieratic poses, for cultural echoes and layers of pastiche, for a deeply aestheticized and stylized reconstruction of reality."[1] He highlights and repudiates his tendency to foreground the theatrical gesture and arresting visual effect in an industry where stunning images can obscure a more ethically urgent reality outside the studio. With the investors in the film and the crowd gathering for a banquetlike "last supper" on the set, these tableaux vivants become a means of turning away from reality, a performance of Pontormo for producers and paparazzi.

Pasolini's theatrical reconstructions of old paintings remain at once committed to a socially engaged cinema and defiantly artificial, artful, fake. In his meditation on the "Nietzschean" cinema of Welles, Gilles Deleuze celebrates the director's "falsifying" plots and images, emphasizing that their falsity results from not a flight from reality but an attempt to "counteractualize"

it through the "powers of the false."[2] He writes that the "power of falsehood must be taken as far as a *will* to deceive, an artistic will which alone is capable of competing with the ascetic ideal and successfully opposing it. It is *art* which invents the lies that raise falsehood to this highest affirmative power, that turns the will to deceive into something which is affirmed in the power of the falsehood. For the artist, *appearance* no longer means the negation of the real in this world but this kind of selection, correction, redoubling and affirmation. Then truth perhaps takes on a new sense. Truth is appearance. . . . In Nietzsche, 'we the artists' = 'we the seekers after knowledge or truth' = 'we the inventors of new possibilities of life.'"[3] The tableaux vivants contrived by Pasolini (and, by proxy, an older Welles) are alternately captivated and repelled by the falsity of their fabrications, by the paradoxical reality of their fakes. These moments in Pasolini gesture toward an unresolved conflict at the core of his work, as they ask, first, how an artist can combat a world captured by spectacle without resorting to a facile concept of the real, and, second, how the flight from history can be countered without submitting to tradition, without merely reciting the canonical masterpieces of the past. That foundational problem recurs throughout Pasolini's work, from the residual faith in the image evident in *The Gospel According to St. Matthew* (*Il Vangelo secondo Matteo*, 1964) or "The Cinema of Poetry" (1965) to the contamination and abuse of art on display in *Salò* (1975). Both averse and attracted to the traditions of cinematic realism and mannerist excess, Pasolini juxtaposes the two in a state of permanent contradiction.

La ricotta prefigures such an impasse in its two biblical epigraphs, which together declare competing and potentially discrepant Gospel truths. In the first Saint Mark attests to the impossibility of concealment and the certainty of revelation: "for there is nothing hid, which shall not be manifested; neither was anything kept secret, but that it should come abroad. If any man have ears to hear, let him hear." The succeeding passage, from St. John, describes Jesus confronting the money lenders, admonishing them for the desecration of a sacred space, the conversion of "my Father's house [into] a house of merchandise." *La ricotta* then reveals the conflict between artistic revelation and the prevalent conditions of cultural commerce, as in the scene when the three crucified men are obscured by the rhyming forms of Roman paparazzi, who focus not on the injustice behind them but the spectacle of arriving celebrities (Figure 4.2). Entry into the kingdom of heaven passes first through a kingdom of images in which things remain hidden, and the utopian social ambitions of art confront the obfuscating effects of the culture industry. This conflict between the noble aspirations of art and the actuality of tabloids and publicity, of images that aspire to pure communication and circulation, propels Pasolini back in time and across media. After a banal and superficial interview with a journalist from a publication owned by the producer, the director reads a 1962 poem from Pasolini: "I am a force of the past. Only in tradition is my

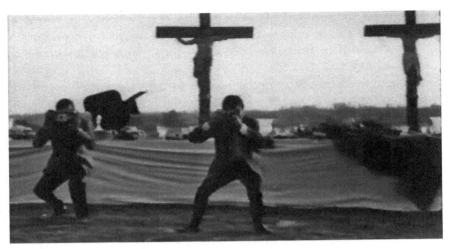

FIGURE 4.2. *La ricotta*

love. I come from the ruins, from the churches, from the altarpieces, from for-gotten hamlets in the Apennines and the foothills of the Alps where dwelt the brothers. I walk about Tuscolana like a madman, the Apia like a dog without a master. Oh I behold the gloaming, the mornings over Rome, over Ciociar, over the world, like the first acts of post-history which I witness through anagraphical privilege from the utmost edge of some buried age. Monstrous is the man born from the bowels of a dead woman. And I, adult foetus, wander, more modern than any modern, in quest of brothers that are no more." *La ricotta*'s poetic incantation prefigures the concept of *post-histoire* studied in 1992 by Lutz Niethammer, with an apocalyptic vision of political failure that contradicts the more famous and optimistic variation on the theme developed by Francis Fukuyama.[4] But the poem and voice-over also invoke a complex web of intertwined temporalities, and the film constructs images that allude to origins in the past even as their contexts subvert any attempt to revive or return to a "buried age."

La ricotta's tableaux vivants embody the dilemmas evident in this phase of Pasolini's career and the practice of the cinematic tableau in the late twentieth-century films to come. Can the "adult foetus," born not as a tabula rasa but with an excess of history, avoid a future of endless repetition? And does the new era of "posthistory" also signal the abandonment of a past that remains, in Pasolini's eyes, "more modern than any modern" and as likely to contain possibilities for the future as the contemporaneous landscape overtaken by consumer objects and promotional images? What Pasolini foreshadows in *La ricotta* is the archaeomodern turn, with the tableau vivant at the center of this at once retro and prospective aesthetic. Existing on the cusp of an exhausted era and the beginning of posthistory, the poet searches for a past effaced by

modernity and a future imaginable only through the apparatus of tradition, through an alchemical combination of allusion and creation. In the late twentieth century the "cinema of painters" explored this posthistorical condition through the tableau vivant and its juxtaposition of art forms and historical eras. A prominent genre in early film and a relatively obscure practice by the time Pasolini heralded its revival, the tableau vivant became one of the signature features of intermedial filmmakers ranging from Marguerite Duras to Jean-Luc Godard and Raúl Ruiz, from Peter Greenaway to Derek Jarman and Sally Potter, from Isaac Julien to Terence Davies and Carlos Saura. Looking back at the history of film as another "buried age," filmmakers deployed the tableau to revisit historical eras and image-making practices while remaining open, adaptive, and alive.

A Painting Ruined

In *Absorption and Theatricality*, his sweeping exploration of eighteenth-century French painting, Michael Fried underscores the continued relevance of Diderot's art criticism to the study of post–World War II modernism, especially his accounts of dramatic tableaulike configurations rendered in paint. Fried concludes his introduction with the controversial assertion that a history of art in the age of Diderot may also "have something to say about the eighteenth-century beginnings of the tradition of making and seeing out of which has come the most ambitious and exalted art of our time."[5] In *Art and Objecthood*, his manifesto for that modernist artwork, Fried maintains that the continual paring down of the medium to its essential elements is one of the key markers of postwar painting. Such art seeks ultimately to eliminate externalities and reveal the *"minimal conditions for something's being seen as a painting,"* and the truly modernist painter engages with only "those conventions that, at a given moment, *alone* are capable of establishing his work's identity as painting."[6] While Fried's extensive interaction with artists in their studios reveals the aesthetic challenge that invigorates this project, his prehistory centered on Diderot also betrays the fear at the core of this ongoing project: as with Diderot, Fried's writing constitutes a "reaction against the Rococo" or the overwrought ornament that threatens to transform the artwork into a kitschy bauble.[7] Fried also reveals his aversion to the confusion of intermixing media and the impurity that disrupts the seeming evolution of art toward its "minimal conditions." "What lies between the arts is theater," he argues, and for Fried "theatricality" serves as shorthand for art tempted by impurity and excess.[8]

In a direct response to Fried, Douglas Crimp argues that since the 1970s critics and artists "have witnessed a radical break with that modernist tradition, effected precisely by a preoccupation with the 'theatrical.'"[9] If, as Stephen

Melville argues, the tableau is "the difficult seam . . . between the canvas and the stage," the tableau vivant in art and cinema is a phenomenon that explores and thrives within the interstitial space between arts and media where traditions merge and collide.[10] Serge Daney notes, for example, that Godard's work in the 1970s displays a "total contempt for any discourse tending to define, to preserve a 'specificity' of cinema. You have to see how he places, how he calmly embeds both the still photograph and the television image into the movie screen. Cinema no longer has any other specificity than that of receiving images that are no longer made for it: *Numéro Deux*."[11] This trajectory in Godard's career leads toward both the collagelike combinations of painting, text, video, and film in his *Histoire(s) du cinéma* project and the tableaux vivants of work by Rembrandt, Delacroix, Goya and others constructed on a television sound-stage in *Passion* (1982). Daniel Morgan argues that by the late 1980s Godard's work rejects the traditional, technologically inflected genealogy of moving pictures and instead "aspires to the condition of painting."[12] This retrospective turn upends the history of cinema and reframes its relationship to modernity, now viewed as one among many influences on the development of the medium, while also confronting the "problem of maturity" that remains a major preoccupation for Godard throughout his late career.[13] As audaciously as any gesture in a Godard film, the tableaux in *Passion* discard the familiar notion of medium specificity and instead celebrate cinema's impurity and theatricality, the qualities best adapted to the historical seam between modernity and whatever comes next.

Throughout its history the tableau vivant has enthralled and repelled audiences because of its eccentric combination of familiarity and aberration, because of its comforting allusions to eminent artworks and its disquieting violation of the borders between established forms. Deleuze writes that cinema "brings together what is essential in the other arts; it inherits it, it is as it were the directions for use of the other images, it converts into potential what was only possibility."[14] Cinema and other modern arts develop "a veritable *theatre* of metamorphoses and permutations," a "theatre where nothing is fixed, a labyrinth without a thread."[15] This potential for theatricality has remained latent in both the dominant, classical filmmaking practices and their primary alternatives, including the minimally altered recording of reality or the avant-garde gesture that draws attention to the medium itself. The tableau vivant in cinema signals a significant departure from both the classical and modernist models of film and instead returns to an even older conception of the medium. André Gaudreault argues that a pre-institutional "cinema of attractions" often downplayed narrative and instead highlighted spectacular visual display, resulting in films that comprise "successions of more-or-less autonomous tableaux."[16] In the late twentieth century the tableau vivant in film became a privileged vehicle for exploring the "difficult seam" between arts and media and an archaeomodern strategy that engaged with earlier manifestations of modernity.

Because it exists at the crossroads of the plastic arts and the theater, and because of its tendency to wax in popularity and wane into obscurity, the tableau vivant has engendered mostly brief and passing criticism over its long history. The tableau vivant surfaced in the German baroque drama studied by Walter Benjamin and on the French Restoration stage, and by the mid-nineteenth century it became a popular form of entertainment in salons and drawing rooms in Europe and the United States.[17] An 1885 French encyclopedia of theater defined the tableau primarily by its immobility and its allusions to acknowledged masterpieces or immensely popular works in the visual arts: it presents "the precise reproduction by living but motionless people of celebrated and universally familiar pictures or sculptural groups."[18] In its periods of utmost popularity critics evaluated performances of the tableau vivant by their precision in reproducing a familiar work of art, their faithfulness to an original, and their capacity to evoke its presence despite the intervening distance of a country or continent. In the late eighteenth and early nineteenth centuries the "attitude," a mute and immobile dramatic display akin to the tableau, peaked in popularity among Europe's grand tourists and generated considerable acclaim for its most respected performers.[19] Goethe wrote enthusiastically about the dramatic attitudes of Emma Lyon as an embodiment of his theory of performance. The attitude begins to mold the body into an imitation of a classical prototype, and "by performing the classical body, one can bring an effective gravity, a 'celestial' aspect to the event. By imitating the fibre of antiquity's statues, the performer is able to elevate her work and evoke awe and wonder from her audience."[20] This variation on the tableau vivant allows the performer to become "a classical statue brought to life, a revitalized antiquity."[21] When constructed in accordance with these standards, the tableau vivant copies paintings, embodies inaccessible artworks, performs scenes from literary classics, or composes a compressed theatrical miniature, approximating under adverse conditions the sort of dramatic action best captured at full throttle on stage. The tableau as embodied masterpiece succeeds when it defers to the original, when it remains faithful to its source, when it basks in the aura of art. These paintings on tour were originally imagined as an early museum without walls, affording access to otherwise sequestered or unapproachable works of art, but they also reinforced a particular cultural heritage that the audience was supposed to share. As the actors inhabited a tableau vivant and the audience recognized its allusion, the original also inhabited them, constituting them as an audience through those very acts of repetition and recognition of a tradition. The performance of the tableau vivant became an exercise in the installation and indoctrination of cultural heritage and an occasion for the conspicuous display of cultural capital.

Homi Bhabha updates this theory of the tableau vivant for the postmodern age and underscores the subservient relationship between the imitation and a masterful original, with Peter Blake's *The Meeting, or Have a Nice Day, Mister Hockney* (1981–1983) the prime recent example. In that painting, two artists

bump into David Hockney at the beach, replicating the scenario and form of Courbet's *The Meeting, or Bonjour Monsieur Courbet* (1854), but replacing the dismissive air that characterizes Courbet's encounter with a patron with a combination of vapid reverence and oceanside insouciance, an in joke among artists. Bhabha writes, "Their studied poses, replicating the Courbet painting, recall a European painterly past surprisingly restaged in the midst of the southern Californian landscape of youth, lust, and leisure that has largely been invented, in the pictorial imaginary, by David Hockney."[22] By means of Blake's painting, Bhabha begins to equate the simulacrum produced through the tableau and the epistemological evasions often ascribed to postmodern art and theory. He writes that choosing to "introduce the concept of the postmodern by means of a tableau vivant is my attempt to capture something quite specific about the postmodern aesthetic as the representation of the 'unpresentable in the presentable.' For the tableau vivant as a living picture captures something of the uncanny, repetitious, or 'retro' . . . structure of the simulacrum. The representational desire of the tableau vivant lies in the pleasure of producing a copy that elides and eludes the original not simply by displacing it but by doubling it; an image that 'catches its breath' to appear still, dead, fixed, in order to infuse the tableau with life and exceed the presence of imaging itself; a reproduction of similitude where the surface of the scenario is the signifying site of a 'difference' that consists in substitution and subversion at the same time."[23] Within what ultimately amounts to an attack on postmodernism launched through the tableau vivant, Bhabha also hints at a potential critical dimension of the tableau precisely because it "catches its breath," because it never quite replicates the original and instead confronts Courbet with the atmosphere of breezy indifference that defines the world depicted by Hockney. What Bhabha overlooks is the engagement, across a broad range of artists and media, with a variation on the tableau vivant that foregoes the acquiescent homage and inserts difference within the serial repetition of the same.

An alternative strain of history and criticism highlights the inevitable discrepancies between an original and its copy, weaving the tableau into a theory of the failure and disintegration of tradition rather than the revival that initially appealed to Goethe. In his *Trauerspiel* book, or what could be called "the work of art in the age of theatrical reproduction," Benjamin foregrounds the allegorical dimensions of the tableaux that appeared within the ruined environments depicted on the baroque stage. According to a study cited by Benjamin, the mourning play is virtually synonymous with the tableau vivant, as it composes "an allegorical picture executed with living figures, and with changes of scene."[24] Benjamin argues that German baroque playwrights designed their work with as much attention to these embodied paintings as to the evolution of plot, and for this reason "the visionary description of the *tableau vivant* is one of the triumphs of baroque vigor and baroque antitheticism."[25] He holds that these stilled and assiduously arranged bodies both produce a

stunning visual impact and embody the key thematic and aesthetic concerns of baroque drama obsessed with the collapse of the existing political and cosmic order. In *Elective Affinities* (1809), the source of Goethe's most celebrated writing on tableaux vivants, these enacted pictures represent a more subtle negotiation between the body of the performer and the regard of the spectator. While the novel's verbal accounts of tableaux are often viewed as a celebration of beautifully costumed and posed women under the gaze of Eduard, taken in this reading as a stand-in for Goethe, Benjamin regards *Elective Affinities* as a satire of audiences engaged in vapid, pseudo-aesthetic contemplation, mistaking artificially constructed scenarios for life. In Benjamin's subtle analysis, and in the novels of George Eliot and Edith Wharton (and in the Terence Davies adaptation of her *House of Mirth* [2000]), the tableau, peopled primarily by women, becomes a metaphor for the fabrications that interfere with experience, including the social construction of femininity subjected to a male gaze that transforms living female bodies into subdued objects for consumption. Reading at times with Goethe and at others against the grain, Benjamin imagines these tableaux not as harbingers of neoclassicism, but as precursors to the modernity he champions first in the baroque *Trauerspiel*, then in Baudelaire, then in Surrealism. The tableau vivant no longer aspires to a formal perfection but instead evokes a fleeting image, a fragment of a larger and inaccessible whole, and an allegory of the modern condition where timeless aesthetic forms are ubiquitous and close at hand but only through mediatized and consumable approximations that betray the underlying ideals of continuity and perfection.

No longer a demonstration of bodily and cultural mastery, the tableau vivant begins to challenge the sanctity and aura of the original in Benjamin's analysis, and other philosophers would uphold it as a figure of high infidelity and the near total loss of control over body and mind. For William James the immobile figures of the tableau vivant exemplify the physical effects of a hypnotic state, as the entranced individual becomes "a *tableau vivant* of fear, anger, disdain, prayer, or other emotional condition."[26] The tableaulike stillness that accompanies the trance becomes proof positive for James of the actuality of hypnosis because it subjects the body to otherwise unbearable feats of endurance. Instead of embodying classical standards of beauty, the tableau vivant becomes a figure for the helpless body wrested from conscious control. Jean-François Lyotard invokes a potentially transgressive variation on the tableau vivant in his 1973 essay "Acinema," which considers alternative strategies available to filmmakers at the outset of postmodernity and gestures toward two "antipodes" or contradictory forces that compel "whatever is intense in painting today" and the "truly active forms of experimental and underground cinema."[27] Lyotard identifies these "poles" as "immobility and excessive movement," and he cites the tableau vivant as one example of postmodern immobility, situates "lyric abstraction" at the opposite pole, and anticipates a "libidinal" cinema

able to match the "drift of desire" that energizes the work of his most revered artists.[28] Lyotard deploys the tableau vivant within a more sweeping argument about art in the postmodern era: only by arresting the flood of images or by accelerating that surge beyond any threshold of domination can the contemporary artist resist the nihilistic tendencies of late capitalism and pervasive spectacle. For artists and filmmakers in the late twentieth century, the tableau vivant became the centerpiece of images organized around the uncanny effects of the trancelike condition described by James or the liberatory potential of stillness identified by Lyotard in a world of chaotic visuality.

In his study of Sade and Leopold von Sacher-Masoch, Deleuze views the tableau vivant as the centerpiece of a sexual spectacle organized around still bodies that both provoke desire and delay its gratification. On the one hand, the tableau displays the arrested eroticism that characterizes the novels of Sacher-Masoch, and, on the other, it contrasts with the Sadist logic of serial conquest, the accumulation of experience, the quantity of encounters. Deleuze writes that Sacher-Masoch "has every reason to rely on art and the immobile and reflective quality of culture. In his view the plastic arts confer an eternal character on their subject because they suspend gestures and attitudes. The whip or the sword that never strikes, the fur that never discloses the flesh, the heel that is forever descending on the victim, are the expression, beyond all movement, of a profound state of waiting closer to the sources of life and death. The novels of Masoch display the most intense preoccupation with arrested movement; his scenes are frozen, as though photographed, stereotyped or painted. In *Venus* it is a painter who says: 'Woman, goddess . . . do you not know what it is to love, to be consumed by longing and passion?' And Wanda looms with her furs and her whip, adopting a suspended posture, like a *tableau vivant*: 'I want to show you another portrait of me, one that I painted myself. You shall copy it.'"[29] Sacher-Masoch's suspended gestures and frozen movements become the paradigmatic quality of his work, a form of art that creates eroticism through the orchestration of anticipation and deferral. For Deleuze the secondary status of the tableau, its role as an always imperfect reproduction of the original, implies both the stricture of law and a libidinal possibility inherent in repetition. The command—"You shall copy it"—is governed by "the sternness of the order," but it also launches into a series of digressions inherent in the process of imitation and replication.[30]

Latching onto the possibilities of the transgressive copy that both imitates and deviates, Pierre Klossowski embraces the tableau vivant precisely because of its inherent falsity, its belatedness, its status as a reproduction in a long sequence of similar images. In his art historical writing (primarily on the tableau-derived paintings of his brother, Balthus) and his novels and screenplays that deploy the tableau vivant, Klossowski develops a theory of the tableau that rejects its traditional role as a conduit for familiar and valued art. For Klossowski the tableau vivant "was not simply life imitating art—it was a pretext. The emotion

sought after in this make-believe was that of life giving itself as a spectacle to life; of life hanging in suspense."[31] Klossowski's tableau combines two seemingly incompatible temporalities: fixed in a pose and stuck in the past, it also evokes feelings of longing and anticipation. As Scott Durham argues, Klossowski's restagings are more "untimely" than nostalgic, and rather than merely duplicate gestures from the past, they rediscover a "fundamental hesitation that haunted that gesture from the beginning, but which could be made manifest only retrospectively, through repetition."[32] Because it remains suspended between past and future, rooted in the faits accompli of history but lingering on and facing the ambiguous prospect to come, "the tableau vivant might be interpreted as a privileged site for the fantasmatic representation of memories whose essential content is not what is over and done with, but a wish unfulfilled in the past that persists in (or is projected backward from) the present. In this sense, it would provide the theater in which the object of a heretofore forgotten wish could return before our gaze, in however masked and indirect a form."[33] While these bewildered figures remain petrified, unable to escape a cycle of eternal reiteration, they appear "at the same time to await the word that will break the spell and set them back into motion: for their frozen gestures remain haunted."[34] Reminiscent of the parable that begins Benjamin's unpublished preface to the *Trauerspiel* book—the imagined addendum to "Sleeping Beauty" in which the scullery boy's slap awakens a slumbering kingdom—these tableaux vivants exist in a state of suspended animation, but that very act of suspension opens the possibility of escape from mythic time and its cycles of mere repetition.[35] Durham calls the tableau vivant a "metafantasy," or a dramatization of "the desire to desire otherwise, the dream of passing from one mode of desire and thought to another," from myth to utopian aspirations.[36] The often provocative gestures that characterize the recent revival of the tableau vivant—the radical anachronisms, the sometimes violent and grotesque imagery—reveal the dialectic between a ruined world and the persistence of hope that energizes the *Trauerspiel*, baroque allegory, and the tableau vivant.

This allegorical potential of the tableau vivant, including its capacity to function simultaneously as an allusion to and a critique of the history of images, was one the major attractions for a new generation of writers and artists—from the novelist Angela Carter to the fashion designer Alexander McQueen to the artists Sam Taylor-Wood, Cindy Sherman, and Joel-Peter Witkin—concerned with the social construction of images and the lingering aftereffects of ingrained ways of seeing. In Carter's *Nights at the Circus* (1984) the central character, an enormous winged woman, earns a living performing in tableaux vivants, her appendages adding credibility to her performance as "Cupid," "Winged Victory," and "Angel of Death." Critics have argued that these tableaux become emblematic of the novel's feminist reappropriation of the gaze, as the winged *"aerialiste"* "actively creates herself as subject *and* object," rather than submitting herself passively to a dominant male gaze.[37]

In these microcosmic tableaux, "Carter gives us woman as something other than Other, someone who is not defined by and absorbed into the patriarchal power structure."[38] Carter's tableaux seek to recapture the image from both the patriarchal gaze and theories of the gaze that implicate all visual spectacle and pleasure into those structures of domination. Sherman's earliest variations on the theme of the tableau vivant, especially her imaginary film stills, experiment with a broad repertoire of image-making strategies and modes of reception, from the accidental quality of Henri Cartier-Bresson's "*images à la sauvette*" to the high artifice of melodramatic staging. As Laura Mulvey argues, "Each pregnant moment is a cutout, a tableau suggesting and denying the presence of a story. . . . The women in the photographs are almost always in stasis, halted by something more than photography, like surprise, reverie, decorum, anxiety or just waiting."[39] Mulvey suggests that Sherman's photographs expose the viewer to "a series of doubletakes, estrangements and recognitions. The camera looks; it 'captures' the female character in a parody of different voyeurisms."[40] And by constructing many of these tableaux as mock film stills, Sherman rips these images from their conventional role as pleasing pictures that accompany narrative cinema, suggesting that when the film and its plot are long forgotten, what remains are these images, frozen, falling out of the story, at once the most evocative and clichéd, the most powerful and therefore the most dangerous acts of cinema. Sherman's later tableaulike parodies of old master paintings construct an art historical lineage that connects the artifice of movie stills to the grotesque, dolled-up appearances of the fashion shoot and the distorted, fragmented, and plasticized bodies that feature in her return to the art historical canon. Sherman extends her assault on the conventions of the gaze backward in time, to the idealized faces and bursting bustiers on the canvases of old masters. Her canon, again reimagined through tableaux vivants, careens between the extremes of the monstrous and the campy, with the synthetic, obviously costumed bodies of today juxtaposed with another tradition of bawdy excess. The photographs of Witkin likewise use the tableau to interject the carnivalesque into the sober and untouchable canon of art, as he restages paintings by Caravaggio, Courbet, Dalí, and many others but with bodies that are marked by disability and disfiguration rather than being representatives of conventional standards of beauty. Not homages, Witkin's photographs are imperfect quotations that foreground their difference from the original and redefine what counts as the ideal body and artistic perfection, a difference emphasized through his scratched negatives and otherwise "ruined" prints. Michel Foucault writes that "genealogy is gray, meticulous, and patiently documentary. It operates on a field of entangled and confused parchments, on documents that have been scratched over and recopied many times."[41] Like nth-generation copies riddled with discrepancies introduced by each pass of the machine, Witkin's metamorphic tableaux recognize the gravitational power of the original still visible in the image while also affirming

the values of diversity and variation. McQueen's legendary runway shows allude directly to Witkin's work and their engagement with Catholic heritage, and McQueen stages a series of tableaux to introduce collections like "Dante" and "The Birds" that revisit historical events or canonical art, literature, and cinema, placing heritage in the unfamiliar context of the catwalk and cameras. McQueen's runway shows embody the late twentieth-century paradox of an anticommemorative history that recalls iconic images through the ephemeral medium of the tableau vivant and locates "timeless" masterpieces within the cycles of revival and forgetting that define the world of fashion.

The tableau has also been mobilized by artists who view the dynamic relationship between the original and the copy or between the historical object and its live performance as a powerful commentary on the status of the colonial subject. Lubaina Himid, an artist born in Zanzibar and working in England, mobilizes the tableau vivant in a series of paintings, drawings, texts, and an installation that together comprise *A Masque in Five Tableaux* (1992). Drawing on and responding to the tradition of the masque, a seventeenth-century form of court entertainment performed for the entertainment and glorification of the monarch, Himid harnesses the theatricality of that genre, creating counter-hegemonic spectacles rather than celebrations of conspicuous wealth and raw power. Yet the vehicle of this critique of spectacles that now persist primarily in heritage culture is itself a traditional medium, for this series of artworks marks Himid's "major, and calculated, re-engagement with *painting*, via the *tableau*—a pun on the use of tableau-vivant in masque, theatre and later cinema, and on the French word for the most achieved and, therefore, highly esteemed level of academic painting: the history painting."[42] As Griselda Pollock argues, this modern-day masque returns to "a historically distant point from the seventeenth-century moment of Britain's colonial expansion" and adopts themes of mourning and revenge dear to drama of the period in order to "rework through them the dire legacies of the very colonial project so celebrated in the seventeenth-century courtly masque."[43] Himid's paintings return to the distant past in order to insert elided histories of black women who continue to haunt conventional narratives of British modernity; and the form of this return—the tableau—becomes a force of arrest in those narratives, with another modernity inhabiting the very spaces once reserved for figures more conducive to the aggrandizement of male heroes and the imperialist project. Pollack argues finally that these tableaux are "historical allegories, their painterly and visual textuality requiring to be read like the stories that furnished the materials for Baroque history painting."[44] And as Jessica Horton points out, colonial subjects have often been conscripted into the performance of narratives and the reenactment of images authored by a colonizing power, as in 1846, when thirteen Ojibwa people created tableaux vivants in Paris and were sketched by Delacroix and other artists, thereby initiating an "unsettling chain of bodies-turned-pictures-turned-bodies-turned pictures."[45] In a 2010

multimedia installation titled *Paris/Ojibwa*, the Saulteaux artist Robert Houle transforms elements of those sketches, including abstract evocations of the background and seemingly incidental gestures, into portraits of the original posed figures, now envisioned as upright bodies that turn away from the viewer and toward a landscape stretching toward the horizon. Framed on flats that construct two walls of an empty stage, the installed portraits allude to the artificiality of the scenario that produced the initial drawings, but they also realize a form of "transcultural materialism" that reclaims and liberates an image produced under conditions of exploitation.[46] Despite important differences in the orientation of their critiques, each of the above artists mobilizes the tableau against the clichés that discipline thinking by limiting the scope of history to a narrow range of familiar subjects and outcomes. In the simultaneously still and moving tableau, in the image that alludes to inherited ways of seeing but maintains the capacity to change, late twentieth-century art and cinema launch what Klossowski calls an "insurrection of images" propelled by "the soul's aptitude for an always-inexhaustible metaphorphosis."[47] During a moment marked by the proliferation of moving pictures and the search for stable and familiar reference points within that chaos, the tableau vivant combined an initial gesture of recognition or return with the spirit of insurrection.

That dynamic of recollection and rebellion motivated a series of cinematic engagements with the tableaux vivant in the late twentieth century. In *Hypothesis of the Stolen Painting* (1978), a film based on Klossowski's *Le Baphomet* and produced in collaboration with the writer, Raúl Ruiz develops a plot thick with intrigue, but in the process elaborates on the theory of the tableau vivant advanced in Klossowski's earlier work and his own meditations on the status of the excessively coded image or cliché. Ruiz has featured the tableau vivant in other films, most notably in *Genealogies of a Crime* (1997), where actors embody the participants in and witnesses to a murder in order to demonstrate a psychoanalyst's claims about the triggering effect of a return to the moment just before a traumatic event. *Hypothesis of the Stolen Painting* focuses on the efforts of an art collector to reconstruct the mysterious atmosphere that enveloped the production and reception of a series of paintings, a mystery reflected on the cryptic canvases themselves. In locations scattered around his house and garden, actors inhabit tableaux vivants, heuristic devices designed to illuminate the secrets planted but concealed in the original paintings. At the center of the cycle of images and at the core of the enigma lies the stolen painting, the missing element that holds the final but irretrievable piece of the puzzle. The collector's conjecture runs the gamut of iconographic, interpretive, and formalist approaches to art history, as he searches for a fleeting resolution to the riddle in the symbolism of a particular object, the mythological narrative represented in a painting, or the location of a light source illuminating the scene. From these momentary impressions the collector speculates about the broader significance of this work to the various

intellectual salons, the aristocratic families, the "eight powers," and the massive conspiracy of Knights Templar who ultimately suppress these purportedly scandalous and politically dangerous canvases. His leaps of scale from the minutiae of representation to the level of secret supranational forces restore these painted traces to the significant position they once appeared to occupy: on these canvases, the collector implies, once rested the fate of Europe. Unable to reproduce the stolen canvas, the collector drifts into silence at the end of the film, a spectator before a scheme that exceeds his capacity for comprehension. In his landmark study of the cycle of American conspiracy films that appeared in the late twentieth century, Fredric Jameson observes that these movies revolve around characters who observe local manifestations of the global system of late capitalism but find themselves powerless to understand or map that system in its totality.[48] Ruiz locates the tableau vivant at the center of the logic of conspiracy because while it holds out the promise of a return to an embodied past, it never quite coincides with the original assumed to be its anchor in reality. The tableau vivant is always an imperfect placeholder for the absent painting. In the work of other artists these apparent deficiencies would be a marker of its success as a mediator between eras and art forms.

Godard's *Passion* (1982) is explicitly organized around the clash of temporalities and the logic of haunting that structure the tableau vivant (Figure 4.3). An art film about the staging of canonical paintings within a

FIGURE 4.3. *Passion*

television studio, *Passion* imagines the tableau as a hinge between art history and new media, with the director occupying the role of the archivist and curator who both gathers and preserves historical materials and transmits them to the public through contemporary technology. At once old and new, archaeological and hypermodern, the tableau vivant in *Passion* reworks old master paintings as television spectacles and critiques the separation between art and the media that accompany our everyday lives. Godard's films in the 1980s, and above all *Passion*, transform canonical artifacts by transporting them away from the museum, library, or concert hall, locating them in unfamiliar series and contexts, violating their integrity as discrete crystallizations of the past. As the film chronicles the creation of its first tableau, a rendition of Rembrandt's *Night Watch*, the actors mill around the set and assume their poses in front of the usual array of lights and cameras, creating a collection of fragments rather than a convincing semblance of the original painting. Alain Bergala argues that the presentation of the tableaux in *Passion* proceeds from relatively tentative "attacks" on the original in the *Night Watch* sequence to more radical disruptions of paintings later in the film.[49] In the tableaux based on *Night Watch*, the first shots display the scene frontally, roughly in keeping with the orientation of Rembrandt's original. But subsequent shots, usually centered on the girl in gold, deviate from that frontal perspective, presenting the faces and figures from oblique angles, approaching the plane of the original picture without ever violating the border that separates the artwork from the beholder. Bergala writes that in the *Night Watch* sequence "Godard never crosses *behind* the imaginary window that separates the space of the viewer from that of the painting, where his camera could see from the back what the painter portrayed from the front. He had just discovered the pleasures of flirting with the transgression of separating bit by bit the attack from the composition, but still obeyed the greatest taboo."[50] In later tableaux, most dramatically in Goya's *Third of May, 1808*, the camera disobeys that taboo, entering the space of the painting, performing a more radical reconstruction of the original than in the collage of portraits borrowed from Rembrandt. Using a shot/reverse-shot sequence, *Passion*'s tableau places the viewer of the film at the end of the gun barrel, enacting through editing the sort of affective identification with the victim that Goya's composition aimed to achieve, while also confronting us, for the first time, with the face of the executioner. The shock in this presentation of the painting derives from the tension immanent in any tableaux vivant, as the assumption that the tableau will resemble the original clashes with the desire to find dissimilarities between the source and the "copy." Another shock, as Jean-Louis Leutrat points out, occurs when a close-up reveals "the flickering eyelids of a dead body. The surprise comes both from seeing a body move (even minimally) in a painting (even if it is a 'living' one) and from the fact that this body is also supposed to be dead."[51] This tableau of *The Third of May* reconstructs the past in order to preserve the

original's affective, propagandistic effects, but that rendering of history is always haunted by other tenses, as present-day actors lie in contorted positions on a soundstage with other actors, technicians, and equipment. The transgressive potential of Godard's work in the 1980s lies in its refusal to foreclose the unfolding history of the work of art that often remains sheltered within an asylum of heritage.

Like the series of still lifes culled from the director's studio that becomes Alain Cavalier's cinematic introduction to *Thérèse* (1986), Godard's *Scénario du film "Passion"* provides a commentary on the film, as well as an early experiment with the format and technique of his upcoming *Histoire(s) du cinéma* (1988–1998). In his *Scénario* Godard suggests that cinema has long been subordinated to writing: first to the screenplay, then to the numbers calculated by producers and accountants, utilizing the economic notation that derives from the first written language, an invention of merchants. Looking back nostalgically to the days of Mack Sennett, when films were concocted out of the can, without a written script, Godard creates a visual, retrospective "screenplay" to resist a pervasive tyranny of the text. That inability to respond to images is never more evident, he suggests, than in the television newscast, when the news anchors look forward from studio desks, unable to see the pictures projected behind them. "The image sees them," but, blind to the complexity of the image, the newscasters present it as an illustration of the text rather than a contradiction or elaboration. The repeated invocations of Mallarmé's blank page in *Scénario*, accompanied by a white screen in his editing studio, evince a desire to start cinema from scratch and return to a mythical, purely visual image, unfettered by the constraints imposed during the long history of art. Yet that quest for new beginnings and purity of form, itself one of the oldest tropes in art and literature, has always been illusory because, as Godard says in *Scénario*, "traces already existed." In *Scénario* the adulteration of that empty image begins almost immediately, as fragments of the tableaux vivants begin to appear on the screen. Like the masterpiece described by Jacques Derrida, these tableaux emerge in video as "an elusive specter" that "*engineers [s'ingénie]* a habitation without proper inhabiting, call it a *haunting*, of both memory and translation. A masterpiece always moves, by definition, in the manner of a ghost."[52] Not the fantastic vehicle for a total break from the past, the blank screen becomes the site where familiar images are superimposed, recomposed, recognized, and seen differently.

In *Passion* and many of his other projects from the late twentieth century, Godard has realized the illusory nature of the avant-garde quest for the destruction of tradition and immaculate rebirth, and his political project develops into what Daney calls "a painful meditation on the theme of restitution, or better, of *reparation*. Reparation would mean returning images and sounds to those from whom they were taken."[53] They illustrate finally the distinction, first raised by Hanna in the film then repeated by Godard in *Scénario*,

between *"voir"* and *"recevoir,"* to see and to receive. Or, as Godard adds, in a slightly different formulation that emphasizes the effect of reception on the original object, "Art is like fire, born of what it consumes." Both the revival and the ruination of a work of art, the tableau vivant places the painted image into an unfamiliar zone where eras and media collide. Billing its setting as the most advanced television studio in Europe, *Passion* demonstrates both the dissemination of these artworks through the tableau and television and their destruction by those same processes of transmission. The baroque allegory, Benjamin suggests, is "constantly convulsed by rebellion on the part of the elements which make it up," resulting not in the preservation of beauty but a momentary glimpse into the process of decay.[54] And he suggests that one of the preferred strategies of the baroque "will to allegory" is the tableau vivant because it both visualizes an exemplum and, through an obviously imperfect performance, reveals its destruction. The paintings embodied and videotaped in *Passion* are simultaneously preserved and manipulated, transformed and ruined. For this reason, Deleuze maintains that "Godard confronts painting in *Passion* and music in *Prénom Carmen* (1983), making a 'serial cinema,' but also a cinema of catastrophe."[55] The purpose of the tableau vivant is to discover something worth preserving in the aftermath of that catastrophe.

Caravaggio's Moving Pictures

In the mid-1980s Michelangelo Merisi da Caravaggio's work experienced a renaissance, as a major exhibition at the Metropolitan Museum in New York and a series of critical studies returned the artist to the center of European and American art historical discourse. A new generation of artists and critics was compelled to reconsider the painter's relevance after an era dominated by minimalism and abstract expressionism and to the broader social project of discovering alternative histories of the early modern world. In response to the Metropolitan exhibition in 1985 artists and critics raised new questions about Caravaggio: they asked whether Caravaggio was their "contemporary" and a tutor figure for the successors of abstract expressionism;[56] or a poor draughtsman with a worse disposition, whose revival merely confirmed that "three hundred and seventy-five years have not dimmed [his work's] power to be showy, pushy, and hollow";[57] or one of the last exponents of a tradition of artistic craftsmanship, which, far from contemporary, "sadly is now past beyond recall."[58] Despite the vast separation in time between Caravaggio's late sixteenth-century Italy and the moment of his revival, his artwork and biography were conscripted into a variety of contemporary struggles: his work became a corrective to formal impasses in abstract and neo-avant-garde art, and his life a model of rebellion and resistance important to revisionist accounts of the early modern era. While some artists and scholars debated the merits

of the few biographical sources concerning his sexuality, others searched for gay shibboleths, for an anachronistically queer iconography, scattered throughout his paintings.[59] Although consideration of Caravaggio's sexuality always involves a significant amount of speculation, his paintings often revolve around sexually inviting or challenging glances and gestures, and they incorporate an iconography associated with homoerotic subcultures of his time. Caravaggio's *Victorious Cupid*, for example, may preserve the "slender thread of a rudimentary 'homosexual tradition'" and represent "the culmination and swan song of openly homosexual expression in the baroque era."[60] As recent critics have suggested, Caravaggio also inserts authorial signatures and self-portraits—including two as decapitated heads—into paintings that seem otherwise unconcerned with autobiography, establishing himself as one of the most self-revelatory of mannerist and baroque artists. For Leo Bersani and Ulysse Dutoit, conjecture about Caravaggio's sexual identity is unfortunate, no matter how well founded, because it deprives the paintings of their "intractably enigmatic quality."[61] They argue that "Caravaggio's enigmatic bodies have not yet been domesticated by sexual—perhaps even gendered—identities."[62] In comments on the conjectural nature of his screenplay for *Caravaggio* (1986), Derek Jarman emphasizes the interplay of biography and fiction in both his film and its necessarily ambiguous sources: "The narrative of the film is constructed from the paintings. If it is fiction, it is the fiction of the paintings."[63] Given Caravaggio's penchant for self-revelation in his paintings, and given the paucity of other biographical information, those images become crucial testimony, ultimately producing a speculative account of the artist's life but a "fiction" grounded in the paintings. What is permissible in reconstructing the life of Caravaggio and what lessons his biography lends to the present depend largely on whether or not the images themselves count as historical documents, and, if they do, whether or not history can incorporate those paintings without subordinating them to the texts they either complement or contradict.

In Jarman's *Caravaggio* the tableau vivant serves as the medium for a history based on images and an interface between art and history, film and painting, the present and the past. One legacy of political modernism in the 1970s was the reassertion of the older modernist and avant-garde claim that politics originates in a bold and decisive break from the past, but Jarman's cinema acknowledges the impossibility and even undesirability of that break for artists and activists hoping to discover and insert themselves within a community of opposition. Rather than rehearse the concerns of political modernism, *Caravaggio* posits the tableau vivant—a force of suspension and possible reorientation, a quotation that foregrounds difference as well as repetition, a medium of historical return that never sloughs off the mediating presence of actual bodies—as a successor to the ideology of the break. The foundational representational problem for Jarman's filmmaking is how to resolve

the formal politics of political modernism and the exigencies of the present, in particular an oppositional queer politics centered on the archaeology of past identity formations and a genealogy of the present. The film's destruction of the organic, mimetic diegesis is reminiscent of similar tendencies in political modernism, but Jarman also establishes identification as a compelling aesthetic model and alternates between extremes of distanciation and closeness. In Jarman's mode of identity politics—specifically, queer activism during the height of the AIDS crisis and under Thatcherite governance—an archaeology of identities submerged beneath dominant histories becomes an explosive political project.[64] Resistance has a history, the film suggests, though that history may remain obscured by centuries of accumulated discourses. The film reanimates gestures suspended on canvas since the cusp of the seventeenth century, subjecting those movements to the retrospective gaze of history and the prospective gaze of contemporary queer activism, joining the paradoxically future-oriented return to art history designed to recuperate Caravaggio for contemporary art and politics. The film reflects what may be called a mannerist sense of history, as it incorporates formal strategies of political modernism while infusing history into this formula, becoming a form of modernism with hindsight, with a historical dimension that allows for both a return to and a return of the past.

Benjamin writes that the "authenticity of a thing is the essence of all that is transmissible from its beginning, ranging from its substantive duration to its testimony to the history which it has experienced."[65] But what constitutes the origin of a work of art? And how does it transmit its history? The historical project in *Caravaggio* centers on a succession of tableaux vivants because through those histrionic copies it alludes to a qualitatively different moment in the social life of art objects, when the artwork existed only as a work in progress. These tableaux shown on-screen serve not to relay the ostensible subject matter of the painting, the narrative announced in titles or museum placards, but instead initiate a speculative re-creation of their immediate conditions of production. *Caravaggio* departs from one of the most conventional genres— the life of the absolute artist—and it forgoes formal, biographical, iconographic, or narrative modes of "reading" pictures. Instead it focuses on the production of pictures, animating them in studio settings to afford access to the moment when a welter of social and economic forces, identities, and desires were inscribed on canvas. Each tableau becomes a microcosm of Rome's sexual, power, and economic relations, as the city's elites insinuate themselves into the lives of Caravaggio and his friends and therefore into the studio of the painter. Jarman uses the tableau vivant to suspend and expand time just before the completion of the painting, before the drama of the studio concluded in a completed picture and dissipated over centuries of interpretation. Just as linguistics provided the operative metaphor as critics in the 1970s reconstituted the "language" of images, *Caravaggio* provides a realization of the project Joan

Copjec alludes to when she exhorts us to become "literate in desire."[66] The tableaux in Jarman's *Caravaggio* derive their power not from the privileged signifiers on their frames, but from the more intimate circumstances of the studio: the moment when the life of the artist—a story of both desire and the effect of power on that desire—was depicted on canvas.

The narrative of Jarman's *Caravaggio* would be difficult to discern from standard biographical information on the artist, such as it is. Little is known about the life of Caravaggio because he left few of the written records normally used in the reconstruction of lives on the cusp of the seventeenth century. The primary contemporaneous documents of his life are police records, which hint at a narrative of habitual criminality, ranging from the peccadilloes of his youth, escalating gradually through an almost annual appearance before the magistrates for brawling, to the murder of Ranuccio Tomassoni, the crime from which the artist ultimately fled before dying on the lam. Official documents, letters, and later biographical accounts confirm many of the salient facts, in particular the more sensational details of this well-documented fight between friends: "it has been a long time since we have had a dispute in Rome such as the one that took place on Sunday in Campomarzo between the painter Michelangelo da Caravaggio and a certain Ranuccio," reads one of the surviving primary sources.[67] The film is most remarkable in its frequent departure from the well-known narrative of crimes and misdemeanors, a narrative that comports very closely with romantic myths of the menacing artist in the Rimbaud mold, whose unstable behavior bespeaks the peculiarity of an "artistic sensibility." Later biographers and critics have been forced to reconcile these salacious official accounts and the sketchy but intriguing story they imply, with the alternative eloquence of the primary extant autobiographical records: Caravaggio's paintings. A history of the completed canvases, of their exchange and ownership, is less schematic than the necessarily speculative biography, but that history only tangentially relates to the artist and his mode of production. The eminent biblical and classical tales related in the paintings also tell little about the artist himself, as the stories predated Caravaggio by centuries and he often rendered them in a contemporary idiom, clothing his characters in the garb of sixteenth-century Roman commoners and removing the conventional trappings of antiquity, escaping insofar as possible the tyranny of stylistic and hermeneutic traditions enveloping those oft-painted stories. And a formal account of styles, of Caravaggio's break with classicism and experiments with mannerism, also reveals little about the life of the artist, in the studio and elsewhere. The warp and woof of art and commerce, styles and subjects, intersect with the canvas at various moments of its career, but they can say little about Caravaggio himself beyond the strictly limited sphere of artistic patronage and the economics of art, or the purely formal realm of individual and period style, or the usually uniform templates of iconography. Adhering only to the most authentic and incontrovertible evidence,

Caravaggio's biography devolves into the story recorded and propagated by the official public discourse of police records and buyers and sellers of art.

Yet as Fried argues in his 1997 essay on Caravaggio's often concealed and disguised self-portraits, many of Caravaggio's paintings contain lingering traces of the artist himself and hint at the particularities of his mode of production. Fried suggests, for example, that Caravaggio's *Boy Bitten by a Lizard* is figured in the act of painting a self-portrait, swiveling between a mirror and a canvas arranged at right angles, constructing a triangle with the canvas and mirror and offering two different takes on the artist/subject, who forms the third vertex. The eponymous boy's expression of shock is also a record of the painter's own discomfort at discovering the difference between the mirror image and the self-representation—in essence, having seen himself in his mirror or canvas, as though for the first time. Michel de Certeau suggests that this dynamic of identification and estrangement became a signature theme in baroque art because "probably no era was more conversant with the ruses of the image."[68] He writes that figurative representations became exercises in the "doubling of the ego," a complex process of dispersal whose stages he describes as follows: "What I see in the image of the other is me; I am not here where I am but elsewhere, in the mirror representing the absent other, and I didn't know it: this was the iconic theme of those years. The other who appears through vision is an unknown me."[69] Fried's essay on Caravaggio also hinges on the expressions of shock and misrecognition that disfigure the artist's self-portraits and then on the artist's compulsion to mark his presence on the canvas despite these misgivings. In most modern studies of the artist's work, Fried writes, "What by and large has not been recognized is that Caravaggio is one of those rare painters . . . whose paintings must be understood as evoking a primary, even primordial, relationship to the painter himself, who afterwards is succeeded, but never quite supplanted, by other viewers, by the viewer in general, in a word, by us."[70]

Jarman's film takes this proposition literally: it searches for the submerged autobiography inscribed on those canvases and reconstructs from these primary extant autobiographical records the "primordial" relationship between Caravaggio and his work. If Caravaggio indeed inscribed so many traces of himself on his canvases, if scenes drawn from biblical sources include the face or telltale gestures of the artist, the obvious but ultimately unanswerable question is "Why?" Jarman responds first with another question, asking why the paintings resort to strategies of obscurity and deferral. He echoes Foucault's observation on the possibility of subversion even within the rules of relatively circumscribed and inhospitable regimes: "The successes of history belong to those who are capable of seizing these rules, to replace those who had used them, to disguise themselves so as to pervert them, invert their meaning, and redirect them against those who had initially imposed them; controlling this complex mechanism, they will make it function so as to overcome the rulers

through their own rules."[71] The director suggests that his starting point in the construction of the narrative was Caravaggio's paintings themselves, particularly his late depiction of David holding the head of Goliath, with its self-portrait as a decapitated head, and another gesture of responsibility inscribed in dripping blood: "I, Michelangelo, did this." From these seminal facts, Jarman expands the film into a work of immanent picture theory, as it offers a "reading" of the desire inscribed in this and other works and reconstructs a partial narrative to locate those desires. In a draft of his "Theses on the Philosophy of History," Benjamin wrote that "the past has deposited in it images, which one could compare to those captured by a light-sensitive plate. Only the future has developers at its disposal which are strong enough to allow the image to come to light in all its details."[72] The representational problem at the core of Jarman's *Caravaggio* is how to activate these anachronistic media technologies and redeem the vestiges of a past that survives only in vague and elusive images.

Frank Stella's Charles Eliot Norton Lectures at Harvard in 1983–1984 centered on Caravaggio's relevance to a generation of artists dealing with the institutionalization of abstract art and advanced a related thesis about the importance of the studio setting to an understanding of Caravaggio's art. For Stella, this belated reemergence affords an opportunity to appropriate his unique response to a classical tradition and his experimentation with mannerism in new contexts, as a panacea to the excesses and limitations of post–World War II art. Stella's Norton Lectures and the subsequent published version, descriptively entitled *Working Space* (1986), offer a more formalist parallel to Jarman's own project, as they pursue a speculative account of Caravaggio's working life and transform a figure from a radically different historical era into a contemporary in spirit. Despite the differences between the painting styles of Stella and Jarman, the two artists present a similar vision of Caravaggio's studio, and both the former's critical appreciation in the lectures and the latter's film biography center on "working space" in the many manifestations of the term. Because of his keen attention to the details of the studio practices of a fellow artist and to the manipulation and modulation of bodies and their translation into shapes and colors on canvas, Stella moves backward in time from the frozen canvas to the configuration of models, the originary tableaux vivants, that became the Caravaggio paintings passed on over the centuries.

Stella's book reflects his profound fascination with the workings of Caravaggio's studio, and in particular the arrangement of painter and model that allowed the artist to choreograph a complex lattice of bodies and extravagant gestures. In critical accounts roughly contemporaneous with the paintings themselves, Giovanni Baglione writes that Caravaggio's innovative chiaroscuro lighting derived in part from his peculiar configuration of models in the studio, as he lit scenes from above, through a skylight placed strategically in the ceiling. Stella also provides a speculative reconstruction of the studio space, suggesting that the artist would situate himself between the canvas and the models,

swiveling toward, then away from the people re-creating a dramatic scene be-
fore, then behind, him. Thus "Caravaggio would be in the center of his uni-
verse, orchestrating the twin realities of pictoriality—subject and object—while
his model/actors reveled in the immortalization of their own performance,
watching themselves in Caravaggio's canvas mirror."[73] If Stella's hypothesis
is correct, then Caravaggio could have painted from carefully arranged tab-
leaux vivants that formed a crucial third element in his studio alongside the
artist and easel.[74] For this reason the scene depicted on canvas becomes more
than captured stillness, its players more than forms and shadows: the studio is
transformed into a performance space, with the canvas akin to a reflective sur-
face, or, more accurately, a device for recording those patterns of light. Using
the same metaphor—the "mirror" that "retains the image"—that André Bazin
upholds as a definitive characteristic of cinema, Stella envisions the canvas al-
most as a proto-cinematic apparatus, capturing an event unfolding in time and
promising immortality for those posing, though that event remains fossilized
in sheets and layers, in a palimpsest rather than cinema's serial succession of
frames.[75] Stella celebrates Caravaggio's construction of a pictorial space where
this drama of the studio can unfold, first through his violation of the viewer's
space by projecting an object or gestures forward in the composition, thereby
breaking the plane of the picture, and second by delimiting that depth with a
vague, unrealized backdrop, a conscious circumscription of Albertian perspec-
tive. Having identified a crisis in abstraction in his own era, a crisis attribut-
able to an obsession with color and surfaces, Stella beckons toward Caravaggio's
canvases as a model for escaping the tyranny of the surface. Caravaggio not only
created "a kind of pictoriality that had not existed before," but he also "changed
the way artists would have to think about themselves and their work. He made
the studio into a place of magic and mystery, a cathedral of the self."[76] As Stella's
mystifying language attests, this retrospective project remains hypothetical and
bears the imprint of Stella himself, as he looks back at a certain apparition of
Caravaggio. But the juxtaposition of these two spaces, the studio and the canvas,
posits Stella's "working space" as the site where the personal intersects with the
materiality of the medium, where the artist inscribes the necessarily ephem-
eral onto the potentially enduring, where the past is translated into a future in
emergence. Of the paintings in the Contarelli Chapel, he writes, "Even though
we know it is not possible, we sense that we are close to the moment when
these paintings were made. We feel that we want to leave the church immedi-
ately; we would like to locate the place and fix the moment where and when
these paintings were made."[77] That moment of production, when the space of
the studio is memorialized on canvas, is also the object of the beholder's desire
in Stella's account: it is something we "would like to locate . . . and fix," some-
thing "close" but always elusive, something endlessly receding before us. This
moment is also the subject of Jarman's film, and the tableau vivant becomes a
vehicle for its representation.

Stella's book does not advance a new argument about Caravaggio's treatment of space, as this discussion of pictorial space was standard commentary in early monographs on the subject, particularly in Walter Friedlaender's *Caravaggio Studies*, written thirty years before Stella's lectures. When Jarman first undertook the project for *Caravaggio*, he read Friedlaender's book and perhaps incorporated the argument about pictorial space into the soundstage.[78] But while Friedlaender argues that Caravaggio's work always gestures outside the frame, toward a transcendent sphere where the artist's lingering religiosity can reside, Stella focuses on the space within the bounds of the canvas and on the "cathedral" an individual artist constructs inside it. Jarman performs one further transformation. For Jarman, the studio is not only a place where the artist inscribes the self on canvas; it is also a social space, at once an escape from and a microcosm of the social forces at work outside that seeming refuge. Jarman and the cinematographer Gabriel Beristain have received praise from most reviewers for the faithful rendering of Caravaggio's lighting and modeled figures, but with its depthless dimensions the film also recalls Caravaggesque space, as the artist infamous for his refusal or inability to master Albertian perspectival paradigms also evokes a strictly limited, forward-reaching rather than infinitely receding space. This "authenticity" is due, in part, to the exigencies of production: the film was made for a half million pounds over six weeks in a London warehouse and as a result features no Italian landscapes. Despite (and perhaps because of) these limitations, Jarman constructs an intimate, domestic, bodily space perfectly attuned to the film's biographical and thematic concerns. Within that space *Caravaggio* presents tableaux vivants designed to reinsert the personal, corporeal, and social realms into the masterpiece whose timeless canonicity depends on the suppression of such ephemera.

Caravaggio's paintings have been praised and criticized for their tendency to transform sacred stories into genre scenes, for their rendering of the most charged biblical events in a domestic idiom. They present a series of epiphanic moments in everyday settings, situating scenes of revelation in a manger or tavern. These humbled stories take place within an equally humble space that forgoes the illusions of infinite regress and intersects with the viewer's world through a contiguity with the viewing space. This distinction between the system of Albertian perspective and Caravaggio's forward projection recalls Newton's discourse on "absolute" and "relative" spaces. Newton writes, "Absolute space in its own nature, *without relation to anything external*, remains always similar and immovable. Relative space is some moveable dimension or measure of the absolute spaces; which our senses determine by its position to bodies; and which is commonly taken for immovable space."[79] The space of Jarman's *Caravaggio* asserts the triumph of the body and the relative space it defines, inviting the viewer's involvement not through incorporation into an abstract system of representation, but by extending the space of the film toward the audience. "Effective history," writes Foucault, "shortens

its vision to those things nearest to it—the body, the nervous system, nutrition, digestion, and energies," and the film's presentation of history focuses primarily on these more mundane activities and the locations where they unfold.[80] The manufactured depth of the filmic image often constructs an illusion of enlightenment, a fantasy that knowledge abides somewhere in these protracted spaces, waiting to be discovered. Bersani and Dutoit emphasize that Caravaggio's aversion to Albertian space signals a departure from paradigms centered on knowledge and an embrace of "the relationality that constitutes the human as we know it."[81] "Art illuminates relationality by provisionally, and heuristically, immobilizing relations," they write.[82] At the opposite extreme from the Albertian model, the film's chronically foreclosed space suggests that knowledge is not obtained by receding deep into the visual field but through the exploration of another locus altogether: the bodies in the image, the material environment that surrounds them, and the relations among them. The principal characters also implicate themselves in this relational space by appearing to ignore the presence of the camera as they enter and exit the frame not through theatrical wings but from the space behind the camera. Lena, for example, enters the film during the boxing match between Ranuccio and the bartender, and she appears first as a hand, implying a body that extends somewhere out into the viewing space. Perhaps more than any character, Jerusaleme seems oblivious to the presence of the camera and the integrity of the frame, inhabiting a space that extends from the foreground forward and resists the illusionistic imperative of Renaissance painting and classical cinema.

This emphasis on the relational also translates into a concern with the everyday economy of art production, as the demands of patrons and the power structures of the larger society are all entangled in the life of the studio. Jerusaleme, a mute boy adopted by the artist to serve as an assistant and the only completely fictional character in Jarman's account, supports the domestic economy of artistic production, as he grinds pigments and mixes the paints, a form of silent participation all the more poignant because portraits of the artist at work too often elide this role. As Benjamin writes in his "Theses on the Philosophy of History," cultural treasures "owe their existence not only to the efforts of the great minds and talents who have created them, but also to the anonymous toil of their contemporaries."[83] One peril of the postmodern simulacrum is its separation from the individuals and the labor that produced it; the danger is not the absence of an original, but the denial of origins. *Caravaggio* situates the labor of artistic production at the center of art historical discourse, countering the threat of sourceless replication with yet another copy, the tableau vivant, whose embodiments emphasize that the painting is not simulated but *made*. Jerusaleme's presence beside the tableau vivant locates the "voice" of these anonymous contributors somewhere outside the dominant linguistic order, in an alternative signifying system to which the body serves as the primary ingress. Alternating and in tension with the mocking superficiality of

its mise-en-scène, so riddled with anachronisms and the trappings of 1980s bourgeois existence, the exigencies of Caravaggio's daily work also assume an important position in the film, especially through his relationship with Jerusaleme. Because the tableau vivant exists in several tenses at once—in the present of the performance, in the past viewed through historical representation, and in the future perfect, through which characters overlap with the paintings and historical figures that will have been—it allows the work that produced the painting to coincide with a premonition of the final product.

Those overlapping time frames signal Jarman's departure from Stella's model of the Caravaggesque studio: not only a cathedral of the self, the studio is also a workshop, a space where the exigencies of art, desire, and commerce intertwine in the simultaneously social and personal act of artistic production. The simultaneity inherent in the tableau is revealed most explicitly when Cardinal Del Monte enters the studio to examine a work in progress and causes the models to snicker. Acting as the Cardinal's surrogate and therefore implicating himself in the systems of power at work in this mode of production, Caravaggio bellows, "You are paid to be still." And in the most explicit visualization of the convergence of money, power, desire, and art, Caravaggio literally feeds coins to Ranuccio as he poses for *The Martyrdom of St. Matthew*. Ranuccio is at once the model for Matthew's executioner in the unfinished picture, a desired and desiring subject, and the recipient of funds funneled through the artist into the production of a work of art, an investment, and propaganda. The model thus occupies the site where these inextricable narratives converge. Caravaggio also plays a multiplicity of roles within the discourses of power everywhere enveloping him. With the canvases all the property of someone else and the models hired hands, the paintings themselves reflect this sense of alienation. If the artwork is supposed to serve as an avenue into a submerged biography of the artist, it reveals instead the labyrinth of discourses surrounding each work of art and infiltrating the studio and canvas. If these paintings are to afford access to an elusive, primary moment in the social life of art, they instead reveal that "what is found at the historical beginning of things is not the inviolable identity of their origin; it is the dissension of other things. It is disparity."[84] As Caravaggio incorporates blood into the surface of his canvases, as Ranuccio's pounding of his head against a prison wall is juxtaposed against the artist pounding his head against a canvas, as the dead body of Lena is used as a model for the *Death of the Virgin*, the artist's attempt to overcome that alienation verges on desperation and despair. The tableau vivant exists in a liminal state, with its living figures suspended between forms of existence: the vitality of the theatrical, the immobility of life translated onto a canvas, and the eventual crystallization of the art object. The tableau vivant is always also a *tableau mourant*. Only the artist's literal collision with the canvas or the incorporation of bodies into the image can mark the painting as irrevocably his. If, as Foucault writes, genealogy is charged with exposing "a body totally imprinted

by history and the process of history's destruction of the body," *Caravaggio* also lays bare the artist's desperate attempts to inscribe traces of that body into those seemingly impermeable official discourses.[85]

The economic exchange between Caravaggio and Ranuccio also introduces the film's peculiar pattern of editing, which reduplicates the triangular config-uration of characters introduced in the earliest moments. In the scene where Caravaggio first sees Ranuccio and Lena at the boxing match, a succession of close-ups—each of the lovers, then Caravaggio—culminates not in the ex-pected close-up of Ranuccio, but in a medium shot of Ranuccio and Lena, into which Caravaggio strolls from behind the camera, creating a triangle centered on the money offered to the victorious fighter. After the introduc-tion of the basic structure, the film continues to depart radically from shot/reverse-shot patterns, usually through some triangulation of that bipolar standard. As Caravaggio and Jerusaleme clean Lena's body, for example, the progression of shots alternates between close-ups of the members of the love triangle and medium shots of the artist caressing the body. As other characters interpolate themselves into the orbit of these relationships, as Ranuccio is displaced by Scipione Borghese, for example, a new triangle is constructed, with Borghese and Caravaggio the new pair of rivals. Or when Pipo enters the narrative, establishing herself as a rival to Lena, she replicates her rival's infatuation with Caravaggio's money and art. This pattern of editing begins to resemble the structural principles elaborated by René Girard in *Deceit, Desire, and the Novel*, where he posits triangular desire as the ur-principle of the novelistic regime.[86] For Girard, despite romantic insistence on the au-tonomy of desire, on the direct connection between a desiring subject and its object, desire is always defined "*according to Another* [as] opposed to this desire *according to Oneself* that most of us pride ourselves on enjoying."[87] Girard's term for that other is a "mediator," and the demonstrated interest of this figure serves to foment desire, to render the object "infinitely desir-able." As that mediator becomes more of an obstacle to ultimate fulfillment, "envy, jealousy, and rivalry" begin to complicate the narrative, as every rivalry "always contains an element of fascination with the insolent rival."[88] These, according to Stendhal, are the quintessential "modern emotions," the traces of "the centrifugal movement of an ego powerless to desire by itself."[89] "Vanity, copy, imitation" become the "key-words" to describe all manifestations of de-sire because the very notion of mediation calls into question the possibility of an original desire somewhere in an individual or collective past.[90] Girard writes that "recapturing the past is recapturing the original impression be-neath the opinion of others which hides it; it is to recognize that this opinion is not one's own. It is to understand that the process of mediation creates a very vivid impression of autonomy and spontaneity precisely when we are no longer autonomous and spontaneous."[91] The story that fills the domestic space of *Caravaggio* is just this tale of triangulated desire, of a craving that,

far from autonomous, is always subordinated to ubiquitous, insistent, and socially constructed rivalries between lovers.

Because rivalry is always a social phenomenon, because the "mediator" always situates triangulated desire in a context of social struggle, Girard's theory remains rooted in history, despite its simultaneous allusion to basic psychological forces. Emotions can be "modern," he suggests, and are always subject to transformation over time. *Caravaggio* situates this triangular desire in a specific social and economic context, as its first instantiation literally revolves around money: Lena, Caravaggio, and Ranuccio circle around and gawk at the winnings the last earned for his victory in the boxing match. Subsequent rivalries also result from concerns with money, prestige, and power, as when Caravaggio asserts his economic power over Ranuccio, sparking an explicit debate about the financial aspects of desire. After their first session where Ranuccio poses for *The Martyrdom of St. Matthew*, Lena accuses him of falling in love with the artist; "I'm in love with his money," Ranuccio responds. After she becomes the mistress of Scipione Borghese, nephew to the Pope, Lena taunts Ranuccio with the prospect that her children will be "rich beyond avarice." Ranuccio then responds with the film's first murder, and Caravaggio responds in turn by killing Ranuccio. Much commentary on the film attempts to reconstruct the motivations for and theoretical ramifications of this sequence of violent actions because the chain of murders, incited by ultimately failed transactions of desire and money, hints at a tragic aftermath for the queer desire figured in the film and for the woman posited as a useful but expendable handmaiden to that desire. Lena's brutal death and aestheticized burial underscore her status first as a token of exchange used to up the ante between two men, and then as an ornament celebrated after death renders her a pliant aesthetic object rather than a defiant subject.[92] But the film also posits a proximate cause of the devolution of this close network of friends and lovers to murder: the reduction of all relationships to economic transactions or to inferior copies of an imagined ideal, both signs of profound alienation at the most intimate levels of human interaction. *Caravaggio* displaces questions of what constitutes an essential queer or heterosexual desire because such inquiries often revolve around an imagined paragon of desire, relegating each particular manifestation to the status of mere copy. Instead the film asserts that the social dimension of desire is fundamental, and it celebrates the possibilities of a desire imagined as absolute openness in a network of relationality rather than the futile pursuit of an illusory ideal. The tragedies in *Caravaggio* are produced not by a failure to achieve that standard of perfection, but by the political and economic strictures that tangle that web of relations and foreclose the movements of desire. Lynne Tillman argues that Caravaggio's murder of Ranuccio proclaims his refusal to "love over this dead woman's body," and more generally, this violence marks the momentarily deferred struggle for a desire founded on openness rather than erasure.[93] In these scenes organized

around the interruption and intensification of desire, the film orchestrates the flow of what Nick Davis calls the "desiring-image," a concept that updates Deleuze's taxonomy for a new historical era, especially the emergence of "late-century movements convened around gendered and sexual dissidence."[94] In *Caravaggio* the "desiring-image" rejects all models of normative subjectivity and replaces them with an ideal of "open-ended variation."[95] No longer marks of failure, the vulnerability of continual transformation and the accumulation of manners are celebrated as acts of creation and liberation.

If triangular desire underlies the basic editing pattern, and if each vertex of the triangle expresses its own mode of mediated desire, what do we make of scenes where this triangulation also includes a painting? What purpose does the canvas serve in this ongoing narrative of mediated desire? Does the painting reflect or transform, imitate or resuscitate, the desire that it purports to reproduce? The most remarkable instance of this action is the three-minute sequence of shots taking place when Caravaggio has just finished (or is just finishing) his painting of *Victorious Cupid*, also called *Amor Vincit Omnia* and *Profane Love* (Figures 4.4–4.7). The painting becomes an important presence in the sequence of shots, and with no dialogue, the scene consists largely of an exchange of glances between Pipo, Caravaggio, and the picture's wide-eyed, Dionysian boy-angel, who seems almost to beg for equal participation in this interchange of desire.[96] Writing of the painted portrait in cinema, Marc Vernet argues that the picture's "impermeable permanence makes it into a representation of the Ideal, of its imposing mystery, of its inexhaustible secret. The portrait would thus serve to represent that which, once approached, can never again be left behind. It comes to signify, iconically,

FIGURE 4.4. *Caravaggio*

FIGURE 4.5. *Caravaggio*

FIGURE 4.6. *Caravaggio*

the obsession of desire, the obsession of duty. The character's mouth is always closed, participating in a mute order, yet always with open eyes, to play the role of a sentinel waiting close-mouthed for the answer to a question."[97] With no answer forthcoming, the picture ultimately becomes a figure for the "unattainable."[98] In *Caravaggio* the triangular interchange of glances between the artist, the tableau vivant, and the painting complicates this formula, as the film alternates among the scanning eyes of the artist and tableau and the

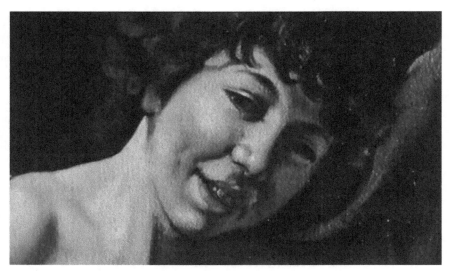

FIGURE 4.7. *Caravaggio*

equally dynamic gaze inscribed on canvas. From the perspective of the artist, lying in a state of almost postcoital relaxation, the painting could serve as a model for one narrative of Caravaggio's life: it bespeaks a narrative of cupidity and Bacchanalian excess, one in keeping with the known facts of his biography. Earlier in the film, Caravaggio's voice-over admits as much, as he says, "I painted myself as Bacchus and took on his fate"; and in a pun on the role-playing implied in human "character," he adds, "man's character is his fate." Because it partakes in this triangular drama of the studio, and because it introduces a discrepancy between the completed picture and a pro-filmic reality, the film also invites a comparison with the model whose likeness it is supposed to reflect, but by design does not. It therefore reveals the artifice of the studio, the process by which a woman with propped-up wings becomes, through an act of transformative gender performance, Cupid materialized in paint. The camera transfigures the subject of the painting, fragmenting it, destroying the imaginary wholeness provided in a museum context. By virtue of the close-up on its eerily active eyes, the painting becomes more than the "detour for the gaze" that a painted portrait in cinema normally invites.[99] Instead, in a quixotic and utopian gesture, this lingering close-up imagines a face that usurps the power of the gaze, and a mouth with the power to speak. Roland Barthes writes at the beginning of *Camera Lucida* that he happened on a photograph of Napoleon's younger brother, "and I realized then, with an amazement I have not been able to lessen since: 'I am looking at eyes that looked at the emperor.'"[100] Lingering on the eyes of the angel, alternating between that gaze and the personal drama performed in the studio, the film suggests that Caravaggio's paintings offer a similar connection to an artist who predates the

advent of photography: these eyes bring us as near to the artist as posterity, endowed only with the power of retrospection, can see.

In his essay on Baudelaire, Benjamin writes that "the deeper the remoteness which a glance has to overcome, the stronger will be the spell that is apt to emanate from the gaze," and despite a distance of centuries between the life of the artist and the present-day spectator, Caravaggio's paintings remain haunted by a gaze.[101] Like the ghostly presence in Derrida's reading of *Hamlet*, "this spectral *someone other looks at us*, we feel ourselves being looked at by it, outside of any synchrony, even before and beyond any look on our part, according to an absolute anteriority (which may be on the order of a generation, of more than one generation) and asymmetry, according to an absolutely unmasterable disproportion."[102] People "inhabit" what they produce in a manner akin to haunting, writes Derrida, and the process of haunting becomes a form of personification.[103] By returning to the moment of inscription, when the canvas is not yet (or just) finished, the scene also evokes an earlier and qualitatively different phase in the social life of art objects. Caravaggio's *Profane Love*, like the other canvases re-created on screen, fans out the elided moment between the inception of the painting and its release into a commercial sphere, inserting it into the precipitate narrative of the artist's life. In these moments the tableau vivant becomes a force of expansion as well as suspension. More than merely holding narrative in abeyance, the tableau engages with the possibilities hidden on the canvases, invisible in public records, and therefore "hidden from history."[104] Like Caravaggio's submerged self-portraits, this painting invites the beholder to succeed the artist who produced them, and, within the larger studio and social contexts alluded to throughout the film, it imagines the communities in which he moved and various objects of desire and proscriptions against that desire. Jarman's comments on the film frame the project in the dual contexts of queer historiography and contemporary LGBT political mobilization, linking each to the other.[105] This archaeology of the artist's identity, this almost desperate search for the submerged story of Caravaggio's sexuality, establishes these early modern models of resistance as a contribution to contemporary oppositional politics. If unmediated desire is unattainable, especially with the advent of the modern era, *Profane Love* represents the survival of desire in the systems where it is manufactured and simulated, bought and sold, outlawed and commercialized. With Cupid balancing acrobatically over the musical instruments, books, and building materials scattered at his feet—the detritus of a culture playfully subverted—the painting presents its "Victorious" subject as a transcendent figure. Jarman's film ascribes that power of transcendence to the scene enacted before the canvas, to the gender performance and playful, boundary-crossing desire cryptically inscribed in paint. This victorious Cupid, whose ancient arrows provoke the oldest form of exogenous desire, also inspires Stendahl's "modern emotions," but "vanity, copy, imitation" become indicators of success rather than degeneration.

The painting that forms the still center of this complex scene is particularly significant in Caravaggio's oeuvre because, as Howard Hibbard points out, "it most clearly exhibits his confrontation with Michelangelo's achievement, a compound of admiration and almost childish rebellion."[106] But "there may well have been more than rivalry or rebellion moiling in Caravaggio's mind when he created these Michelangelesque images," he speculates.[107] *Victorious Cupid* recasts the master's idealized male nudes as a more earthy, sexualized figure, thus establishing "a profound identification . . . with a great artist of the past whom Caravaggio must have believed to have been homosexual."[108] The same combination of rivalry and identification marks Jarman's relationship with Caravaggio in his film biography. Jarman's film disrupts and fragments the paintings included in the film, as it attempts to renovate these now well-known and widely circulated images through a directed tour of the canvas and the uniquely cinematic project used to reveal their submerged autobiography. In the era of cinematic homage, an undertheorized mutation of the simulacrum, *Caravaggio* rejects the currency of cultural capital and resists the temptation to quote without commentary and critique. At the same time, this rebellion against inherited images coexists with a strain of profound identification with Caravaggio, especially the artist's own attempts to rework the usual subjects by inserting markers of his own identity into canvases targeted for appropriation and thereby altering a long hermeneutic tradition. With a trace of rebellion, Jarman enlists Caravaggio in the paradoxical project of writing a prehistory of contemporary queer resistance. Antonio Negri has argued that the problem of social change is "to think the new in the total absence of its conditions."[109] Political modernism, like previous manifestations of the avant-garde, encountered a similar problem even as it preached the value of a break with ideologies of the past. Jarman's film returns to Caravaggio's work with the hope of finding the new buried somewhere in the past, or, more precisely, because traces of the past exist on the canvases themselves, hidden in plain sight.

Girard's model of triangular desire is useful again because his foundational work on internal mediation, the mediation of a literary master or model, has also inspired later work on the status of art in a condition of belatedness. Girard begins with an extended quotation from *Don Quixote*, from a passage where the would-be knight errant, using the analogy of literary and artistic models, explains to Sancho Panza how to venture closest to perfection in their vocation: "I think . . . that, when a painter wants to become famous for his art he tries to imitate the originals of the best masters he knows; the same rule applies to the most important jobs or exercises which contribute to the embellishment of republics. . . . In the same way Amadis was the pole, the star, the sun for brave and amorous knights, and we others who fight under the banner of love and chivalry should imitate him. Thus, my friend Sancho, I reckon that whoever imitates him best will come closest to perfect chivalry."[110] The paradox underlying Jarman's art of imitation is that it both celebrates the power

of artifice and foregrounds its own inadequacy as reproduction through a parade of excessive images destined to fail according to centuries-old standards of verisimilitude. This duality of orientation begins with an ostentatious rejection of classical Hollywood cinema and its illusions, a refusal of mimetic mythology most evident in *Caravaggio*'s anachronistic props—a calculator, typewriter, scooter, and tractor, along with nouvelle cuisine and immediately dated 1980s clothing—that identify *Caravaggio*'s sixteenth century as a historically and logically impossible one and therefore a self-conscious construction rather than a quasi-natural mirror of reality. At the same time, these devices, including the typewriter perched over a bathtub in an allusion to Jacques-Louis David's *Death of Marat*, construct a media archaeological short circuit that links historical eras through conspicuous objects left behind, as though by a visitor from the past or future. The film exists within a temporal dimension akin to Jean-Luc Nancy's "unbound time" rather than the more familiar chronologies of narrative history.[111] These temporal confusions disrupt ingrained habits of being and launch the film into what José Esteban Muñoz calls "queer futurity," which throws a "posterior glance at different moments, objects, and spaces" that might "offer us an anticipatory illumination of queerness."[112] In Jarman's filmmaking, anachronism is intimately intertwined with an overarching political project: the development of oppositional communities and filmmaking practices in a Thatcherite moment when the manipulation of a national past and its histories and images remained an integral strategy in a conservative ideological program.[113] Much of Jarman's oeuvre—from *Jubilee* (1977) to *The Last of England* (1987), from *The Tempest* (1979) to *Edward II* (1991)—can be read as an attempt to destabilize that burgeoning and exclusionary identity by overwriting Britain's cultural institutions with both estranging, graffitilike visual excess and an untimely history that puts the lie to dominant constructions of that national past. Strategies of distanciation coexist with attempts to establish alternative forms of identification. *Caravaggio*'s moments of estrangement are at the same time markers of an alternative history of both Caravaggio's time and Jarman's. The film's obtrusive and improper, but oddly familiar props—the jarring yet prosaic calculator, tractor, and scooter—can also be seen as a trace of the director's signature, as an attempt to solidify the film's connection to his own time and place, as a more playful alternative to the flesh and blood that his Caravaggio incorporates into the canvas. Campy acting plays a similar role in the film, as minor players often perform in hyperbolic fashion, both destroying the film's illusionism and establishing a link between two historical eras: the film's repeated, knowing, sexualized glances mirror those of Caravaggio's camped-up Cupid in *Profane Love* and beckon toward the trail of gay shibboleths in both Jarman and Caravaggio.[114] The distancing effects of political modernism resurface here as strategies to spark identification, particularly among a specific subset of queer viewers.

Other Jarman films betray more ambivalence about his own influences because even those who fought against their times can succumb to the powerful force of nostalgia. Graffiti scrawled during the Paris uprisings of 1968 declared "art is dead, don't eat its corpse," an admonition to steer clear of a rotting heritage, but also, as Benjamin might have added, an exhortation to preserve evidence that might later prove the best witness to its own demise.[115] Jarman's ambivalence emerges most provocatively in the opening moments of *The Last of England* (1987), when Spring, a young squatter living amid piles of rubble in a landscape at once postapocalyptic and postindustrial, first tramples on then simulates sex with Caravaggio's *Profane Love*. As Benjamin writes, "Visions of the frenzy of destruction, in which all earthly things collapse into a heap of ruins . . . reveal the limit set upon allegorical contemplation, rather than its ideal quality."[116] *The Last of England* bridles at the restrictions of *Caravaggio*'s allegories, its confinement to a world of corpses and more intellectual contemplation of desire. Jarman's millennial film, riddled with haunting images of power violently exerted and victims huddled together in their powerlessness, posits Spring's resistance as a double-edged sword: while rebelling against the political structures that seemingly everywhere oppress, he also destroys records of earlier acts of resistance, relegating Caravaggio's attempt to rework and transcend the culture scattered at Cupid's feet to just another piece of rubble. Spring's desperate, purely sexual advances toward the artwork reflect a poverty of critical tools at his disposal: his only means of accessing the image are the either/or of indiscriminate destruction of or rapt fascination with the image. *Caravaggio*'s tableaux return these paintings to the archive of useful art history through an act of critical reincorporation. The film alludes to but transforms the *Death of Marat*, David's painting of the revolutionary who died while penning a political tract in his bathtub.[117] In the film the Jacobin becomes a rival painter and hostile critic searching for the most acerbic phrases to attack Caravaggio, just as David's neoclassicism is founded on an implicit critique and abandonment of Caravaggio, an abject figure for his anti-Albertian construction of space and his search for a contemporary idiom to renovate and transmit biblical tales. The tableau with Cardinal Del Monte as Caravaggio's *St. Jerome Writing* becomes a knowing wink at the subject's inadequacy in such an exalted role, his corruption clashing with the stores of wisdom scattered on his desk. These two quotations seem anomalous in the film because they contrast dramatically with the seriousness of the studio reanimations of other Caravaggio masterpieces. The former quote famous tableaux as vehicles for trivial commentaries on trivial characters. Flat and still, these images are the filmic equivalents of the glossy magazine that Baglione carries around to demonstrate to all willing ears the limitations of Caravaggio's work. Divorced from the moment of their production, these quotations advertise their status as simulacra, as consumable

and disposable objects devoid of the context present elsewhere, in the tableaux that provide evidence of the artist's production process and the craftsmanship it entails.

If a canvas with "I, Michelangelo, did (or made) this" sparked the filmmaker's interest in the project, *Caravaggio* emphasizes the verb as well as the subject, positing the act of making as an integral part of the personality embodied in the film. Shown as works in progress, within the studio, the tableaux transform their original canvases into protocinematic devices used to record gestures, motion, labor, even the duration of their own creation. Jarman rereads Caravaggio's paintings as early avatars of Deleuze's opsigns and chronosigns. They not only, as Stella says, "telescope art history," but they also represent a struggle against the temporal and spatial constraints of the medium.[118] The film becomes a search for the palimpsest implied in the layering process of painting, the process Clouzot reveals in his quest for a filmic means to represent the *Mystery of Picasso* (1956), an earlier attempt to capture the elusive biography of an artist through moving images. Centering on the production of the artwork, Caravaggio also provides a tentative answer to W. J. T. Mitchell's vexing and ultimately unanswerable question about the nature of pictorial "language" and "desire": "What do pictures really want?" he asks.[119] The cumulative subject of Jarman's film is the masses of information that the paintings themselves cannot tell: the story, at once economic and formal and biographical, of their own production. The film presents the unrepresentable history of the moment of production, of the spaces, stories, and desires elided in a conventional life of the artist or even on the surface of the canvases themselves. Perhaps pictorial desire is not unlike human desire in this respect: perhaps pictures, too, hope most of all to reveal their histories, what they have witnessed, what is beneath the surface; but they, too, are forced to do so only with the surfaces that become their interface with the world. The tableau vivant reconstructs those static surfaces, transforming the stability of being into a process of becoming. The tableau exists in what Deleuze calls the pure form of time, the infinitive form of the event, a synthesis of virtual past and virtual future that combines what has already happened and what will happen.[120]

The film ends by returning to the close-up of Caravaggio's face that opened the film, with the artist reduced to the status of corpse and the earlier carnivalesque atmosphere dampened into mourning. Yet as Benjamin writes of the atmosphere of mourning and the omnipresent corpses around which the *Trauerspiel* revolves, these dead bodies expire, then linger on stage because "the allegorization of the physis can only be carried through in all its vigor in respect of the corpse. And the characters of the *Trauerspiel* die, because it is only thus, as corpses, that they can enter into the homeland of allegory. It is not for the sake of immortality that they meet their end, but for the sake of the corpse."[121] "The corpse becomes quite simply the pre-eminent emblematic property," writes Benjamin. "The apotheoses are barely conceivable without

it."[122] The lifeless body of Caravaggio bookends the film because that corpse embodies precisely what is absent from images and from histories based on texts and pictures. The film presents a biography of Caravaggio, but not one based on his police records or his patronage but his body. The self-portraits inscribed by Caravaggio onto canvas continue to haunt the paintings because they gesture toward a record of the body otherwise inaccessible to history. These spectral bodies are the object of *Caravaggio*'s hauntology. The film's final corpse becomes the crux of an allegory for the film's historical project because, while it mirrors the body of Caravaggio, it also marks the failure of representation necessarily devoid of the desires that constitute the body. In the published version of *The Last of England* Jarman describes the acts of filmmaking and viewing as akin to archaeology: "My world is in fragments, smashed in pieces so fine I doubt I will ever reassemble them. So I scramble in the rubbish, an archaeologist who stumbles across a buried film. An archaeologist who projects his own private world along a beam of light into the arena, till all goes dark at the end of the performance, and we go home. . . . An artist is engaged in a dig."[123] That digging takes place on a small scale, in intimate sites. Jarman's film recasts Caravaggio as a precursor in that project, as an artist who counters the eventual appropriation of his canvases by inscribing indelibly upon them both self-portraits and group portraits of friends, transforming monumental artworks into artifacts of his immediate personal, domestic, and social surroundings. The reconstructive process in *Caravaggio* becomes a search for those lost desires and ultimately unrecoverable bodies, and the excavation wills them into being precisely as an object of inquiry. Jarman enlists Caravaggio as a model of an artist who likewise constructed within grand biblical and historical narratives, within his own enveloping economic context—in short, within the dominant discourses of his society—a small space where a cohort of artists and friends could together contribute to a covert history of desire. In his introduction to the second volume of the *Realms of Memory* series, Pierre Nora defines "tradition" as "memory that has become historically aware of itself."[124] Jarman constructs the past in a different manner: the tradition invoked in *Caravaggio* is memory that has become aware of the difference in itself.

Near the beginning of the film, Jerusaleme picks up the shield bearing Caravaggio's Medusa, stares into its petrifying gaze, then prances around the studio, flashing the Medusa at the artist. Caravaggio then scoops up the boy, looks into the face of Medusa, and laughs. This exchange of glances with Medusa exemplifies a strategy used throughout the film, as the artist returns to an emblem from the past, a mixture of abjection and the mythology deployed to contain it, and discovers difference that might otherwise have remained obscure. Nietzsche famously likened his concept of eternal return to the head of Medusa, venturing in his notebooks that "the great thought" also resembles a "*Head of Medusa*: all the world's features petrify, a congealed death-throe."[125] Yet, as Derrida points out, Nietzsche's proposed hymn to Medusa also

recognizes the laughter and sense of injustice with which she accepts her banishment. The identification with the abjection of Medusa appears as early as antiquity; and from the defiant, aggrieved Medusa of Shelley to the laughing, almost joyful version in Cixous, the countenance of Medusa has represented both abjection solidified through myth and the possibility of a jubilant escape from that lore. What simultaneously frightens and attracts in the engagement with Medusa is immobility itself and its departure from the cycle of repetition. The tableau vivant also operates through a kind of Medusa effect, feigning immobility in order to avoid the eternal repetition of the same. To see Medusa through the lens of myth crystallizes the viewer into a pattern of eternal return, but in that instant of paralysis the repetition of myth also ceases, if only momentarily. To see the tableau through the lens of heritage merely reiterates that heritage in all its limitations, but within its moment of uncanny immobility, other possibilities emerge. Daryl Hine captures the possibilities of the Medusa story in his poem "*Tableau Vivant*," which evokes a sixteenth-century German image of Perseus approaching Medusa, "In his right hand/A sword, in his left a mirror."[126] In this ekphrastic account, Hine describes two still figures, with Perseus hesitating before his attack, while "She looks asleep/As if dreaming of petrified forests,/Monumental dryads, stone leaves, stone limbs,/Or of the mate that she will never meet/Who will look into her eyes and live."[127] Jerome McGann argues that "this poem is, among other things, a brief allegory about what has happened to western art between the sixteenth century and our own day," with Shelley's invented lover for Medusa the harbinger of a monumental change in thinking about Medusa, and Hine's poem "as far from Shelley as Shelley is from the sixteenth century."[128] What distinguishes Hine's take on this perennial theme is his fascination with the moment just before Perseus slays Medusa, as the poet deviates from a narrative of heroic action and focuses instead on the divagation that precedes it. The moment of hesitation becomes a flash of possibility. The poem's title, "*Tableau Vivant*," underscores the connection between the momentarily immobilized tableau and this instantaneous vacillation, this indecision before the act that forever cements Medusa's place in myth. The purpose of modern art, writes Theodor Adorno, is to "teach the petrified forms how to dance by singing them their own song," but modernity veils those paralyzed forms behind the blur of movement and the dazzle of innovation. The tableau vivant stills bodies to display that stupefaction, and then to petrify the viewer, allowing for the return of difference, leading to "a discovery of the joints and sutures in the stone. So that the statues—the forms, the fetishes—do finally creak into motion."[129] The past turned to stone, the tableau vivant in Jarman's *Caravaggio* also echoes with haunting voices, with the songs of those momentarily stilled bodies who have gazed at Medusa and lived.

The Afterlife of Art and Objects

THE CINEMATIC STILL LIFE IN
THE LATE TWENTIETH CENTURY

With average shot lengths steadily declining over the past several decades and an acceleration in the pace of editing, the slow, deliberate still life is one of the most anachronistic strategies in cinema. Informed by a long tradition of painting and photography, it inserts the lens of art history between the camera and the world at a time when directors strive more often for immediacy and dynamism. A contrived and meticulously posed image, it also departs from the realist ideal that has guided a major strain of filmmaking and theory from the days of Auguste and Louis Lumière. It disrupts the illusion that life unfolds on-screen in real time; instead it remains suspended in a protracted hesitation, an uncanny, frustrating, or vaguely ominous delay reminiscent of a video on pause or a technological glitch that interrupts the smooth playback of a film. The image seems to go nowhere, as it departs from more standard cause-and-effect chains or linear narratives rushing forward and lingers instead in a warped time and space where nothing happens. Because they signal a moment of arrest in a medium usually defined by motion, Gilles Deleuze presents the cinematic still life and the tableau vivant as paragons of the time-image that counteract habits of perception developed in the context of narrative film and open onto the vast expanse of time.[1] Yet, because the cinematic still life is never literally immobile, because it merely simulates stillness through repetition, because the objects continually reappear twenty-four times per second, this device is as artificial as any special effect. Its illusion of repose is created by struggling against the movement inherent in the medium of film. Throughout the 1980s and 1990s the still life became a strategy of resistance against both the spectacular cinema of the blockbuster era and forms of realism that developed within mainstream studios and on their margins. Filmmakers discarded cinema's more familiar trappings, along with much of the conceptual and aesthetic baggage accumulated over the course of a century that regarded it

as a device for the faithful recording of reality or the fanciful reinvention of the world. Framing cinema as an extension of artistic practices dating back centuries, the cinematic still life constructs an alternative genealogy of the medium that unfolds over the longue durée rather than a narrow period defined by particular technology. In the process it rediscovers an archaic idea of modernity that concentrates on the potential of still, overlooked objects and disregards film's more common obsession with bodies and machines in motion.

The Object as Event

Soon after its consolidation as an established genre of painting in the seventeenth century, two broad categories of still life emerged, each arising from very different art worlds and cultural practices: the first, usually associated with Dutch still life during the economic boom of the early seventeenth century, presented a collection of objects as a celebration of abundance, a call to responsibility and abstinence (especially in the *vanitas* variation of the theme), or a focus of scientific inquiry; the second, practiced most prominently in Spain among painters exposed to the asceticism of monastic culture, involved spare arrangements of objects subjected to the fervent attention of the artist and viewer, transforming these simple, everyday items into occasions for intense contemplation. Svetlana Alpers argues that a version of the Dutch still life was valuable for its utility as a practical tool, for its capacity to open up a carefully delimited and disciplined environment to scientific investigation.[2] This mode of Dutch still life became an analytical and pedagogical device, like a slide placed under a microscope, its contents sliced open and made accessible to the eye. The still life has also been dedicated to the aesthetics of conspicuous consumption, with illusory objects appealing to the sense of taste or touch, and actual images incorporated by the eye.[3] Norman Bryson suggests that "behind the images" of the still life "stands the culture of artefacts, with its own, independent history," a record of rapidly changing patterns of consumption and glacial alterations in the form and function of domestic implements over long stretches of time.[4] As Meyer Schapiro writes, "Still life . . . consists of objects that, whether artificial or natural, are subordinate to man as elements of use, manipulation and enjoyment. . . . They convey man's sense of his power over things in making or utilizing them; they are instruments as well as products of his skills, his thoughts and appetites."[5] Overflowing from the table and even from the bounds of the frame, rare, valuable, or perishable objects attest to the social status and power of their owners, while the artist's fastidious rendering and minute detail become evidence of the patron's affluence, of his or her capacity to purchase the painter's labor and consume not just an abundance of necessities but superfluous images as well. When it reveals an opulent array of

sumptuous objects, and when the painting and property communicate little beyond the bare fact of abundance, the still life becomes a cornerstone of the "aesthetics of consumption."[6] Over time the genre itself was subjected to increasingly serialized production and consumed in a burgeoning art market directed at individual buyers hoping to furnish their newly prosperous homes. Like the objects on display within them, still life paintings were designed to enhance the pleasure of elite and bourgeois publics, a more durable counterpart to the ephemeral things arranged on the canvas to appeal to the analytical or covetous eye.

In the other major variation on the still life usually associated with the Spanish baroque—especially the *bodegones*, or kitchen scenes, of Juan Sánchez Cotán and Francisco de Zurbarán—the rapt attention of the artist and viewer estrange and transform objects that would otherwise be neglected in everyday life. As Charles Sterling argues, the more exalted genres, especially history painting, constitute a discourse of "megalography," as they depict and aggrandize heroic people and events, while the domain of the still life remains "rhopography," the idiom through which the detritus and trivia of civilization are displayed.[7] Bryson suggests that Sánchez Cotán's hyperreal depictions of common fruits and vegetables are charged with retraining the eye, transforming it from a scanning organ to one that latches onto objects, discovering significance in the ostensibly ordinary.[8] Zurbarán's paintings construct a space centered on bodily movements rather than vision alone. In his work the primary spatial value is nearness, with the absence of a recognizable background or vanishing point signaling his indifference to anything outside the reach of the body. In the still life "the unit of direction is not the line, as in Albertian or perspectival painting, but the *arc*, since bodily movements always curve."[9] These still lifes centered on the body become the epitome of "smooth space" as described by Deleuze and Félix Guattari: a space "filled by events or haecceities, far more than by formed and perceived things. It is a space of affects, more than one of properties. It is *haptic* rather than optical perception."[10] These arcing bodily movements reveal an aspiration to proximity rather than depth, and they destroy the fiction of a window onto a world expanding backward from the picture plane, one of the key metaphors later adapted by film theorists to explain the power and appeal of cinematic realism. The still life, writes Bryson, is therefore "the great anti-Albertian genre."[11] Bryson also suggests that the compositions of Zurbarán exist in a "theatrical" relationship to the viewer: harshly lit and precisely displayed, they force the viewer to examine them primarily with the eye even as they present themselves to the touch. This tension between body and eye creates a paradoxical effect in the work of Zurbarán and in subsequent practitioners of the genre: "Zurbarán first creates a scene which greatly depends on ideas of touch and the memory of hands, and belongs to the visually lazy or sightless journeys of the body through its immediate envelope of space. Then he floods the stage

with light, separates visual from tactile form, and offers the eye—alone—a spectacle so immaculately self-contained that the only appropriate response is to disown the tactile reflexes as crude and ham-fisted."[12] The ultimate paradox of the genre is highlighted in these paintings, and especially in the work of Chardin: "Since still life needs to look at the *over*looked, it has to bring into view objects which perception normally screens out. The difficulty is that by bringing into consciousness and into visibility things that perception normally overlooks, the visual field can come to appear radically *un*familiar and estranged."[13] The still life displays the most familiar objects of everyday life, but it creates a relationship of both intimacy and distance, as objects appear close enough to touch but unlike anything the viewer has seen before.

Because of this capacity to unsettle and transform habitual ways of seeing, the modern artists who most vehemently opposed the routines and conventions of vision quickly adopted the still life as a vehicle for that critique and an exploration of something new. The cubists focused on everyday objects, on the overlooked items most obscured by habits of perception, from newspapers and musical instruments to glasses and bottles. They altered the mechanics of seeing by introducing variability and multiplicity into the representation of the simplest things. More attuned to the psychology than the mechanics of perception, the Surrealists also featured the still life of seemingly trivial objects, but they hoped to startle the jaded and inattentive viewer through their extraordinary attention to the commonplace. They subjected those everyday articles to bizarre or chance juxtapositions, imagining that the conflict between mundane subjects and outlandish presentation would initiate the artist or viewer into a world beyond the surfaces of customary life. The Surrealists discovered a prototype for the ostensibly arbitrary juxtaposition of common objects in the Comte de Lautréamont's famous declaration that beauty resides in "the fortuitous encounter upon a dissecting-table of a sewing machine and an umbrella!"[14] A perplexing still life, this image prefigures both the form and the substance of a prevalent Surrealist practice: many Surrealist still lifes, the photographs and collages of Man Ray, for example, merely extend the whimsical theme sounded by Lautréamont into visual media. By manipulating quotidian objects, the Surrealists hoped to discover the sublime in the mundane and alterity in the familiar. As Mary Ann Caws suggests, they aimed to link the sublime with ennui and "insist that exaltation is always accompanied by tedium."[15] Writing of Louis Aragon and André Breton, Walter Benjamin emphasizes the often-neglected political potential of their fascination with obsolete objects, arguing that the Surrealists were "the first to perceive the revolutionary energies that appear in the 'outmoded,' in the first iron constructions, the first factory buildings, the earliest photos, the objects that have begun to be extinct, grand pianos, the dresses of five years ago, fashionable restaurants when the vogue has begun to ebb from them. The relations of these things to revolution—no one can have a more exact concept of it than these authors.

No one before these visionaries and augurs perceived how destitution—not only social but architectonic, the poverty of interiors, enslaved and enslaving objects—can suddenly be transformed into revolutionary nihilism."[16] The impossibly complex logistics of that transformation from ennui to "revolutionary nihilism" developed into an obsession for both the Surrealists and Benjamin, whose early and continued interest in Surrealism derived from a shared intuition that those "enslaved and enslaving objects" could help the artist and critic understand the subservience and objectification of human beings. As a first step of this process, the artist would provoke a "salutary estrangement between man and his surroundings."[17] In Surrealist practice, retrieving objects from the rubbish heap became an avenue into repressed regions of the psyche, but it also became a form of ethnographic analysis, a means of studying culture through the objects people consume and discard. The Surrealists therefore staked their thoroughgoing hopes on the least likely foundations: last year's fashions, ruined buildings, trash heaps, debris, the detritus of modernity. In his studies of Surrealism, Benjamin was most intrigued by the "relation of these things to revolution," because he recognized the "outmoded" as an allegory for the destruction wrought by capitalist modernity.[18] Benjamin was fascinated by a strain of modernist art and literature that revolved around the possibilities of the vast piles of waste produced in a capitalist society, and the still life offered a revelatory vision of coruscating commodities, moldering junk, and the intimate relationship between them.

In his study of the baroque, Benjamin had also emphasized a heightened attention to objects in the allegorical imagination and the link between that keen awareness of the object world and a modern sensibility. In the *Trauerspiel* "objects stare out from the allegorical structure," becoming an armature used to decode the play itself, but remaining "incomplete and imperfect," resisting interpretation immediately after an initial provocation.[19] The object is embroiled in the lives of the human subjects, a sign of their mutual entanglement and degradation. For that reason, "destiny is not only divided among the characters, it is equally present among the objects. . . . For once human life has sunk into the merely creaturely, even the life of apparently dead objects secures power over it."[20] Benjamin describes baroque drama's obsession with the "deadening of the emotions, and the ebbing away of the waves of life which are the source of these emotions in the body"; it expands the "distance between the self and the surrounding world to the point of alienation from the body."[21] To illustrate this sense of alienation, Benjamin invokes Albrecht Dürer's *Melencolia*, with its deliberate attention to "the utensils of active life . . . lying around unused on the floor," as a prefiguration of the baroque concern with the manifestation of human suffering in the object world and the possibility of emancipation through a more profound understanding of objects.[22] In his book on the baroque and elsewhere, Benjamin's difference from many traditions of materialist analysis lies in his refusal to furnish a

straightforward assault on this descent into objectification, thereby merely reversing the valence of the capitalist celebration of the consumer. If a purely materialist analysis establishes a "realist tautology," through which a human subject is reducible to an encompassing material environment, then nothing exists outside those social constrictions. Desire—for objects, for others, for social change—becomes "essentially an 'equals' sign between the self and its social or cultural possibilities."[23] Mark Seltzer argues that the "possibility of a politics, or at least of a cultural politics, seems to require precisely the discontinuity or discrepancy between persons and conditions that cultural critique programmatically forecloses."[24] Benjamin's challenge to materialist analysis hinges on his peculiar approach to objects, which serve neither as a mirror of human objectification, nor as mere things to be desired and possessed. Instead, these objects mark the "discontinuity or discrepancy" between subject and object that allows for the "possibility of politics." Benjamin's writing on objects, from his book on the baroque to his essay on Surrealism, parallels a tradition of still life painting that responds to this captivation by the material world by presenting the object in a state of unresolved paradox: of nearness, familiarity, accessibility, and openness to possession, on the one hand; and, on the other, estrangement produced in a spell of acute attention. The still life can introduce a discrepancy between what we see and what we know, and it reframes that difference as a space of possibility.

For many early theorists of modern media, including Benjamin, the power of film and photography derived from the same sources as the still life: their capacity for disruption or revelation when focused on habitually overlooked objects in the everyday environment. In an essay titled "Painting and Cinema," Fernand Léger most succinctly and audaciously proclaims the "revolution" launched by the coming of cinema: "Here it is: 80 percent of the clients and objects that help us to live are only noticed by us in our everyday lives, while 20 percent are *seen*. From this, I deduce the cinematographic revolution is *to make us see everything that has been merely noticed*."[25] Antonin Artaud's mysterious and enchanting piece on witchcraft and cinema asserts that the camera can transform the objects it frames or peruses in passing. On-screen, he writes, "the smallest detail, the most insignificant object assume a meaning and a life which pertain to them alone."[26] And "by being isolated, the objects obtain a life of their own which becomes increasingly independent and detaches them from their usual meaning. A leaf, a bottle, a hand, etc., live with an almost animal life which is crying out to be used."[27] Jean Epstein's discourse on "magnification," Louis Delluc's meditations on the transformative power of "*photogénie*," and Aragon's essay "On Décor" sound similar themes and explicitly associate these effects with painting rather than the mechanical dimension of cinema.[28] In his 1931 essay outlining a "short history of photography," Benjamin first considers the metaphor of an optical unconscious to characterize the at once familiar and estranged world of objects. Beginning with the earliest portraits

produced after the invention of photography, Benjamin sketches a history of the medium centered on the relationship between human subjects and their surroundings. In the late nineteenth century bourgeois sitters dressed themselves in all their finery and enveloped themselves in a phalanx of possessions, the better to reinforce and protect an identity based on accumulation. But in Eugène Atget's photographs taken amid Parisian street life, the human form was relegated to the margins of the frame, displaced by the objects littering courtyards and shop windows, from rows of bootlasts to a carpenter's tools to the postprandial table laden with plates and glasses. For Benjamin those photographs effected an "emancipation of the object" from an increasingly debased and commercialized aura. He writes, "By close-ups of the things around us, by focusing on hidden details of familiar objects, by exploring commonplace milieus under the ingenious guidance of the camera, the film, on the one hand, extends our comprehension of the necessities which rule our lives; on the other hand, it manages to assure us of an immense and unexpected field of action. Our taverns and our metropolitan streets, our offices and furnished rooms, our railroad stations and our factories appeared to have us locked up hopelessly. Then came the film and burst this prison-world asunder by the dynamite of the tenth of a second, so that now, in the midst of its far-flung ruins and debris, we calmly and adventurously go traveling. . . . Evidently a different nature opens itself to the camera than opens to the naked eye—if only because an unconsciously penetrated space is substituted for a space consciously explored by man."[29] The revolutionary potential of modern media, according to Benjamin, stems from their capacity to counteract the catastrophic illusion of human progress by renewing our relationship with a world of objects viewed, as though for the first time, as a site of ruinous waste and enduring possibility.

In his book on Leibniz and the baroque, Deleuze is less concerned with the still life as a historical "series" divided into various periods and instead concentrates on its "serial" qualities, on the momentum of repetition that characterizes the production of still lifes and seeps into the image itself. For Deleuze the overwhelming visual excess of the still life of consumption serves as a palliative to what Jacques Lacan calls the "*belong to me* aspect of representations, so reminiscent of property" and the epitome of the baroque crisis of property.[30] As it heaps on object after object, the still life reveals a surplus of details and resists the impulse to create an exhaustive inventory and possess the image in its totality. Deleuze argues that the still life is defined not only by its attention to objects but also by its succession of folds, by the details that sweep the eye across splendid surfaces and initiate the sort of contemplation usually ascribed to the monastic still life tradition. He writes, "In fact, if we want to test the definition of the Baroque—the fold to infinity—we cannot be limited to masterpieces alone; we must dig into the everyday recipes or modes of fashion that change a genre. For example, the object of the *still life* is the study of folds. The usual formula of the Baroque still life is: drapery,

producing folds of air or heavy clouds; a tablecloth, with maritime or fluvial folds; jewelry that burns with folds of fire; vegetables, mushrooms, or sugared fruits caught in their earthy folds. The painting is so packed with folds that there results a sort of schizophrenic 'stuffing.' They could not be unraveled without going to infinity and thus extracting its spiritual lesson. It seems that this ambition of covering the canvas with folds is discovered again in modern art, with the *all-over* fold."[31] Whether stuffed with an abundance of material wealth or reduced to the simplest things, the still life for Deleuze is an exercise in viewing isolated objects through the visible and hidden folds that traverse the painting and extend beyond the frame. Deleuze suggests that the relationship to objects manifested in Leibniz's writings and the baroque still life calls for a new term—the "objectile"—to underscore both its novelty in the baroque age and its continued relevance in contemporary systems of production. Citing Bernard Cache's studies of this historically emergent category and informed by the work of Gilbert Simondon, Deleuze writes that "this is a very modern conception of the technological object: it refers neither to the beginnings of the industrial era nor to the idea of the standard that still upheld a semblance of essence and imposed a law of constancy ('the object produced by and for the masses'), but to our current state of things, where fluctuation of the norm replaces the permanence of a law; where the object assumes a place in a continuum by variation; where industrial automation or serial machineries replace stamped forms."[32] In the baroque still life the object, regardless of its singularity or cost, had already been serialized, inserted into a continuum, subordinated to the play of curves on its surfaces. Using the still life as an inspiration, Deleuze views these paintings of assembled objects as the interplay of an infinite number of variables rather than a snapshot of the material world in a solid state. In the baroque still life "sounds and colors are flexible and taken in modulation. The object here is manneristic, not essentializing: it becomes an event."[33]

Deleuze's writings on the cinematic still life and the time-image extend this argument into modern cinema: the stilled image in film is an exercise in mannerism, variation, and modulation. Deleuze writes that "if cinema does not die a violent death, it retains the power of a beginning. Conversely, we must look in pre-war cinema, and even in silent cinema, for the workings of a very pure time-image which has always been breaking through, holding back or encompassing the movement-image: an Ozu still life as unchanging form of time?"[34] In Deleuze's formulation modernist cinema is simultaneously revolutionary and relentlessly antimodern, as its most forward-looking strategies also gesture back to the foregone practices of early cinema and paintings that long predate the invention of film. One of the attractions of early cinema and the still life for Deleuze is their marginalization of the human form and its habitual actions. In the late nineteenth and early twentieth centuries the body had not yet assumed the axial status it would occupy in classical narrative

cinema, and the still life almost always excludes human figures from the frame. While history painting and portraiture help reinforce the visual identity of the human subject, Bryson argues that the still life "negates the whole process of constructing and asserting human beings as the primary focus of depiction. Opposing the anthropocentrism of the 'higher' genres, it assaults the centrality, value, and prestige of the human subject."[35] The still life series, while defined most obviously by its attention to objects, marks an early "crisis of the action image," insofar as the often clichéd and prescribed movements implied in history painting disappear from the scene. Illustrating a well-known historical narrative or legend, the artist allows that conventional wisdom about the past to cue a particular response, while the painting itself so often illustrates the moment when a hero launches into action, when cause becomes effect and the chain reactions of historical narrative appear inevitable. Deleuze argues that classical Hollywood narrative structures perform a similar function as the regime of the movement-image evolves and institutionalized strategies begin to normalize the cinematic image. The viewer begins to perceive primarily through identification with a particular character, a process that, as Gregory Flaxman suggests, "necessarily implies the impoverishment of the image."[36] In the regime of the "time-image," the character or viewer becomes "vaguely indifferent to what happens to him, undecided as to what must be done. But he has gained in an ability to see what he has lost in action or reaction: he SEES so that the viewer's problem becomes 'What is there to see in the image?' (and not now 'What are we going to see in the next image?')."[37] Deleuze catches a glimpse of this new mode of seeing in Italian neorealism's long visual detours onto objects and spaces with little narrative significance. He detects in Luchino Visconti's *Ossessione* (1942), often characterized as the first neorealist film, a fascination, even an obsession, with the objects of everyday life previously glossed over in European cinema of the period. He writes, "After *Obsession* . . . something appears that continues to develop in Visconti: objects and settings [*milieux*] take on an autonomous, material reality which gives them an importance in themselves. It is therefore essential that not only the viewer but the protagonists invest the settings and the objects with their gaze, that they see and hear the things and the people, in order for action or passion to be born, erupting in a pre-existing daily life."[38] The process of learning to see begins with a renewed attention to objects and spaces that usually serve as the backdrop to narratives centered on heroic action and that through the time-image undergo a radical transformation: they become accumulations of folds, events in themselves, and elements in a network of social and political relations. While the failure of the action-image may seem to signal the end of effective political action, Deleuze argues that a cinema that reveals the deliberate unfolding of time does not "[turn] away from politics, it becomes completely political, but in another way."[39] This alternative politics would depose the more common narratives and ways of seeing organized around human

action and instead place humanity within a web of living creatures, objects, and environments. The cinematic still life lingers on the screen like a portal to that other universe.

Modernity and the Sacred Object: Alain Cavalier's *Thérèse*

Four years before shooting began on *Thérèse* (1986), Alain Cavalier documented the earliest stages of the screenwriting process in a short 16mm film and accompanying diary. Produced for the magazine *Cinéma-Cinémas* and published with the diary excerpted alongside frame enlargements, this cinematic chronicle unfolds through a series of still lifes: first, of the blank sheet of paper lying on the director's desk, folded in half to provide a column for both image and sound; then paper and pencil as the director begins to scrawl plans for the scenario and storyboards; a sink, a bottle of wine, and a glass; an orange being sliced on a cutting board; a superannuated Super-8 camera that "two years ago had been very sophisticated";[40] a heap of canisters of undeveloped film; a model of the quarters in the Carmelite convent; and the final still life of bread, butter, a glass, a knife.[41] Interspersed with these lugubrious images of objects is a series of photographs of Thérèse Martin, pictures originally published along with her autobiography and now removed from that context, lying on the director's desk. These objects and photographs, which together constitute the working environment of the screenwriter, stand metonymically for the process of creating a film, as they allude to the basic strands woven together in film, from the personal and biological to the technological and historical. This short film concludes with an extreme long shot of the roofs of Paris, a shot with its own complex history encompassing René Clair and Bernardo Bertolucci, among many others, with each moment in that history hoping or failing to represent an ever-expanding, increasingly diverse and divergent metropolis from a single, privileged perspective. These roofs of Paris attest to the possibility—emerging and retreating in various historical epochs—of depicting a social totality or of bafflement before an "unmappable system."[42] If these rooftops allude to various cinematic and geographic "lieux de mémoire," they also represent a chaos of memories, a history and a present that resist the insistent process of domestication through which memory manages the past. The most telling aspect of Cavalier's conclusion is its departure from the enclosed spaces that encompass both the short film and *Thérèse*. With the jagged contours of Paris outside and Cavalier's voice directing the camera operator to film the interior again, this shot leaps dramatically from one order of magnitude to the next, from a circumscribed area proximate and accessible to the body to the infinite complexity of an expansive horizon, from the uncannily close to a vision of the totality possible only from a vast distance.

Both limited in scope and extraordinarily ambitious, *Thérèse* accepts the charge issued by this cinematic preface, as it explores the various routes by which the relentlessly claustrophobic chambers of the convent and the similarly bounded spaces of the still life might open onto and illuminate a more extensive network of social relations. Although *Thérèse* itself takes place in cramped, windowless spaces, although it depicts a site restricted to only a handful of visitors, although the cloister houses only a few tens of women and their strictly limited supply of precious mementos, the film also invites a leap onto the infinitely broader stage implied by the final shot of Cavalier's prefatory images. A series of vignettes from the life of Thérèse Martin, darling of the French troops during World War I and inaugurator of the "little way" to sainthood, the film also issues a challenge: how to focus on the circumscribed milieu of objects and seemingly trivial quotidian events, how to display this everyday life in stunning and defamiliarizing images, without becoming isolated in a world of images too eerily reminiscent of the spectacular world it opposes, without developing a cloistered aesthetic virtue that leaves everything outside undisturbed. Like the cinematic still lifes of its filmic screenplay, *Thérèse* unfolds in a context overloaded with the traffic in images and in an era of commemoration marked by what Nietzsche called a "certain excess of history," a "historical fever."[43] And it responds by invoking the still life and the alternative histories—of art, of objects, and of silence—it contains.

Given its fragmented and meandering structure, *Thérèse* unfolds less like a comprehensive historical biopic than a series of discrete segments whose significance lies less in the trajectory they trace between scenes than the wanderings they compel within each image. Rather than found its conception of history on already well-known narratives, the film approaches the past through "the questioning of the *document*."[44] Because the Carmelites remain a relatively secretive and enclosed order, documentation on convent life is limited to the testimony of former Carmelites who left the cloister due to illness or disaffection; the corroboration of family members of nuns, inhabitants of surrounding communities, and other people tangentially associated with the order; and the chronicles produced by nuns themselves, by women whose few possessions included the implements used to document their everyday existence and spiritual lives within those walls. Both Thérèse Martin, who entered the convent with a notebook and pen, and her sister, Céline, who lugged along a large view camera, produced records of their experience as young Carmelites: the former, poems, voluminous letters, and an autobiographical manuscript published after her canonization under the title *Histoire d'une âme*; and the latter, a series of photographs that accompany her sister's autobiography and provide a history of the convent through the simultaneously limited and revelatory media of documentary photographs and portraiture. While Cavalier and his collaborator on the screenplay, Camille de Casabianca, engaged in intensive research into the lives of the Carmelite nuns—"I initially did an extensive investigation,

the real work of a historian"—they eventually "threw it all out the window," relying primarily on the biography and photographs produced by the Martin sisters.[45] While the film has been criticized for its departure from traditional standards of historiography and a tendency to lapse into "fabricated or prefabricated" "hagiography," this engagement with the photograph as a document inaugurates a new conception of the historical film that undermines the very conception of history on which those attacks are founded.[46] *Thérèse* instead heeds the exhortation of Marc Ferro, issued in 1977 but still largely ignored: "Go back to the images. Do not seek in them merely the illustration, confirmation, or contradiction of another knowledge—that of written tradition. Consider images as such at the risk of using other forms of knowledge to grasp them even better."[47] Cavalier and Casabianca share the fascination with photographic images evident in the writings of Raphael Samuel, who hoped that the recent deconstructive wave in historiography would propel the discipline toward "a more central engagement with graphics" and thereby generate a greater understanding of historical ways of seeing.[48] The photographic origins of Thérèse also recall the "graphically-oriented" theory of knowledge underlying Benjamin's writings on the philosophy of history and his unprecedented interest in the photographic dimension of history.[49] If photographic technology and images have become inseparable from recollections of the modern past and now color retrospectively our return to moments in the past before the age of mechanical reproduction, "there can be no thinking of history that is not at the same time a thinking of photography."[50] Yet, in a paradox at the core of the film's stilled and painterly aesthetic, there can be no thinking of the photographic image that does not account for photography's long drawn and painted prehistory. If the biography of Thérèse Martin is relayed inevitably through the image, the film wanders between different modes of image making, each opening onto the intertwined history of people, objects, and images.

In elevating the truth value of the image to a status equal to narrative, *Thérèse* alters the flow and the pace of conventional historical films. Rather than present a chain of causes and effects, bestowing a momentum on events themselves, propelling the story ineluctably forward, reducing the pictures to an illustration of a prescribed narrative, *Thérèse* often uses the image as a force of arrest. The film consists of approximately sixty vignettes, most bracketed before and after by up to two seconds of blackness. Seemingly anachronistic in cinema, these relentlessly repeating moments of blackness beg for an analogy with other, precinematic arts. Like the walls of a "diorama" or "certain Cornell boxes," they enclose stationary characters and scattered props on humble stages, creating an array of "modest shrines to the unfathomable."[51] Like the frame of a painting, they define the limits of each segment, some rendered with as little movement as a painted portrait or still life. Like the armature of a slide, they mark the boundary between the fullness of the image and the concealed mechanics of projection. Like a photographic negative printed full

frame, with the black border and exposed notches demonstrating precisely where the image ends, these brackets embrace the fragmentation that they create, announcing that each segment is both strictly limited and saturated within those boundaries. Like a film unreeling too slowly for the persistence of vision to take effect, the black becoming visible between frames, the film invokes the hidden filmic substrate. The film alludes repeatedly to what Garrett Stewart calls the "tropic poles . . . of screen movement": the freeze-frame and the reshot photo.[52] As Stewart argues, cinema habitually represses the filmic material that supports its illusion of motion, and its return marks a rupture in that customary process of concealment and evasion. "In roving past or fixating upon photographs," he writes, "cinema undergoes—which is only to say stages—a pregnant suspension. The motion picture stalls upon a glimpse into its own origin and negation at once."[53] The peculiarity of *Thérèse* lies in its simultaneous invocation of both the media of mechanical reproduction and traditions of the still life and painted portrait, obscuring that glimpse of its origin and negation, and alluding to other origins. At irregular but ineluctable intervals, something goes wrong: an archaic scaffolding reemerges even though the technological advances of cinema have long since rendered those structures obsolete. And that scaffolding, a trace of an elided filmic base or an outmoded framelike device, situates the film precisely within those seemingly incompatible spheres: the cinematic, the photographic, and the precursor that returns to partake in a new pedagogy of the image, the mere painting.

Beyond their status as formal or technical devices, and beyond any aesthetic consideration of their contribution to the beauty (or, perhaps, clumsy pacing) of the film, these brackets are also important historical markers. Based principally on photographs of a woman who lived at the end of the nineteenth century, the film suggests that her life is accessible only through the partial mediation of the photograph and that any historical rendering of her life must also take into account the limiting but also productive possibilities of a photographic take on the past. These photographs of history can be productive for precisely the reasons emphasized in Benjamin's philosophy of history: because the photograph renders the past not as a string of facts emplotted into narrative but as a still image, it slows the momentum that modernity imposes on events, stalling time long enough to reassess and counteract the myth of progress. In this sense *Thérèse* envisions history in the wake of photography, with its archaic moments of blackness also a movement backward in time. Although they introduce and conclude longer vignettes with less frequent breaks, the black spaces in Jacques Rivette's Joan of Arc films serve a similar purpose, as they disrupt the continuity upon which her encompassing nationalistic myth depends: *Jeanne la pucelle* (1994), deliberate and unspectacular in its treatment of the icon of icons, is also photographic in its stuttering, intermittent, and arrested approach to the past. In both *Thérèse* and *Jeanne la pucelle* these interruptions introduce discontinuity into the presentation of

history by reviving an atavistic way of seeing. Not the eternal present of myth, these photographic moments refer to the "vanished voice," the always other past whose manner of picturing the world evokes a sense of alienation from the stories represented in the here and now.[54]

When discussing the portraits of Thérèse Martin, Cavalier mentions that photographic technology of the period required the sitter for a portrait to remain immobile for several seconds and therefore to adopt a tolerable pose, avoiding the extremes of happiness, sadness, or excitement. In those portraits every gaze looks out through a mask of imposed restraint, and every seemingly solid figure, now fixed in silver, once struggled with the urge to shudder and waver like a tableau vivant. In *Thérèse* pictures endure on-screen, resembling the protracted process that produced them, imposing an unfamiliar way of seeing that restores the forgotten variable of duration. The significance of the photographs of Thérèse Martin, like that of the film made after those photographs, resides not only in their facticity, in the materiality they document, but also in the way they stage and frame a world. The film posits history as both a set of facts and a way of seeing, an inquiry into what is lost in the seconds between the opening of the shutter and the closing that seals a partial truth for posterity. Saint Theresa herself has become an icon of the Church and a symbol of the French nation; as with so many now-institutionalized religious figures, the images and objects associated with her life have been appropriated by "pious collectors of mystic traces."[55] But, as Michel de Certeau suggests, other lives, averse to the monumentalizing gestures of canonization, haunt the margins of those hagiographies. Such stories, he writes, are "written on that black page from which we must relearn to read them."[56] While ostensibly subordinate to an account of Thérèse Martin's life in a Carmelite convent, these archaic moments of blackness and the film's pervasive stillness also serve an implicit pedagogical function as they require us to "relearn" how to view the obsolescent image. For Serge Daney, doing time in school and waiting through a period of deferral in cinema serve a similar purpose: "To hold onto an audience of students in order to delay the moment when they could pass too quickly from one image to another, from one sound to another, seeing too quickly, arriving at an opinion prematurely, thinking they are done with the cinema when they don't sense how complex, serious, and not at all innocent is the arrangement of these images and sounds. School permits us to turn cinephilia against itself, to turn it inside out like a glove... and to take enough time for this reversal."[57] It confronts the enigma of images and sounds by "not losing sight of them, keeping an eye on them, *retaining* them."[58] In *Thérèse*, in pictures that also convey biographical information, the film engages in what Pier Paolo Pasolini calls a "pedagogy of the image" by teaching us how to keep an eye on the pictures that hesitate before us, by resisting the more dominant contemporary paradigm of the image overload or flow that needs to be managed or curated.

When Thérèse first broaches the subject of her vocation, the visuals consist of a series of portraitlike close-ups of the girl and her father, each appearing to stare silently at the other. But the nonsynchronous soundtrack presents their voices in conversation, divorcing the spoken words from the faces normally presumed to be the original source of language. Deleuze and Guattari argue that the face regularly serves as a mooring for the signifier, a restriction of its possibilities, the obstruction rather than the production of meaning. "The face," they write, "is the Icon proper to the signifying regime, the reterritorialization internal to the system. The signifier reterritorializes on the face."[59] Reminiscent of de Certeau's assertion that mysticism separates image from discourse, with "the composition of the eye and traversals of voice go[ing] along two different tracks," a strategy analogous to the cinematic "voice off," these shots invoke a discourse of religious belief irreducible to an individual author.[60] These early shots establish Thérèse as an *acousmatic* presence, or a voice of indeterminate origins, "a special being, a king of talking and acting shadow," a "voice . . . wandering along the surface, *at once inside and outside*, seeking a place to settle."[61] While the voice-over often emanates from an unseen "voice of authority" in documentary films, the voice-off that alludes to but remains nonidentical with an originating body, an "*acousmêtre*" in Michel Chion's terms, can undermine the effect of authority produced by an actual or presumed unity of body and voice. "The *acousmêtre*," writes Chion, "cannot occupy the removed position of commentator, the voice of the magic lantern show. He must, even if only slightly, have *one foot in the image*, in the space of the film; he must haunt the borderlands that are neither the interior of the filmic stage nor the proscenium—a place that has no name, but which the cinema forever brings into play. Being in the screen and not, wandering the surface of the screen without entering it, the acousmêtre brings disequilibrium and tension. He invites the spectator to *go see*, and he can be an *invitation to the loss of the self, to desire and fascination*."[62] Although *Thérèse* is ostensibly a tale of enclosure inside the walls of the convent or within a deteriorating body, and although it verges on one of the most confining and circumscribed of genres—hagiography—that initial voice-off introduces movement into those stable boundaries and initiates the wanderings possible when the image loosens its anchoring in the text. In these moments, as in the films of Jean-Marie Straub and Danièle Huillet, Marguerite Duras, and Hans-Jürgen Syberberg, "the visual and the sound do not reconstitute a whole, but enter into an 'irrational' relation according to two dissymetrical trajectories. The audiovisual image is not a whole, it is a '*fusion* of the tear.'"[63] And as in de Certeau's model of historiography, these movements join a wide-ranging departure from conventions of historical representation, as they question the metaphysics of presence that establishes the authority of this torn history text.

Thérèse also violates a cardinal rule of historical filmmaking by fabricating a thoroughly unrealistic setting, thereby announcing itself as the product of the

theater and studio as well as the fruit of historical inquiry. Rather than borrow an aura of authenticity from existing architectonic structures or assemble an illusionistic re-creation of the world outside, the film accentuates the artificiality of its setting; rather than display its architecture as an indicator of actuality, the film uses these structures as a backdrop for faces, bodies, and objects. With the illusion of depth always nullified by a gray studio backdrop, with no architectural sets to reconstitute the Carmelite convent or Martin home, with no exterior establishing shots to situate the film in a recognizable or convincing space, and with no windows or doors affording access to the more familiar cinematic world of populated streets or buildings and landscapes that once stretched backward in three dimensions, the film denaturalizes its environment and the history located there. The gridlike barrier and curtain that separate the Carmelites from their visitors establish the convent as a theatrical, staged environment. But the grid also mimics the various devices that facilitate the transferral of Renaissance perspective onto paper or canvas and aid the faithful rendering of reality (Figure 5.1). The barrier in *Thérèse* evokes these metallic overlays or interlocking lines traced on a drawing surface—a staple of the science of representation and representation within the sciences, from da Vinci's anatomical drawings to Frank Gilbreth's motion studies. But the set immediately frustrates this systematic rendering of space with its vague, shallow, unrealized backgrounds, which obstruct the next step in the Albertian paradigm, the extension of this lattice back into the imaginary space of the page or canvas. The film foregrounds this dominant system of representation—and a foundational paradigm for the medium of cinema, according to both realist film theory and the counterrealist "political modernism" associated with *Screen* and *Tel Quel* in the 1970s—then actively confounds it.[64] The camera leaps from the lattice used to approximate expansive, naturalistic spaces into the most artificial depthlessness. Only in a shot constructed around an explicitly artificial scenario—when another nun adjusts an enormous view camera while Thérèse poses in a homemade Joan of Arc costume, evoking the familiar rituals of the photography studio—only in a shot concerned with playing roles and capturing artifice on film, does *Thérèse* skirt the verges of a naturalistic construction of space (Figure 5.2). And in this moment the connection between convent and studio emerges in all its complexity, for, as Alain Philippon argues, "the studio is less the setting of Carmel than its metaphor."[65] Philippon locates that crux of that metaphor in their shared tendency to efface all traces of work, but both also demonstrate the power of mythology, through a formula as compelling as any history, to insinuate itself into reality. A young Carmelite, who became a national icon as the "little flower" of the French army during World War I and was named the country's secondary patron saint, bears the mantle of the nation only once in the film, when she poses as Jeanne d'Arc in armor manufactured from foil chocolate wrappers. That Thérèse faints on the set implies a constitutional aversion to the monumentalizing impulse that

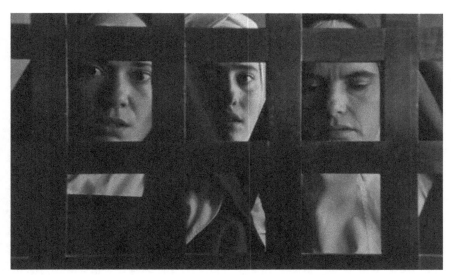

FIGURE 5.1. *Thérèse*

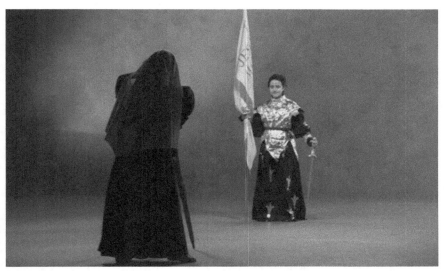

FIGURE 5.2. *Thérèse*

would posthumously beatify and befall her. Her collapse illustrates the incongruity between the myth of the "little flower" and her Carmelite existence, suggesting that the studio can serve not only to efface work, but also to interrupt or undo the laborious, incessant reiteration that allows mythology to persist indefinitely.

As it impedes the construction of Albertian space, the film also uses its repeated allusions to the still life—"the great anti-Albertian" series—as a

vehicle for this departure from conventions of history painting that abide into historical cinema (Figure 5.3).[66] Interspersed among the segments devoted to events in the life of Thérèse Martin—the more narrative elements concerned with the politics of the convent hierarchy, the medical treatment available to Thérèse, or the relationship between the nuns and visitors from outside the convent—are long, lingering shots of objects with little or no obvious significance according to the standards of hagiography: a clock encased in a glass dome; a chessboard; a pair of cloth shoes; a rosary coiled on a cloth surface; handkerchiefs; freshly cleaned and gutted fish; a lobster; flowers, pencils, a box holding a book; and, the film's final image, a return to Thérèse's shoes (Figure 5.4). These objects serve a crucial function in establishing the physical environment of the cloister, and in published interviews, Cavalier has repeatedly stressed the occupational aspect of life in a religious order, its status as a "*métier*" as well as a vocation. The existing portraits of Thérèse Martin recall a popular genre of portraiture during the last decade of the nineteenth century, in which people were photographed in the garb of and with the tools of their trade. Cavalier points out that "in this epoch one made photographs of coopers, people in front of their array of tools. . . . To be a Carmelite is also a craft. One sees them in their uniform, with a leather apron. It is straight out of the workshop. They line up a row of onions. They pose around the cross."[67] Many of the objects that occupy the film establish the *métier*-like atmosphere of the convent by showing the Carmelites together with their tools, both religious artifacts and more banal items associated with the domestic economy that structures much of their everyday lives, like the onions mentioned by Cavalier. Beyond this metonymic value as materials associated with the

FIGURE 5.3. *Thérèse*

FIGURE 5.4. *Thérèse*

Carmelites' craft, these objects also contain some narrative significance: the Martin sisters play chess; their father maintains the clock; Thérèse and her most intimate companion in the convent, Lucie, clean fish on kitchen duty; Thérèse transcribes her thoughts and observations in a notebook, which will later become her published diary, a primary source for the film and the spark for her rapid ascension to sainthood. But the presence of each object on the screen serves more to interrupt than to advance the story, as ostensibly minor objects occupy the frame long after any possible narrative motivation has been exhausted. If the display of objects in classical cinema tends to answer a question, to provide an addendum of timely information, the still lifes in *Thérèse* rapidly deplete all the significance objects can convey according to the paradigm of conventional historical narratives. And they continue to linger on-screen.

Rather than define a character or event, rather than conclude a brief and tangential line of inquiry, these objects generate a surplus of attention. If the image in cinema often remains subservient to a prescribed text, to a spoken or implied caption, these still lifes, pared down to a minimum of explicit content, shuffle off those textual restraints, defy all conceptions of narrative economy, and interfere with the customary production of meaning. This handful of humble objects becomes the epitome of excess and visual overload. De Certeau emphasizes the role played by everyday details in the writings of baroque mystics, for "the mystics, too, lead us back to these particularities that block the demonstrations of meaning. Interspersed in their writings are the 'almost nothing' of sensations, of meetings or daily tasks. What is of fundamental significance is inseparable from the insignificant. This is what makes

the anodyne stand out in bold relief. Something stirs within the everyday. The mystic discourse transforms the detail into myth; it catches hold of it, blows it out of proportion, multiplies it, divinizes it. It makes it into its own kind of historicity. This pathos of the detail (which is reminiscent of the delights and the torments of the lover and the erudite scholar) is manifested first in the way the minute detail suspends meaning in the continuum of interpretation. A play of light arrests the reader's attention: ecstatic instant, a spark of insignificance, this fragment of the unknown introduces a silence into the hermeneutic medley. Thus, little by little, common everyday life begins to seethe with a disturbing familiarity—a fragmentation of the Other."[68] De Certeau's observation highlights the role of these everyday details in the production of an idiosyncratic form of "historicity" because they refuse to defer to the aggrandizing conventions that allow for the production of history as usual. In the context of a historical film like *Thérèse*, these still lifes function as doubly defamiliarizing gestures: first, as their deliberate pace and painterly quality declare their difference from the narrative norm of conventional historical filmmaking; and, second, as they embrace a genre that quietly rebels against the strictures of history painting. By departing radically from the strategies usually taken to constitute the portrayal of history, and by moving ever backward into archaic forms of representation—from the photograph to the slide show to the still life—the film begins to equate these archaizing gestures. If historical filmmaking merely repeats the oversights and copies the clichés inherited from history painting, if the new technology associated with cinema evolved into a more efficient distribution mechanism for old myths, filmmakers in the late twentieth century contested the hegemony of the historical cliché by adopting strategies that once challenged the predominance of history painting. The film returns to the terrain of painting to wage a long-deferred struggle against the conventions of historical representation. Philippon calls *Thérèse* a return to "the infancy of the art," to the earliest days of cinema and the promise it once embodied.[69] The film also returns to the infancy of other arts, primarily to photography, as the film is based largely on those portraits of Thérèse Martin. But with the origins of historical cinema firmly rooted in history painting, the film also revisits the alternate historiographic possibilities manifested in the still life.

This simultaneously new and old form of history takes place in a space inhabited exclusively by women, visited by only a handful of men (whose presence usually elicits mistrust or derision), and isolated from the political and economic institutions traditionally considered masculine domains. As Angela Dalle Vacche writes, "Cavalier in *Thérèse* confines himself to the exploration of a uniquely feminine space: the convent. By definition this area is removed from the hustle and bustle of the world, just as the kitchens or the domestic interiors depicted in Dutch and Spanish seventeenth-century genre paintings continue to exist outside the public square, the market, and the harbor, for

those are spaces reserved to and controlled by men."[70] *Thérèse* pursues in parallel its challenge to the conventions of historical filmmaking—another public undertaking traditionally reserved for and controlled by men—and its exploration of a qualitatively different space where women's history has been written. Because it exists outside the confines of history painting, and because it focuses on a subject unfit for conventional history, the still life also becomes the genre for overlooked persons.[71] The still life of luxury overwhelms this domestic space, as it "appropriates the table and recasts it in terms of male wealth and social power."[72] But "throughout its history," Bryson writes, "still life has been a genre regarded as appropriate for women painters to work in."[73] Painters like Rachel Ruysch and Margareta Haverman, excluded from the practice of history painting, became specialists in the still life, representing history otherwise, through the material realm of objects rather than the grand narratives of history proper. By intervening in a series whose primary strategy is stillness, they obstruct the flow of narrative without resigning themselves to the false dichotomy between narrative history and ahistorical nihilism.

Thérèse also constructs a history of spaces and objects that resist narrative conventions, exploring instead the elements usually consigned to the margins of history. It focuses, for example, on the bodily reality of the convent, on the effects of illness and aging on the body, on communal efforts to wash the bodies of the sick. The aging and enervated body is almost by definition lost to historians, even to Foucault, who treat the body as an abstraction, a variable in a complex negotiation between discipline administered by the state and depersonalized subjects. A Foucauldian rendering of life in the Carmelite cloister might focus on the daily disciplining of bodies enclosed within walls, harnessed by inhibiting costumes, and constrained by a rigorous code of celibacy; it might situate the Carmelite between the Scylla and Charybdis of a religious order that demands mastery over, even infliction of pain on, the body, and a skeptical scientific mentality (represented in the young doctor) that dismisses their austerity as a form of hysteria.[74] But as Monica Furlong argues, the nineteenth-century French convent, disciplined by extraordinarily restrictive rules of conduct, also represented a lapse in the patriarchal system that pertained elsewhere and opened possibilities that bourgeois life, fraught with its own manner of bodily suffering, otherwise foreclosed.[75] As several of the Carmelites suggest, however, the cloister is far from utopia. If the young novice imagines the convent as a reprieve, within its walls Lucie protests against the effects of deprivation on the body: "This isn't a sacrifice, it's a massacre." The young doctor charges the Mother Superior with wanton infliction of suffering: "They ought to burn this place down. . . . You're dangerous," he reproaches. "No, the salt of the earth," she replies. Yet these compelling condemnations, voiced repeatedly in the film, ignore the possibilities of an alternative community tentatively realized among the women of the convent. If freedom from physical suffering is earned only by submission to the

prescribed categories of medical science, the convent accepts only a minimum of medical treatment while inhibiting the invasive gaze of institutions eager to brand their disaffection as a manifestation of disease.

If society recognizes sexuality as legitimate only within the bonds of marriage, if having a body is a privilege granted only in return for significant sacrifices, the convent becomes a space of experimentation where other models of sexuality are explored. As Dalle Vacche argues, Thérèse and her cohort only partly succumb to the sexual repression generally associated with the cloister; instead, the film demonstrates how "in representing an alternative to the patriarchal order, the convent fosters the expression of feminine desire."[76] Dialogue in the convent, much of it in violation of the cloister's mandated silence, includes extremely honest and explicit sexual banter between Thérèse and Lucie, as they await the literal consummation of their symbolic marriage to Jesus. Because of this breach between the authoritative, biblical incantations and the idiosyncratic, rhetorical manifestations of Jesus, the term for the savior becomes a free-floating signifier for a desire whose object changes with each supplication or solicitation. And as "The Song of Songs" overshadows the rest of the Bible in the prayers recited by the nuns; as an elderly nun asks Thérèse for a kiss, "a real kiss, the kind that warms you up"; and as the homoerotic sexual banter becomes increasingly frank and intense, the sexual restrictions of the convent fail to dampen a desire left unaffected, or even enabled, by relative isolation.

This fascination with the erotics of religious life thrives in a long tradition of counterinstitutional writings, ranging from the meditations of mystics to the economics of desire proposed by Georges Bataille.[77] Citing Bataille, Marc Chevrie underscores the intimate connection between sainthood and eroticism in *Thérèse*, for both forsake the demands of efficiency to concentrate exclusively on the imperatives of desire.[78] Like Bataille's appeal to erotic and mystical possibilities outside the predominant model of economic efficiency, *Thérèse* recovers a neglected history of desire omnipresent in the Catholic canon but submerged beneath inherited orthodoxies. This return to religious texts and hagiography, potentially a rehearsal of familiar rites and doctrine, becomes an occasion for infusing desire back into the history of religion and thereby retrieving something vital from scriptures that have been institutionalized into vehicles of conformism. The film itself adopts a mystical approach to its subject, for, as de Certeau writes, "mysticism is less a heresy or a liberation from religion than an instrument for the work of unveiling, *within* religion itself, a truth that would first be formulated in the mode of a margin inexpressible in relation to orthodox texts and institutions, and which would then be able to be exhumed from beliefs. The study of mysticism thus makes a nonreligious exegesis of religion possible. It also gives rise, in the historical relation of the West to itself, to a reintegration that eradicates the past without losing its meaning."[79]

The limits of this exhumation process are clear, however, in the omnipresent danger of hermeticism and isolation, the inability to act beyond a limited space and to think outside the rites of a particular group. Thérèse and her sister hope that their prayers will result in real-world consequences, and they secretly consult a newspaper to learn the fate of a condemned prisoner moved, they believe, to repent just before his execution. This newspaper, an artifact of the public and political world normally closed and impervious to them, crystallizes the arbitrary restrictions that allow convent life to appear relatively free; but it also invokes a world occasionally curious about but more often indifferent to the aspirations of the nuns separated by both walls and barriers of belief. Thérèse has faith that her prayers have resulted in the salvation of a prisoner, and she exults in her triumph. But such moments of perceived mastery become far less frequent during her years as a Carmelite, as interaction with the world outside the convent takes the form of unbearable financial burdens imposed by the tax assessor and by mutually baffled interactions with interlopers who deliver their observations on convent life along with goods or services. When a group of men shout "Vive la République!" after delivering a decadent Christmas gift of champagne to the convent, this chasm between inside and outside appears in all its immensity: the men who unthinkingly chant paeans to the state offer the most cogent argument for escaping from those exhausted, clichéd, thoughtless models of the public sphere; yet after those delivery men leave, the Christmas party livens up, and the Republic lives on, virtually oblivious to the goings on inside the convent. Thérèse's earlier desire to affect a broader world emerges again in her plan to leave France and work in a Carmelite mission abroad, an itinerary of escape and influence foreclosed by her illness and death.

Chevrie begins his review of the film by repeating a question left unanswered by the film's cryptic title: "Which Thérèse?"[80] Any initial confusion between the two obvious possibilities—Teresa of Avila and Thérèse, "la petite sainte de Lisieux"—dissipates quickly because of the specifics of time and place. But the questions raised by the former, a seventeenth-century Spanish mystic best known for her *Moradas*, continue to echo in Cavalier's film: "Who are you?"; "who else lives inside of you?"; "to whom do you speak?"[81] Lucie, a character added to the screenplay by Cavalier and de Casabianca and who, as Cavalier suggests, functions as a double for Thérèse, embodies a utopian desire for flight into a world where the restrictions of the convent no longer obtain, where the possibility of desire is not limited by the illegality of action. Through Lucie's relentlessly cynical comments about the endlessly deferred rewards of religious conviction and her unashamedly sexual discussions with Thérèse, the film alludes to the frustrations inherent in a desire that speaks its name only within a cloistered and marginalized environment. Through her actions, through her very desire for escape and the movements that she initiates in pursuit of that goal, Lucie exposes the limit of the "little way" advocated by

Thérèse and embodied by the still life. Lucie's movements repudiate the still life's cloistered aesthetic as they rebel against the convent's enclosure. But as Cavalier suggests, "One must not exaggerate the role of simplicity. It is blended with a sort of baroque madness."[82] Cavalier mentions the contrast between, on the one hand, the seemingly spontaneous sentiments of the Carmelites, their occasional outbursts of affect, the intensity of their devotion, and, on the other hand, the "encoded" costume that signifies their enclosure, the impossibility of pure affect. This contradiction becomes their "fardeau léger," he says.[83] For Lucie the lightness of life returns through her acts of refusal, her decision to remain unencumbered by the tradition that occupies Thérèse, and her faith in a body committed to continuous motion; her burden is the impossibility of residing anywhere in a world of institutions and stable structures. She flees the convent, but she ultimately disappears into a kind of oblivion, a fate closer to Oedipus at Colonus than a character achieving her freedom. Her freedom and limitations are reminiscent of those inherent in the schizophrenia celebrated by Deleuze and Guattari and the excessive, unfurling folds of a Deleuzian baroque. The lightness of Thérèse resides in a devotion and conviction that the artificial strictures of the world are obstacles easily surmounted by a mystical faith; her burden remains her mooring in a body and the inability to intervene outside her tradition. Her strength and fragility are those of Benjamin's ruins, his arcades, and his *Trauerspiel*.

The film concludes with a still life of Thérèse's shoes, a pair of cloth, rope-soled sandals or espadrilles (Figure 5.4). Dalle Vacche notes the similarity between this still life and van Gogh's painting of well-worn boots, the subject of Heidegger's excursus on the emergence of artistic truth in *The Origin of the Work of Art*, which in turn prompted a caustic response from Meyer Schapiro, who objected to Heidegger's invocation of a peasant life close to the soil and countered that mythology with a biographical anecdote attributing the shoes to the artist himself. According to Schapiro, the still life in van Gogh's hands becomes a "personal object."[84] Another generation of scholars has conscripted van Gogh's still life into the ideological skirmishes of postmodern theory, with those same peasant shoes becoming for Fredric Jameson the crystallization of a social world centered on the economic reality of hard physical labor in the fields. Andy Warhol's *Diamond Dust Shoes* (1980) reveal by contrast, a celebration of shallowness, a pure surface doggedly resistant to the "depth model" of analysis possible in the boots of van Gogh, which register the terrain where they travel and toil.[85] Hal Foster defends Warhol against this charge of vapid indifference, arguing that, in the spectacular world of Warhol's New York, images drawn from the realm of fashion constitute a reality as incontrovertible as the soil and creases on van Gogh's shoes.[86] Viewed within the context of the artist's lifelong obsession with forlorn and forsaken lives, his still lifes of glittery shoes and later shadowy skulls, all symptoms of an immersion within a seemingly omnipresent culture of images, use these stilled surfaces

to allegorize and mourn human estrangement from spectacular society itself. The logic of Jameson's depth model, with buried truth lying irretrievable beneath postmodernity's proliferation of mere surfaces, gives way to the logic of allegory, with preservation possible only in the aftermath of fragmentation and dispersal, with the totality visible only through the traces recovered from ruins and decay. Warhol's still lifes are relics from a broken world. Stepping back from van Gogh's still life, Derrida's *The Truth in Painting* examines the parameters of the debate inspired by this work of art, focusing in particular on on the audacious bidding process that compels Heidegger and Schapiro to invest more and more in that single painting and ultimately overwhelm it with the unbearable burden of entire traditions of aesthetic and art historical inquiry. He also rehearses the concept of hauntology that will structure his later *Specters of Marx*: he imagines those shoes not as the possessions of a particular owner but as the site of a possession, a perpetual process of return by a series of competing revenants. Like Schapiro he attributes a ghostly presence to old shoes, a presence best described by Knut Hamsun, who discovered in their worn contours "the ghost of my other I."[87] Derrida suggests that "as soon as these abandoned shoes no longer have any strict relationship with a subject borne or bearing/wearing, they become the anonymous, lightened, voided support (but so much the heavier for being abandoned to its opaque inertia) of an absent subject whose name returns to haunt the open form."[88] Despite decades spent pondering the mystery of the wearer's identity, the inescapable and defining quality of these shoes is their emptiness, which implicates a figure knowable only as an absence. The scope and passion of this ongoing debate, which encompasses van Gogh's work of the 1880s and lurches forward to Warhol's in the 1970s, suggest that more than dirty shoes are at stake. As Michael Steinberg writes, the "debate as to who shall inherit modern culture has . . . seized on the reading of van Gogh's shoes."[89] These critics all circle around a crucial and still vital question: "Who controls (walks the path of) modernity?"[90]

But given the sheer volume of criticism devoted alternately to these "peasant shoes" or to a "personal object" of the artist, one obvious shortcoming remains: the minimal discussion of this painting as a still life, as an artwork inserted by an artist and decades of criticism into a series concerned with the world of objects and with human investment in things. Using various philosophical, aesthetic, and ideological frameworks, critics have envisioned the painting primarily by speculating about the owner of the depicted shoes. Like B-movie sleuths they construct a narrative from the laces and creases and clues sticking to the leather, they discuss the painting as though it were a portrait *manqué*, and they strive to rectify this oversight. Searching desperately for the "artist's presence in the work," Schapiro distances this particular image from the rest of van Gogh's still lifes and instead constructs an aura of portraiture around the shoes: the artist "has rendered them as if facing us, and

so worn and wrinkled in appearance that we can speak of them as veridical portraits of aging shoes."[91] While assigning proprietary rights over the shoes, these critics envelop the painting in the most clichéd life stories: Heidegger, by attributing ownership to a peasant woman, plucked from the enormous pool of possible owners because she evokes the fertility of the landscape and the glory of the motherland; Schapiro, by granting possession to the vagabonding painter, remaking those shoes into a symbol of the cosmopolitan artist, the footwear of the *flâneur*. Derrida reports retrospectively the surprise he experienced on first reading this passage from Heidegger and his inescapable conclusion that it marked "a moment of collapse, derisory and symptomatic," though also "significant" because of those too-obvious failings.[92] But he records equal frustration with Schapiro, who too easily identifies and delimits the milieu of the artist, asserting that van Gogh painted his peasant shoes while "a man of the town and city."[93] Derrida laughs most heartily at the pedestrian narratives invoked first by the radical philosopher of language, especially since those clichés appear totally superfluous, bearing no relationship to the argument itself, and then by one of the great art historians of the twentieth century, an expert on van Gogh, and author of one of the most perceptive essays yet written about the still life (Schapiro's "The Apples of Cézanne").[94] The foundational gesture of the still life—the decision to decenter the human subject and concentrate instead on the object world—disappears in these narratives of ownership, as the philosopher and critic skip indifferently over that crucial act. These narratives ultimately bury the object, transforming the still life into a "belong-to-me" form of representation, familiarizing it by association with formulaic tales, and reinstalling the very clichés that the genre's stalling tactics and stuttering rhythm struggle against. Painted objects suggest that the people are mssing, that they have disappeared or not yet arrived. The still life can assert, with Deleuze, that "there is no work of art that does not appeal to a people who do not yet exist."[95] Rather than discipline the image within a hackneyed framework, the still life can compel a rethinking of the object; it can contribute to the project outlined by Artaud: it "strips" away the "obsession" with "making objects other," and instead challenges us to "dar[e] in the end to risk the sin of *otherness*."[96] Confronting the sense of sight with the simplest objects, the most literally objective reality, the most soothing or alarming physical records of a human presence, it then confounds those habits of seeing with a surplus of attention, with the realization that habituated ways of seeing rarely stand up to close scrutiny.

Of course, there is always another cliché in the offing. The spiritual still lifes of Zurbarán can spawn routinized, conventionalized, serialized successors as easily as the soup cans of Warhol. Their promise lies in a capacity to disrupt habits of thought and vision, to conjure up "the ghost of my other I"; but what matters are the possibilities they imagine at a particular moment and what they vie against. Cavalier's charge emerges directly from the spectacle

described by Guy Debord, though his response remains committed to a particular tradition of European painting. He argues that "people are assaulted by a whole series of messages destined for their eyes and ears, and I think that they sleep with a welter of noise and images in their heads. And I say to myself that it's necessary to discover something, to find a simplification of the image in a manner that gives meaning to the film. Otherwise it would have reproduced the cacophony of the outside and done nothing but add chaos to chaos. All this led me to my choice."[97] This "concentration" through "simplification" taps into one tradition of the still life in order to counteract the spectacular proliferation of images in the late twentieth century.[98] Cavalier also hints at another possibility latent in the force of arrest that resists the foreclosure of predetermined movements. During one exceptional moment, the film abandons its characteristic editing pattern, jettisoning the black brackets between scenes and relying instead upon a slow camera movement between sets to initiate a virtually unmarked transition. As the first set fades to black, the Mother Superior begins to disappear into shadows, but the always incomplete darkness leaves her figure visible but impalpable, a ghostlike presence who hovers behind the succeeding scene. Commenting on this effect, Cavalier says, "What interests me are transitions. . . . In my mind, transitions always pass through shadow. Which is to say that when you pass from a certain state to another, from a certain desire to another, there is a moment of anguish that plunges you into the black."[99] Although characterized primarily by the intense immobility of the still life, *Thérèse* also evokes this second category of space, where one scene or setting folds into the next. More importantly, it traces the connection between these two spaces: the still life is imagined not only as a space of confinement, but also as a platform for transitions and for excess made possible in a moment of arrest; and the imperceptible folds between scenes document an itinerary and bear traces of the authority that constrains them. Stillness is momentary, a transition; the most furious motion is glimpsed in a snapshot and haunted by a past. The still lifes of *Thérèse* vacillate between these interconnected roles: as the now-dormant ruins of history and as overloaded afterimages of motion.

The final shot of Thérèse's shoes emerges out of that paradox of stillness and movement: these objects attest to her history, to the fact that a trace always remains; but those shoes also assert that Thérèse is a paragon of baroque movement. As soon as those objects appear to anchor her in a particular environment, she moves on: there is her trace, but Thérèse is gone. Despite the stillness of the film, the errancy of Thérèse also recalls the meandering of Labadie the Nomad, the baroque mystic whose intensity of hope was equaled only by his fear of habit, whose life espouses moments of belief but also embodies a trajectory of movement, "a man whose wanderings continue to elude the learned, who only see him cross the narrow field of their competency, and who, like Empedocles, leaves us nothing but his sandals."[100]

Moving Pictures, Still Lives: On Terence Davies

Terence Davies's *Distant Voices, Still Lives* (1988) is a film about images and sounds that linger on. Together with *The Long Day Closes* (1992), *Distant Voices* and *Still Lives* comprise an expansive autobiographical series set in working-class Liverpool between 1940 and 1959, and all look back with a combination of remorse and nostalgia at a poor and often brutal upbringing on the cusp of Britain's "age of affluence."[101] Produced two years apart, the two halves of this diptych are often described as separate films, with the first half marked primarily by furious violence inflicted by the family's father and the second by nostalgic remembrance of the mother. But that paternal cruelty remains a forceful presence even after the father's death, as it insinuates itself into the calmed domestic space of *Still Lives*, and in *Distant Voices*, moments of stillness arrest that violence, evoking other possibilities for the family amid random explosions of wrath. The two halves are linked by their common narrative structures (with loosely connected vignettes emphasized over a continuing story); by the mobilization of popular period songs, which provide both extra-diegetic sound and a significant component of the story itself (as the community, especially the women, gather around to sing); and an image track most striking in its succession of still lifes and portraits of the family in stiff poses, each tarrying on the screen far longer than the already attenuated narrative can sustain. In both halves, this fragmented structure, this mobilization of a musical hit parade, and this indulgence in hyperstylized images leave the film vulnerable to the criticism that it values the beautiful illusion of nostalgia over the banalities of history and geography, that its ethereal still lifes and isolated outbreaks of song forestall the narrative progress that would otherwise make sense of the father's violence and result in a more faithful rendering of this working-class locality. Critics such as John Caughie have constructed a powerful critique by contrasting these discrete images with the more sociologically inflected writing associated with British cultural studies, especially the Birmingham School of the 1970s.[102]

But as in Cavalier's *Thérèse*, these stilled images invoke an alternative model of history and the socius that these admonishments must also reckon with. The film bridges a period of Labour triumph (culminating in the election victory of 1945) and subsequent decline, implicitly juxtaposing that trajectory with the contemporary context of working-class reversals in Thatcherite Britain. As Geoff Eley suggests, Davies constructs an account of working-class life for an era when the unraveling of the welfare state and the conversion to a postindustrial economy have provoked a profound identity crisis within traditional Labour politics; when class politics have been displaced in Conservative discourse by the cult of the individual and in the New Left by a less threatening class "culture," defined as a "whole way of life"; and when mythologies of the stalwart, white, masculine laborer continue to burden leftist politics.[103] *Distant*

Voices, Still Lives returns to an era often celebrated as a pinnacle of British socialist solidarity, then to the moment of its decimation. Rather than indulge in nostalgia for bygone triumphs and a golden age, and rather than construct an illusory tale of progress, Davies examines the still-prominent myths that authorize such nostalgia or triumphalism. The film asks what compels the seemingly endless repetition of structures of domination, what constitutes an effective history, and what restricts access to this more usable past.

Andrew Higson has chastised scholars of British cinema for a realist bias that left critics reading almost exclusively for the plot and for direct correspondences between character types presented on-screen and their real-life counterparts.[104] Lost in this realist equation is any consideration of the mediating structures that inevitably frustrate the application of cinematic templates to historical reality. Among filmmakers, critics, and audiences, another bias guides the production and reception of mainstream British cinema because, as Christopher Williams argues in his essay on the British "social art cinema," a tradition of social realism often yokes political engagement together with conventions of realist representation, establishing an orthodoxy by which all other social cinema is evaluated.[105] More specifically, this orientation in British cinema installs as the basis of political filmmaking a variation on Lukácsian realism that seeks "to present the audience with a representation of the individual within the social, with characters who possess an element of individuation but who nevertheless remain representative without becoming stereotypical."[106] As Martin Hunt argues, "The realism of Davies's films—if indeed it is a realism—does not do this."[107] Hoping to incorporate it into a tradition of socially engaged filmmaking while also marking its difference, critics devised a litany of hybrid categories to accommodate the film: *Distant Voices, Still Lives* is a variation on the theme of poetic realism;[108] or poetic realism combined with the musical;[109] or "the first realist musical."[110] Christopher Hobbs, the film's production designer, describes the artificially deepened shadows, exaggerated textures, and illusions of moving objects as a form of "hyperrealism";[111] some critics place the film within an "anti-realist" tradition;[112] another, perhaps most suggestively, emphasizes its "gritty surrealism," a juxtaposition that announces its tenuous connection to the contemporary literary phenomenon of "dirty realism" but also alludes to the artistic tradition that transformed simple subjects—isolated objects and immobile bodies in hallucinatory, tableaulike poses—into unsettling images.[113] For this reason, the British touchstone for many critical responses to Davies is not the "kitchen sink" realism often associated with the industrial north but the surreal documentaries of Humphrey Jennings, which most closely anticipate the uncanny attention to objects and oddly artificial poses that reemerge in the films of Davies. Like Rosalind Galt in her study of the "pretty" cinematic image, Davies insists that the "decorative" is always "historically and geographically embedded."[114] As he couples the familiar terrain of realist filmmaking with an

aesthetic influenced by still life painting and portraiture, Davies acknowledges that the dominate representations of British working-class life have become stereotypes, whose association with realism merely naturalizes their mythologies. As Eley points out, by the 1950s those ingrained forms of realist filmmaking had devolved inadvertently into conservative images, with the heroic, physical, masculine worker celebrated as the embodiment of the culture of the common man but denied any agency in the momentous events of history.[115] The political economy of class had disappeared, with the working class no longer celebrated as the motor of history but instead reduced to stereotypes or colorful cutouts—"chirpy cockneys," Davies calls the cinematic cliché, "you know, chirpy cockney voice: 'We've survived the War!'"—in the background of narratives devoted to society's more powerful players.[116]

By the end of the 1950s the British New Wave became the emblem of a reconfigured cinema based in the industrial north, yet, as Eley points out, that new brand of realism often transported the same mythology to another environment, as narratives of flight transferred the mantle of the male hero from those rooted in the community to those poised to escape.[117] In each instance Lukács's historically emergent social type is embodied in a physically powerful man, whose productive capacity in the factory, occupation of the public sphere, and (in the "angry decade" of the 1960s) potential mobility contrasts with a feminized domestic world, a space characterized by incessant consumption, resistance to public and community life, and rootedness in an outmoded past. Carolyn Steedman notes that this tradition continues into the writing of a generation of scholarship boys nostalgic for the more masculine rigors of the olden days and critical of a new generation unaware of their relative good fortune.[118] Even in the brilliant and influential work associated with the Birmingham School and the New Left, the myth of the masculine agent of history often persists. By the 1980s the unraveling of the welfare state and decline of British industry resulted in a crisis of identity for the working class and a threat to its culture and political movements. While encouraging that decline, Thatcherite conservatism also recirculated and celebrated particular elements of this tradition of working-class representation, most notably the archetype of the patriarch and patriot, which appealed to the target audience for propaganda about the depredations of a "Permissive Society" no longer abiding by the values of "self-discipline" and "moderation."[119] Davies reverses the valence of most elements in this schematic history, but his film most ardently attacks the myth of the heroic working-class father. Fear of a brutal patriarch becomes a dominant emotion in *Distant Voices, Still Lives*, casting a pall over every moment of family life, attenuating every moment of joy, foreclosing the possibilities for more than the most fleeting escape. Along with this fear of physical and emotional violence resides an equally powerful dread of repetition, especially among the male characters charged with inheriting the familial and social status of the father. For this reason any mode of realism that even

skirts the borders of stereotype becomes problematic in a film concerned first with life in working-class Liverpool, but also with the mythology of the patriarch that continues to dominate retrospective imaginings of the period. To continue tinkering with easily recognizable character types merely reinscribes those already prevalent myths and ensures their replication into the future. The artistic brief for *Distant Voices, Still Lives* centers around the possibility of a history without stereotype, or at least a past that defies the inertia of the cliché and resists its continuation. Phil Powrie maintains that Davies responds to the contemporary heritage phenomenon by developing a genre of "alternative heritage" cinema characterized by its working-class setting rather than bourgeois or aristocratic milieu, its provincial rather than metropolitan location, its frozen narrative structures, and its critique of male violence coupled with a celebration of maternal community.[120] The problem for Davies is how to respond to the hegemonic heritage of the Thatcher era without merely resorting to the established, quasi-official alternative based in a tradition of social realism.

The relationship between the aesthetic stillness and the social environment is crucial in Davies because provincial working-class films are nothing new, because they already constitute a tradition of realist filmmaking that can congeal into a variation on the heritage film, with different characters in different settings reinforcing another litany of clichés. Merely to stage a social realist film in the Liverpool of Davies's childhood would invoke that already extant alternative heritage, with its own repertoire of paralyzing conventions. Davies has been criticized for alluding to rather than reconstructing the geographical and social specificity of Liverpool at the time, but the film adopts a fitful and stuttering presentation of that social sphere, a succession of still lifes and stilled bodies, in order to stall the momentum of mythology that looms inevitably in the background. As soon as the film evokes the time and setting through songs or old movie titles or clothing or heavily accented Liverpudlian speech, it interrupts the play of nostalgia with stilled images or flurries of anger. While attempting to salvage a model of community from the past, *Distant Voices, Still Lives* also tries to extricate that community from the cliché of heroic and violent masculinity that always threatens to overtake even its most hopeful invocations.

In his introduction to the "social art cinema," Christopher Williams argues that the films of Stephen Frears, Derek Jarman, Neil Jordan, and Davies help define "a moment in the history of British film and television culture" because they struggle against the orthodoxy of social realism in Britain and engage tentatively with the tradition of Continental art films. Rather than present a succession of character types, each threatening to lapse into cliché, the social art cinema focuses on the "social-diffuse," the "mixed forms" that elude the categories of sociological analysis.[121] Although this scenario verges on another hackneyed formula—with sophisticated European artists educating a less

aesthetically inclined Britain—this hybrid film genre also seeks to alter the institution of art cinema by shifting its emphasis from the alienation of the individual to the communitarian concerns of a social group.[122] While engaging with a European "pedagogy of the image," these films also draw on a distinctly British tradition of sociological analysis. Williams considers this emerging genre a "specifically British" form of cinema that nevertheless bridges the often antagonistic traditions on both sides of the Channel, wandering between the two poles represented, for example, by British cultural studies and the theoretical analysis of the image undertaken by Deleuze and Daney in the 1980s.[123] Beyond its location in a northern working-class environment and its stylized treatment of that setting, *Distant Voices, Still Lives* is significant for the way it juggles the matter and antimatter of British social realism and European art cinema, or perhaps even suspends those categories altogether, creating a genre where sociological analysis informs and engages with the politics of the image. As Raymond Durgnat suggests, the result is closer to the "micro-history" practiced by Carlo Ginzburg—with its focus on the "local-and-family micro-culture" and its minute study of familiar objects from a perspective of disorienting closeness—than the sweeping, sociologically inflected categories of British historiography.[124] *Distant Voices, Still Lives* shuns the major events of the period and focuses instead on seemingly insignificant and overlooked people and objects, including family photographs that hang in the background and, oscillating between the cliché and the promise of a reimagined community, continue to structure and haunt the domestic life around them (Figure 5.5).

Because of this micro- rather than macrohistorical approach, because it conjures up the past without including most recognizable events from the period, the film has been subjected to sharp criticism focused on a perceived lack

FIGURE 5.5. *Distant Voice, Still Lives*

of historical grounding. Even when it alludes in passing to recognizable markers from the period—the national service program, for example, or popular films and radio programs—those references usually evoke ongoing circumstances, the progression of weeks or months, the generalized atmosphere of everyday life, rather than specific events. Because they are often billed as installments in a fictionalized autobiography, the two halves of *Distant Voices, Still Lives* and *The Long Day Closes* have also provoked criticism based on discrepancies between the wartime and immediate postwar context and the life of the director, born in 1945. That distance of a few years allows Davies to replace the specifics of a lived experience with the golden-hued generalities of nostalgia. John Caughie's review of *The Long Day Closes* remains the most detailed bill of particulars against all of the director's Liverpool films, as it identifies the sentimentality that seeps into Davies's work, especially in the nurturing and nearly infallible mother and "the familiar habitat of working-class nostalgia: a rain-drenched urban landscape transcended by community."[125] He also notes the seeming passivity of all the characters, who "seem deprived of emotional complexity, the possibility of change, or even of the desire that things be different. They become figures in a built set, object memories in a still life landscape."[126] The result, he writes, is an "attempt to construct the past of individual experience through a museum of collective traces; what it risks is that everything—the streets, the rain, the pubs, Kathleen Ferrier, the people—becomes an exhibit."[127] While the rain-soaked streets of Liverpool are familiar territory in cinema about the postwar working class, the museumlike environment described by Caughie is the equally recognizable domain critiqued in much contemporary theory, including the work of Patrick Wright, Tony Bennett, and Sylvère Lotringer. The age-old question facing artists in this atmosphere is whether or not the critique of nostalgia dissipates in a wash of images, which themselves satisfy the sentimental yearnings under intellectual assault. Sean French argues that *Distant Voices, Still Lives* is "a film about nostalgia, not an exercise in it," but as with the caesura in the film's title, whose grammar only pretends to keep categories separate, the critique of nostalgia always verges on its practice.[128] Given the background of working-class mythology that inevitably shapes the production and reception of the film, Caughie writes, "The problem is how to remember the class, now from outside it, other than in the images which the myth provides, memorialising a loss which can only be registered in moving pictures and still lives. Despite the distance of its formal brilliance, *The Long Day Closes* seems to me still to linger lovingly on the old images of passivity and endurance which can only celebrate happiness by celebrating stasis, a fantasy of the past in which memory holds things in place."[129] But even then, Caughie suggests, "something remains."[130] That unruly remainder, so resistant to the discourse of critical analysis, also determines the fate of the films, which either fail as insufficiently historical social realism or concentrate instead on the excess swept to the margins in a British realist tradition. In *Distant Voices,*

Still Lives, memory does not instigate the "consoling play of recognitions" in the family; "instead, memory haunts them."[131] The dilemma for contemporary filmmakers is how to explore the possibilities that exist between the history of big events—a discipline that either disregards the Liverpool of Davies or invokes it through already pervasive clichés—and the nostalgia that too often accompanies remembrance of the everyday.

In nearly all of Davies's films the song performed in the pub or accompanying a scene devoid of action, the photographic portrait, and the still life become the preferred mechanisms for evoking a history that alternates between the eerily familiar and the surreal. Rather than serve as mere accessories to a prescribed narrative, these songs, images, and objects become events in themselves, altering the standard formula for what qualifies as a significant historical occurrence and what constitutes the most fundamental level of historical analysis. For Thomas Elsaesser the characteristic feature of the films of Davies is his attention to seemingly minor details and the psychological ramifications of that concentration. Davies creates "a heightened, emblematic or dream-like realism . . . for which the implements, objects, customs, the visual (and often musical) remnants of a bygone popular culture have become the icons of subjectivity."[132] But each of these icons reveals a ruptured and ambivalent subjectivity rather than the comfortable and complacent self of nostalgia, for even the popular songs from the period—usually a force powerful enough to melt stone—vacillate between sites of memory and sources of dread. The film's monochromatic appearance—a product of a limited palette in the sets and costumes, coral filters, and Cooke lenses—lends a golden hue to these still lifes and group portraits, almost literalizing the platitudes about a lost golden age.[133] At the same time, the bleached, desaturated color also robs the image of its richness, imbuing it simultaneously with nostalgia and mourning. Though the singalongs in the local pub predominate, other, less joyful songs linger in even those pleasurable moments. In *Distant Voices* the father instructs his children to collect firewood to sell, then the air-raid siren sounds and the children run for cover from a heavy bombardment. When they finally reunite with the family in an underground shelter, he viciously beats his daughter, and, in order to dissipate the resulting atmosphere of fear and violence, orders the family to sing. In this instance the community activity of singing merely glosses over the brutality that makes it a strategy of containment, and performance becomes pure diversion rather than the joyful spark of remembrance. The household objects also alternate between triggers of nostalgia and markers of brutality, as warm images of cups and candlesticks, evocative of the "culture of the table," are also haunted by the lingering memory of the father's cruelty in the spaces shared by the family, especially in the scene when he inexplicably overturns the dinner table, sending its objects flying and the family scurrying for shelter. These outbursts of violence alternate with moments of oddly static drama centered on still objects and people rather than action, and in those few seconds of stasis the violence both

wanes and lingers, leaving every memory colored with the threat and the history of brutality, or, as in the still life with boots, the experience of bare subsistence at a time of supposed affluence (Figure 5.6). In the published screenplay Davies remarks on these moments of still drama and suggests that, "as in painting, the drama lies not so much in the bowl of fruit or the vases of flowers but the ways in which these objects are perceived—in effect, stasis as drama."[134] *In Distant Voices, Still Lives* these objects become emblems of an absent drama inspired by yearnings for a golden age and painful memories of its far-from-utopian reality.

The most immediate influence on the manner of filmmaking adopted in *Distant Voices, Still Lives*—especially the still life that arrests the momentum of persistent mythologies and disturbs that preconceived past—is another autobiographical trilogy from a filmmaker from the margins of the United Kingdom: Bill Douglas's *My Childhood* (1972), *My Ain Folk* (1973), and *My Way Home* (1978). As Caughie suggests, Douglas always occupied a tenuous position within British film culture because his work was mistaken "as yet more British humanist realism," and as a result, "the films that make up the Trilogy slipped through the theoretical and political net with which many of us trawled in the 70s: too individualistic to point to film as a social practice, and too realist to open the way to the avant-garde whose absence had always (has always) deformed British film culture and whose advent was eagerly awaited after the events of 1968."[135] Douglas relates the story of his impoverished upbringing through the objects that form the protagonist's environment and help map his location in the world. Throughout the trilogy these still lifes—from flowers in a simple earthenware vase in the first film, to a heap of books and photos of writers and film stars in the last—chart his movements away from the constrictions of home, then away from the outpost of empire he occupies

FIGURE 5.6. *Distant Voice, Still Lives*

on national service in Egypt, then back "home" to a Scotland defined in contrast to the usual litany of clichés. Like Davies, Douglas engages with persistent mythologies: on the one hand, the Brigadoon and tartans myth of Scottish heritage; and, on the other, the colonial myth of perpetual backwardness. Early in *My Childhood* Douglas's alter ego, Jamie, steals a bunch of flowers from a grave, carries them home, and places them in a vase, constructing a Spartan still life. In a sequence of apparently wasteful acts, he proceeds to dump the flowers on the floor and pour boiling water into the vase until it overflows onto the table. Only in the next shot, as Jamie brings this warmed vase to his elderly grandmother, does the importance of this object, the household's sole receptacle of its kind, achieve its secondary but more tangible significance as the only source of portable warmth and bodily comfort. In this scene, an emblematic moment in the film, the prospective drive of chronology confronts a still object, which attains its significance only in retrospect, and a visual and narrative misunderstanding gives way to haptic truth. As Caughie argues, this still life and its aftermath serve "to mark off this poverty as other: poverty not simply as a deprived version of everyday norms—the same, but less of it—but as a system which has developed other norms and rationalities; poverty as a peculiarity which is not simply given. . . . Time and again within the film, the meaning of a scene does not refer simply to a particular version of the familiar, cannot be read along the lines of generic or cultural coding, but is built out of concrete bits of the lived experience of poverty."[136] For Douglas the still life provides the vehicle for this particularized version of history because it solicits the application of monumentalizing clichés, then it lingers, distorting those preconceptions, disrupting their inertia, continuing in a local environment radically estranged from those encompassing myths. In the Douglas trilogy the still life becomes historical because it is first untimely.

In Davies the still life is an outbreak of stillness that interrupts the automatism of the cliché. As Tony Williams points out, these moments confront the brutality of ingrained attitudes with an unpleasurable but necessary force of arrest. Williams likens the film's stillness to the cinema of "unpleasure" advocated by Laura Mulvey as an alternative to the dominant regime of visual pleasure, and he argues that these images engage the viewer "in a more masochistic than voyeuristic manner."[137] Viewed against the ubiquitous standard of classical Hollywood and European cinema, *Distant Voices, Still Lives* rejects the primary source of cinematic pleasure: the illusion of power and control offered the (presumed male) viewer within the narrative and before the image. The film's narrative, such as it is, advances haphazardly and in fragments, providing few of the markers of authority that privilege a particular spectator position, and the pared-down images leave little to fetishize and possess. Revolving around a series of physically or emotionally violent marriages (the mother and father, and Les and Jingles) or, at best, joyless and barely tolerated relationships (Maisie and George, and Eileen and Dave), the film envisions

little promise in that old chestnut of classical Hollywood cinema: the marriage plot, in which second-reel conflicts resolve into cozy reconciliation. The film evinces little reverence for the patriarchal hero and his domain. *Distant Voices* begins with a marriage, with the family gathered around for a group portrait and the father's portrait hanging on the back wall, an absence that nonetheless lingers in the present festivities. An inordinately long take, this group portrait seems to alternate between a still photograph and a moving picture, between a pose memorialized forever in an image and a momentarily stilled tableau vivant. The father's revenant haunts the image in both of those modes: the photograph in the background hints at his ineradicable presence in the lives of his family; and the moving picture threatens merely to reproduce his likeness into the future, with new generations adopting their prescribed positions within the patriarchal family. The memorable image of his son on the threshold of the family house, crying on the day of his wedding, becomes emblematic of this dilemma: his fear of marriage is a fear of repetition, of his own entry into a system that engendered him and that seems poised to overtake him, continuing ad infinitum. As Steedman writes, "The young man cries because he knows that *it will go on like this*, that nothing will change; that the endless streets, the marriages made like his parents', the begetting of sons and daughters, all will stretch on forever: no end in sight."[138] The film begins with this picture of the father, a snapshot and cliché, and its stuttering, hesitant movements result from a fear of the agonizing sameness it represents. The filmed still lifes divert attention onto the world of objects, resulting in a masochistic, immobile, virtually evacuated image where such repetition comes to a momentary halt. Taken together, the still life and tableau vivant in the films of Terence Davies become a force of arrest, with their limitation lying in their inability to lead elsewhere, and their power best evoked by Benjamin: while "Marx says that revolutions are the locomotives of world history," "perhaps it is quite otherwise. Perhaps revolutions are an attempt by the passengers on this train— namely, the human race—to activate the emergency brake."[139]

But what remains after the singing subsides and the stillness comes to an end? *The Long Day Closes* begins with an exquisite still life of a vase against a black background, bathed in yellowish light, an allusion to the director's predilection for beautiful moments of repose (Figure 5.7). This shot also serves as a transition from the aesthetic concerns of *Distant Voices, Still Lives* and an acknowledgment that the still life itself can also devolve into a lovely but insipid convention. While *The Long Day Closes* revels in moments of stillness, the fear of the father's shadow mingles with the equally devastating and paralyzing dread that nothing will take the place of their broken family, that the dream of arrest might eventually stall the development of a community even after it throws off the burden of clichés past. The most remarkable sequence in *The Long Day Closes* is therefore the most anomalous in its mobility. A stunning crane shot late in the film sweeps over three different "audiences"—spectators

FIGURE 5.7. *The Long Day Closes*

at the cinema, a congregation in their pews during a church service, and a class of students at their desks at school—linking these various models of community even as it critiques the presiding institutions and authorities for remaining beholden to their regnant illusions. With the 1957 pop song "Tammy" by Debbie Reynolds and the voices of a preacher and teacher providing a counterpoint on the soundtrack, this penultimate sequence returns movement and crowds to a film characterized by their absence, and it begins to haunt the intensely still aesthetic that came before it. If the still lifes and tableaux vivants of *Distant Voices, Still Lives* are tormented by the image of the father hanging on the wall behind them, if their overriding fear is endless repetition with future generations embodying that same eerie formation, if the film's stillness hopes to arrest this endless cycle, then *The Long Day Closes* asks what specter will return to trouble, then animate, this beatific tranquility. And as those incessantly mobile crane shots suggest, the evacuated, contemplative, arrested image in a cinematic still life can impose its own form of tyranny. While the title and opening sequence foregrounds the film's exquisitely wrought cinematic paintings, *Distant Voices, Still Lives* is also haunted by the community that remains absent from the screen. Davies disrupts familiar habits of linking images together by lingering on objects and bodies arrested in a pose, but those characteristic devices mark the beginning rather than the culmination of a cinema of painters, a way of reviving and reinventing social institutions rather than a vehicle for escape. Not a symptom of nostalgia for auratic art and museum pieces, these austere films take a detour through the history of art and cinema in order to rediscover what aesthetic and social practices can be preserved when the long twentieth century closes.

Caliban's Books

OLD AND NEW MEDIA IN
THE WORK OF PETER GREENAWAY

In early Westerns there are those classic chase scenes in which we
see a train and men on horses galloping beside it. Sometimes a rider
succeeds in leaving his horse and pulling himself aboard the train. This
action, so beloved by directors, is the emblematic action of cinema. All
film stories use cross-overs.

—JOHN BERGER[1]

The Canonical Artifact in a Thatcherite Moment

Like Shakespeare's original, Peter Greenaway's version of *The Tempest*,
Prospero's Books (1991), dramatizes a series of stormy passages. The most literal
are geographical, as Prospero's exile takes him from Milan to a Mediterranean
island, and after he exacts his revenge, back to his dukedom. But the film and
play (and centuries of criticism) also suggest that the powerful conjurings
of Prospero, his "arts" and "magic," tease us out of a literal mode of reading
and into an allegorical one: Prospero's island becomes an alchemical labora-
tory for a reconfiguration of the geological elements, a microcosm of colo-
nial relations, or a stage peopled only by actors and a director, thereby laying
bare the practice of stagecraft and artistic illusion. While Greenaway's film
performs the literal action of the play proper, it also includes a meditation on
its web of allegories by inserting another narrative, both embedded within and
superimposed on the play: the expanded story of Prospero's books. A running
commentary on the process of "reading" a film, and, in particular, a screen
adaptation, those books illustrate the issues at stake in both a contemporary
filmmaker's encounter with the First Folio and Shakespeare's crossing to the
late twentieth century.

In the extended horizontal tracking shot accompanying the opening
credits, the film enacts a series of exchanges, as a book is passed from person
to person in a space teeming with objects, elaborately costumed and half-nude
actors, and all manner of incongruous sounds. The sequence then continues

into Prospero's library, where his spirits blow dust off the volumes scattered throughout the room. In these moments, the film foregrounds the transmission of a seemingly sacred book within a spectacular setting and, in the process, addresses three issues of overriding concern in contemporary film adaptation: first, will the text be overwhelmed by the spectacle on the screen (as heritage films double as museums for sumptuous period objects) or off (as those films become standard star vehicles)?[2]; second, will the film present an unreflexive, "faithful" rendition of the original, or will it interrogate and unsettle the book's canonical status, and thereby reconsider its exchange value within the "imagined community" it addresses?; and, third, can the film incorporate a classic text without inviting comparisons to an idealized original, without capitulating to that original's cultural capital, without merely blowing the dust off old and venerated volumes?

Prospero's Books is, of course, yet another adaptation of the Bard and it emerged in a moment replete with cinematic Shakespeares, but it also embarks on a formally radical presentation of the play with broader cultural implications. It incorporates books and paintings into a reconfigured cinematic space, situating the viewer (or reader or beholder) in a liminal position somewhere at the crossroads of the arts: as a reader, but of an oddly vertical text; as a beholder of a framed art object, but one that is always in motion; and as a spectator at the movies, but at a film that often threatens to become a still or textualized object. The whole film unfolds in this disorienting environment, a space of instability and heterogeneity, the apotheosis of a Deleuzian "any-space-whatever." The parallel series of Prospero's books tells a related tale: it leads us back through a genealogy of illustrated and illuminated manuscripts, and forward to new technologies that make possible the baroque ideal of an "*entr'expression*" outside the confines of page or screen, and between the categories of text and image. *Prospero's Books* thus relates its *Tempest* in a distinctly baroque idiom designed to undermine the certainties of heritage and the sanctity of the canon. If the viewer expects to find an adaptation of Shakespeare rooted in British history or aligned with a single medium or aesthetic tradition, she instead discovers an interstitial geography and a screen that evokes stages, books, paintings, cinema, and new media. Rather than an authentic evocation of Shakespeare, the film combines an antiquarian fascination with the sounds of early modern English or Italianate costumes and architecture with an embrace of the most cutting-edge digital technology available at the beginning of the 1990s. In his interpretation of *The Tempest* Greenaway explores the mechanics of crossing over from the archaeological to the ultramodern, from a meticulously reconstructed past to the formal possibilities of the digital. At the same time, the film views the play as an allegory for the aesthetic and political implications of this transformation from the past/book to the explosive visuality of the digital future, and it insists that

the archaeomodern impulse never arrives at a stable temporal or formal end-point but instead maneuvers into one more turn.

As it meanders among media, Greenaway's baroque *Tempest* relates its aesthetic concerns to the play's allegory of social boundaries and border crossings. The clash between Prospero's books and their adversaries on the island parallels the problematic relationship between the classic text and the film adaptation, often figured as a conflict between a masterful original and an (un)faithful follower. For this reason, *The Tempest*, one of Shakespeare's most adapted plays, is the emblematic story of literature translated from one "inscription system" to another, especially the adaptation of the book to the screen.[3] A central text in postcolonial theory, *The Tempest* also allegorizes the power relationships played out in its microcosmic society and manifested in the struggle to destabilize the fetishized books that become the instrument and symbol of Prospero's dominance. At the core of the play's various allegories (be they figurations of political struggle or of artistic illusion) lies the book, and in Greenaway's version that privileged object is always undergoing a transformation into a visual medium. Although Greenaway is more renowned as a formal innovator than as an overtly political filmmaker, by foregrounding Prospero's books he implicitly critiques the social and cultural status of the book, an act with wider implications in a Thatcherite moment when Britain's literary heritage served more than ever as a mooring in a reified national past. As a film about books, a visualization of the spoken and written word, a farrago of anachronistic visual and literary cultures displayed in digitally constructed images, a clash between the First Folio and new technologies of representation, and a revisionist reading of Shakespeare in the heyday of heritage films, *Prospero's Books* emphasizes the kindred nature of these aesthetic and social concerns, while it also experiments with a neobaroque idiom capable of supporting such cross-overs.

Prospero's Library and the Unbound Book

Prospero's Books seizes on a promising conceit for its presentation of *The Tempest*—promising because the books in Shakespeare's play, although they serve as mere props for most of the action, also function as a site where the agonistic relationship between Prospero and his subjects is contested. Each mention manifests a different conception of the utility and authority of the book and establishes a continuum of power relations marked by varying degrees of access to power through language and the aura of the canon. Prospero first broaches the issue early in the play, as he recounts his ouster from the seat of power in Milan and his hastily arranged exile. Upon his departure a "noble Neapolitan, Gonzalo," arranges "out of his charity" to provide

"rich garments, linens, stuffs, and necessaries" to soften Prospero's fall from grace. Prospero also says of Gonzalo:

> Knowing I lov'd my books, he furnish'd me
> From mine own library with volumes that
> I prize above my dukedom.
>
> (1.2.165–168)[4]

Prospero's thankfulness rests on a qualitative distinction between the books and political power, as he elevates those volumes to a status above and beyond the realm of dukedoms and "Absolute Milan." But this dichotomy between worldly ambition and a rarefied conception of literature and pure knowledge contrasts dramatically with the play's further action: Prospero draws on the knowledge and instrumental value contained in his books to summon a storm and avenge the usurpation of power in his dominion. As Caliban makes clear when plotting his own escape and revenge, those books lie at the core of his master's actual and mystified power. Instructing Stephano and Trinculo on the surest means of performing a coup, he says,

> Remember
> First to possess his books; for without them
> He's but a sot, as I am; nor hath not
> One spirit to command: they all do hate him
> As rootedly as I. Burn but his books.
>
> (3.2.91–95)

Homi Bhabha traces a similar trajectory of thought into the nineteenth century and beyond, as the "English book" continues to elicit the mixture of fear and wonder evident in Caliban's words. In the colonial context, the battle of the books becomes a struggle over power, origins, and, ultimately, the "status of truth." Bhabha writes that "it is precisely to intervene in such a battle for the *status* of the truth that it becomes crucial to examine the *presence* of the English book. For it is this *surface* that stabilizes the agonistic colonial space; it is its *appearance* that regulates the ambivalence between origin and *Entstellung*, discipline and desire, mimesis and repetition."[5] For Bhabha, the "English book" comes to embody the paradox of the colonial situation: even an object of obscure origins can become "an insignia of colonial authority" and a source of unified power, while the "signs" contained within this "wonder" are productive of endless hybridity and dissemination.[6] Thus, the book—as surface and insignia—transforms literature as a phenomenon of language into a mystified symbol and instrument of colonial power.

With books arrayed everywhere on shelves and desktops, with the massive cast of characters constantly engaged in reading and writing, with words inscribed on surfaces of stone, paper, water, and celluloid, Greenaway's film presents an extended meditation on the relationship between the mystical

authority of the book and the hybridizing act of reading and writing. More than just a cinematic performance of *The Tempest*, *Prospero's Books* provides a running commentary on the struggle between the book as a cultural object and the text it strives but fails to contain. Greenaway saturates the screen with a torrent of rich visual detail, overwhelming the signs on the page, reintroducing the many aspects of the word elided in the moment of inscription. The director has described the film as the process of a mind reviewing its contents, as a recapitulation of "the masses and masses of knowledge that a scholar accumulates, some of it quite wasteful, some of it quite bad."[7] And he has maintained that all works of art are "encyclopedic by nature," the product of a reconfiguration and manipulation of cultural allusions.[8] The film's baroque mise-en-scène, deep-focus cinematography, and constantly moving camera reveal just such an encyclopedia of allusions through that flood of visual images, startling in their number and density. The long horizontal tracking shot that accompanies the opening credits surveys a group of figures with an allegorical relationship to water, the subject of Prospero's first book. Noah, Moses in the bulrushes, Leda and the Swan, and Icarus all make cameo appearances as the visuals virtually exhaust the connotative capacity of the word "water," made visible and audible in the rhythmic dripping that begins and ends the film. Add to this the visual pun on "making water" as Ariel urinates and Prospero calls forth a storm, the toy galleon and countless other nautical references, the waves and waterfalls, the bathhouse supplied with "large, exotic shells and a basin and brushes, sponges and towels," and the visual images begin to reflect some of the connotations and cultural complexity of the word.[9]

From this perspective, the film meanders through the reading process in a fashion reminiscent of Roland Barthes's *S/Z*, which also represents a reading experience through an expansive annotative apparatus. The volumes in Prospero's library serve as an outline of Renaissance knowledge and, adjusted for time and place, make visible the "Books" of cultural knowledge, which construct the paradigm of any reading experience and which Barthes cites in his study of Balzac's novella. In many instances, Prospero's books share the title or thematic concern of Barthes's mythic reference works: both have a *Book of Love*, for example, and both attach special importance to the standards of popular science and mythology. Indeed, Greenaway's oeuvre as a whole, particularly the aesthetic based on seventeenth-century Dutch and Italian art that governs *Prospero's Books*, could function serviceably as a chapter of Barthes's *History of Art*. Greenaway's most recent work—from the collection of images of flight on display in *Flying Out of This World* (1994) to his digital re-creations and annotations of Old Master paintings to his series of films based on Dutch art—has expanded the more marginal art historical dimension present in all his films into one of his primary preoccupations, as he compiles an archive of ingrained habits and unexamined possibilities for seeing. Greenaway once commented on a "slightly facetious note" that "If *The Cook, The Thief* . . . was

a film about 'You are what you eat', *Prospero's Books* is a film about 'you are what you read.'"[10] Conceived in that spirit, Prospero's array of books confronts us with an encyclopedic version of the "school manual" that tutors Barthes's reading of the cultural codes, the book most responsible for constructing our experience as readers. Like his earlier work in *A T.V. Dante* (1989), which inserts scholarly commentary into a wildly illustrated and animated visualization of the text, Greenaway's *Tempest* spotlights the gamut of cultural knowledge and institutions that inform and interfere with the reading process. Jonathan Romney argues that Greenaway adds to "the cacophony of Prospero's 'isle full of noises' . . . a visual and conceptual 'cacography'" that both invites and defies the reading process (Figure 6.1).[11] In doing so, Greenaway performs one of the essential functions of literature because, as Barthes says, "Literature is an intentional cacography."[12] The film creates a field of "static" between author and reader, and Greenaway's visual excess performs a similar function, as the images ramify to the verge of "countercommunication."[13]

The tour of Prospero's collection of books also provides a compendium of theories of reading, and the various volumes establish a range of possible relationships with the reader. While Miranda flips through the enormous *End Plants*, for example, she introduces a profusion of leaves and flowers, one per page, with hundreds of potential variations. From the initial categorization signaled in the title, the complexities of language unfold moment by moment, recalling the devolution from "primal form" to specific utterance described in Friedrich Nietzsche's "On Truth and Falsity in Their Ultramoral Sense," an early gesture in the direction of poststructuralist literary theory. Nietzsche writes, "Every idea originates through equating the unequal. As certainly as

FIGURE 6.1. *Prospero's Books*

no one leaf is exactly similar to any other, so certain is it that the idea of 'leaf' has been formed through an arbitrary omission of these individual differences, through a forgetting of the differentiating qualities, and this idea now awakens the notion that there is, besides the leaves, a something called *the* 'leaf', perhaps a primal form according to which all leaves were woven, drawn, accurately measured, coloured, crinkled, painted, but by unskilled hands, so that no copy had turned out correct and trustworthy as a true copy of the primal form."[14] Far from exhaustive despite its length, Prospero's book of *End Plants* exemplifies visually the failure of language to contain the manifold particulars and rich ambiguity of a world beyond the ideal form of the word. The mere presence of the diverse objects glued to a page demonstrates the inadequacy of the title signifier's taxonomic gesture. And with water and swimming bodies filling a letterbox-like frame around the book, the film rapidly becomes a fluid spectacle that surrounds and overwhelms the page rather than a ritual of devotion to language and its vessels.

Likewise, *A Book of Love* underscores the limitations of the word by extending the metaphors inevitable in all language into the doubly metaphorical realm of abstraction. If the word tends to eliminate all traces of difference and circulate around what Nietzsche calls a "*qualitas occulta*," this *Book of Love* provides only a brief glimpse of a "naked man and woman" and "clasped hands" while everything else remains "conjecture."[15] Beyond these literal figures of love, the pages are unable to materialize the concept promised by the title, and its contents remain elusive and ineffable. As Greenaway writes in the screenplay, these icons "were once spotted, briefly, in a mirror, and that mirror was in another book."[16] All such abstractions are founded on an infinite *mise en abyme*, and as in Paul de Man's theory of reading, the abstraction is writeable only through the invocation of an endless regression of further abstractions. The naked bodies provide a figure for "love" not because of any necessary connection between the picture and some essential form of affection—they could introduce a *Book of Lust* or *Gray's Anatomy*—but because Renaissance convention dictates such a figuration, or perhaps more accurately, because the privileged signifier on the spine announces their presence as "Love." As de Man writes of an allegory of *Karitas* in a Giotto fresco, "We accede to the proper meaning by a direct act of reading, not by the oblique reading of the allegory."[17] A strict "thematic" reading of the allegory therefore forecloses other readings, other "incompatible meanings between which it is necessary but impossible to decide in terms of truth and error."[18] All reading, for de Man, entails a manner of "crossing, or chiasmus" between "two modes of reading," between the "literal" and the "allegorical." *Prospero's Books* constantly performs this sort of crossing, as a literal reading of the play performed on the screen alternates with various allegorical readings that center on the archive presented through those books.

A Book of Mirrors implies a purely subjective relationship between reader and text, with the mirrored pages serving both as a reflection of a beholder's

desires and, as Maurice Yacowar argues, a "prototypical postmodernist fabrication" in which different "sheets of past" are conjured up on the "pages" of the book.[19] Instead of reflecting a "realistic" vision of a world external to the text or reader, the mirrors show a world of "lies," a world seen "backwards, another upside down," and finally a *mise en abyme* in which, again, "one mirror simply reflects another mirror across a page."[20] *A Book of Mirrors* abandons all conceptions of literature as mimesis, and the book physically enacts the dissolution that its pages evoke, as quicksilver drips down the page, the most explicit illustration of the immateriality of the sign. This liquefied text also announces its kinship with Prospero's first book: *The Book of Water*, the Ur-text of both the island and the library, as all writing emerges from the liquid in Prospero's inkwell and all of the books are subjected to a final drowning. The drips of water at the film's beginning and end, the pool where Prospero writes and conjures up the tempest, and the misty atmosphere that thickens the air into a medium for spectacular light effects all establish water as the master element in the world of the film, pitting its fluid amorphousness against the imaginary unity that each book strives to uphold.

Perhaps most exemplary of Greenaway's conception of the book is *A Book of Motion*, an unruly volume that lies in Prospero's study, restrained Gulliver-like in a web of straps and buckles, spilling the ink perched on its cover with its incessant rumbling. This animated volume demonstrates "all the possibilities for dance in the human body" and most directly questions the unitary conception of the book, as it threatens to escape its comic discipline and unbind itself, joining the cascade of pages filling the air in Prospero's library.[21] The book also demonstrates in its unseen insides "how the eye changes shape when looking at great distances," another affirmation of the beholder's role in a transformation and re-creation of the site or object seen.[22] The mythical integrity of the book as an object, as an element in a scholarly still life arranged on a dusty desk, begins to disintegrate as the book is cracked open and its contents examined.

Prospero's library also harbors an alternative genealogy of the book, one that emphasizes a tradition of visuality leading from illuminated and illustrated manuscripts to contemporary digital media. Greenaway has argued that "cinema is related to 2000 years of image-making in Europe," and his idiosyncratic history of the book situates one branch of bookmaking within that tradition of image production.[23] Using high-definition television facilities for the editing and effects processes, Greenaway added motion and depth to the flat images stamped or drawn into the surface of the book.[24] On the pages of *A Harsh Book of Geometry*, the diagrams of the Renaissance science of space are updated by televisual technology, as computer-generated shapes and figures inhabit and animate geometric principles. Similarly, in *Architecture and Other Music*, virtual structures rise from the page as though from a pop-up book before undergoing a final, undetectable transformation into physical sets. Prospero introduces the book and describes its contents, only to summon

forth the visible and ultimately the material structures, through which he soon strolls.

Such animation and materialization of textual images, as Romney argues, "contribute[s] to a general undermining of the smooth surface of the text, obstructing the (already slender) certainties of the play with words' tendency to become flesh (or water, or metal, or colour, or any of the other metamorphoses the book exhibits)."[25] The film presents a variation on Borges's "Chinese encyclopaedia," or a book collection organized with total disregard for Dewey and his decimal system.[26] In Greenaway's conception, the book belongs not in a library traditionally defined but in a museum of image making and intermediality founded on an alternative organizing principle. The book is a space where architecture coexists with related manifestations of "music," and where text and image body forth the same lineage. The film not only adapts *The Tempest* to the screen, but also translates the text into a flood of literal, architectonic images that deconstruct categorical distinctions between the book and visual culture and employ what Walter Benjamin describes as the translator's most effective strategy: "For if the sentence is a wall before the language of the original, literalness is the arcade."[27] As Rey Chow points out, translation "is primarily a process of *putting together*. This process demonstrates that the 'original,' too, is something that has been put together. . . . It is *also* a process of 'literalness' that *displays* the way the 'original' itself was put together—that is, in its violence. . . . What needs to be translated from the original . . . is not a kind of truth or meaning but the way in which 'the original' is put together *in the basic elements of human language—words*."[28] Greenaway's adaptation, at times literally word for word, both demonstrates how those words were themselves "put together" and performs their disintegration into constituent elements. The result is not the standard "literate" adaptation, which attempts to emulate the canonical status of a literary object, but a "literal" film that deconstructs its subject into infinitesimal elements and translates them, word by word, and image by image.

Prospero's Books also demonstrates how films are "put together," and its anachronistic books propose a forward-looking lineage, one that prefigures the age of mechanical reproduction, cinema, and a new generation of digital technology. Greenaway positions protofilmic moving images prominently in his mythical texts. For instance, in *Ninety-Two Conceits of the Minotaur*, a hybrid bird-man leaps from the flipping pages in a reenactment of the experiments of Étienne-Jules Marey, the pioneering inventor of a series of precinematic devices, and the inventions of Eadweard Muybridge, who translated the same principles into a new technology whose mechanical movement more closely resembled cinema (Figure 6.2). (Greenaway suggests in the screenplay that Caliban, who becomes allegorically associated with cinema as the film progresses, "would find this book of great interest.")[29] Likewise, through a seemingly misplaced image of a boxer, *The Autobiographies of Pasiphae and Semiramis* also refers to

FIGURE 6.2. *Prospero's Books*

later manifestations of the moving picture, namely, the first filmed heavyweight fight, a match between Ruby Robert Fitzsimmons and Gentleman Jim Corbett in 1897.[30] This series of animated books is imprinted with a history of cinema and constantly folds between these domains. The references to film history continue Greenaway's longtime interest in the possibilities of early cinema, possibilities that the institutionalization of classical narrative structures often foreclosed.[31] In films like *The Draughtsman's Contract* (1982) and *A Zed and Two Noughts* (1986), the meticulously rendered or photographed scene—art conceived as a means of circumscribing nature or as a tool of social or biological science, as in the motion studies of Frank Gilbreth or Muybridge—coexists with other conceptions of the visual image: as anarchic excess and as a site for the irruption of the uncanny. Through a series of metamorphoses, *Prospero's Books* transforms the traditional site of inscription into a medium more akin to cinema, a place where image and text occupy the same ontological sphere and where the visual excess reminds us of the book's tendency to limit the ramifications of the text. The film itself displays the strategies that such a transformation entails.

Illuminated Manuscripts

The film's presentation of Vesalius's lost *Book of Anatomical Birth* alludes to a long tradition of paintings that address the relationship between text and image within the context of a disfiguring violation of bodily integrity, the most notable being Rembrandt's *The Anatomy Lesson of Dr. Nicholaes Tulp* (1632) and Thomas Eakins's *The Gross Clinic* (1875). In the former, the actions involved in

painting and writing are performed and displayed within the operating the-
ater, identifying "the painter with the role of one—butcher, hunter, surgeon—
whose hand cuts and delves into the body."[32] Both Rembrandt's painting and
Greenaway's invocation establish an intimate connection between paint, text,
and flesh, and between the institutional spheres associated with each: mu-
seum, library, hospital, and slaughterhouse. As Bridget Elliott and Anthony
Purdy point out, Greenaway's work shares Georges Bataille's interest in the
conjunction of exalted and abject social spaces, a concern expressed most suc-
cinctly in Bataille's short dictionary entries on "The Museum" and its shadow
space, "The Slaughterhouse."[33] In his study of Eakins, centering on *The Gross
Clinic*, Michael Fried situates the painter's work within a related problem-
atic in the late nineteenth century. Eakins was educated by a writing master
father who considered penmanship an extension of the visual arts and in a
school system in which drawing and writing both were considered graphic
arts subsumed by what Fried calls the "writing / drawing complex."[34] Fried
discusses the spatial organization of Eakins's work as an attempt to reconcile
the horizontal surfaces of writing and the vertical orientation of the painted
canvas. He sees in Eakins's paintings of rowers on the Schuylkill River, for ex-
ample, a sheet of water extending horizontally across the perspectival system
of the canvas's constructed space; and he sees in the ripples on water a graphic
equivalent of the words that crop up more conspicuously in other paintings—
in scraps of paper incorporated into the composition, in carvings on wooden
surfaces within the painting, and in frames where Eakins (an accomplished
woodworker) inscribed relevant passages, thereby transgressing both the tra-
ditional compass of the frame and the perceived boundaries between script
and picture. His frame for *The Concert Singer* (1892) beckons toward a further
medium, as he carves thereon the opening bars of a Mendelssohn opera, as if
giving voice to the singer pictured on the canvas. Fried sees in *The Gross Clinic*
the apotheosis of these intermedial concerns, as the bloody, scalpel-wielding
hand of the surgeon becomes an iconic figure for the writing and painting hand
as well, conflating various modes of art and science in one unsettling image.
Eakins further embodies the writing process through a doctor (modeled on
himself) transcribing notes from the operation on an unseen book, but x-rays
of *The Gross Clinic* have revealed traces of another picture of a rower on the
water, a subliminal configuration of horizontal, waterlike, writing surfaces be-
neath the less obviously inscribed anatomy lesson. Thus beneath the surface of
the painting, the implicit depth of the medium enacts the thematic concerns
laid bare on its surface.

 In Greenaway's film, scenes of reading and writing present those processes
both in medium shots, which show Prospero at his desk with the book, and
in extreme close-ups of the words themselves. These two compositions re-
flect different paradigms of cinematic space: the former, a mise-en-scène
tradition that emphasizes composition in depth and the long take designed

to communicate through choreographed movements and the meticulous placement of objects; the latter, a more frontal and vertical model, in which most information exists on the surface, as though contained in a book held upright. The scene in the operating theater demonstrates the tension between these two spaces, between the operating table, which extends in depth surrounded by a throng of onlookers, and the screen's vertical surface, whose flatness is underscored by an internal frame and by diegetic spectators beholding the scene as though it were a painting. The anatomy lesson exists both in depth, as the camera circumnavigates the space in which the scene unfolds, and as a framed surface, as the camera pulls back through that frame, dissolving ultimately into the superimposed text of Vesalius's book itself. By overwriting and redesigning the filmed image with the Quantel Paintbox available in the studios of NHK, Japan's largest broadcasting corporation, Greenaway suggests that he wields as much freedom to manipulate the image as a painter has when working on a canvas.[35] Through this movement of the camera and subsequent act of inscription, Greenaway underscores the both/and or neither/nor status of his medium in relation to its constituent arts. Instead of staging a performance of canned theater or an insistently literary adaptation of a classic, the film uses digital pyrotechnics to reaffirm the potential hybridity of those arts and the cinema.

In both Rembrandt and Eakins this violation of boundaries also bears the burden of castration, disfiguration, and what Fried calls a "wounding of seeing": the depicted assault on the body is both "painful to look at . . . and all but impossible, hence painful, *to look away from*."[36] Greenaway's work often returns to painful visions, to images that both draw attention and shock the eye because of their content and their transgression of the boundaries between media. *Death in the Seine* (1989), his documentary about bodies recovered from the Seine between 1795 and 1801, foregrounds the act of inscription, as it focuses on notations by two morticians, Bouille and Daude, who receive and catalog the bodies. The film also displays the bodies of actors standing in for corpses dragged from the river, the matter-of-fact word yielding to what C. David Bertolini calls the "post-mortem image," the cinematic cadaver that remains hauntingly proximate to life.[37] Their fate already pronounced, some of the bodies also seem to hover between life and death, as the twitches of the actors and actresses momentarily revive them, and as one "dead" character rises to get a drink of water and returns to her pose, the actress reminding us that performing in cinema has often involved wandering between two temporalities and between life on-screen and the death of a historical figure whose official fate has already been declared in writing.

Using the same strategies—the superimposition of image and text and the multiplication of media—*Prospero's Books* reframes the crossing over between language and image, word and flesh, museum and slaughterhouse as the fundamental act of making art rather than an assault on the body and embodied

vision. Text and image occupy the same ostensible space, and their transparency allows the two to bleed together until previously separate identities and spaces become indistinguishable. As Greenaway writes in the screenplay, when Prospero inscribes the play's first words and they appear vertically on the screen, occupying the entire frame, "for the moment, there is no clue whatsoever where this handwritten word on paper is situated."[38] These words are, for the moment, written outside the book, occupying a liminal, disorienting space at once horizontal and vertical, and neither. Just as the books disintegrate, signifiers disseminate, and diagrams are animated in the film, text and image lose their separate identities and merge onto one hybridized screen that has become a site of translation and transgression rather than medium specificity and purity. Such moments unfold in the apotheosis of Gilles Deleuze's "any-space-whatever," or a "perfectly singular space, which has merely lost its homogeneity . . . so that the linkages can be made in an infinite number of ways. It is a space of virtual conjunction, grasped as pure locus of the possible."[39] Greenaway's most recent cinematic and digital paintings—including *Nightwatching* (2007), his film about Rembrandt's *The Night Watch*, and his series of installations titled "Nine Classical Paintings Revisited," an attempt to re-create paintings by making them move and speak, by rendering them cinematically—jettison the baggage of medium specificity and explore the intermediate grounds between art forms and temporalities. They do not belong in or belong to the past or the present, painting or cinema. Greenaway's multiyear multimedia project, *The Tulse Luper Suitcases*, uses films, DVDs, websites, installations, and books to recount an idiosyncratic history of the nuclear age. The suitcases serve as both metaphorical containers in the digital environment and physical objects in the gallery, and they overwhelm through the sheer volume of information, curiosities, and memories they contain. The suitcase becomes a transitional vessel that links the twentieth and twenty-first centuries by embracing the qualities of both the virtual and material realms and balancing the threat of media obsolescence with the old-fashioned habits of the collector. At once digital creations that exist primarily on-screen and bulky objects arranged in a room, the suitcases in *Tulse Luper* invoke an alternative conception of space and form, and they resist the intellectual habits that draw clear distinctions between media and their proper spheres of influence and action. Foreshadowing this career-defining turn in Greenaway's work, *Prospero's Books* explores an any-space-whatever and a terrain of deterritorialization that deviate from ingrained viewing conventions. In these environments the aesthetic migrates into the social dimension, and a cinematic "nomad space" clashes with Prospero's claims to ownership of the island. Alternately oblivious and hostile to the chaos surrounding him, Prospero writes, entrusting his words to the familiar confines of the book or using his library as an instrument of control. But this paradigm of both the book and the island as bounded territory becomes increasingly untenable, as the film

foregrounds another model of the arts, including the book: as multiplicity, assemblage, and "line of flight."[40]

Soon after the anatomy sequence, Prospero's quill returns to the inkwell, and his calligraphy re-creates more moments from the play. Shot in extreme close-up, the quill in a container of limpid blue liquid is a metaphor for the process of writing on-screen and for the transition between the surface of writing and the fluidity and depth implied by the camera in motion. Running fuguelike throughout the film, this close-up of the inkwell calls attention to the medium that both makes inscription possible and colors and transforms all representation. Like Prospero's quill plumbing the depths of its well, Greenaway's digital paintbox and *caméra-stylo* likewise negotiate the passage between surface inscription and depth, between the word and the meandering it compels. As Andrew Higson says of the British "heritage film," "Literary authorship, the process of writing itself, is foregrounded in the recurrent narrative episode of a character writing or reading a letter or a book, either aloud or in voiceover, thus celebrating the purity of the word."[41] In contrast, *Prospero's Books* celebrates the extravagant *impurity* of the word, reveling not in the books themselves, but in the ramifications they initiate. An illusionist in the tradition of Georges Méliès, Greenaway runs the risk of drowning the text in the eye-catching potential of new media and the spectacular baroque environment that envelops the film's source material. But the trajectory of the film emphasizes that the reader and viewer are already engaged in spectacular and hybridizing cognitive processes, in a crossing-over between modes of reading and between words and images.

Critics over almost three decades have described Greenaway as a baroque filmmaker, establishing him as one of the exemplary figures in this neobaroque tendency in the late twentieth century.[42] Others, including Michel Ciment and Greenaway himself, describe the filmmaker as a "mannerist" haunted by the legacy of his predecessors and fascinated by historical figures from the mannerist age, including, most recently, the Dutch printer and engraver Hendrik Goltzius.[43] Regardless of the terminological disparities, all of these critics underscore either the burden or the potential liberation of the artist who arrives late in a tradition, as well as the period's anticlassical impulse, with Greenaway's elaborate, convoluted works providing one example of his departure from classical models, be they literary, painted, or cinematic. Benjamin writes that the baroque differs from the Renaissance in the object of its inquiry: the baroque shifts its attention from the universe to the library; it meditates on the archive, envisioning the world only through the mediation of those collected texts.[44] The neobaroque tendency in contemporary cinema likewise involves an exploration of libraries and museums, and it often adopts a critical approach to contemporary mobilizations of the heritage housed in those settings. This phenomenon is most evident in the work of Derek Jarman and Sally Potter in Britain, and on the Continent in films by Jacques Rivette,

Raúl Ruiz, and Jean-Luc Godard during the 1980s. Through its radical impurity and its incessant rummaging through an archive of archaic knowledge, *Prospero's Books* offers an extreme case in which this baroque or mannerist tendency assumes its most extravagant form.

According to Deleuze, the baroque (in both its historical and contemporary manifestations) is characterized primarily by an idiom based on "the fold," as described by Leibniz. After the calligraphy of the earliest scenes establishes the curved rather than the perpendicular line, the baroque rather than the classical, as the film's fundamental graphic principle, *Prospero's Books* devolves into a mass of seemingly endless convolutions. The entropic shots of innumerable books unbinding, for example, are a visualization of the film's aesthetic principles: these shots suggest that the book and the film do not consist of a series of discrete, flat sheets or images leading from a beginning to an end, but a mass of curves, convolutions, and folds that, like the baroque in Deleuze's definition, "unfurls all the way to infinity."[45] Greenaway's later work in *The Pillow Book* (1996) offers a further instantiation of this process, as it discards the sheet of paper altogether, replacing it with the single, idiosyncratically undulating and involute surface of the human body, which serves as the site of inscription for the omnipresent calligraphic curves. The body reveals the kindred curvature of the book that it becomes. *Prospero's Books* also rehearses the director's obsession with mathematics and geometry, but rather than a Cartesian or Euclidean system, Greenaway's film operates within mathematical ordinances modeled on what Deleuze calls Leibniz's "Baroque mathematics," in which the "straight line always has to be intermingled with curved lines."[46] Greenaway's mathematical bent and obsession with graphic systems derive less from a compulsion to impose an exogenous order on his films than the desire to use those foundations as a staging ground for another universe.[47] Prospero's twenty-four books, a number chosen to replicate cinema's twenty-four frames per second, present themselves not as a sequence of discrete objects, but as a series of unfoldings, with each book becoming the source of endless visual ramifications. Each of the books, and by extension, each of the frames, becomes a gesture toward "incompossible" worlds, toward the alternate referents and media elided in the moment of inscription. In *Prospero's Books*, as in Leibniz's baroque philosophy, the "monad" "is the book or the reading room," from which the film constantly folds into the alternative, incompossible spaces, media, and images that exceed Prospero's initial attempt at circumscription.[48] As Deleuze puts it, "The visible and the legible, the outside and the inside, the façade and the chamber are, however, not two worlds, since the visible can be read (Mallarmé's journal), and the legible has its theater (both Leibniz's and Mallarmé's theaters of reading). Combinations of the visible and the legible make up 'emblems' or allegories dear to the Baroque sensibility. We are always referred to a new kind of correspondence or mutual expression, an *entr'expression*, fold after fold."[49] By following these baroque

curves, Greenaway suggests that an authoritative ideal posited on the stage or page is itself a fiction. The film becomes the cinematic equivalent of what W. J. T. Mitchell calls "ekphrastic hope," the belief that crossing over—between genres, media, and modes of reading—is the foundational trope of language and the arts.[50]

A Nomadic Shakespeare and the Confines of Heritage

Why undertake all of these formal and technical innovations in a screen version of *The Tempest*? What do Prospero's books, HDTV, the palimpsest of text and image, and the countless idiosyncrasies of Greenaway's *Tempest* have to do with Shakespeare's original? These questions subtend many critical responses to the film, and their answers determine whether *The Tempest* provides more than just an occasion for televisual pyrotechnics and whether Greenaway's rendering of the text affects the play's interpretive tradition in any significant way. Many critics have explored the relation between the autobiographical elements that unite the play with the film. While Prospero's farewell to illusionism at the end of the play seems to signal the playwright's departure from the conjurings of pen and stage, the actor John Gielgud and Greenaway, conflated in the figure of Prospero, also announce their exits: the octogenarian actor says farewell after a half-century playing Prospero on the stage, while the director embraces new media after a career working primarily as a painter and filmmaker. The fantastic surroundings of Prospero's island also afford a dramatically coherent opportunity for Greenaway's technical and formal innovations. Because Prospero practices his own brand of magical "arts," Greenaway's tricks are justified in the diegesis. But the play's "isle full of noises" provides more than a fantastic setting for the film, and its characters are more than figures for its various authors. As a tradition of postcolonial readings has demonstrated, the play is structured around the relationship between a dominant power and its others, constructing their difference through alterity of language and the body, through the discrepancy between the curses emanating from the "monster" Caliban and the standards of linguistic and bodily propriety established by Prospero and enforced by his minions.[51]

From the First Act, Caliban's character is marked by a lack, by a seeming deficiency in his capacity to communicate and, by extension, to move beyond mere reference to artful turns of phrase. Miranda, for example, emphasizes her own role in bestowing the power of language on Caliban. She says,

> I pitied thee,
> Took pains to make thee speak, taught thee each hour
> One thing or other. When thou didst not, savage,
> Know thy own meaning, but wouldst gabble like

A thing most brutish, I endow'd thy purposes
With words that made them known.

<div align="right">(1.2.353–358)</div>

Miranda's refusal to value the full range of communicative practices
underscores the fact that the hierarchy of signifying systems is founded on
indifference or ignorance. Such a tenuous hierarchy needs and receives con-
stant reinforcement, as Prospero's "spirits" "set upon" Caliban to punish "every
trifle," making their status known through their mocking "mow and chatter,"
their display of superiority in matters of language. Caliban says,

> sometime am I
> All wound with adders, who with cloven tongues
> Do hiss me into madness.

<div align="right">(2.2.12–14)</div>

And Caliban's lines often resemble a kind of doggerel, bearing few of the
trappings of poetry present in the speech of Ariel, for example, who breaks
into rhyme and song at every opportunity. Caliban's language thus exists in a
tacit hierarchy, which renders his every utterance deficient when compared to
the posited, imagined ideal. Caliban's linguistic alterity is accentuated in the
film by the mechanical reverberations that accompany his lines, in stark con-
trast to the clipped, precise enunciation of the other impersonated lines, nearly
all recited by Prospero. Played by one of Britain's most renowned "theatrical
knights," Prospero inherits the mantle of a long tradition of stagecraft; Caliban's
lines sound like the product of a soundstage and technological manipulation.

The binary logic of the island's social system becomes most apparent when
Prospero invokes Caliban's position in the hierarchy during an extended crit-
icism of Ferdinand and his co-conspirators. Implicitly reinforcing already es-
tablished hierarchies, Prospero says of Ferdinand,

> To th' most of men this is a Caliban,
> And they to him are angels.

<div align="right">(1.2.481–482)</div>

A similar form of binary logic situates Sycorax, a witch and Caliban's mother,
at one end of a spectrum that confirms Miranda's status as elevated beyond any
possibility of comparison. According to Caliban, Prospero

> himself
> Calls her a nonpareil. I never saw a woman
> But only Sycorax my dam and she;
> But she as far surpasseth Sycorax
> As great'st does least.

<div align="right">(3.2.99–103)</div>

Miranda's status is only affirmed by the seeming impossibility of other Mirandas, by the unthinkability of her being equaled, by the assertion that her beauty is "nonpareil," "perfect and peerless." Deprived of contact with women because of his isolation on Prospero's island, Caliban attributes this policy to Prospero's fear of his ability to reproduce and to be reproduced. Without Prospero's restrictions, Caliban says,

> I had peopled else
This isle with Calibans.

> (1.2.350–351)

If Miranda's value derives in part from an enveloping aura of uniqueness, Caliban's negative valence results from the absence of that aura, as he becomes the embodiment of unrestrained reproduction and reproducibility. An "abhorred slave" and "capable of all ill," according to Miranda and Prospero, Caliban's debased state is marked not only by this fear of his potential ubiquity, but also by his resistance to Prospero's efforts at redirection. To his master, Caliban will forever remain outside the established linguistic order, at the lower reaches of the established hierarchies because he operates in a body and a language "which any print of goodness wilt not take" (1.2.352). And in the film Prospero makes every effort to overwrite him, as among the written lines appearing on the screen, the majority belongs to Caliban. If his speech is unrefined by the rarefied standards of the likes of Miranda and Ariel, Caliban is doubly disturbing to Prospero because he remains so resistant to this reinscription and beyond the reach of books and print culture. This outsider status is accentuated in the film, as Caliban's first appearance is accompanied by a frenzied defilement of books, with excrement and vomit serving as a weapon in this attack on Prospero's instruments of power, the body thus serving as a defense against the book.

In *Prospero's Books*, Caliban's departure from his master's ideals is also a function of visuality and the body, of his relentlessly physical and sexual presence in a world where the body is everywhere else de-eroticized. Relegated to the lower reaches of the linguistic order, Caliban becomes a phenomenon of movement and the body. Played by the dancer Michael Clark, Caliban is in constant motion in the film, and his incessant writhing emphasizes his difference from the stillness of Prospero at work in his study, from the library, where only the falling pages break the dusty stillness, and from the grand halls, where every movement seems eerily controlled and choreographed. Like *The Book of Motion* strapped down in Prospero's reading room and subject to violent restraint, Caliban shares a propensity for movement, identifying him as a target for his master's impulsive discipline. Caliban's body is likewise stamped as outside the bounds of normality by its hypersexuality, by the visualization of Prospero's fears in the exposed, raw genitalia of the "vile creature" he has kept isolated from his daughter since their childhood. His threatening, overt, and proscribed sexuality

stands in stark contrast with the playful urination of the various Ariels and unself-conscious nudity of the other spirits, whose actions all recall the Freudian conception of an infantile sexuality that predates social interdiction.

Caliban, the book's other, becomes the embodiment of the opening lines of Fredric Jameson's *Signatures of the Visible*: "The visible is *essentially* pornographic, which is to say that it has its end in rapt, mindless fascination; thinking about its attributes becomes an adjunct to that, if it is unwilling to betray its object."[52] Like Miranda and Prospero, who situate Caliban at the lower, debased end of all hierarchies based on language and the body, Jameson dismisses the inscrutable visual image as an essentially prurient mode of communication.[53] According to this formulation, any attempt to study the image must betray it by translating it into a more intelligible linguistic order, a movement signaled by Jameson's title, which itself imagines that the visible must leave a "signature" to be properly understood. *Prospero's Books* received caustic criticism in the mainstream press on related grounds, because of the visual excess presented on-screen and, in particular, the extreme degree of nudity. Critics have questioned whether the legions of nude bodies fit within any coherent thematic structure. The most voluble source of this incredulity remains H. R. Coursen's descriptively titled "'Tis Nudity."[54] Greenaway has offered only a tepid defense against charges of gratuitous sensuality, situating his costumes (or lack thereof) in Renaissance theatrical conventions, but, as Keith Gumery observes, the unclothed human figure in his films often assumes the unconstrained, liberating form of "being as being" or "body as body" instead of adhering to a prescribed identity.[55] This presentation also serves an important thematic function, as it embodies, embraces, and attempts to transvalue all of the standard early prognostications about the harmful effects of cinema, and now the new media with which Greenaway engages. The film is carnal, hyperkinetic, hybrid, and all of Prospero's worst fears realized before us.[56]

In her study of "film and the rival arts," Brigitte Peucker sees in Balzac's *Sarrasine* one explanation of the problematic status of the body in intermedial representations: "one body constitutes the model for sculpture, painting, and narration; transposed repeatedly from one medium into another, it may be said to embody the meeting point of all the arts."[57] Now old, "motionless and somber," with a "cadaverous skull" and smelling of death, this abject body appears to the narrator as a "creature for which the human language had no name, a being without life, a form without substance."[58] Seen together with a beautiful young woman, "this shadow" causes the narrator to gasp at the vastness of their difference: "ah! here were death and life indeed, I thought, in a fantastic arabesque, half hideous chimera, divinely feminine from the waist up."[59] Barthes points out that the confusion of the sister arts is also embodied in a similar baroque arabesque, since the genealogy of this body and its portrait winds endlessly through narrative, sculpture, and painting, with every turn policed by the threat of castration. As Peucker writes, "In thus alluding to

the Horatian trope of generic transgression (comely woman above, grotesque fish below), Balzac strengthens the connection of this body, now figured as androgyne, with the instability of generic boundaries."[60]

In *Prospero's Books*, Caliban serves as a site of abjection and transgression, and as the "composite substance" on which the film's generic transgressions are played out.[61] A hybrid, mysterious being in the eyes of Stephano and Trinculo, Caliban is described not as a being in himself, but as some unspeakable combination of other categories. Trinculo exclaims in a passage reminiscent of the Horatian trope, "What have we here? a man or a fish? dead or alive?" (2.2.24–25), and continues through a variety of possible categories to contain the complexity before him: "monster," "savage," "islander, that hath lately suffer'd by a thunderbolt" (2.2.35–36). Caliban's hybridity confounds the linguistic capacity of his companions, who project onto his transgressive body their anxieties about the death-dealing effects of such boundary crossings. Prospero's fear of Caliban parallels what Peucker describes as the "fear that film, as a hybrid form comprised of image and narrative, is nothing less than a 'monstrous birth,'" the fear that when text and image commingle, the result will elicit a response not unlike Stephano's at the sounds emanating from Caliban: "Where the devil should he learn our language?" (2.2.66–67).[62]

In his study of ekphrastic poetry and its relation to patterns of social othering, Mitchell argues that anxieties about the mixing of artistic media are often "grounded in our ambivalence about other people" and are therefore intimately related to the maintenance of social boundaries.[63] If an aesthetic based on exclusive categories often mimics practices of exclusion in other domains, Mitchell argues against the position, elaborated most famously by Gotthold Ephraim Lessing in *Laocoön*, that each art should occupy only its proper sphere. Recent British history attests both to the persistence of these social and artistic boundaries and to their unsettled and contestable status. Although Thatcherism posited an antiquarian, idealized, and totalizing conception of British identity, emerging British cultures put the lie to those claims of consensus and homogeneity. The privileging of canonical English literature in the heritage industry—and the performance of this ascendancy in the heritage film's recurrent scenes of reading, those celebrations of the "purity of the word"—underscores the connection between reified literary monuments and the reified nation that upholds them as its cultural patrimony.[64] At the same time, in films such as Isaac Julien's *Looking for Langston* (1989) a political meditation on sexual and racial injustice coexists with a cinematic meditation on the politics of the film's interlacing arts: photographic images, poetry, music, and cinema. The emergence of mannerist and neobaroque cinema in contemporary Britain—in films ranging from Jarman's literary adaptations, *The Tempest* (1980) and *Edward II* (1991), and painterly films, *Caravaggio* (1986) and *Blue* (1993), to Sally Potter's *Orlando* (1993)—is symptomatic of the recurrent cultural crises caused by sociopolitical boundary crossings. One of

Greenaway's contributions to the debates is a baroque *Tempest*, in which a no-madic Prospero ultimately parts with his books and their phantasmatic unity and vestigial powers, in order to embrace the complexity through which he has been wandering all along.

The film's final moments involve a curious recuperation of Caliban, when the character who once defecated and vomited on Prospero's books sud-denly saves one—Shakespeare's First Folio—after his master makes good on a pledge to "drown [his] books." The strangeness of Caliban's final gesture has elicited quizzical comments from many critics, who ask whether the film's "meaningless Caliban" deserves such a prominent role in the salvation of the First Folio: "Why Caliban?" asks Coursen.[65] These final moments, after Prospero abjures the power of his books, imply that a hybrid art form—one that "vandalized" Shakespeare for some of its earliest story material—can also salvage something vital from the text. Such a salvage operation became increasingly germane during the late twentieth century, as the heritage in-dustry threatened to transform the book into another exquisite object and the Bard into a guarantor of "quality." Often an unnamed but still domineering presence, the playwright was sometimes called on to endorse a production, as his name was explicitly invoked in the spate of adaptations that advertised themselves as "William Shakespeare's *Hamlet*" (Kenneth Branagh, 1996) or "William Shakespeare's *Much Ado about Nothing*" (Branagh, 1993). Those adaptations, and the literary branch of the heritage film more generally, aspired to the condition of "literature," approximating the experience of viewing first editions at auction or a performance at Stratford-upon-Avon. In an era when Shakespeare as a cultural icon went "big-time," when his name and likeness were enlisted as expert pitchmen and exchanged as the plugged nickel of cul-tural capital, drowning the book, abjuring its cultural power, "Calibanizing" literature offered one strategy for reinvigorating the text.[66] In its excess of vis-uality, *Prospero's Books* prevents its overloaded images from becoming a dis-play of exquisite objects, short-circuiting any desire to reify and consume the past. By abdicating the power of book and Bard, by celebrating its own rad-ical inauthenticity and its departure from the traditions of stage and page that too often constrain such adaptations, the film invokes the always unrealizable but intriguing possibility of experiencing Shakespeare after the "death of the author," by drowning the First Folio then rediscovering it in a radically es-tranged form. Just as Deleuze links a cinema of time with a philosophy of the emergent event and integrates retrospection into a process of hopeful anticipa-tion, Greenaway's *Tempest* is concerned less with maintaining Shakespearean drama as it was than with envisioning what it might become.

While *The Cook, the Thief, His Wife, and Her Lover* constructs an allegory of Thatcherite economic conditions, *Prospero's Books* also constructs a political allegory, but one that responds to the cultural politics of an era when "Royal Shakespeare" has become a marker of national culture.[67] The Thatcherite

conception of heritage as commodity and national patrimony tends to uphold artistic values favored either by the market or by caretakers of traditional "Englishness"; like Prospero at the outset of the play, it marshals power behind the unifying force of the book (especially the First Folio). Faced with the centrifugal pressures of a collapsing empire, the European Union, and globalization, the nation responds by returning to heritage, to documents attesting to Britain's certainty, stability, and ascendancy. According to Stuart Hall, "Culturally, the project of Thatcherism is defined as a form of 'regressive modernization'—the attempt to 'educate' and discipline the society into a particularly regressive version of modernity by, paradoxically, dragging it backwards through an equally regressive version of the past."[68] Brimming with allusions to European cultures extending beyond national borders, *Prospero's Books* transforms Shakespeare from the apotheosis of English culture into a playwright whose concerns can be extended into a new, pan-European and postcolonial configuration. And if the literary adaptation and the heritage film can lead to the sedimentation of the present "imagined community" around a single canonical conception of past culture, *Prospero's Books* provides a critique of this mode of heritage making by underscoring the hybridity of that culture and its adaptability to the exigencies of the present. It is the rare literary adaptation that crosses over instead of harking back.

Greenaway is not generally considered a political filmmaker because he usually approaches politics obliquely, either through allegory or through the textual politics of his formal experimentation. In this regard, in words that could apply to Greenaway himself, Deleuze writes of an affinity between Leibniz and Prospero, "the Mannerist hero par excellence," "magician and rationalist, who knows the secrets of life, a mountebank, a dispenser of good fortune, but who is himself lost in his splendid isolation."[69] Greenaway's critical reputation rests primarily on praise for his Prospero-like manipulation of spectacular surfaces and façades. His detractors dismiss him as a "mountebank" peddling images in a hermetic world of museums and art-house theaters, the most prominent sanctuaries of heritage. But the politics of heritage has remained a major concern throughout his career: in early features such as *The Draughtsman's Contract*, which stages a politically charged clash between classes and interpretive frameworks within the sort of manor house slated for preservation under the Heritage Acts, a site dripping with excessive Englishness; in *The Belly of an Architect* (1987), in which Rome's ancient edifices become a contested site, as enthusiasts and financiers applaud for that architecture's eminently marketable performance of heritage and struggle under the weight of its attendant artistic and economic burdens; and in his more recent adaptations of Dante and Shakespeare.[70] If the national past was the terrain on which many of the conflicts of global capitalism and its Thatcherite variation took place in the late twentieth century, Greenaway's work makes heritage itself an object of inquiry and destabilizes many of its most precious monuments, along with

the "discourse network" that establishes the link between literary heritage and the timeless nation. While a modernist response to the persistence of the past might advocate an ideology of the break, a "make-it-new" mentality, Greenaway's more recent films instead deterritorialize the objects and spaces that help solidify a sense of heritage. Not just a fashionable "nomadic" cinema in which "everybody now goes everywhere," these films also perform the more difficult work of contesting the heritage industry's myth of origins.[71] They are nomadic works that know where they came from. And if, as Hall says, renewal depends on "occupying *the same world* that Thatcherism does, and building from that a *different* form of society," Greenaway's films shake the cultural underpinnings of Thatcherism's mythical nation.[72]

Prospero's Books ends with a departure from the sacrosanct world of the reading room, where fetishized texts normally exist in splendid isolation. Instead, the film protests against the reification and commodification of literary culture and the book and their misuse as part of a project of regressive modernization. Underlying this process is not a desire to jettison the canon whole, but a fear that "the Bard" used as a shibboleth for defenders of traditional Englishness not only entrenches conservative values, but also forces an emerging political formation to leave Shakespeare behind. The film's final moments underscore this desire to salvage and recuperate the text, for the film ends not with Caliban, Prospero, or Miranda, but with Ariel, at once the source of much of the play's poetry and the enforcer of Prospero's will, a confluence of art and power, running through the crowded halls and launching himself into a space that is neither a page nor a cinematic space, escaping into something in between (Figure 6.3). This final image suggests that only if the text breaks away from the constraints of the heritage industry, if it remains perpetually in

FIGURE 6.3. *Prospero's Books*

flight, can it then cross over from Shakespeare's time to the cultural situation of the late twentieth century.

Filmmakers at the turn of the millennium were also involved in a salvage operation aimed at preserving the twentieth century's most popular and influential medium while passing into the twenty-first. "Cinema is dead," Greenaway proclaimed in 2007, and he predicted that much of the history of film would be lost, not because of technical obstacles like those outlined by Paolo Cherchi Usai in *The Death of Cinema*, but due to the wandering attention and indifference of contemporary audiences attracted to other forms of entertainment.[73] Greenaway's response to that problem was not merely to embrace the digital tools of the present and future, but also to link film to other archaic media like the painted canvas and the book and to position its obsolescence as a paradoxical source of power. With the end of cinema as we knew it, film was slowly morphing from the paragon of modernity it embodied for most of its history into yet another heritage object. Greenaway's work has responded to that condition by both advancing into the digital age and venturing back into the history of art and literature. As he displays animated canvases and illuminated pages that flicker and dance on the screen, he embeds the infinitely malleable images of the future within a historical framework that includes the deep time of media and the increasingly archaic medium of film. Greenaway's films in the 1980s and 1990s experimented with digital technology and gestured toward the hypermediated culture of the next century, but they were also freighted with the history of literature, painting, and cinema. Like his alter ego, Tulse Luper, who crammed suitcases full of mementoes from the twentieth century, Greenaway refused to leave bygones behind and insisted on carrying forward as many traces of the past as a screen could possibly bear.

Old Haunts

COMMEMORATION AND MOURNING
IN AGNÈS VARDA'S LANDSCAPES

Unearthed

Agnès Varda's *Vagabond* (*Sans toit ni loi*, 1985) begins with several competing origin stories. The second focuses on the emergence of Mona, the young woman at the center of the narrative, nude and under the gaze of two male observers, from the warm Mediterranean waters that offer her a respite from her travels and the rare luxury of a bath. Varda's voice-over echoes the notes of mystery and romanticized detachment sounded by the witnesses who together construct an impressionistic account of Mona in the film: "It seemed as though she came from the sea." With visuals and a verbal description reminiscent of Sandro Botticelli's *The Birth of Venus*, this moment from the beginning of the film has been crucial to feminist interpretations, which often locate Varda's politics within her direct confrontation with the centuries-old practice of male artists depicting an idealized female beauty for presumed male audiences. Like Mona, *Vagabond* emerges from that tide of images, from a tradition extending backward through Botticelli, but with the express purpose of breaking away from and thereby rewriting that mythological heritage. Much of the most suggestive writing on Varda's work has focused on her recurrent critique of the construction of the image of woman in art and popular media, from the model trying to escape a photographic and medical gaze in *Cléo de 5 à 7* (1962) to the hybrid of militant feminist cinema and the musical in *L'Une chante, l'autre pas* (*One Sings, the Other Doesn't*, 1977). But juxtaposed against that rehearsal of Botticelli (and his predecessors and imitators) *Vagabond* opens with another tale of origins, one originating in the other art historical archive that Varda explores in the film: images of the landscape. Another consistent theme of Varda's art and politics, this critical return to the images and implications of the landscape begins to unravel the long-standing ties between the land (the

seaside, vineyard, river valley, or southern farmland) and the nation during the era of commemoration, and it explores the relationship between that bounded territory and the marginalized woman at the center of the narrative.

This fascination with landscapes and urban settings has shaped Varda's career from the outset, from her return to the seashores around the southern town of Sète in *La Pointe Courte* (1955) to the cartographic rendering of Paris presented in *Cléo*, from the Southern California sprawl unified through the practice of mural painting in *Mur Murs* (1980) to the reconception of the environment through the lens of easily portable digital cameras in *The Gleaners and I* (*Les Glaneurs et la glaneuse*, 2000) and *The Beaches of Agnès* (*Les Plages d'Agnès*, 2008). If the cultural significance of the landscape has always been a major intellectual concern for Varda, *Vagabond* signals a shift away from her earlier attention to the physical manifestations of urban modernity in *Cléo* or *Mur Murs* to her late-career interest in ruins, waste, and survival in the aftermath of environmental devastation. Though the narrative concentrates primarily on Mona as she wanders, hitchhiking, with the combination of loneliness and freedom that characterizes life on the road, *Vagabond* opens with an immobile long shot of a wintry landscape, with rows of barren and twiggy vines extending off toward rolling hills on the horizon (Figure 7.1). The only movement and change to disrupt the stillness of this shot is created by a tractor plodding toward the camera, with clouds of dust billowing up then vanishing behind it. A setting reminiscent of the actively worked fields painted by Jean-François Millet, Jules Breton, and Gustave Courbet, this shot also evokes their most cherished and politically charged subject: the strenuous efforts of farm laborers within an environment notable for the counterpoint of elemental

FIGURE 7.1. *Vagabond*

ruggedness and raw beauty. But far from an evocation of the bitter agricultural politics of the nineteenth century or the documentary depiction of farm labor that appears later in the film and becomes an organizing concern in *The Gleaners and I*, this opening shot of *Vagabond* blends labor into the landscape. In these opening seconds the fields are still susceptible to the mythologizing power that transforms that land into the omnipresent objective correlative of the nation and rock-solid evidence of its essential coherence.[1] The painterly near-stillness of the opening shot attests to the timelessness of these visions of the land and their central position within the massive archive of politically and emotionally charged mnemonic images.

A slow zoom in, then a tracking shot through the leafless vines, finally introduces exogenous motion to the film and disrupts its painterly calm. A farm worker collecting twigs walks past a furrow on the side of the field and discovers a body lying dead in the ditch. Police officers come to investigate the scene, take measurements, and collect evidence, while brushes shot in close-up scrub splotches of red from walls in town. A cliché of innumerable cinematic genres, especially the detective film and its film noir cousins, the discovery of a dead body (along with blood-red intimations of foul play) launches *Vagabond* into an inevitable search for origins and causality: who is the victim, where did she come from, where was she going, and, most urgently, how did she die? As Susan Hayward writes, "An entire film in flashback to explain a death or murder is part of the classical canon . . . but an entire film in flashback to elucidate one shot is not. To suffuse one shot with so much signification is to impregnate it with geological proportions of textural significance whose structures are as deep as they are dense, and whose references within those structures traverse discourses ancient and modern."[2] This ur-device of narrative cinema usually counterbalances that initial violence with the promise of investigation, discovery, and resolution, but the landscape at the beginning of *Vagabond* and the film's regular and obsessive return to images of the French countryside suggest that the vineyards around Nîmes are more than the setting for a mystery, that the film's discoveries do indeed take on "geological proportions." In the frequent shots where the landscape precedes the appearance of a character and lingers on the screen after everyone has gone, there is ample time to consider these primeval implications and trace the intimate connections between the narrative and this at once natural and nationalized environment.[3] While the camera's gaze focuses initially and persistently on Mona, the landscape is also the object of an obsessive gaze, as its fate is consistently intertwined with hers. The wintry landscape also becomes an object of detectivelike inquiry: where did it come from, and how did it die?

The shocking image of Mona lying in the ditch recalls another common tale of nations and their origins: the discovery, usually by a farm worker digging a well or levee or children playing in the countryside or a cave, of an ancient body, preserved by an accident of nature, that establishes a genealogy of the

nation through the science of archaeology. The body, at once immersed in and distinct from the landscape, becomes yet another point in a national time-line that reaches ever backward, tracing a dotted-line history into the past and transforming what used to be pure legend into the more fact-based domain of history. In one version of the film's backstory, Varda describes the aston-ishing contrast between the wealthy and enlightened façade of France and the barbaric reality that every winter people freeze to death while sleeping outside: "We are such a sophisticated civilization," she says, "yet, for some of us, it's still like the Middle Ages."[4] The discovery of Mona marks an initiation into a serious social problem: the plight of the poor, the outcasts, the rebels subjected to the unmitigated vicissitudes of nature. This confrontation with the brute fact of her body also evokes the scene of long-interred ancestors fi-nally unearthed, those petrified corpses that help establish the continuity of the national past, avatars of the state to come. *Vagabond* tells the intersecting stories of Mona in the last days before her death and of a ruined winter land-scape almost constantly on-screen, and through those narratives and images, it launches a critique of the gendered and naturalized mythology of the nation. Rather than the picturesque vistas that constitute the most beloved form of nature painting, the landscapes in *Vagabond* are records of failed human in-tervention. They are allegorical spaces: no longer the domain of unadulter-ated nature or the opposite of civilization, these landscapes are reimagined as casualties of the encroachment of humanity, as ruins in the realm of na-ture. To understand Varda's landscapes either as formal objects open to aes-thetic contemplation or as backdrops on which characters etch their narrative trajectories is to neglect their crucial role in *Vagabond*. Through a process that she calls "cine-painting," Varda films the late twentieth-century French landscape in order to reveal what remains of nature in modern times, what resists the ownership claims of the state or landowner in a world of nations and private property, and what Mona discovers on her flight from a society that, within its cities and fields, has no place for her.

Nature's Studio

Landscape has rarely been an important conceptual category in film studies, despite its prominence in the history of painting and photography.[5] Studies of landscape art seldom include examples from films, except for the occa-sional, offhand reference to a relatively narrow range of experimental cinema or documentaries engaged in "green" politics. The land occupies the orna-mental, supplementary background of nearly every film but rarely emerges into a more prominent position. Godard once suggested that the history of cinema is buried, before adding that nobody knows where. The history of cinematic landscapes is among the most deeply interred and habitually

overlooked elements in film, despite its importance in establishing the links between characters and stories, on the one hand, and the space where they act and exist. In cinema the land is the epitome of the Derridean *parergon*, the space that stands alongside the focus of the artwork but insinuates itself silently into the center, reconstituting the scene despite being relegated to its margins.[6] The obvious reasons for this consistent neglect of landscapes are the dominance of narrative cinema, especially since the development of a classical, institutional mode of representation and a prevailing mode of criticism more attuned to stars and stories than mise-en-scène. In these contexts, the land functions primarily as a picturesque interlude between segments of narrative development, the centerpiece of an establishing shot, an elemental force tamed through heroic action, or the backdrop against which movement takes place. While the landscape occupies a more significant position in a particular mode of documentary or avant-garde film—in Pare Lorentz's *The River* (1938), for example, or Michael Snow's *La Région centrale* (1971)—the land's combination of glacially slow change and overly rapid and repetitive movements leaves it virtually inaccessible to narrative cinema. For film studies, categories like landscape—so redolent of an art history conceived primarily as the taxonomy of formal categories, so deeply implicated in the postcard aesthetic of beautiful or picturesque scenes framed for mass appreciation and consumption— appear to belong to another period in the history of criticism, before our more technologically oriented age. The closest analogue to the art historical study of painted landscapes has developed in research into the Western, the musical, or the road movie, where critics are more likely to veer into the margins of the images, a space both on the screen and apart from the intricacies of plot, a site where what Pasolini called "the second film" begins to materialize.[7]

Because of his own predilection for natural history and his attention to mise-en-scène, Bazin often digresses into the landscape in both his analysis of particular films and his more generalized theory of cinema. In his study of the nascent neorealist aesthetic visible in the work of Rossellini, for example, Bazin writes, "The technique of Rossellini undoubtedly maintains an intelligible succession of events, but these do not mesh like a chain with the sprockets of a wheel. The mind has to leap from one event to the other as one leaps from stone to stone in crossing a river. It may happen that one's foot hesitates between two rocks, or that one misses one's footing and slips. The mind does likewise. Actually it is not of the essence of a stone to allow people to cross rivers without wetting their feet. . . . Facts are facts, our imagination makes use of them but they do not exist inherently for this purpose."[8] Here and throughout his work, this penchant for metaphors drawn from the natural sciences inscribes a vision of the landscape within his theory of cinema. The natural history in Bazin's film theory in places invokes a river carving into its bank, or a still pool covered by algae, or a shallow, braided stream dotted with stones visible through the surface.[9] Bazin also characterizes key filmmakers

through their idiosyncratic relationship to the environment. He writes, "For Anthony Mann landscape is always stripped of its dramatically picturesque effects. None of those spectacular overhanging rocks in the deserts, nor those overwhelming contrasts designed to add effect to the script or the *mise en scène*. If the landscapes that Anthony Mann seems fond of are sometimes grandiose or wild, they are still on the scale of human feeling and action. Grass is mixed up with rocks, trees with desert, snow with pastures and clouds with the blue of the sky. This blending of elements and colours is like the token of the secret tenderness nature holds for man, even in the most arduous trials of its seasons."[10] Why does Bazin develop a theory of cinema from the elements of landscape, and why does he insist on this fundamental relationship between individual filmmakers and the environment around them? Bazin suggests that viewing landscapes provides the perfect metaphor for the possibilities opened by a cinematic recording of reality: the image is a space to be crisscrossed and explored, a space for purposeful navigation and potential discovery, an opening onto Nature viewed in a more totalizing sense as God or the totality of the universe captured in widescreen or through the furtive glimpse of the mobile camera. Bazin focuses on the stones that offer infinite paths toward some transcendent meaning inaccessible without the affordances of cinema.

Deleuze likewise constructs a theory of cinema that foregrounds the role of the "milieu" or "situation" and its determinative function in the development of a narrative or sequence of images. That milieu is the "Ambiance" or "Encompasser" that "incurves," squeezing the space in which characters act, forcing their hand, provoking particular responses, which in turn alter the environment.[11] In Deleuze's model, space is as active as any character, participating in the chain of causes and effects rather than merely accompanying human action. The irony in both Bazin and Deleuze is that they make no distinction between the natural landscape of mountains and deserts, on the one hand, and cities, roads, and other human interventions in a preexisting environment, on the other. They also overlook the irony that a mechanical apparatus provides these revelatory visions of nature, that a cinematic landscape is always an example of what Leo Marx famously called "the machine in the garden."[12] That this passes without extended comment in their work suggests that cinematic landscapes are always intimately intertwined with their antitheses, the domains of modernity and commerce. In cinema there is a landscape but no nature.

While the art historical and vernacular use of the term "landscape" often evokes unending expanses of wilderness or pastoral greenery, landscape art has more often explored the contested space between the natural world on one side and its conceptual opposites: urbanity, commerce, and political boundaries. The German word *Landschaft* originally denoted the area on the periphery of a town, a usage that persists in some Swiss cantons. Far from dense forests and sublime mountain passes, the landscape in its original sense denoted an area

under the influence and protection of the city, adjacent to the built environment that housed people and supported commercial activity and therefore just a stone's throw away from the intensive exploitation of land. From its inception, first in reference to an exurban space and then as a genre evocative of nature, "landscape" was etymologically grafted to the city. In his history and theory of the landscape as a cultural category, Denis Cosgrove argues that the concept emerged during the early modern period as a burgeoning capitalism threatened the feudal system of land ownership and tenure. For people who derived their sustenance from the land and for whom fields and mountains were the environment of everyday life, the distance and division implicit in a modern understanding of landscape were inconceivable: "For the insider there is no clear separation of self from scene, subject from object. There is, rather, a fused, unsophisticated and social meaning embodied in the milieu. The insider does not enjoy the privilege of being able to walk away from the scene as we can walk away from a framed picture or from a tourist viewpoint."[13] Cosgrove suggests that the transformation of land from a whole way of life into a commodity ushered in a new conception of landscape with symbolic value, exchange value, and capital value. Landscape art became a means of negotiating or obscuring that transformation: it represented the nostalgia for a timeless pastoral life unadulterated by the crude mediation of commerce; it reflected the human capacity to subjugate nature and refashion it as a token of exchange; it stood awestruck before nature's sublime resistance to regimes of management and representation; or it charted the middle regions between nature and markets, exploring their complex abutments, examining the grassy verges between the natural world and human creations like art and commerce. For example, the Dutch landscapes of artists like Jacob van Ruisdael and Jan van Goyen mapped the space between urban areas during an economic boom and the countryside that surrounded them. In van Goyen's work the "extent of the land is scattered with standard landmarks—church towers, hayricks, trees, even cows. A city, which is never far away in Holland and on which the country so depended, is the major landmark."[14] Likewise in van Ruisdael's views of Harlem, which usually depict "a major product and economic support of the city—the bleaching of linen in the field."[15] As W. J. T. Mitchell argues in a series of propositions about the role of landscape in modern culture, "Landscape is a medium of exchange between the human and the natural, the self and the other. As such, it is like money: good for nothing in itself, but expressive of a potentially limitless reserve of value. . . . Landscape is a natural scene mediated by culture."[16] The landscape's function in these complex cultural processes is incompatible with the ideal of nature envisioned as the repository of last resort for something eternal and distinct from an imperial urbanity, as a guarantor that something endures outside the world of human intervention. The landscape genre instead represents a negotiation between the urban and the natural, charting the middle ground between them, bearing witness to their turbulent coexistence. In his 1932 speech on "The Idea

of Natural History" Theodor Adorno argued that nature, because of its osten-
sible purity and distance from human affairs, provides a primary repository
of myth, a space outside history where sameness can abide unquestioned for
centuries. Adorno instead expressed a desire to transcend the antiquated dis-
tinction between nature and history in order to *"grasp historical being in its
most extreme historical determinacy, there where it is most historical, as itself
natural being, or . . . to grasp nature there where it appears to harden most pro-
foundly within itself, as historical being."*[17] Nature, suggests Adorno, is always
already modern.

In Derek Jarman's films, artworks, and, most strikingly, his garden, nature
serves not as a space apart from history but as a record of the devastation
taking place in time. Built around 1910 on a shingle at Dungeness, Jarman's
Prospect Cottage occupies a setting where fragments of modernity—in the
form of scrap metal from World War II and countless formerly glistening
and new objects—wash ashore or litter the open land. Jarman writes, "For
two months after moving here I spent hours each day picking up fragments
of countless smashed bottles, china plates, pieces of rusty metal. There was a
bike, cooking pots, even an old bedstead. Rubbish had been scattered over the
whole landscape. Each day I thought I had got to the end of the task only to
find the shingle had thrown up another crop overnight."[18] Jarman incorporated
this detritus into the garden, interspersing it with roses and kale, harvesting
it like a crop. Just beyond the cottage lies a nuclear power plant that Jarman
frequently photographed in conjunction with the garden, a potentially cata-
strophic hypermodernity looming nearby. While the garden survives without
walls or fences, while its "boundaries are the horizon," the gardener has to re-
sist the temptation to isolate it from history and cloister it within the cult of the
traditional English garden and the myth of the pristine countryside.[19] In his
diary Jarman recounts a conversation about his garden and the desire to write
a book about the process of cultivating it:

> I was describing the garden to Maggi Hambling at a gallery opening. And
> I said I intended to write a book about it.
>
> She said: "Oh, you've finally discovered nature, Derek."
>
> "I don't think it's really quite like that," I said, thinking of Constable and
> Samuel Palmer's Kent.
>
> "Ah, I understand completely. You've discovered modern nature."[20]

Like the landscape in the mourning plays studied by Benjamin, Jarman's
garden foregrounds the losses inherent in the process of modernization and
celebrates the unlikely survivors who persevere amid the ruins. And as in
Benjamin's writing, that combination of ruination and endurance is evoked
in what Daniel O'Quinn calls a "cascade of quotations," an "ambush by quota-
tion."[21] As O'Quinn argues, "Jarman's narrativization of the process of tending

his garden focuses on the surprising survival of herbs and flowers in a place where they should not thrive. The allegory is palpable here, for just as violets and daffodils and poppies make a living among the stones in the shadow of the nuclear power plant which overlooks his cottage, so also Jarman and the communities he invokes—[people with AIDS], queers, communists, inverts, and saints—demonstrate their strength and their resilience in the face of the personal, cultural, and social crisis of Thatcherite Britain."[22] For Jarman "gardening is an emergency praxis," and within his wasteland of a garden, he discovers a constellation of discarded but venerated objects.[23] With the nuclear power station just beyond, nature itself joins the litany of endangered objects relegated to the scrapheap, the marginalized other rejected by a modern world that now encompasses everything.[24]

In a project that explored the same terrain as *Vagabond*, the photographers associated with the Délégation à l'aménagement du territoire et à l'action régionale (DATAR) documented the transformations of the French environment in modern history. In a published collection of photographs from DATAR, Jacques Sallois writes that the project was modeled on the French Mission héliographique of 1851 and the Farm Security Administration of the Franklin Roosevelt era, and was charged with documenting the various categories of French landscape and their particular human activities ("cities and suburbs, mountain and river, factories, farms and offices, industrial spaces, rural spaces").[25] But by 1985 the project had undergone subtle changes, as the photographers were assigned a more specific mission centered on "the most recent transformations" in the environment: "the decline and conversion of traditional industrial landscapes, the appearance of new zones of high technology development, urban mutations."[26] Originally conceived as a force of preservation motivated by social and economic transformation, DATAR instead documented the modernity of the landscape, its intimate connection with the vicissitudes of history. For Roger Brunet the mission as a whole sparked a "reevaluation of the landscape" by reminding the viewer of the simultaneity and multiplicity of the natural world.[27] He writes, "One could think that, like the classical tragedies and even more so, photography responds by definition to three golden rules: unity of place, unity of action, unity of time. But it's not so simple. For a place is a site of many systems, of several simultaneous actions: the field and the factory side by side but not necessarily joined together; the willowy bank and the high tension wire."[28] Such spaces exist in "several times"; they contain "traces of systems that have disappeared," and on those sites they "inscribe the new, without always completely effacing the past, and at times recuperating it."[29] "All is there, too much is there," writes Brunet, and "it follows that things get complicated."[30] The landscapes of DATAR, these locations and images imbued with memory and novelty, became palimpsests, allowing physical manifestations of the past and present to coexist with each other. With this archaeological project relentlessly in mind, the photographers

"play[ed] with the banes of the amateur photographer, the pylons, the electric lines, the water towers and barriers."[31] The physical manifestations of a post-industrial information economy created a striking juxtaposition with their industrial and agricultural predecessors, but far from evoking an ecstasy of communication or a network of relations (as in the now-clichéd cinematic effect that zooms along phone lines and fiber-optic cables at light speed from origin to destination), these signs of the new economy were equally indicative of the loss all around them. In his influential and important essay on the transformations that accompany the process of globalization, Arjun Appadurai outlines a research agenda focused on an emerging multiplicity of –scapes (ethnoscapes, mediascapes, technoscapes, financescapes, and ideoscapes) that afford access to processes of movement obscured by the relatively firm geopolitical boundaries that found more traditional scholarly disciplines.[32] But what disappears from this cultural economy of emerging –scapes is precisely the landscape, the physical and material reality, as well as the conventions of representation left behind, even rendered archaic, by the vertiginous development of a new world order. For the photographers associated with DATAR and for Varda in *Vagabond*, the landscape gains a renewed prominence as a mode of representation because of its seeming obsolescence, because it reveals a space of ruin where traces of history remain.

Land and Escapes

The opening shot of *Vagabond* installs this ruined landscape as a principal element of the film's mise-en-scène, as an active and prominent organizing principle rather than the backdrop for human action. What accounts for this vehement and insistent relocation of the landscape from the margins to the center of French cinema and visual culture? First, it reveals a desire to rescue the land from the nation, to release territory from the discourses of the state that have long succeeded in enveloping and claiming it. And, second, it responds to the increasing dominance of the museum—with its overtones of the mausoleal, the encapsulation that signifies the end of a process of becoming—as the primary model for realizing the ethical imperative of preservation. In the nineteenth century, nationalism, along with a "return to nature," was an essential motivating force in representations of the French countryside: in its purity and intimations of eternity, the land stood metonymically for the state. In the work of Claude Berri and Yves Robert, the primary vehicles of the Marcel Pagnol resurgence in recent French cinema, the discourses of the state and the museum again become intertwined, with the nation and its patrimony displayed and cherished as equally timeless works of art. The irony of heritage cinema, especially the films based on the precedent of Pagnol, is the elision of the regional difference that contradicts

the universalizing claims of the nation and that so concerned Pagnol him-
self. As Lynn A. Higgins writes of the regional identity expressed in Pagnol's
films, "Ultimately, despite efforts on the part of the fiction to reconcile all its
contradictions, the center does not hold, and, when examined closely, all these
conflicting layers collapse under the weight of the very contradictions that de-
fine the Provençal region. . . . A search for identity yields only difference, be-
cause even (or especially) the most indigenous identity meets its crisis if you
trace it back far enough or dig deep enough. It is not coincidental that many
of Pagnol's characters are diggers. . . . The heart or source of identity, both
individual and national, is scattered, *ailleurs*."[33] For Varda the return to a tra-
dition of landscape art involves these related processes of digging (for the past
buried in particular locations) and scattering (to escape the national iden-
tity that subsumes and eradicates difference under the pretext of preserva-
tion). The unorthodox representations of the land in *Vagabond* are concerned
above all with this exhumation of history and then a process of dispersal in
the face of the national patrimony that claims the landscape for itself.

The film's mosaic of testimony creates this idiosyncratic pattern of ex-
cavation and scattering. This compilation of eighteen discrete accounts of
Mona's last days aspires to a detectivelike reconstruction of her whereabouts
and movements before evolving into the more ambitious project of under-
standing her increasingly complex embodiment of total freedom and unfix-
able identity. From these various perspectives, the film paints what Varda calls
an "an impossible portrait of Mona."[34] Varda's previous work—most promi-
nently in *Cléo* and *Jane B. par Agnès V.* (1987)—is often framed as the portrait
of a woman, but instead of pretending to begin with a blank canvas, these
films investigate the various preexisting images that capture and immobilize
women for a seemingly omnipresent male gaze. In her film on Jane Birkin,
that return to an archive of clichéd images takes the form of tableaux vivants,
with Birkin embodying canonical works of art with the campy irreverence of
a home movie. Obscured and overwhelmed by the burden of innumerable
past representations, Cléo, Varda argues, is "the cliché-woman": "The whole
dynamic of the film lies in showing this woman at the moment when she
refuses to be this cliché, the moment when she no longer wants to be looked
at, when she wants to do the looking for herself. . . . From the object of the
look, she becomes the subject who looks."[35] And within *Vagabond*'s collage
of perspectives, the various people who encounter Mona—from the farmer
and the academic to the truck driver and goatherd—recount their fixed but
mutually contradictory impressions of her, leaving behind overlapping circles
of confusion rather than a precise image of her person. As Hayward suggests,
each of the speakers "fixes their gaze not on Mona but on their perception of
Mona as a figure of their desire."[36] These witnesses try to "establish author-
ship of Mona," inventing and manipulating her story even as they partake in
a performance of documentary objectivity.[37] The film thus reframes the act of

giving testimony, of establishing a baseline of documentary evidence, as the recirculation of clichés.

Varda's portrait of Mona is impossible not only because it portrays her from a variety of angles (as in the Cubist strategy), but also because a complete compendium of perspectives is an unattainable ideal, a delusion.[38] The film is concerned less with the discovery of a privileged outlook on the life of a young drifter than with the trail of fragmented, partial viewpoints she leaves behind. For some (from the woman who teaches her to operate a pump to David, another squatter) Mona's nomadism marks her as a literally Utopian figure: belonging nowhere, she is a perfectly free and independent spirit unencumbered by the oppressive obligations of place and identity. For others, Mona becomes a confirmation of individual values and prejudices, a reminder of their failed ambitions, a "reproach" for their inhospitality, in short, an externalization of their own phantasmatic identities. The goatherd, a university-trained philosopher who chose to abandon that career path for the deliberate existence of farm life, initially admires and even longs for her even more extreme state of abandonment. Yet, as he offers Mona a trailer and a plot of land to cultivate, weaning her off a life on the road and directing her into a poor imitation of his own mode of existence, the goatherd betrays his own desire to construct Mona in his own image. He says that he "chose a middle road between freedom and loneliness. . . . If you want to live, you stop." He condemns Mona for her lack of discipline and dedication: "You're not serious about anything. . . . You say you want things, but you won't work. . . . You're not a drop-out, you're just out. You don't exist." To live, he suggests, one must be rooted in a particular location because being a perpetual outcast and remaining in motion leads to an almost spectral (non)existence. The vehemence of their mutual rejection hints at both the similarity of their ambitions and the goatherd's need to secure his own sense of self, to bolster his increasingly complacent idea of freedom by recruiting an apprentice who rehearses his own life decisions.

Initially and ultimately an outsider, Mona issues a string of tacit challenges as she alternates between positions of extreme otherness and friendship or love. The distance that allows her hosts to project their most cherished desires or maintain a stance of aloof superiority soon gives way to the closeness of a mirror image so uncannily familiar that it provokes the most forceful denial. Madame Landier epitomizes the dynamic of enchantment and rejection that appears in all the encounters with Mona. Like the goatherd, she romanticizes Mona's freedom and enjoys the liberation and abandon that her new companion inspires; at the same time, she maintains a safe distance from a younger woman whose existence is predicated on a total rejection of the values and lifestyle of Landier and other bourgeois intellectuals. When Landier tells a friend about her encounter with a hitchhiker, her comments emphasize Mona's exoticism and estrangement, especially the overwhelming smell of the unwashed

vagrant. She later sends a coworker to her car to stare at the spectacle of rebellion and poverty, at the specimen displayed for anthropological scrutiny and entertainment: "she amuses me," says Landier, "you should go see her." Later, after leaving Mona on the side of the road, Landier is compelled to search for her when an electric shock causes her to review her life in "bits of images," returning Mona to her thoughts in the manner of a haunting, erasing the previously comforting boundaries between the two women. Rather than a complete portrait of Mona consisting of various fragments assembled over time, the film leaps from one extreme to the other, from indifference and conflict to intense intimacy and community sparked by images that return.

Although Varda's work engaged with the phenomenon of the gendered gaze before it was precisely named and theorized in the 1970s, the director has sometimes been dismissed as a conventional, even old-fashioned feminist by critics and filmmakers searching for something more overtly radical. Claire Johnston writes that the "law of verisimilitude" governing institutional cinema must be violated by an emergent counter-cinema and that filmmakers must rebel against the strictures imposed by the camera, which "was developed in order to accurately reproduce reality and safeguard the bourgeois notion of realism which was being replaced in painting."[39] With her art-school training and a lifelong interest in photography sustained from her Paris home on rue Daguerre, Varda has rarely aspired to a mode of counter-cinema that turns away from the history of the medium and its historical connection to other arts. The inspirations for her depiction of a community of women often derive from painting, photography, or other "old media" framed as precursors to cinema rather than harbingers of political and aesthetic upheaval. Hayward argues that films like *Vagabond* are most unconventional in their rejection of classical norms and ways of seeing: "Mona's independence from a fixed identity is an assertion of her *altérité* (her otherness); her autonomy from male fetishization is an obligation to recognize her *différence*—woman as an authentic and not a second sex."[40] "Because there are so many points of view," she adds, "Mona cannot be caught in any of them. In this criss-crossing of gazes, Mona has already moved on or has not yet arrived."[41] Mona chooses the relative liberty of incessant movement to participation in social and signifying regimes that reduce her to the status of a cliché. "No one can ascribe a meaning to her," writes Hayward, "because she has placed herself outside that which can be defined. Mona's response is, in effect, the perfect one to woman's ahistoricity. I will represent myself as nothing—as 'sans.'"[42] While the eighteen witnesses all affirm and depend on Mona's alterity, their stories fail to capture her character in its totality and complexity because they ascribe a series of recognizable, fixed identities to someone defined above all by her elusiveness and anarchic movement. Framed initially as a search for answers, *Vagabond* is a record of those failures. Although her lover urges her not to leave clues behind when she inscribes their names on a mirror and the voice-over confirms that she died without leaving a trace, does the Mona defined

as a woman without effects and qualities really leave no marks of her existence behind? If, like all the most remarkable protagonists of the French New Wave, Mona is a phenomenon of motion, is it possible to envision her as anything other than that which escapes our grasp?

Vagabond's response to that challenge is not to arrest the movement of Mona, thereby making her a more suitable object of both the sympathetic and the hostile gaze; instead the film sets everything in motion and allows that kinetic excess to infiltrate the film's lush images and its very structures of address. With a mobile camera that seems to disregard the guidelines of classical cinema and a succession of constantly shifting storytellers, *Vagabond* is that volatility made visible. As Sandy Flitterman-Lewis points out, the film's many interviews blur the boundaries between direct and indirect address by obscuring the position of the interviewer, who alternately speaks and remains silent as the witness addresses either her or the audience (or both).[43] In some instances (when, for example, Yolande moves seamlessly from her role as caregiver during Mona's lifetime to a witness staring straight at the camera and audience after her death) this fluidity reigns within the usually stable boundaries of a single shot. Like the alternating perspectives that trouble Velázquez's *Las Meninas*, this wavering between subject positions can compel the viewer to seek the hidden clue that resolves the apparent structural conflict. But the undecidable, unstable perspectives of the viewer and filmmaker also initiate a movement between subject positions, destabilizing the identities of maker and observer, introducing the same fluidity that makes Mona herself so difficult to apprehend. While the film is concerned with capturing a glimpse of Mona as she wanders through the countryside and from town to town, while it conveys the ethical imperative of understanding why she died, *Vagabond* also suggests that her fate is intimately related to the clash between mobility and stability that the moving pictures of her life and the categorical language of testimony reveal. At once a window, a screen, and a mirror, the "impossible portrait of Mona" undermines the viewing positions through which one sees a discrete and objective reality or imagines a world that conforms to our desires. Mona is emblematic of the figure who belongs within neither of those conceptions of cinema.

Vagabond pursues this imperative of movement at the unlikeliest times and places, often in violation of classical filmmaking rules. Varda describes the film as "one long tracking shot": "we cut it up into pieces," she says, "we separate the pieces and in between them are the adventures."[44] If classical cinema concentrates on the point of departure and the destination, eliminating the "wasted" travel time in between or compressing it into a rapid-fire montage sequence, *Vagabond* foregrounds the extraneous motion that usually falls to the cutting-room floor. In *Vagabond* Varda elaborates on Godard's famous remark about the ethical implications of the tracking shot by fleshing out that aphorism into a feature film where a cinematic morality is revealed in the spaces glimpsed as the camera rolls by. In this series of tracking shots, accompanied

by Joanna Bruzdowicz's alternately lyrical and industrial soundtrack, the camera occasionally follows Mona, structuring the shot around her actions, but more often it encounters her midway through its divagations, or responds to the movement of other characters, or alights on objects isolated in the landscape. Once again, the film is concerned not only with the wandering of Mona, with her relentless motion, but also with the excess accumulated during these languorous mobile shots. Tracking right to left, against the flow of traffic and of time, these shots return to the spaces Mona once occupied to discover the clues contained in what she left behind and, as importantly, to reencounter what the observers missed on their first voyage down the road. Just as Mona's life is too complex to capture even through the combined testimony of the people who saw her last, even the landscape and its accumulated objects fail to perform their prescribed roles as the stable backdrops and accompaniments that bestow meaning on human action.

In *Vagabond* the landscape, and especially the plane trees and vineyards, become the site where difference is inserted into familiar categories of identity and belonging. Varda describes the film as an account of the "adventures and solitude of a young vagabond (neither withdrawn nor talkative), told by those who had crossed her path, that winter in the South of France. But can one render silence, or capture freedom? The film wanders between Mona and the others. We glimpse their lives, and then move on."[45] These witnesses and wanderers appear "like small 'figures' in a winter landscape."[46] In addition to the many instances when the camera departs from its conventional attachment to the protagonist and lingers on a shot of the countryside, painted and photographed landscapes appear at several crucial moments of the film. When Mona is expelled from her squatter's paradise on an abandoned and overgrown country estate, one of her only interludes of slow and settled pleasure, she steals a painting from the walls of the mansion. From a house dominated by portraits, Mona takes an impressionistic landscape, though it does not survive her escape from the house: she pulls it from her backpack, discovers a hole in the center of the canvas, and burns it. Mona also carries with her postcards of landscapes and flips through them just after being sexually assaulted in the woods, an attack that reminds her of the danger ever-present in the society around her and provokes her own return to more idealized images of the land. And when the camera lingers on the walls of Landier's house, it displays a collection of artworks and postcards consisting almost exclusively of landscapes and trees (Figure 7.2). Immediately after this exploration of artful environments, she receives the accidental electric shock and envisions a reproachful image of Mona. Both Mona and Landier want to preserve a landscape free from the ravages of the disease spreading uncontrollably among the iconic plane trees, but far from a natural environment, the landscape Mona walks through is replete with barbed wire, abandoned tires, and rusted metal (Figure 7.3). The landscape has become a receptacle

FIGURE 7.2. *Vagabond*

FIGURE 7.3. *Vagabond*

for the detritus of a civilization in transition, with the remains of industry shuffled off beyond the city and new suburbs being constructed in the middle of barren fields. While several of Varda's films, including *Vagabond*, center on the fabrication of woman through the photographic and cinematic image, this film signals an exponential expansion of that project, as it explores the archive of images that construct other enduring and naturalized categories, from

the postcards that depict women frolicking on the beach (as in the scene immediately following Mona's emergence from the sea) to the pictures of idyllic landscapes that decorate the walls of Landier's house. If the cinema of painters at once ruins and preserves the canvases represented through the tableau vivant and still life, *Vagabond* is devoted to the protection of the land through the destruction of an ideal of natural beauty that renders all landscapes a poor imitation and therefore open to exploitation.

Varda's exploration of that archive of images takes the ruined form of allegory, as described by Benjamin in his book on the baroque mourning play. In one extended allegory, Assoun introduces Mona to the process by which grapes from the vineyards around Nîmes are cultivated, picked, transported, and finally pressed and fermented into wine. The vineyards and the wine that Georges Durand describes as "an intimate memory," "a national memory," and "a cultural memory" are now tended and produced by workers from the North of Africa, a fact that Assoun both explains and embodies.[47] In these cherished landscapes, the spaces most profoundly associated with French culture, the film finds difference, inequity, and exploitation rather than national unity. In another such allegory, Landier explains how *platanes*, or plane trees in the South of France, were infected with a virus spread by the crates used to transport weapons for American soldiers during World War II. The very forces that allowed for the survival of the nation now threaten the defining features of its landscape and erase its local specificity. Dotted throughout the countryside, the trees become markers of that destruction. Landier and her colleagues try desperately to stop the spread of the disease by searching for a treatment and sawing down hopelessly decayed *platanes*, as the hollowed-out and felled trees become harbingers of a dying landscape and metonyms for the tragic fate of Mona: "If they perish, think of me," she says. Like Mona, these trees are both living beings and projections of the desires of their beholders, and to recognize their vulnerability is to acknowledge the illusory nature of those desires, the gap between what the beholder hopes to see and the reality that unfolds. Benjamin writes, "By its very essence classicism was not permitted to behold the lack of freedom, the imperfection, the collapse of the physical, beautiful, nature. But beneath its extravagant pomp, this is precisely what baroque allegory proclaims, with unprecedented emphasis."[48] *Vagabond*'s allegory of the plane trees reveals the collapse of a timeless ideal into modern nature, a condition of precarity that also holds out the possibility of liberation from the tyranny of that ideal.

Viewed as a distinct phase in her career, the late twentieth-century films of Agnès Varda gesture toward the political and aesthetic agenda that would guide her work in the twenty-first, during her transition into a digital filmmaker and her concentration on smaller-scale documentaries. What distinguishes that later work is its obsession with the environment and its figuration of Varda herself as an artist who trains the new generation of

small digital cameras on the French landscape. *The Beaches of Agnès*, which consists of voice-over memories and photographs drawn from Varda's long life, as well as contemporary footage from the locations and sites where those events took place, asks what it means to be an aging artist practicing an old art form in a world where nostalgia can be a dangerous sentiment and where novelty is prized more than ever. Varda's response has been to apply these digital tools to her at once atavistic and forward-looking cinema of painting. In one of the signature shots in *The Gleaners and I*, Varda poses, sheaf of wheat slung over her shoulder, as Breton's *Woman Gleaning* (1894). The film then cuts to a self-portrait of Varda with a mini-DV camera in her hand (Figures 7.4 and 7.5). While the most direct implication of this shot is that the low cost and portability of these cameras allow the filmmaker to salvage images from the world in the manner of a gleaner, the structure and style of the comparison are equally significant. Varda begins this sequence of images by making herself into a tableau vivant, by inhabiting the pose and holding the archaic object that appeared in the paintings adopted as an aesthetic and political guide for her return to the long history of gleaning. This transition into the digital age begins with an invocation of the painted canvas, with the history of art reframed as a tale of images and stories gleaned from the world rather than a narrative of innovation and creation ex nihilo. Like the characters in her documentary, Varda suggests that an artist also lives "off

FIGURE 7.4. *The Gleaners and I*

FIGURE 7.5. *The Gleaners and I*

the leftovers of others." Mireille Rosello elegantly describes *The Gleaners and I* as "a portrait of the artist as an old woman," and she traces the development of the theme of aging in the film, as Varda turns the camera to her own body, in extreme close-ups that distort their subject or in static shots, "as if she was painting a still life."[49] But Rosello also argues that the film is impossible to pigeonhole as either a heroic narrative of progress into the digital age or its opposite, a tale of inevitable decline. Instead the film highlights the "waste disguised as technological advance" and deliberately incorporated into systemic planning, and it redeems the potential of the bodies, objects, and spaces habitually dismissed as waste: "Depending on how you film the harvested field, you will either see nothingness or abundance. Either nothing is left, it is the end. Or it is the beginning of the gleaning season."[50] Through this invocation of the gleaner, the film reveals Varda's allegorical response to the end of cinema. Her approach is to search for the age-old precedents for today's supposed revolutions, to use digital technology as a tool for intermedial explorations that necessarily lead her back in time, and to regard the end of cinema as the opening of the gleaning season in the history of film. When she poses as a gleaner for her tableau vivant and then as a digital cinematographer, she refuses to reside exclusively in the realm of memory or the present. She wields a new device but with traces of Millet's and Breton's paintings still visible in the pose, subject matter, and props,

filling in the background, transporting those signs of survival and endurance into an age of new media. Varda, like many of the figures examined in this book, insists that her social, political, and artistic role is to collect material artifacts from the world around her, to carry them forward into an uncertain future, and, above all, to keep moving.

Early in *Vagabond*, when asked about her occupation and abode, Mona answers only, "I move." But she also mentions that she abandoned a job as a *dactylo* for her new life on the road. Leaving behind the duties of a typist, this modern-day scrivener joins what Giorgio Agamben calls "a literary constellation" connecting the "polar star" of Akaky Akakievich, to the "twin stars" of Bouvard and Pécuchet, Simon Tanner, Prince Myshkin, and Kafka's courtroom clerks.[51] And, of course, the primary object of Agamben's study, Bartleby. In Herman Melville's "Bartleby the Scrivener," the eponymous copyist "prefers" not to work on the tasks assigned to him and thereby becomes the personification of a minor form of resistance. By withdrawing from his professional duty, he refuses to make his body into a vehicle for the replication of power through the compulsory reproduction of the same. Mona's departure from the world of the *dactylo* constitutes her first act of rebellion, and her constant movement is energized by a desire to flee from the clichés that would otherwise envelop her. As the end of the film reveals belatedly, she dies as the result of a Dionysian festival, with men dressing as trees and attacking women, a literal conscription of nature for the purposes of patriarchy and its traditions. In this sense Mona's tragedy is that she was unable to escape far and fast enough in a society fiercely resistant to change. Agamben's essay on Bartleby also recounts the infinitely complex accumulation of "compossible" worlds imagined by Leibniz as the best conceivable universe, but this ideal world "projects an infinite shadow downward, which sinks lower and lower to the extreme universe—which even celestial beings cannot comprehend—in which nothing is compossible with anything else and nothing can take place."[52] Piecing together Mona's last days, the film celebrates her capacity for flight and refusal, as she counteracts the clichés that reduce all communication to dead letters, but it also questions the possibility of resistance in a world where rebellion is relegated to the margins and ultimately subdued. Varda's response, evident in her engagement with landscape painting and the tradition of allegory, is to provoke a confrontation between history and the present, to explore the possible worlds that were never realized, to look backwards through time and, in Agamben's formulation, "save what was not."[53] *Vagabond*, like most of the films addressed in this book, wanders between two poles: anarchic mobility and the stillness of refusal. Unwilling to accept either pole as a final resting place, Varda's work bounces from one extreme to another, alternating between the excessive movement of cinema and the captivating stillness of the landscape, the search for new directions and the momentary pause for gleaning.

Conclusion

Alongside the vital history of painting explored in the work of Terence Davies, Peter Greenaway, Derek Jarman, Agnès Varda, and many others, cinema itself became a favorite topic for filmmakers in the late twentieth century. Almost from the moment the medium was invented, filmmakers realized that the studio and movie theater—brimming with modern technology and star power, magic and glamour—were among the most cinematic topics. From the parody of naïve spectatorship in *Uncle Josh at the Moving Picture Show* (Edwin S. Porter, 1902) to the parade of stunts and special effects in *Sherlock, Jr.* (Buster Keaton, 1924), from the somber decadence of *Sunset Boulevard* (Billy Wilder, 1950) to the Technicolor optimism of *Singin' in the Rain* (Gene Kelly and Stanley Donen, 1952), from the pervasive compromise and corruption on display in Jean-Luc Godard's *Contempt* (*Le Mépris*, 1963) to the uncertain but still hopeful future glimpsed in François Truffaut's *Day for Night* (*La Nuit américaine*, 1973), each era has produced a cinematic mirror image consistent with the aspirations of its artists and the possibilities open to them at a particular time and place.

In the late twentieth century, filmmakers often approached cinema as an object of archaeological inquiry rather than a vehicle leading inexorably into the future, as an archive of possible futures buried in the recent but rapidly receding past. In *Comrades*, a 1986 film by Bill Douglas about the Tolpuddle Martyrs, the history of trade unions in the 1830s is intertwined with an exploration of precinematic devices, especially the magic lantern and its characteristic succession of tableaux. As one character remarks in the film, "In our short lives we move about so little, we see so little," and the media that succeeded the magic lantern would allow audiences to see more and indulge in the illusion of movement, though the film also looks forward to an emancipated world that would never come to pass. In Olivier Assayas's *Irma Vep* (1996) a seemingly doomed remake of Louis Feuillade's *Les Vampires* (1915–1916) explores the dismal fate of a French art film in the blockbuster era and a period of creative depletion, but it ends with hand-scratched and tinted images more

reminiscent of the Letterist International of the 1950s and the Situationists than anything playing in theaters in the late twentieth century. Archaic and new again, the practices of the postwar avant-gardes flicker on the screen with the capacity to shock that Walter Benjamin glimpsed in the earliest films. Even in *Cinema Paradiso* (*Nuovo Cinema Paradiso*; Giuseppe Tornatore, 1988), a film organized around the undying appeal of nostalgia, the climactic scene displays precisely what was never shown on the screens of the Sicilian village at the center of the plot: the amorous life clipped out of movies by the local censor for decades and preserved miraculously, despite fires and neglect, through the love of an aging cinephile. This archival interest in the history of cinema continues into the twenty-first century, with Greenaway's *Eisenstein in Guanajuato* (2015), a biopic remarkable for its attempt to queer the Soviet avant-gardes, making explicit and foundational an element of Eisenstein's biography usually swept to the margins, and for its celebration of the techniques filmmakers embraced in the early twentieth century then relegated to the margins of a more standardized filmmaking practice. Greenaway imagines another possible world where an unfamiliar mode of cinema challenges mainstream narrative forms as the global orthodoxy, where, for example, the split screen is the norm rather than an idiosyncratic practice revived at irregular intervals by a handful of outliers isolated from the dominant trends in the film world. What if, the film asks, the history of cinema unfolded out of Eisenstein's experiments in Mexico rather than the path it eventually followed? In *Goodbye, Dragon Inn* (*Bu san*, 2003) Tsai Ming-Liang imagines cinema as both an image on the screen and a journey to the movies, as the totality of private and communal experiences awaiting in the auditorium, hallways, and hidden recesses of the theater. Shot in Taipei's Fu Ho Grand Theater, a historic movie palace slated for demolition, Tsai's film trains the camera on an audience watching King Hu's *Dragon Gate Inn* (*Long men ke zhan*, 1967) on the silver screen in a majestic but crumbling edifice. It both basks in the aura of cinema and experiences the era of celluloid and theaters as a phenomenon of the past.

At the end of his life Serge Daney suggested that he first decided to write about cinema because it allowed the spectator to "go in with everybody else or by yourself" and to enter a "house with two doors": one that opens onto the street and "that you have to use, or else you understand nothing about cinema"; and a "hidden door" that from the beginning promised "absolutely extravagant things."[1] Looking back at cinema in the late twentieth century and beyond has involved both a backward glance at a medium whose most vibrant days seem to reside in the abandoned theaters or "cinema paradiso" of the past, and a recovery operation aimed at reviving an art form that never exhausted all its possibilities, that suffered a premature demise before fulfilling its most extravagant promises. The archaeomodern turn leads us back into the ruins of cinema. Like Jarman's garden, with its shards of glass and rusted sheets of metal opening onto the wreckage of modernity, or like the devastated

landscape surveyed by Benjamin's angel of history, the first century of cinema is open to redemption only if we understand why those promises captured the imagination of the world and recognize that the medium failed to realize the revolutionary potential envisioned by its earliest advocates and practitioners.

Jarman's final film, *Blue* (1993), reveals the immanent theory of cinema and new media that animated the cinematic painters and archaeomodern thinkers of the late twentieth century. Created when Jarman was dying and going blind due to the effects of AIDS, the film consists of spoken words and music recited and played in fragments over a blue screen. Jarman called the film a flight from the "pandemonium of images," and, in its near-total denial of visual pleasure, it appears to be a throwback to the era of political modernism. Yet as it lingers on-screen, the film blends this atmosphere of mourning with the monotonous blue screen, the background against which the most spectacular effects unfold and the epitome of the studio film's invention and artificiality. Emblematic of the creative process itself, and the cinematic equivalent of Stéphane Mallarmé's blank page, the blue screen begins as a bare surface, redolent of both emptiness and the promise of new beginnings. What then surrounds, fills, infiltrates, and inundates this empty screen? Fragments of poetry, diary entries recording the ravages inflicted on his own body by the disease and medical treatment, and language that recalls the collected artifacts of a public and private past. This blue screen responds to the exigencies of the present by plunging into a cultural and personal history that transforms the almost evacuated screen into a zone of possibility. As Giorgio Agamben points out, the celebrated *tabula rasa* is more accurately rendered as *rasum tabulae*, or the wax surface upon which the stylus engraves and which itself bears the traces of innumerable previous writings.[2] Art emerges from the burdensome task of inscribing over and around the site where others have already written. Jarman envisions the blue screen as a contemporary variation on the blank slate, as a machine capable of interrupting the endless repetition of exhausted images. But like the other directors discussed in this book, he uses this moment of emptiness not to escape from the past and begin anew, but to rediscover forgotten refrains and to reframe persistent memories against a new background. Rather than a nihilistic postmodern cinema, Jarman's film reveals a vibrant color that extends on to infinity and challenges the standard opposition between surface and depth, aesthetics and the promise of an emancipated world to come. As in Gaston Bachelard's meditation on an impossibly ethereal looking glass and the unfathomable blueness of the sky, we pass through to the "other side of the unsilvered mirror" and discover what we failed to see, day after day, decade after decade.[3] "First there is nothing," writes Bachelard, "then there is a deep nothing, then a blue depth."[4]

{ NOTES }

Introduction

1. Walter Benjamin, *Illuminations*, ed. Hannah Arendt, trans. Harry Zohn (New York: Schocken Books, 1968), 255.

2. See Tom Gunning, "The Cinema of Attraction: Early Cinema, Its Spectator, and the Avant-Garde," *Wide Angle* 8.3–4 (1986): 63–70.

3. Wanda Strauven, ed., *The Cinema of Attractions Reloaded* (Amsterdam: Amsterdam University Press, 2006).

4. Jay David Bolter and Richard Grusin, *Remediation: Understanding New Media* (Cambridge, MA: MIT Press, 2000). At the turn of the millennium, Lev Manovich argued that new media consist largely of basic elements of cinema that have been "poured into a computer." Manovich, *The Language of New Media* (Cambridge, MA: MIT Press, 2001), 86.

5. Jacques Rancière coins this phrase to describe the latter part of the career of Walter Benjamin. See "The Archaeomodern Turn," in *Walter Benjamin and the Demands of History*, ed. Michael P. Steinberg (Ithaca, NY: Cornell University Press, 1996).

6. The history of cloud computing dates back to the 1960s, but it began to reach a mass audience in the 1980s, when companies like CompuServe offered consumers the option of uploading and storing files remotely.

7. Laura Mulvey, *Death 24x a Second: Stillness and the Moving Image* (London: Reaktion Books, 2006), 17, 24.

8. Jacques Revel, "Introduction," trans. Arthur Goldhammer, in *Histories: French Constructions of the Past*, ed. Jacques Revel (New York: New Press, 1995), 35.

9. Nietzsche, "On the Utility and Liability of History for Life," trans. Richard T. Gray, in *Unfashionable Observations*, ed. Richard T. Gray (Stanford, CA: Stanford University Press, 1995), 86. On the relationship between historiography, historicity, and film, see Philip Rosen, *Change Mummified: Cinema, Historicity, Theory* (Minneapolis: University of Minnesota Press, 2001), xi.

10. Nora's concluding essay on the *lieux de mémoire* at the core of the "era of commemoration" comments on the receptivity of much of the French population to the activities of 1980's *année du patrimoine* in France. One measure of the year's success, he suggests, was the alteration of the meaning of the word *patrimoine* from inheritance in the strictly legal sense to heritage as the cultural legacy begat by generations past and available to all who envision themselves as citizens of the nation. See Nora, "The Era of Commemoration," in *Realms of Memory: The Construction of the French Past*, volume III: Symbols, under the direction of Nora, English edition, ed. Lawrence D. Kritzman, trans. Arthur Goldhammer (New York: Columbia University Press, 1998), 624.

11. Revel, "Introduction," 34. Revel draws a comparison between history and "ethnological literature," and this parallel is particularly instructive because with the end of colonialism as an overt enterprise and its continuation through new modalities, the new

"regime of historicity" translates many of the strategies also used to identify a colonial other into representations of the past. Raj nostalgia in contemporary Britain, or the fascination with stories culled from colonial childhoods in French Indochina: these doubly colonizing gestures offer the most concentrated examples of a more general trend in representations of the national past, in which the exoticizing techniques of colonial literature and art are repatriated, transforming the domestic past into a terrain simultaneously to be mined and exploited by the heritage industry and refortified as a stable base from which to launch neocolonial adventures.

12. Pierre Nora, "General Introduction: Between Memory and History," in *Realms of Memory: Rethinking the French Past*, volume I: Conflicts and Divisions, under the direction of Nora, English edition, ed. Lawrence D. Kritzman, trans. Arthur Goldhammer (New York: Columbia University Press, 1996), 1. See also François Herzog, *Regimes of Historicity: Presentism and Experiences of Time*, trans. Saskia Brown (New York: Columbia University Press, 2015), 150–151.

13. Pierre Nora, "General Introduction: Between Memory and History," 1.

14. Nora, "Era of Commemoration," 608.

15. Ibid., 609.

16. Ibid., 610. Several contributors to Nora's editorial project frame the contrast between critical history and commemoration as the difference between the past viewed as a site of struggle and the cultural tourism that seeks to minimize this division and conflict. For example, in an essay devoted to the origins and evolution of Bastille Day, Christian Amalvi writes that a *lieu de mémoire* often recalls moments of bitter struggle and partisanship but devolves into an empty "holiday ritual" and "tourist attraction." Bastille Day becomes an "institutionalized celebration," invoking rebellion not to spark renewed insurrection but as "a way of warding off the specter of another Commune." See Amalvi, "Bastille Day: From *Dies Irae* to Holiday," in *Realms of Memory*, volume III, 156, 127.

17. Nora, "Era of Commemoration," 622.

18. Angelo Quattrocchi and Tom Nairn, *The Beginning of the End: France, May 1968* (London: Verso, 1998), 121.

19. Jean-Pierre Babelon, "The Louvre: Royal Residence and Temple of the Arts," in *Realms of Memory*, volume III, 284.

20. Ibid.

21. *Heritage in Danger* is the title of a catalytic early account of the threats faced by emblematic elements of the national past. The book's author, Conservative M.P. Patrick Cormack, was also involved in parliamentary debates that culminated in the Heritage Acts and oversaw their administration on the committees dedicated to arts and heritage and works of art in Parliament. Heritage discourse thus moved imperceptibly between the public, the commercial, and the official spheres. See *Heritage in Danger* (London: New English Library, 1976). As Patrick Wright suggests, the National Heritage Act of 1980 "has two main co-ordinates: it is concerned with the preservation of that range of property which it defines as 'the heritage,' but it also seeks to secure public access (of an acceptable sort), to ensure that 'the heritage' is available for cultural consumption and in this case especially that it is *displayed* as such" (44). The mechanisms employed by the Act include facilitating the transfer of property to the State to offset estate and other tax burdens, reducing the insurance costs incurred when owners of precious heritage objects lend them to other museums, and establishing the National Heritage Memorial Fund, a modest pool of money administered by appointees of the prime

minister and intended to further the preservation of that still vaguely defined category: "the heritage." See Wright, *On Living in an Old Country: The National Past in Contemporary Britain* (Oxford: Oxford University Press, 2009).

22. From an interview with Robert Hewison quoted in Hewison, *The Heritage Industry* (London: Methuen, 1987), 24.

23. Theodor W. Adorno, "Valéry Proust Museum," in *Prisms*, trans. Samuel and Shierry Weber (Cambridge, MA: MIT Press, 1990), 175.

24. Wright, *On Living in an Old Country*, 66.

25. Ibid.

26. Eric Hobsbawm and Terence Ranger, eds., *The Invention of Tradition* (Cambridge: Cambridge University Press, 1983); Raphael Samuel, *Theatres of Memory*, volume I (London: Verso, 1994); Samuel, *Island Stories: Theatres of Memory*, volume II (London: Verso, 1998); Samuel, ed., *Patriotism: The Making and Unmaking of British Identity*, 3 vols. (London: Routledge, 1987–1989).

27. Paul Gilroy, *The Black Atlantic: Modernity and Double-Consciousness* (Cambridge, MA: Harvard University Press, 1993), 33.

28. See James Clifford, *Routes: Travel and Translation in the Late Twentieth Century* (Cambridge, MA: Harvard University Press, 1997); David Harvey, *The Condition of Postmodernity: An Inquiry into the Origins of Cultural Change* (Oxford: Blackwell, 1989).

29. Harvey, *Condition of Postmodernity*, 306–307.

30. Ibid., 303. The heritage phenomenon is founded on the flexible accumulation of a particularly valuable commodity: the national past. According to government figures cited by Hewison, the crowds drawn to historic houses grew immensely in the early 1980s, reaching forty-eight million visitors by 1983; museums and galleries were more popular yet, attracting fifty-eight million; total ticket sales for the cinema fell somewhere in between, at fifty-three million. Hewison, *Heritage Industry*, 27.

31. Nora, "Introduction to *Realms of Memory*, Volume III," in *Realms of Memory*, volume III, xii.

32. Svetlana Boym, *The Future of Nostalgia* (New York: Basic Books, 2001), xiv.

33. Ibid.

34. Ibid., 10.

35. Sean Wilentz, "America Made Easy," *New Republic* (July 1, 2001). Accessed online at https://newrepublic.com/article/90636/david-mccullough-john-adams-book-review.

36. Allan Bloom, *The Closing of the American Mind* (New York: Touchstone, 1987), 353.

37. Daniel Bell, *The Cultural Contradictions of Capitalism* (New York: Basic Books, 1996), 170.

38. See Michael Hanchard, "Afro-Modernity: Temporality, Politics, and the African Diaspora," in *Alternative Modernities*, ed. Dilip Parameshwar Gaonkar (Durham, NC: Duke University Press), 272–298.

39. Ibid., 277, 279, 297.

40. Fredric Jameson, *Postmodernism, or, The Cultural Logic of Late Capitalism* (Durham, NC: Duke University Press, 1991), 18.

41. Andrew Higson, "Re-presenting the National Past: Nostalgia and Pastiche in the Heritage Film," in *Fires Were Started: British Cinema and Thatcherism*, ed. Lester Friedman (Minneapolis: University of Minnesota Press, 1993), 109. For a more favorable reception of the heritage film, with particular emphasis on its audiences, see Claire Monk, "The British

Heritage Film Debate Revisited," in *British Historical Cinema*, ed. Claire Monk and Amy Sargeant (London: Routledge, 2002).

42. For a detailed historical and theoretical account of "Cinema's Victorian Retrofit," see the chapter by that title in Garrett Stewart's *Between Film and Screen: Modernism's Photo Synthesis* (Chicago: University of Chicago Press, 2000). For a discussion of Austen and recent cinema and television, see Erica Sheen's "'Where the Garment Gapes': Faithfulness and Promiscuity in the 1995 BBC *Pride and Prejudice*," in Robert Giddings and Erica Sheen, eds., *The Classic Novel: From Page to Screen* (Manchester: Manchester University Press, 2000). For James, see *Henry James Goes to the Movies*, ed. Susan M. Griffin (Lexington: University of Kentucky Press, 2001).

43. F. R. Leavis, *For Continuity* (Freeport, NY: Books for Libraries Press, 1968).

44. On the relationship between historical films and the Academy Award for Best Picture, see James Tweedie, "Steve McQueen's Low-Tech Triumph: Looking at This Year's Oscar Winners," OUPblog. Accessed online at http://blog.oup.com/2014/03/academy-awards-2014-results/.

45. Peter Greenaway, "Architecture through the Lens," *Blueprint* (July–August 1991), 23.

46. Guy Debord, *The Society of the Spectacle*, trans. Donald Nicholson-Smith (New York: Zone Books, 1994), 120.

47. Fredric Jameson, *Signatures of the Visible* (New York: Routledge, 1992), 217–229.

48. *Karl Marx and Friedrich Engels: Selected Works* (New York: International Publishers, 1968), 99, 97.

49. Jameson, *Postmodernism*; Linda Hutcheon, *A Poetics of Postmodernism: History, Theory, Fiction* (London: Routledge, 1988); Linda Hutcheon, *The Politics of Postmodernism* (London: Routledge, 1989).

50. Paul Ricoeur, *History and Truth*, trans. Charles A. Kelbley (Evanston, IL: Northwestern University Press, 1965), 277.

51. Michel de Certeau, *The Writing of History*, trans. Tom Conley (New York: Columbia University Press, 1988), 2.

52. Ibid., 136.

53. Timothy Hampton, "Introduction: Baroques," *Yale French Studies* 80 (1991), 2.

54. Christine Buci-Glucksmann, *La Folie du voir: De l'esthétique baroque* (Paris: Éditions Galilée, 1986); Buci-Glucksmann, *Tragique de l'ombre: Shakespeare et le maniérisme* (Paris: Éditions Galilée, 1990); Buci-Glucksmann, *Baroque Reason: The Aesthetics of Modernity*, trans. Patrick Camiller (London: Sage Publications, 1994); Martin Jay, *Downcast Eyes: The Denigration of Vision in Twentieth-Century French Thought* (Berkeley: University of California Press, 1993).

55. See Lois Parkinson Zamora and Monika Kaup, *Baroque New Worlds: Representations, Transculturation, Counterconquest* (Durham, NC: Duke University Press, 2010).

56. Iain Chambers, "History, the Baroque and the Judgment of Angels," in *The Actuality of Walter Benjamin*, ed. Laura Marcus and Lynda Nead (London: Lawrence and Wishart, 1998).

57. Benjamin, *Illuminations*, 262, 255.

58. Ibid., 255.

59. Michel de Certeau, *The Mystic Fable: Volume One, The Sixteenth and Seventeenth Centuries*, trans. Michael B. Smith (Chicago: University of Chicago Press, 1992), 6.

60. Ibid., 20.

61. Stephen Calloway, *Baroque Baroque* (New York: Phaidon Press, 2000), 182; Omar Calabrese, *Neo-Baroque: A Sign of the Times*, trans. Charles Lambert (Princeton, NJ: Princeton University Press, 1992).

62. Raphaël Bassan, "Trois néo-baroques français: Beineix, Besson, Carax, de *Diva* au *Grand Bleu*," *Revue du cinéma* 449 (May 1989), 45.

63. See Eric L. Santner, *Stranded Objects: Mourning, Memory, and Film in Postwar Germany* (Ithaca, NY: Cornell University Press, 1990).

64. Mary Hivnor, "The Baroque Equation in Spanish Films," *Partisan Review* 57.4 (Fall 1990), 616.

65. Ibid., 617.

66. Simon Field, "The Troublesome Cases," *Afterimage* 12 (Autumn 1985), 4.

67. See Timothy Murray, *Digital Baroque: New Media Art and Cinematic Folds* (Minneapolis: University of Minnesota Press, 2008); Angela Ndalianis, *Neo-Baroque Aesthetics and Contemporary Entertainment* (Cambridge, MA: MIT Press, 2005).

68. Manovich, *Language of New Media*, 13; Belén Vidal, *Figuring the Past: Period Film and the Mannerist Aesthetic* (Amsterdam: Amsterdam University Press, 2012).

69. For a collection and translation of Daney's writing on mannerist cinema and media, see http://sergedaney.blogspot.com/2013/05/mannerism.html.

70. Serge Daney, *Devant la recrudescence des vols de sacs à main: Cinéma, télévision, information (1988–1991)*, 2nd ed. (Lyon: ALÉAS, 1997), 100.

71. Gilles Deleuze, *Negotiations: 1972–1990*, trans. Martin Joughin (New York: Columbia University Press, 1995), 75.

72. Gilles Deleuze, *The Fold: Leibniz and the Baroque*, trans. Tom Conley (Minneapolis: University of Minnesota Press, 1993), 33.

73. Michel Foucault, "Space, Knowledge, and Power," trans. Christian Hubert, in *The Foucault Reader*, ed. Paul Rabinow (New York: Pantheon Books, 1984), 250.

74. Hal Foster, *The Return of the Real: The Avant-Garde at the End of the Century* (Cambridge, MA: MIT Press, 1996), x.

75. Foucault, "Nietzsche, Genealogy, History," trans. Donald F. Bouchard and Sherry Simon, in *Foucault Reader*, 79.

76. Perry Anderson, *A Zone of Engagement* (London: Verso, 1992), 375.

77. Raymond Williams, *Keywords: A Vocabulary of Culture and Society* (New York: Oxford University Press, 1983), 208.

78. Ibid., 208–209.

79. Stephen Kern, *The Culture of Time and Space: 1880–1918* (Cambridge, MA: Harvard University Press, 1983), 1–2.

80. Michael Fried, *Three American Painters: Kenneth Noland, Jules Olitski, Frank Stella* (Cambridge, MA: Fogg Art Museum, 1965), 9.

81. For a wide-ranging account of cinema's peculiar and shifting relation to modernity, see Leo Charney and Vanessa R. Schwartz, eds., *Cinema and Invention of Modern Life* (Berkeley: University of California Press, 1995).

82. Jameson, *Signatures of the Visible*, 157.

83. Ibid.

84. Note also the implicit anachronism of Jameson's repeated references to postmodernism *avant la lettre* or to equally abundant "survivals of the modern." For example, Jameson cites Godard's 1982 film *Passion* as evidence that the director represents a "survivor of the

modern" in postmodern times. Jameson, *The Geopolitical Aesthetic: Cinema and Space in the World System* (Bloomington: Indiana University Press, 1992), 162. See also Jameson, *The Political Unconscious: Narrative as a Socially Symbolic Act* (Ithaca, NY: Cornell University Press, 1981), 9.

85. Jacques Derrida, *Writing and Difference*, trans. Alan Bass (Chicago: University of Chicago Press, 1978), 280.

86. Jean Rousset, *La littérature de l'âge baroque en France: Circé et le paon* (Paris: J. Corti, 1953), 233.

87. Walter Benjamin, *Walter Benjamin: Selected Writings, Volume 3: 1935–1938*, trans. Edmund Jephcott, Howard Eiland, and others, ed. Howard Eiland and Michael W. Jennings (Cambridge, MA: Belknap Press of Harvard University Press, 2002), 390.

88. Clement Greenberg, "Modernist Painting," *Art and Literature* 4 (Spring 1965), 200.

89. Stephen Melville, "Notes on the Reemergence of Allegory, the Forgetting of Modernism, the Necessity of Rhetoric, and the Conditions of Publicity in Art and Criticism," *October* 19 (1981), 82.

90. Ibid., 91.

91. Ibid., 92.

92. Ibid.

93. Foucault, "What is Enlightenment?," trans. Catherine Porter, in *Foucault Reader*, 39. Michael Hardt and Antonio Negri identify the recent rise of fundamentalism with a similar impulse to resist modernity. They write, "In general, one might say that fundamentalisms, diverse though they may be, are linked by their being understood both from within and outside as anti-modernist movements, resurgences of primordial identities and values; they are conceived as a kind of historical backflow, a de-modernization." *Empire* (Cambridge, MA: Harvard University Press, 2000), 146.

94. José Antonio Maravall, *Culture of the Baroque: Analysis of a Historical Structure*, trans. Terry Cochran (Minneapolis: University of Minnesota Press, 1986), 263.

95. Benjamin, *Illuminations*, 255.

96. Walter Benjamin, "N [Theoretics of Knowledge; Theory of Progress]," trans. Leigh Hafrey and Richard Sieburth, in *Benjamin: Philosophy, Aesthetics, History*, ed. Gary Smith (Chicago: University of Chicago Press, 1989), 63.

97. Wolfgang Ernst, *Digital Memory and the Archive*, ed. Jussi Parikka (Minneapolis: University of Minnesota Press, 2012), 43.

98. Friedrich A. Kittler, *Gramophone, Film, Typewriter*, trans. Geoffrey Winthrop-Young and Michael Wutz (Stanford, CA: Stanford University Press, 1999), 4.

99. Friedrich A. Kittler, *Discourse Networks 1800/1900*, trans. Michael Metteer with Chris Cullens (Stanford, CA: Stanford University Press, 1990), 211.

100. Geoffrey Winthrop-Young, "On Friedrich Kittler's 'Authorship and Love,'" *Theory, Culture & Society* 32.3 (2015), 9–10.

101. Alexandra Ludewig, *Screening Nostalgia: 100 Years of German Heimat Film* (Bielefeld: transcript, 2014), 389.

102. Friedrich A. Kittler, "De Nostalgia," trans. Geoffrey Winthrop-Young, *Cultural Politics* 11.3 (November 2015), 395–396, 403.

103. Alon Confino, *Germany as a Culture of Remembrance: Promises and Limits of Writing History* (Chapel Hill: University of North Carolina Press, 2006).

104. Kittler, *Discourse Networks*, 240.

105. Siegfried Zielinski, *Deep Time of the Media: Toward an Archaeology of Hearing and Seeing by Technical Means*, trans. Gloria Custance (Cambridge, MA: MIT Press, 2006), 7.

106. Seb Franklin likewise views precursors to the logic of digitality dating back centuries, for example, in the meditations on machine logic in Charles Babbage, which "suggest a historical connection between digitality and capital that precedes the discourse of post-Fordism, immaterial labor, the information economy, and so on." See Franklin, *Control: Digitality as Cultural Logic* (Cambridge, MA: MIT Press, 2015), 24.

107. Bruno Latour, *We Have Never Been Modern*, trans. Catherine Porter (Cambridge, MA: Harvard University Press, 1993).

108. Ernst, *Digital Memory and the Archive*, 113.

109. Ibid., 24.

110. Ibid., 37.

111. Ibid., 117.

112. D. N. Rodowick, *The Virtual Life of Film* (Cambridge, MA: Harvard University Press, 2007), 42. Rodowick's book focuses primarily on the implications of digital media for film theory and philosophy, using Stanley Cavell's *The World Viewed* (1971), "the last great work of classical film theory" (79), as its main intellectual guide. Its key reference points gesture back to the 1970s or forward from the turn of the millennium. This book takes one more retrospective turn into the late twentieth century to explore the images and ideas of cinema that emerged in that gap between the end of the classical age and the beginning of the new digital era. Looking forward from 1970, Gene Youngblood describes the media landscape to come as a "Paleocybernetic" age, and his prospective (and at times prophetic) account of a cybernetic future provides a useful bookend to the more retrospective concept of the archaeomodern developed in this book. See Youngblood, *Expanded Cinema* (New York: Dutton, 1970), 41.

113. See Michel Foucault, *The Order of Things: An Archaeology of the Human Sciences* (New York: Vintage, 1994).

114. Ibid., 16.

115. Jean-Pierre Oudart, "The Reality Effect," trans. Annwyl Williams, in *Cahiers du Cinéma, 1969–1972: The Politics of Representation*, ed. Nick Browne (Cambridge, MA: Harvard University Press, 1990), 191.

116. Svetlana Alpers, "Interpretation without Representation, or, The Viewing of *Las Meninas*," *Representations* 1.1 (February 1983), 36.

117. Foucault, *Order of Things*, 4, 11.

118. Deleuze, *Fold*, 20.

119. Ibid.

120. Ibid., 4. Foucault's engagement with the simultaneity of the image anticipates his fascination with the "seven discourses in a single statement" in Magritte's The Treachery of Images, which also wanders between incompatible regimes of representation, "unfolding from itself and folding back upon itself." Foucault, *This Is Not a Pipe*, trans. James Harkness (Berkeley: University of California Press, 1983), 49.

121. John R. Searle, "*Las Meninas* and the Paradoxes of Pictorial Representation," *Critical Inquiry* 6.3 (Spring 1980), 487.

122. Foucault, *Order of Things*, 9.

123. Gilles Deleuze, *Difference and Repetition*, trans. Paul Patton (New York: Columbia University Press, 1994), 56.

124. Joel Snyder, *"Las Meninas* and the Mirror of the Prince," *Critical Inquiry* 11.4 (June 1985), 545.

125. Joel Snyder and Ted Cohen, "Reflections on *Las Meninas*: Paradox Lost," *Critical Inquiry* 7.2 (Winter 1980), 433–436.

126. Fredric Jameson, "Benjamin's Readings," *Diacritics* 22.3–4 (Fall–Winter 1992), 25.

127. André Bazin, *What Is Cinema?*, vol. 1, ed. and trans. Hugh Gray (Berkeley: University of California Press, 1967), 97.

128. Like the reflecting apparatus alluded to by the artist in Jean-Luc Godard's *La Chinoise* (1967), these theoretical and painted mirrors attest to an altered understanding of the realistic image: "Art is not a reflection of reality. It's the reality of a reflection," he says.

129. Searle, *"Las Meninas,"* 486.

130. Kenneth Clark, *Looking at Pictures* (Boston: Beacon Press, 1968), 40.

131. Thomas Elsaesser, "Freud as Media Theorist: Mystic Writing Pads and the Matter of Memory," *Screen* 50.1 (Spring 2009), 108.

132. Ernst, *Digital Memory and the Archive*, 57.

133. Manovich, *Language of New Media*, 295.

134. Ibid. The late twentieth century also sparked a stunning revival of scholarly interest in the relationship between cinema and other art forms, including painting. See, for example, Brigitte Peucker, *Incorporating Images: Film and the Rival Arts* (Princeton, NJ: Princeton University Press, 1995); Angela Dalle Vacche, *Cinema and Painting: How Art Is Used in Film* (Austin: University of Texas Press, 1996); and Susan Felleman, *Art in the Cinematic Imagination* (Austin: University of Texas Press, 2006).

135. Mulvey, *Death 24x a Second*, 22.

Chapter 1

1. Walter Benjamin, *The Origin of German Tragic Drama*, trans. John Osborne (London: Verso, 1998), 135.

2. Richard Wolin, *Walter Benjamin: An Aesthetic of Redemption* (Berkeley: University of California Press, 1994), xxi.

3. Irving Wohlfarth, "The Measure of the Possible, the Weight of the Real and the Heat of the Moment: Benjamin's Actuality Today," in *The Actuality of Walter Benjamin*, ed. Laura Marcus and Lynda Nead (London: Lawrence and Wishart, 1998), 29.

4. Walter Benjamin, *Walter Benjamin: Selected Writings, Volume 1: 1913–26*, ed. Marcus Bullock and Michael W. Jennings (Cambridge, MA: Belknap Press of Harvard University Press, 1996), 6.

5. Shoshana Felman, "Benjamin's Silence," *Critical Inquiry* 25 (Winter 1999), 234.

6. Ibid., 202.

7. In his most straightforward statement of the effects of cinema on tradition, Benjamin writes that the resulting decline in the aura and proliferation of copies "lead to a tremendous shattering of tradition which is the obverse of the contemporary crisis and renewal of mankind. Both processes are intimately connected with the contemporary mass movements. Their most powerful agent is the film. Its social significance, particularly in its most positive form, is inconceivable without its destructive, cathartic aspect, that is, the liquidation of the traditional value of the cultural heritage. This phenomenon is most palpable in the great

historical films. It extends to ever new positions. In 1927 Abel Gance exclaimed enthusiastically: 'Shakespeare, Rembrandt, Beethoven will make films . . . all legends, all mythologies and all myths, all founders of religion, and the very religions . . . await their exposed resurrection, and the heroes crowd each other at the gate.' Presumably without intending it, he issued an invitation to a far-reaching liquidation." *Illuminations: Essays and Reflection*, ed. Hannah Arendt, trans. Harry Zohn (New York: Schocken Books, 1968), 221–222.

8. John McCole, *Walter Benjamin and the Antinomies of Tradition* (Ithaca, NY: Cornell University Press, 1993), 18.

9. Fredric Jameson, "Marx's Purloined Letter," in *Ghostly Demarcations: A Symposium on Jacques Derrida's Specters of Marx*, ed. Michael Sprinker (London: Verso, 1999), 41.

10. Miriam Bratu Hansen, "Room-for-Play: Benjamin's Gamble with Cinema," *October* 109 (Summer 2004), 4.

11. Ibid., 6.

12. Ibid., 8.

13. McCole, *Walter Benjamin*, 32. Studies of Benjamin's work repeatedly mention the proto-modernity of his writing style in the *Trauerspiel* book, often emphasizing its connection to contemporaneous modernist works. Hannah Arendt, for example, argues that "like [his] later notebooks, this collection was not an accumulation of excerpts intended to facilitate the writing of the study but constituted the main work, with the writing as something secondary. The main work consisted in tearing fragments out of their context and arranging them afresh in such a way that they illustrated one another and were able to prove their *raison d'être* in a free-floating state, as it were. It definitely was a sort of surrealistic montage." Arendt, "Introduction: Walter Benjamin: 1892–1940," in Benjamin, *Illuminations*, 47. And as George Steiner maintains in his introduction to the *Trauerspiel* book, "Benjamin's hermeneutic of and by citation also has its contemporary flavor: it is very obviously akin to the collage and montage-aesthetic in the poetry of Ezra Pound and T. S. Eliot, and in the prose of Joyce—all of whom are producing major works at exactly the same date as Benjamin's *Ursprung*." Steiner, "Introduction," in Benjamin, *Origin of German Tragic Drama*, 22.

14. Jacques Rancière, "The Archaeomodern Turn," in *Walter Benjamin and the Demands of History*, ed. Michael P. Steinberg (Ithaca, NY: Cornell University Press, 1996), 27, 28.

15. Benjamin, *Origin of German Tragic Drama*, 134.

16. Jeffrey Sconce, *Haunted Media: Electronic Presence from Telegraphy to Television* (Durham, NC: Duke University Press, 2007), 6.

17. Friedrich Kittler, *Gramophone, Film, Typewriter*, trans. Geoffrey Winthrop-Young and Michael Wutz (Stanford, CA: Stanford University Press, 1999), 75.

18. See Jussi Parikka, "What Is Media Archaeology?—Beta Definition 0.8." Accessed online at http://mediacartographies.blogspot.com/2010/10/what-is-media-archaeology-beta.html.

19. Roland Barthes, *Camera Lucida*, trans. Richard Howard (New York: Hill and Wang, 1981), 79, 32.

20. Eduardo Cadava, *Words of Light: Theses on the Photography of History* (Princeton, NJ: Princeton University Press, 1997), 11.

21. Kittler, *Gramophone, Film, Typewriter*, 130.

22. André Bazin, *What Is Cinema?*, vol. 1, ed. and trans. Hugh Gray (Berkeley: University of California Press, 1967), 9.

23. This ghostly presence becomes the foundational conceit for Derrida's *Specters of Marx*, whose relevance to Benjamin and contemporary media studies will be discussed below.

24. Bazin, *What Is Cinema?*, vol. 1, 97.

25. Like the mirror around which Foucault constructs his analysis of *Las Meninas*, that reflection is also a recorded and projected image. See this book's introduction.

26. Bazin, *What Is Cinema?*, vol. 1, 16.

27. Miriam Hansen, *Cinema and Experience: Siegfried Kracauer, Walter Benjamin, and Theodor W. Adorno* (Berkeley: University of California Press, 2012), 87. On belatedness in Benjamin, see also 115–116.

28. Miriam Hansen, "Benjamin, Cinema and Experience: The Blue Flower in the Land of Technology," *New German Critique* 40 (Winter 1987), 182.

29. Because it speaks of petrifaction rather than perfect preservation, Adorno describes Benjamin's thought as "medusan," positing a "medusa effect" that complements Bazin's "mummy complex." Adorno, "Introduction to Benjamin's *Schriften*," trans. R. Hullot-Kentor, in *On Walter Benjamin: Critical Essays and Recollections*, ed. Gary Smith (Cambridge, MA: MIT Press, 1991), 11.

30. Richard Wolin maintains that this ambivalence toward tradition first surfaced in Benjamin's youthful involvement with the German Youth Movement, a flirtation that ended poorly when the organization's celebration of Teutonic heritage began to acquire fascist overtones, or, more precisely, when barely submerged fascist and anti-Semitic undertones became impossible to ignore. See Wolin, *Walter Benjamin*, 4.

31. Benjamin, "N [Theoretics of Knowledge; Theory of Progress]," trans. Leigh Hafrey and Richard Sieburth, in *Benjamin: Philosophy, Aesthetics, History*, ed. Gary Smith (Chicago: University of Chicago Press, 1989), 63. Benjamin's travel essays read almost like prefigurations of contemporary writing on the homogenizing effects of globalization and the heritage industry. His Naples travelogue, for example, laments the commodification of ancient excavation sites and popular rituals in terms that remain remarkably familiar. As Susan Buck-Morss writes, Benjamin describes a Naples where "traditional life goes on except now, as a tourist show, everything is done for money. Tours and replicas of the ruins of Pompeii are for sale; natives perform the legendary eating of macaroni with their hands for tourists for a price. . . . Political events are turned into festivals." See Susan Buck-Morss, *The Dialectics of Seeing: Walter Benjamin and the Arcades Project* (Cambridge, MA: MIT Press, 1999), 27. Benjamin also remarks with evident surprise and disdain that the Bolshevik revolution has become yet another commodity to be sold by Moscow street vendors in the form of political icons.

32. Benjamin, "N," 63.

33. Wolin, *Walter Benjamin*, 51.

34. Benjamin, *Illuminations*, 263.

35. Jürgen Habermas, "Walter Benjamin: Consciousness-Raising or Rescuing Critique," in *On Walter Benjamin: Critical Essays and Recollections*, ed. Gary Smith (Cambridge, MA: MIT Press, 1972), 121.

36. Benjamin, *Illuminations*, 143.

37. Benjamin, "N," 65.

38. Hansen, "Benjamin, Cinema, and Experience," 186.

39. Benjamin, "N," 50.

40. Cadava, *Words of Light*, xx.

41. Susan Sontag, *Under the Sign of Saturn* (New York: Farrar, Straus, Giroux, 1980), 129.

42. Adorno, "Introduction to Benjamin's *Schriften*", 7.

43. Ibid., 12.

44. Walter Benjamin, *Walter Benjamin: Selected Writings, Volume 2: 1927–34*, trans. Rodney Livingstone and others; ed. Michael W. Jennings, Howard Eiland, and Gary Smith (Cambridge, MA: Belknap Press of Harvard University Press, 1999), 484.

45. Quoted in Irving Wohlfarth, "Resentment Begins at Home: Nietzsche, Benjamin, and the University," in Smith, *On Walter Benjamin*, 234.

46. Ibid.

47. Walter Benjamin, *The Arcades Project*, trans. Howard Eiland and Kevin McLaughlin (Cambridge, MA: Belknap Press of Harvard University Press, 2002), 463.

48. Benjamin, *Illuminations*, 262.

49. Wohlfarth, "Resentment Begins at Home," 245.

50. Rancière, "Archaeomodern Turn," 37.

51. Ibid.

52. Zygmunt Bauman, "Walter Benjamin, the Intellectual," in Marcus and Nead, *Actuality of Walter Benjamin*, 76, 77.

53. Benjamin, *Walter Benjamin: Selected Writings, Volume 2*, 78.

54. Craig Owens, "The Allegorical Impulse: Toward a Theory of Postmodernism," in *Art after Modernism: Rethinking Representation*, ed. Brian Wallis (New York and Boston: The New Museum of Contemporary Art and David R. Godine, 1986), 203, 210.

55. Ibid., 211.

56. Benjamin, *Origin of German Tragic Drama*, 176.

57. Ibid., 178.

58. Charles Baudelaire, *Les Fleurs du mal*, ed. Jean Delabroy (Paris: Magnard, 1987), 156.

59. Buck-Morss, *Dialectics of Seeing*, 164.

60. Ibid., 170.

61. Hansen, "Benjamin, Cinema, and Experience," 203. Because of its imminent political critique, Benjamin's idea of allegory has migrated to the center of much writing on the avant-garde, as in Peter Bürger's *Theory of the Avant-Garde*, which draws heavily if implicitly on Benjamin. See Wolin, *Walter Benjamin*, 136. See also, Bürger, *Theory of the Avant-Garde*, trans. Michael Shaw (Minneapolis: University of Minnesota Press, 1994), 68–73.

62. Hansen, "Benjamin, Cinema, and Experience," 209.

63. Owens, "Allegorical Impulse," 203.

64. Adorno, "Introduction to Benjamin's *Schriften*," 6.

65. Walter Benjamin, "Central Park," trans. Lloyd Spencer, *New German Critique* 34 (Winter 1985), 38.

66. Ibid., 50.

67. Walter Benjamin, "Lichtenberg: A Cross Section," trans. Gerhard Schulte, *Performing Arts Journal* 14.3 (September 1992), 38.

68. Jameson, "Marx's Purloined Letter," 34.

69. Jacques Derrida, *Specters of Marx: The State of the Debt, the Work of Mourning, and the New International*, trans. Peggy Kamuf (London: Routledge, 1994), 46–47.

70. Ibid., 54.

71. Ibid., 28.

72. Jameson, "Marx's Purloined Letter," 63, 33.

73. Derrida, *Specters of Marx*, 92.

74. Ibid., 90. Derrida contends that the theological and the messianic occupy a crucial position in Marx's own writing, appearing in the ghostly figures analyzed throughout *Specters of Marx*, but also in the concept of the fetish or the becoming-god of gold, which "announces or confirms the absolute privilege that Marx always grants to religion, to ideology as religion, mysticism, or theology." Ibid., 148.

75. Ibid., 168.

76. Jameson, "Marx's Purloined Letter," 35.

77. Ibid., 62. De Certeau's writing on mysticism also balances this mourning of a fundamental loss and faith that something remains, and, like Derrida, he invokes *Hamlet* as a preeminent example of the pursuit of justice after a loss. Michel de Certeau, *The Mystic Fable: Volume One, the Sixteenth and Seventeenth Centuries*, trans. Michael B. Smith (Chicago: University of Chicago Press, 1992), 2.

78. Derrida, *Specters of Marx*, 54.

79. Jameson, "Marx's Purloined Letter," 60.

80. Ibid., 62; Francis Fukuyama, "The End of History," *National Interest* (Summer 1989), 3.

81. That same passage from *Hamlet* on a time "out of joint" also introduces Deleuze's "Preface to the English Edition" of *Cinema 2—The Time-Image*, written in response to prophesies of the end of cinema. See *Cinema 2: The Time-Image*, trans. Hugh Tomlinson and Robert Galeta (Minneapolis: University of Minnesota Press, 1989), xi.

82. Martin Heidegger, *Early Greek Thinking*, trans. David Farrell Krell and Frank A. Capuzzi (San Francisco: Harper and Row, 1984), 41, 54.

83. Derrida, *Specters of Marx*, 27.

84. Benjamin, *Origin of German Tragic Drama*, 136.

85. Derrida, *Specters of Marx*, 54.

86. Ibid., 51. Primarily a work of political philosophy and only partially attuned to the media environment to come, Derrida's analysis nonetheless anticipates the work of Hito Steyerl, whose "defense of the poor image" characterizes the glitch, low-resolution pictures of the early digital age as "a ghost of an image, a preview, a thumbnail, an errant idea, an itinerant image distributed for free, squeezed through slow digital connections, compressed, reproduced, ripped, remixed." See Steyerl, "In Defense of the Poor Image," *e-flux* 10 (November 2009). Accessed online at http://www.e-flux.com/journal/10/61362/in-defense-of-the-poor-image/.

87. Warren Montag, "Spirits Armed and Disarmed: Derrida's *Specters of Marx*," in Sprinker, *Ghostly Demarcations*, 71.

88. Derrida, *Specters of Marx*, 6.

89. Ibid., 11.

90. Ibid., 7.

91. Ibid., 100–101.

92. Ibid., 63.

93. Gilles Deleuze, *Difference and Repetition*, trans. Paul Patton (New York: Columbia University Press, 1994), 10.

94. Derrida, *Specters of Marx*, 81; Owens, "Allegorical Impulse," 204.

95. Jameson, "Marx's Purloined Letter," 58.

96. Ibid., 59.

97. Benjamin, *Origin of German Tragic Drama*, 193. Jane Brown also emphasizes the ghostly, otherworldly quality of baroque allegory and allegorical drama more generally. She writes, "By allegory I understand, basically, a mode of representation which renders the supernatural visible, by mimesis a mode which imitates the natural, what is already visible." *The Persistence of Allegory: Drama and Neoclassicism from Shakespeare to Wagner* (Philadelphia: University of Pennsylvania Press, 2007), 5. This distinction between allegory and mimesis is also relevant to the study of cinema because of the long theoretical tradition characterizing photographic arts as mimetic and because of the late twentieth-century embrace of a counterposed allegorical mode.

98. Antonio Negri, "The Specter's Smile," in Sprinker, *Ghostly Demarcations*, 13.

99. Ibid., 12.

100. Jacques Derrida, "Marx and Sons," trans. G. M. Goshgarian, in Sprinker, *Ghostly Demarcations*, 257.

101. Ibid., 258.

102. Benjamin, *Illuminations*, 255.

103. Laura Mulvey, *Death 24x a Second: Stillness and the Moving Image* (London: Reaktion Books, 2006), 196.

104. Stephen Prince, *A New Pot of Gold: Hollywood under the Electronic Rainbow, 1980–1989* (Berkeley: University of California Press, 2000), 89.

105. Thomas Elsaesser describes this simultaneously retrospective and prospective return to early cinema as a sign of the many "non-congruent and a-synchronous moments today." See "The New Film History as Media Archaeology," *Cinémas: Revue d'études cinématographiques* 14.2–3 (2004), 85.

106. Derrida, *Specters of Marx*, 9.

107. Garrett Stewart, *Between Film and Screen: Modernism's Photo Synthesis* (Chicago: University of Chicago Press, 1999), 37.

108. De Certeau, *Mystic Fable*, 13.

109. Francesco Casetti's focus on the status of cinema as a "relic" in the new millennium signals some overlap with the type of spectral analysis and the mood of mourning discussed above, though elsewhere he tends to be more resolutely optimistic about the survival of cinema in digital media and its new technological manifestations. See Casetti, *The Lumière Galaxy: Seven Key Words for the Cinema to Come* (New York: Columbia University Press, 2015), 9.

110. Derrida, *Specters of Marx*, 18.

111. Casetti, *Lumière Galaxy*, 215.

Chapter 2

1. Gilles Deleuze and Félix Guattari, *A Thousand Plateaus: Capitalism and Schizophrenia*, trans. Brian Massumi (Minneapolis: University of Minnesota Press, 1987), 295.

2. Ibid., 121. For a discussion of Deleuze's refusal to "do history" and the uses of this antihistory, see Angelo Restivo, "Into the Breach: Between *The Movement-Image* and *The Time-Image*," in *The Brain Is the Screen: Deleuze and the Philosophy of Cinema*, ed. Gregory Flaxman (Minneapolis: University of Minnesota Press, 2000).

3. Walter Benjamin, *Walter Benjamin: Selected Writings, Volume 2: 1927–34*, trans. Rodney Livingstone and others, ed. Michael W. Jennings, Howard Eiland, and Gary Smith (Cambridge, MA: Belknap Press of Harvard University Press, 1999), 573.

4. Deleuze and Guattari, *Thousand Plateaus*, 296.

5. Ibid.

6. Ibid., 23.

7. Ibid., 294.

8. Brian Massumi, "Translator's Foreword: The Pleasures of Philosophy," in Deleuze and Guattari, *Thousand Plateaus*, xiii.

9. Michel Foucault, "What Is Enlightenment?," trans. Catherine Porter, in *The Foucault Reader*, ed. Paul Rabinow (New York: Pantheon Books, 1984), 39.

10. Gilles Deleuze, *The Fold: Leibniz and the Baroque*, trans. Tom Conley (Minneapolis: University of Minnesota Press, 1993), 137.

11. This fascination with extremes of speed and stillness returns in a variety of important architects of contemporary critical theory. Roland Barthes's essay on "Tacitus and the Funerary Baroque" defines the baroque first by the relations established between the part and the whole, and second by a tendency toward accelerating movements: "Perhaps that is what the baroque is: a growing contradiction between unit and totality, an art in which extent is not additive but multiplicative, in short, the density of an acceleration." Barthes, *A Barthes Reader*, ed. Susan Sontag (New York: Hill and Wang, 1982), 162. Karen Beckman and Jean Ma identify a similar potential at the intersection of photography and cinema, especially at the turn of the millennium and the beginning of a postphotographic age. They view the relationship between those media as a site of "suspended animation" where "we find a model for simultaneously looking forward and backward at the vicissitudes of the media in question, and see that new media do not simply displace what came before, but rather shine a light onto older media, permitting us to see them differently." Beckman and Ma, "Introduction," in *Still Moving: Between Cinema and Photography*, ed. Karen Beckman and Jean Ma (Durham, NC: Duke University Press, 2008), 10. See also Justin Remes, *Motion[less] Pictures: The Cinema of Stasis* (New York: Columbia University Press, 2015).

12. José Antonio Maravall, *Culture of the Baroque: Analysis of a Historical Structure*, trans. Terry Cochran (Minneapolis: University of Minnesota Press, 1986), 210, 21.

13. Michel de Certeau, *The Mystic Fable: Volume One, the Sixteenth and Seventeenth Centuries*, trans. Michael B. Smith (Chicago: University of Chicago Press, 1992), 29.

14. Walter Benjamin, *The Origin of German Tragic Drama*, trans. John Osborne (London: Verso, 1998), 160–161.

15. Dorothea Olkowski, *Gilles Deleuze and the Ruin of Representation* (Berkeley: University of California Press, 1999), 2.

16. Deleuze, *Fold*, 8.

17. Deleuze and Guattari, *Thousand Plateaus*, 7–12.

18. Ibid., 103.

19. Deleuze and Guattari, *Thousand Plateaus*, 21.

20. Ibid., 34.

21. Timothy S. Murphy, "Quantum Ontology: A Virtual Mechanics of Becoming," in *Deleuze and Guattari: New Mappings in Politics, Philosophy, and Culture*, ed. Eleanor Kaufman and Kevin Jon Heller (Minneapolis: University of Minnesota Press, 1998), 222.

22. Deleuze, *Fold*, 34.

23. Maravall, *Culture of the Baroque*, 256.

24. See Ana Hatherly, "Reading Paths in Spanish and Portuguese Baroque Labyrinths," *Visible Language* 20.1 (1986), 52–64.

25. Susan Buck-Morss, *The Dialectics of Seeing: Walter Benjamin and the Arcades Project* (Cambridge, MA: MIT Press, 1999), 161.

26. Benjamin, *Origin of German Tragic Drama*, 177.

27. Deleuze, *Fold*, 31.

28. Rosalind E. Krauss, *A Voyage on the North Sea: Art in the Age of the Post-Medium Condition* (New York: Thames and Hudson, 1999), 3.

29. Deleuze, *Fold*, 43–44.

30. Tom Conley, "Translator's Foreword: A Plea for Leibniz," in ibid., ix.

31. Deleuze, *Fold*, 53.

32. Ibid., 125.

33. Deleuze and Guattari, *Thousand Plateaus*, 98.

34. Ibid., 99.

35. Benjamin remained critical of a contemporary trend toward neologisms in philosophy, and he preferred to transform and transvalue the terms inherited from his various traditions, treating them as relics from a past subject to constant reappraisal. Tradition is the battleground of philosophy, he suggests, a "struggle for the representation of a limited number of words which always remain the same." *Origin of German Tragic Drama*, 37. Yet Benjamin also celebrated the *Trauerspiel's* "vigorous style of language, which would make it seem equal to the violence of world-events. The practice of contracting adjectives, which have no adverbial usage, and substantives into a single block, is not a modern invention. 'Grosstanz', 'Grossgedicht' (i.e. epic), are baroque words. Neologisms abound" (55).

36. Gregory Flaxman, *Gilles Deleuze and the Fabulation of Philosophy* (Minneapolis: University of Minnesota Press, 2012), 21.

37. Deleuze and Guattari, *What Is Philosophy?*, trans. Hugh Tomlinson and Graham Burchell (New York: Columbia University Press, 1994), 8.

38. Deleuze, *Fold*, 53.

39. Deleuze and Guattari, *Thousand Plateaus*, 255.

40. Ibid., 281.

41. Ibid., 261.

42. Ibid.

43. Ibid., 98.

44. Ibid., 267.

45. Ibid.

46. Ibid., 281.

47. See, for example, Christopher L. Miller, "The Postidentitarian Predicament in the Footnotes of *A Thousand Plateaus*: Nomadology, Anthropology, and Authority," *Diacritics* 23.3 (Autumn, 1993): 6–35.

48. See Paul Virilio, *Speed and Politics*, trans. Mark Polizzotti (Cambridge, MA: MIT Press, 2006).

49. Deleuze, *Fold*, 81.

50. Deleuze and Guattari, *Thousand Plateaus*, 231.

51. Ibid., 22. By way of a definition of a plateau, Deleuze and Guattari write that a "plateau is always in the middle, not at the beginning or the end. A rhizome is made of plateaus.

Gregory Bateson uses the word 'plateau' to designate something very special: a continuous, self-vibrating region of intensities whose development avoids any orientation toward a culmination point or external end" (22).

52. Ibid., 381.

53. Ibid., 378.

54. Ibid., 500.

55. Ibid., 20–21.

56. Deleuze, *Fold*, 26. See also Fredric Jameson, *The Geopolitical Aesthetic: Cinema and Space in the World System* (Bloomington: Indiana University Press, 1995).

57. At the end of his essay on conspiracy films and their paranoid image of the world system, Jameson also posits "Spinoza's God or Nature" as the model of the whole being replaced in cinema by conspiratorial plots and in economics by global capitalism itself. Jameson, *Geopolitical Aesthetic*, 82.

58. Ibid., 171.

59. Gilles Deleuze, *Proust and Signs*, trans. Richard Howard (London: Athlone Press, 2000), 164.

60. Ibid., 163.

61. Deleuze, *Fold*, 25.

62. Robert Rosenstone, *Visions of the Past: The Challenge of Film to Our Idea of History* (Cambridge, MA: Harvard University Press, 1995), 3.

63. Dudley Andrew, *Concepts in Film Theory* (New York: Oxford University Press, 1984), 12.

64. Victor Burgin, "The City in Pieces," in *The Actuality of Walter Benjamin*, ed. Laura Marcus and Lynda Nead (London: Lawrence and Wishart, 1998), 67.

65. Deleuze, *Fold*, 27.

66. Ibid.

67. For an outline of the history of this metaphor, see Sarah Kofman, *The Camera Obscura of Ideology*, trans. Will Straw (London: Athlone Press, 1998).

68. Jonathan Crary, *Techniques of the Observer: On Vision and Modernity in the Nineteenth Century* (Cambridge, MA: MIT Press, 1995), 24.

69. Ibid., 24, 26.

70. Gottfried Wilhelm Leibniz, *New Essays on Human Understanding*, trans. Peter Remnant and Jonathan Bennett (Cambridge: Cambridge University Press, 1982), 145.

71. Deleuze, *Fold*, 27.

72. Svetlana Alpers, *The Art of Describing: Dutch Art in the Seventeenth Century* (Chicago: University of Chicago Press, 1984), 13.

73. Ibid.

74. Sanford Schwartz, "Camera Work," *New York Review of Books* (May 31, 2001). Accessed online at http://www.nybooks.com/articles/2001/05/31/camera-work/.

75. Paul Virilio, *L'Horizon négatif: Essai de dromoscopie* (Paris: Éditions Galilée, 1984), 18.

76. Walter Benjamin, *Illuminations*, trans. Harry Zohn, ed. Hannah Arendt (New York: Schocken Books, 1968), 262–263.

77. Andrew, *Concepts in Film Theory*, 12.

78. In his "Postscript on Control Societies," Deleuze uses a similar metaphor to describe the new, flexible strategies of control which operate "like a sieve [*tamis*] whose mesh

[*mailles*] varies from one point to another." Rather than a momentary orchestration of chaos, this sieve in a control society functions more like an unpredictable exercise of power and exclusion. See Gilles Deleuze, "Postscript on Control Societies," in *Negotiations: 1972–1990*, trans. Martin Joughin (New York: Columbia University Press, 1995), 179. See also Gilles Deleuze, *Pourparlers: 1972–1990* (Paris: Minuit, 1990), 242.

79. Deleuze, *Fold*, 76.

80. Gilles Deleuze, *Cinema 2: The Time-Image*, trans. Hugh Tomlinson and Robert Galeta (Minneapolis: University of Minnesota Press, 1989), 157.

81. Ibid., 157, 164.

82. Ibid., 164.

83. Ibid., 76.

84. Ibid., 7.

85. Ibid., xii. Francesco Casetti makes a similar point about the potential of cinema three decades later, in a supposedly postcinematic age: "Cinema is still an object to be discovered." See Casetti, *The Lumière Galaxy: Seven Key Words for the Cinema to Come* (New York: Columbia University Press, 2015), 215.

86. This would be consistent with Gregory Flaxman's observation that Deleuze was always writing "philosophy in an inhospitable age" and therefore out of joint with his time. See *Gilles Deleuze and the Fabulation of Philosophy*, 237.

87. Gilles Deleuze, *Cinema 1: The Movement-Image*, trans. Hugh Tomlinson and Barbara Habberjam (Minneapolis: University of Minnesota Press, 1986), 206.

88. Deleuze, *Cinema 2*, xi.

89. Deleuze, *Cinema 1*, 207; Deleuze, *Cinema 2*, 47; Deleuze, *Cinema 1*, 213.

90. Deleuze, *Cinema 1*, 206.

91. Ibid., 2–3.

92. Ibid., 25.

93. Deleuze, *Cinema 2*, 43.

94. Deleuze, *Cinema 1*, ix.

95. Ibid., ix–x.

96. Ibid., 2.

97. Ibid., 4.

98. Ibid., 7.

99. Ibid., 58–59.

100. Deleuze, *Cinema 2*, 189.

101. Ibid., 195.

102. Deleuze, *Fold*, 24.

103. Deleuze, *Cinema 1*, 35.

104. Ibid., 36, 35.

105. Ibid., 32.

106. Ibid., 59.

107. Ibid.

108. Ibid., 208.

109. Deleuze, *Cinema 2*, 20.

110. Ibid.

111. Ibid., 23.

112. Deleuze, *Cinema 1*, 163.

113. Ibid., 141.

114. Ibid., 132.

115. Deleuze, *Cinema 2*, 37–38.

116. Ibid., 98.

117. Ibid., 80.

118. Ibid., 91.

119. Ibid., xii; Deleuze, *Negotiations: 1972–1990*, 69.

120. Deleuze, *Cinema 1*, 100.

121. Deleuze, *Cinema 2*, 243–244.

122. Ibid., 41.

123. Michel Foucault, "Of Other Spaces," trans. Jay Miskowiec, *Diacritics* (Spring 1986), 26.

124. Deleuze, *Cinema 2*, 125.

125. See Gregory Flaxman, "Introduction," in Flaxman, *The Brain Is the Screen*.

126. Deleuze, *Cinema 2*, 92.

127. Deleuze, *Cinema 1*, x.

128. Ibid., 12, 18.

129. Ibid., 18.

130. Deleuze, *Cinema 2*, 265.

131. Alexander R. Galloway is probably the most prominent scholar to extend Deleuze's concept of the control society from a foreshadowing of the future into the governing logic of the digital age. See *Protocol: How Control Exists after Decentralization* (Cambridge, MA: MIT Press, 2004), 81–87. See also Wendy Hui Kyong Chun, *Control and Freedom: Power and Paranoia in the Age of Fiber Optics* (Cambridge, MA: MIT Press, 2006); Barbara Filser, "Gilles Deleuze and a Future Cinema: Cinema 1, Cinema 2, and Cinema 3?" in *Future Cinema: The Cinematic Imaginary after Film*, ed. Jeffrey Shaw and Peter Weibel (Cambridge, MA: MIT Press, 2003); Seb Franklin, *Control: Digitality as Cultural Logic* (Cambridge, MA: MIT Press, 2015); and K-F Yau, "Cinema 3: Towards a Minor Hong Kong Cinema," *Cultural Studies* 15.3/4 (2001).

132. Deleuze, *Cinema 2*, 65–66.

133. Ibid., 265.

134. Ibid., 266–267.

135. Ibid., 269.

136. Ibid., 270.

137. Deleuze, "Postscript on the Societies of Control," *October* 59 (Winter 1992), 5. Galloway argues that this formulation positions Foucault as a theorist of the modern past and Deleuze, despite the brevity of his sketch on control societies, as a theorist of the digital future. See *Protocol*, 87.

138. Deleuze, "Postscript on the Societies of Control," 5.

139. Ibid.

140. Ibid.

141. Ibid., 6.

142. Ibid.

143. Ibid.

144. Ibid.

145. Ibid., 7.

Chapter 3

1. Serge Daney, *Postcards from the Cinema*, trans. Paul Douglas Grant (New York: Berg, 2007), 39. Daney's suggestion that looking at film in the "rear-view mirror" is "better" than many other viewing positions distinguishes his use of that phrase from Marshall McLuhan's more famous lament about the sluggish dissemination of new media technology: "The past went that-a-way. When faced with a totally new situation, we tend always to attach our-selves to the objects, to the flavor of the most recent past. We look at the present through a rear-view mirror. We march backwards into the future." Marshall McLuhan and Quentin Fiore, *The Medium Is the Massage: An Inventory of Effects* (Berkeley, CA: Gingko Press, 1967), 74–75.

2. Daney, *Postcards from the Cinema*, 39.

3. T. L. French [Bill Krohn], "*Les Cahiers du Cinéma* 1968–1977: Interview with Serge Daney," trans. Steve Erickson. Accessed online at http://home.earthlink.net/~steevee/Daney_1977.html.

4. Jacques Derrida, *Specters of Marx: The State of the Debt, the Work of Mourning, and the New International*, trans. Peggy Kamuf (New York: Routledge, 1994).

5. Tom Gunning, "An Unseen Energy Swallows Space: The Space in Early Film and Its Relation to American Avant-Garde Film," in *Film before Griffith*, ed. John L. Fell (Berkeley: University of California Press, 1983), 355–366.

6. Lynne Kirby, *Parallel Tracks: The Railroad and Silent Cinema* (Durham, NC: Duke University Press, 1997).

7. Serge Daney, *La Maison cinéma et le monde, 2: Les Années Libé 1981–1985* (Paris: P.O.L, 2002), 91, 463. Translations mine.

8. Ibid., 465, 466.

9. Ibid.

10. Ibid., 467.

11. Ibid., 469.

12. Ibid.

13. Ibid., 471. See also Angelo Restivo, *The Cinema of Economic Miracles: Visuality and Modernity in the Italian Art Film* (Durham, NC: Duke University Press, 2002), 46–76.

14. Daney, *La Maison cinéma et le monde, 2, 473*

15. After Daney became a *Cahiers* critic in 1964, he reported back from film festivals as its roving "foreign correspondent" and served as editor-in-chief from 1974 to 1981 (along-side Toubiana for six of those years). Although he began working primarily for *Libération* in 1981, he had already contributed to the newspaper for several years and continued to write occasionally for *Cahiers* in the 1980s. At *Libération* his focus shifted steadily toward television and the media spectacles of sports and politics. He founded the journal *Trafic* in the early 1990s.

16. Daney, *La Maison cinéma et le monde, 2*, 723.

17. Christian Keathley, *Cinephilia and History, or The Wind in the Trees* (Bloomington: Indiana University Press, 2006), 31.

18. Serge Daney, *La Maison cinéma et le monde, 1: Le Temps des Cahiers, 1962–1981* (Paris: P.O.L., 2001), 37. Raymond Bellour writes that Daney wanted to return to the film at the end of his career, in an essay planned for the fourth issue of *Trafic*. See "L'autre," in

Serge Daney, ed. Olivier Assayas, Xavier Beauvois, and Raymond Bellour (Paris: Cahiers du Cinéma, 2005), 105.

19. Daney, *La Maison cinéma et le monde, 1*, 40.

20. Ibid., 41.

21. Daney, *La Maison cinéma et le monde, 2*, 337.

22. Ibid.

23. Daney, *La Maison cinéma et le monde, 1*, 112.

24. Ibid.

25. Ibid.

26. Ibid.

27. Daney, *Postcards from the Cinema*, 54.

28. André S. Labarthe, *Essai sur le jeune cinema français: Comment peut-on être martien?* (Paris: Le Terrain Vague, 1960).

29. In her *Short History of Cahiers du Cinéma* (London: Verso, 2011), Emily Bickerton outlines several stages in the history of the magazine, from its founding in the early 1950s to the heyday of the "yellow years," when young critics wrote under a cover of that color, to the more politicized "red years," to the period of recovery and reorientation under Daney.

30. D. N. Rodowick, *The Crisis of Political Modernism: Criticism and Ideology in Contemporary Film Theory* (Berkeley: University of California Press, 1995), 1–2.

31. Daney, *La Maison cinéma et le monde, 1*, 156.

32. Ibid., 155.

33. Ibid., 157.

34. Published in three parts in 1973 and 1974, these essays are collected in ibid., 315–339.

35. Ibid., 99.

36. Ibid., 100.

37. Ibid., 101. See also Giorgio Agamben, "Bartleby, or On Contingency," in *Potentialities: Collected Essays on Philosophy*, ed. and trans. Daniel Heller-Roazen (Stanford, CA: Stanford University Press), 243–271.

38. Daney, *La Maison cinéma et le monde, 1*, 103.

39. Ibid.

40. Laura Mulvey, "Visual Pleasure and Narrative Cinema," in *Narrative, Apparatus, Ideology*, ed. Philip Rosen (New York: Columbia University Press, 1986), 198–209.

41. Daney, *La Maison cinéma et le monde, 1*, 157.

42. Ibid., 158.

43. Ibid., 159.

44. Ibid., 175.

45. Ibid.

46. French [Krohn], "*Les Cahiers du Cinéma 1968–1977*: Interview with Serge Daney."

47. Quoted in Antoine de Baecque, *Les Cahiers du cinéma, histoire d'une revue, Tome I: à l'assaut du cinéma, 1951–1959* (Paris: Cahiers du Cinéma, 1991), 64.

48. See André Bazin, "L'avenir esthétique de la télévision," *Réforme*, September 17, 1955. See also Michael Cramer, "Television and the Auteur in the Late '50s," in *Opening Bazin: Postwar Film Theory and Its Afterlives*, ed. Dudley Andrew and Hervé Joubert-Laurencin (New York: Oxford University Press, 2011), 268–274; and Dudley Andrew, ed., *André Bazin's New Media* (Berkeley: University of California Press, 2014).

49. Editorial, *Communications* 1 (1961), 1.

50. See, for example, Daney, *La Maison cinéma et le monde*, 2, 275, 671, 683, 893.

51. Ibid., 89.

52. Ibid., 871. In his use of the word *archaeology* here, in the context of a discussion of the historical "failure" of media technology, and below, Daney could be considered an early practitioner of media archaeology.

53. Ibid., 158.

54. Ibid.

55. See the 1992 documentary *Serge Daney, itinéraire d'un ciné-fils: Entretien avec Régis Debray* (Pierre-André Boutang and Dominique Rabourdin).

56. Daney, *La Maison cinéma et le monde*, 2, 174.

57. Ibid., 14, 20.

58. Ibid., 870.

59. Ibid., 871.

60. Ibid.

61. Ibid., 950.

62. Ibid., 952.

63. Ibid., 27.

64. Daney, *Postcards from the Cinema*, 122.

65. Ibid., 125.

66. See Henry Jenkins, *Convergence Culture: Where Old and New Media Collide* (New York: New York University Press, 2006), 2.

67. Raymond Williams, *Television: Technology and Cultural Form* (New York: Routledge, 2003), 77–120.

68. Richard Dienst, *Still Life in Real Time: Theory after Television* (Durham, NC: Duke University Press, 1995), 3, ix.

69. D. N. Rodowick, *The Virtual Life of Film* (Cambridge, MA: Harvard University Press, 2007), 28.

70. Daney, *Postcards from the Cinema*, 137.

71. I use the literal English translation *zapping* because the more idiomatic English equivalents lack both the onomatopoeia and the sense of audacity and comic-book heroism implied by Daney's use of the French "le zapping." With its connotations of beach-town coolness, *channel surfing* sounds too passive and leisurely. The word *click* has been colonized by Web 2.0: "Click here to purchase," "click here to like this page," etc. As Dienst suggests, *zapping* carries with it the "infantile, tactile fascination" that combines "two kinds of digitality—of the fingers and of the signal," and Daney likewise attempts to explore the physical dimension of seeing and spectatorship through the practice of zapping. Using a metaphor drawn from one of his other favorite pastimes, tennis, he writes that with the remote control, "the ball is in the court of the spectator." At the end of his life, Daney would question whether he truly deserved the title of "zappeur" because he tended to watch programs from start to finish and may not have zapped enough. But in the 1980s he clearly organized his critical work around that persona and concept. See Daney, *Le Salaire du zappeur* (Paris: P.O.L, 1993), 22. See also Dienst, *Still Life in Real Time*, 28.

72. Daney, *Le Salaire du zappeur*, 10.

73. Ibid., 12.

74. Ibid., 52.

75. Ibid., 53.

76. Ibid., 85.

77. Ibid., 26.

78. Ibid., 122–123.

79. Daney, *Postcards from the Cinema*, 73.

80. Ibid., 113.

81. Jacques Rivette, "De l'Abjection," *Cahiers du Cinéma* 120 (June 1961), 54. For Daney's response to Rivette, see *Postcards from the Cinema*, 17–35.

82. Daney, *Postcards from the Cinema*, 25.

83. Ibid., 90.

84. Daney, *La Maison cinéma et le monde, 1*, 168.

Chapter 4

1. Naomi Greene, *Pier Paolo Pasolini: Cinema as Heresy* (Princeton, NJ: Princeton University Press, 1990), 63.

2. Gilles Deleuze, *Cinema 2: The Time-Image*, trans. Hugh Tomlinson and Robert Galeta (Minneapolis: University of Minnesota Press, 1989), 137–147.

3. Gilles Deleuze, *Nietzsche and Philosophy*, trans. Hugh Tomlinson (London: Continuum, 2005), 96.

4. See Lutz Niethammer, *Posthistoire: Has History Come to an End?*, trans. Patrick Camiller (London: Verso, 1992); Francis Fukuyama, *The End of History and the Last Man* (New York: Avon Books, 1993).

5. Michael Fried, *Absorption and Theatricality: Painting and Beholder in the Age of Diderot* (Berkeley: University of California Press, 1980), 5.

6. Michael Fried, *Art and Objecthood: Essays and Reviews* (Chicago: University of Chicago Press, 1998), 169.

7. Fried, *Absorption and Theatricality*, 2.

8. Fried, *Art and Objecthood*, 164.

9. Douglas Crimp, "Pictures," *October* 8 (Spring 1979), 76.

10. Stephen Melville, "Notes on the Reemergence of Allegory, the Forgetting of Modernism, the Necessity of Rhetoric, and the Conditions of Publicity in Art and Criticism," *October* 19 (1981), 69.

11. Serge Daney, *La Rampe: Cahiers critique 1970–82* (Paris: Cahiers du Cinéma-Gallimard, 1996), 92.

12. Daniel Morgan, *Late Godard and the Possibilities of Cinema* (Berkeley: University of California Press, 2013), 4. Morgan's book contains the most detailed and insightful discussion of Godard's relationship to painting in the late stage of his career. See pages 155–202.

13. Ibid., 170.

14. Deleuze, *Cinema 2: The Time-Image*, 156.

15. Gilles Deleuze, *Difference and Repetition*, trans. Paul Patton (New York: Columbia University Press, 1994), 56.

16. André Goudreault, "Temporality and Narrative in Early Cinema, 1894–1908," in *Film Before Griffith*, ed. John L. Fell (Berkeley: University of California Press, 1983), 328.

17. See Hillel Schwartz, *The Culture of the Copy: Striking Likenesses, Unreasonable Facsimiles* (New York: Zone Books, 1996), 57.

18. Quoted in Ben Brewster and Lea Jacobs, *Theatre to Cinema: Stage Pictorialism and the Early Feature Film* (Oxford: Oxford University Press, 1997), 38.

19. Volker Schachenmayr, "Emma Lyon, the Attitude, and Goethean Performance Theory," *New Theatre Quarterly* 13.49 (1991), 3.

20. Ibid., 6.

21. Ibid.

22. Homi K. Bhabha, "Postmodernism/Postcolonialism," in *Critical Terms for Art History*, ed. Robert S. Nelson and Richard Shiff (Chicago: University of Chicago Press, 1996), 308.

23. Ibid., 310.

24. Walter Benjamin, *The Origin of German Tragic Drama*, trans. John Osborne (London: Verso, 1998), 195. Benjamin is citing Sigmund von Birken.

25. Ibid., 193. Benjamin also writes of the popularity of tableaux vivants during the Biedermeier period, listing them as a principal interest of the *flâneur*. See *Illuminations: Essays and Reflection*, ed. Hannah Arendt, trans. Harry Zohn (New York: Schocken Books, 1968), 173.

26. William James, *The Principles of Psychology*, vol. 2 (New York: Dover, 1950), 603.

27. Jean-François Lyotard, "Acinema," trans. Paisley N. Livingston, in *Narrative, Apparatus, Ideology: A Film Theory Reader*, ed. Philip Rosen (New York: Columbia University Press, 1986), 351.

28. Ibid., 356, 351. On the "drift of desire" as a subversive force, see Jean-François Lyotard, *Driftworks* (New York: Semiotext[e], 1984), 14.

29. Gilles Deleuze, *Masochism: Coldness and Cruelty*, trans. Jean McNeil (New York: Zone Books, 1991), 70.

30. Ibid.

31. Pierre Klossowski, *Roberte ce Soir and the Revocation of the Edict of Nantes*, trans. Austryn Wainhouse (New York: Grove Press, 1969), 100.

32. Scott Durham, *Phantom Communities: The Simulacrum and the Limits of Postmodernism* (Stanford, CA: Stanford University Press, 1998), 77.

33. Ibid., 80.

34. Ibid., 79.

35. See chapter 1 of this book.

36. Durham, *Phantom Communities*, 100.

37. Magali Cornier Michael, "Angela Carter's *Nights at the Circus*: An Engaged Feminism via Subversive Postmodern Strategies," *Contemporary Literature* 35.3 (1994), 500.

38. Carol Siegel, "Postmodern Women Novelists Review Victorian Male Masochism," *Genders* 11 (1991), 12.

39. Laura Mulvey, "A Phantasmagoria of the Female Body: The Work of Cindy Sherman," *New Left Review* 188 (1991), 142.

40. Ibid., 141.

41. Michel Foucault, "Nietzsche, Genealogy, History," trans. Donald F. Bouchard and Sherry Simon, in *The Foucault Reader*, ed. Paul Rabinow (New York: Pantheon Books, 1984), 76.

42. Griselda Pollock, *Differencing the Canon: Feminist Desire and the Writing of Art's Histories* (London: Routledge, 1999), 169–170.

43. Ibid., 170.

44. Ibid., 196.

45. Jessica L. Horton, "Ojibwa *Tableaux Vivants*: George Catlin, Robert Houle, and Transcultural Materialism," *Art History* 29.1 (2016), 125.

46. Ibid., 147.

47. Pierre Klossowski, *Such a Deathly Desire*, trans. Russell Ford (Albany: State University of New York Press, 2007), 119.

48. Fredric Jameson, *The Geopolitical Aesthetic: Cinema and Space in the World System* (Bloomington: Indiana University Press, 1995), 9–84.

49. Alain Bergala, "The Other Side of the Bouquet," in *Jean-Luc Godard: Son + Image 1974–1991*, ed. Raymond Bellour and Mary Lea Bandy (New York: Museum of Modern Art, 1992), 61.

50. Ibid.

51. Jean-Louis Leutrat, "Traces That Resemble Us: Godard's *Passion*," *Substance* 15.3 (1986), 43–44.

52. Jacques Derrida, *Specters of Marx: The State of the Debt, the Work of Mourning, and the New International*, trans. Peggy Kamuf (London: Routledge, 1994), 18.

53. Daney, *La Rampe*, 94.

54. Benjamin, *Origin of German Tragic Drama*, 207.

55. Gilles Deleuze, "The Brain Is the Screen: An Interview with Gilles Deleuze," trans. Marie Therese Guirgis, in *The Brain Is the Screen: Deleuze and the Philosophy of Cinema*, ed. Gregory Flaxman (Minneapolis: University of Minnesota Press, 2000), 367.

56. James Gardner, "Is Caravaggio Our Contemporary?" *Commentary* (June 1985), 55; Frank Stella, "Caravaggio," *New York Times Magazine* (February 3, 1985), 1.

57. Sanford Schwartz, "Not Happy to Be Here," *New Yorker* (September 2, 1985), 75.

58. Gardner, "Is Caravaggio Our Contemporary?," 55.

59. For an iconographic approach to the artist's biography, see Adrienne Von Lates, "Caravaggio's Peaches and Academic Puns," *Word and Image* 11.1 (January–March 1995), 55–60. For an overview of the debates about the artist's sexuality and an attempt to rebut Hibbard's argument, see Creighton E. Gilbert, *Caravaggio and His Two Cardinals* (University Park: Pennsylvania State University Press, 1995), 191–238.

60. James M. Saslow, *Ganymede in the Renaissance: Homosexuality in Art and Society* (New Haven, CT: Yale University Press, 1986), 116–117.

61. Leo Bersani and Ulysse Dutoit, *Caravaggio's Secrets* (Cambridge, MA: MIT Press, 1998), 13.

62. Ibid.

63. Derek Jarman, *Derek Jarman's "Caravaggio": The Complete Film Script and Commentaries* (London: Thames and Hudson, 1986), 75.

64. In 1988 the Local Government Bill passed by Parliament included a provision, known as Clause 28, prohibiting the "promotion of homosexuality" and forbidding schools from teaching "the acceptability of homosexuality as a pretended family relationship." For a discussion of the relationship between Jarman's cinema and queer politics in the 1980s, see Chris Lippard and Guy Johnson, "Private Practice, Public Health: The Politics of Sickness and the Films of Derek Jarman," in *Fires Were Started: British Cinema and Thatcherism*, ed. Lester Friedman (Minneapolis: University of Minnesota Press, 1993), 292.

65. Benjamin, *Illuminations*, 221.

66. Joan Copjec, *Read My Desire: Lacan against the Historicists* (Cambridge, MA: MIT Press, 1995), 14.

67. Quoted in Howard Hibbard, *Caravaggio* (New York: Harper and Row, 1983), 206.

68. Michel de Certeau, *The Mystic Fable: Volume One, the Sixteenth and Seventeenth Centuries*, trans. Michael B. Smith (Chicago: University of Chicago Press, 1992), 276.

69. Ibid.

70. Fried, "Thoughts on Caravaggio," *Critical Inquiry* 24.1 (Autumn 1997), 21.

71. Foucault, "Nietzsche, Genealogy, History," 86.

72. Quoted in Eduardo Cadava, *Words of Light: Theses on the Photography of History* (Princeton, NJ: Princeton University Press, 1997), 85–87.

73. Frank Stella, *Working Space: The Charles Eliot Norton Lectures, 1983–4* (Cambridge, MA: Harvard University Press, 1986), 18.

74. Caravaggio's mode of painting would then have resembled that of the fictional artist Tonnere in Klossowski's *Revocation of the Edict of Nantes*. See *Roberte ce soir and the Revocation of the Edict of Nantes*, 99.

75. André Bazin, *What Is Cinema?*, vol. 1, ed. and trans. Hugh Gray (Berkeley: University of California Press, 1967), 97.

76. Stella, *Working Space*, 4, 12.

77. Ibid., 17.

78. Jarman cited Friedlaender's book as an important source in his research into the life and work of Caravaggio.

79. Quoted in W. J. T. Mitchell, "Spatial Form in Literature: Toward a General Theory," in *The Language of Images*, ed. W. J. T. Mitchell (Chicago: University of Chicago Press, 1980), 275.

80. Foucault, "Nietzsche, Genealogy, History," 89.

81. Bersani and Dutoit, *Caravaggio's Secrets*, 40. Bersani and Dutoit elaborate on this difference between paradigms of knowledge and relationality in *The Arts of Impoverishment: Beckett, Rothko, Resnais* (Cambridge, MA: Harvard University Press, 1993).

82. Bersani and Dutoit, *Caravaggio's Secrets*, 72.

83. Benjamin, *Illuminations*, 256.

84. Foucault, "Nietzsche, Genealogy, History," 79.

85. Ibid., 83.

86. See René Girard, *Deceit, Desire, and the Novel: Self and Other in Literary Structure* (Baltimore, MD: Johns Hopkins University Press, 1976). Timothy Murray also notes the relationship between the love triangle represented in Caravaggio and the paradigm set forth in Girard's study. He compares Girard's model with that proposed by Luce Irigaray, who suggests that woman becomes the abject vortex in these diagrams of triangular desire because she serves as a token and provocation of male desire while being denied desire herself. See Murray, *Like a Film: Ideological Fantasy on Screen, Camera, and Canvas* (New York: Routledge, 1993), 134.

87. Girard, *Deceit*, 4.

88. Ibid., 12.

89. Quoted in ibid., 15.

90. Ibid., 29.

91. Ibid., 38.

92. Tmothy Murray's essay on the film outlines the possible ramifications of these violent actions. See Murray, *Like a Film*, 134–142.

93. Lynne Tillmann, "Love Story," *Art in America* 75.1 (January 1987), 23.

94. Nick Davis, *The Desiring-Image: Gilles Deleuze and Contemporary Queer Cinema* (New York: Oxford University Press, 2013), 9.

95. Ibid., 8.

96. Jarman's screenplay details the production problems associated with this scene, as no casting agencies would allow child actors to play the part of Cupid in a tableau vivant based on Caravaggio's painting. Ultimately, a fully clothed Dawn Archibald assumed the role of Cupid, emphasizing the disparity rather than identity between model and finished painting. See Jarman, *Derek Jarman's "Caravaggio,"* 75.

97. Marc Vernet, "Irrepressible Gaze," *Iris* 14–15 (Autumn 1992), 10.

98. Ibid., 14.

99. Dominique Païni, "A Detour for the Gaze," *Iris* 14–15 (Autumn 1992), 5.

100. Roland Barthes, *Camera Lucida*, trans. Richard Howard (New York: Hill and Wang, 1981), 3.

101. Benjamin, *Illuminations*, 190.

102. Derrida, *Specters of Marx*, 7.

103. Ibid., 158.

104. See *Hidden from History: Reclaiming the Gay and Lesbian Past*, ed. Martin Bauml Duberman, Martha Vicinus, and George Chauncey Jr. (New York: NAL Books, 1989).

105. For Jarman's discussion of Caravaggio's transformation into "the most homosexual of painters," despite a relentlessly "hostile environment," see Shaun Allen, ed., *Dancing Ledge* (London: Quartet Books, 1991), 21–24.

106. Hibbard, *Caravaggio*, 155.

107. Ibid., 159.

108. Ibid.

109. Antonio Negri, "Notes on the Evolution of the Thought of the Later Althusser," in *Postmodern Materialism and the Future of Marxist Theory: Essays in the Althusserian Tradition*, ed. Antonio Callari and David F. Ruccio (Hanover, NH: Wesleyan University Press, 1996), 54.

110. Girard, *Deceit*, 1.

111. Jean-Luc Nancy, *The Sense of the World*, trans. Jeffrey Librett (Minneapolis: University of Minnesota Press, 1997), 142.

112. José Esteban Muñoz, *Cruising Utopia: The Then and There of Queer Futurity* (New York: New York University Press, 2009), 22.

113. See Higson, "Re-presenting the National Past."

114. See, for example, Von Lates, "Caravaggio's Peaches and Academic Puns."

115. Angelo Quattrocchi and Tom Nairn, *The Beginning of the End: France, May 1968: What Happened, Why It Happened* (London: Panther, 1968), 39.

116. Benjamin, *Origin of German Tragic Drama*, 232.

117. In his screenplay for *Caravaggio*, Jarman criticizes David for reintroducing a "scientific" element to painting, thereby reducing the image to the grids imposed upon it. See Jarman, *Derek Jarman's "Caravaggio,"* 45.

118. Stella, "Caravaggio," 39.

119. W. J. T. Mitchell, "What Do Pictures Really Want?" *October* 77 (Summer 1996), 71–82.

120. Deleuze, *Difference and Repetition*, 86.

121. Benjamin, *Origin of German Tragic Drama*, 217–218.

122. Ibid., 218–219.

123. For Jarman's extended comparison of filmmaking and archaeology, see Derek Jarman, *The Last of England*, ed. David L. Hirst (London: Constable, 1987), 168.

124. Pierre Nora, "Introduction," trans. Arthur Goldhammer, in *Realms of Memory: The Construction of the French Past*, vol. 2, ed. Lawrence D. Kritzman (New York: Columbia University Press, 1997), ix.

125. Quoted in David Farrell Krell, *Postponements: Women, Sensuality, and Death in Nietzsche* (Bloomington: Indiana University Press, 1986), 69.

126. Daryl Hine, *Minutes* (New York: Atheneum, 1968), 45.

127. Ibid.

128. Jerome J. McGann, "The Beauty of the Medusa: A Study in Romantic Iconology," *Studies in Romanticism* 11 (1972), 24.

129. Quoted in T. J. Clark, "Origins of the Present Crisis," *New Left Review* 2 (March–April 2000), 91.

Chapter 5

1. Gilles Deleuze, *Cinema 2: The Time-Image*, trans. Hugh Tomlinson and Robert Galeta (Minneapolis: University of Minnesota Press, 1989), 10, 16–17.

2. Svetlana Alpers, *The Art of Describing: Dutch Art in the Seventeenth Century* (Chicago: University of Chicago Press, 1984), 90–91.

3. Arnold Hauser, *The Social History of Art*, vol. 2 (New York: Routledge, 1999), 200.

4. Norman Bryson, *Looking at the Overlooked: Four Essays on Still Life Painting* (Cambridge, MA: Harvard University Press, 1990), 13.

5. Meyer Schapiro, "The Apples of Cézanne: An Essay on the Meaning of Still-life," *Modern Art, 19th and 20th Centuries: Selected Papers* (New York: George Braziller, 1978), 19.

6. Mark Seltzer, "The Still Life," *American Literary History* 3.3 (1991), 455.

7. Charles Sterling, *Still Life Painting: From Antiquity to the Twentieth Century* (New York: Harper and Row, 1981), 27.

8. Bryson, *Looking at the Overlooked*, 63–70.

9. Ibid., 72.

10. Gilles Deleuze and Félix Guattari, *A Thousand Plateaus: Capitalism and Schizophrenia*, trans. Brian Massumi (Minneapolis: University of Minnesota Press, 1987), 479.

11. Bryson, *Looking at the Overlooked*, 71.

12. Ibid., 76. Because of his theatricality and dramatic lighting, Zurbarán was nicknamed the "Spanish Caravaggio."

13. Ibid., 87.

14. Comte de Lautréamont, *Les Chants de Maldoror*, trans. Guy Wernham (New York: New Directions, 1965), 263.

15. Mary Ann Caws, *The Poetry of Dada and Surrealism* (Princeton, NJ: Princeton University Press, 1970), 34.

16. Walter Benjamin, *Reflections*, trans. Edmund Jephcott, ed. Peter Demetz (New York: Schocken Books, 1986), 181–182.

17. Walter Benjamin, *Walter Benjamin: Selected Writings, Volume 2: 1927–34*, trans. Rodney Livingstone and others, ed. Michael W. Jennings, Howard Eiland, and Gary Smith (Cambridge, MA: Belknap Press of Harvard University Press, 1999), 519.

18. Benjamin, *Reflections*, 181.

19. Walter Benjamin, *The Origin of German Tragic Drama*, trans. John Osborne (London: Verso, 1998), 186.

20. Ibid., 132.

21. Ibid., 140.

22. Ibid.

23. Seltzer, "Still Life," 462.

24. Ibid.

25. Fernand Léger, "Painting and Cinema," trans. Richard Abel, in *French Film Theory and Criticism: Volume I, 1907–1929*, ed. Richard Abel (Princeton, NJ: Princeton University Press, 1988), 273.

26. Antonin Artaud, *Collected Works*, vol. 3, trans. Alastair Hamilton (London: Calder and Boyars, 1972), 65.

27. Ibid.

28. See Jean Epstein, *Écrits sur le cinéma, 1921–53* (Paris: Seghers, 1974); and Louis Aragon, "On Décor," trans. Paul Hammond, in *The Shadow and Its Shadow: Surrealist Writings on the Cinema*, ed. Paul Hammond (London: British Film Institute, 1978).

29. Walter Benjamin, *Illuminations*, trans. Harry Zohn, ed. Hannah Arendt (New York: Schocken Books, 1968), 236–237.

30. Jacques Lacan, *The Four Fundamental Concepts of Psychoanalysis*, trans. Alan Sheridan (New York: Norton, 1978), 81.

31. Gilles Deleuze, *The Fold: Leibniz and the Baroque*, trans. Tom Conley (Minneapolis: University of Minnesota Press, 1993), 122–123.

32. Ibid., 19.

33. Ibid.

34. Deleuze, *Cinema 2: The Time-Image, xiii.*

35. Bryson, *Looking at the Overlooked*, 61.

36. Gregory Flaxman, "Introduction," in *The Brain Is the Screen: Deleuze and the Philosophy of Cinema*, ed. Gregory Flaxman (Minneapolis: University of Minnesota Press, 2000), 35.

37. Deleuze, *Cinema 2: The Time-Image*, 272.

38. Ibid., 4.

39. Ibid., 19.

40. Alain Cavalier, "A propos de Thérèse," *L'Avant-scène cinéma* 364 (1987), 8.

41. These film stills and complementary "*Lettre de cinéaste*" were later published along with the screenplay in *L'avant scène cinéma*, 6–10.

42. Fredric Jameson, *The Geopolitical Aesthetic: Cinema and Space in the World System* (Bloomington: Indiana University Press, 1995), 2.

43. Friedrich Nietzsche, "On the Utility and Liability of History for Life," trans. Richard T. Gray, in *Unfashionable Observations*, ed. Richard T. Gray (Stanford, CA: Stanford University Press, 1995), 86.

44. Michel Foucault, *The Archaeology of Knowledge and the Discourse on Language*, trans. A. M. Sheridan-Smith (New York: Pantheon Books, 1972), 6.

45. François Ramasse, "Entretien avec Alain Cavalier: Sur *Thérèse*," *Positif* 308 (October 1986), 23.

46. Susan Hayward, *French National Cinema* (London: Routledge, 1993), 287.

47. Marc Ferro, *Cinema and History*, trans. Naomi Greene (Detroit, MI: Wayne State University Press, 1988), 29.

48. Raphael Samuel, *Theatres of Memory*, vol. 1 (London: Verso, 1994), 39.

49. Richard Wolin, *Walter Benjamin: An Aesthetic of Redemption* (Berkeley: University of California Press, 1994), xxxix.

50. Eduardo Cadava, *Words of Light: Theses on the Photography of History* (Princeton, NJ: Princeton University Press, 1997), xviii.

51. Angela Dalle Vacche, *Cinema and Painting: How Art Is Used in Film* (Austin: University of Texas Press, 1996), 222; Robert Benayoun, "L'Agenda d'une dévotion: Le miracle laïque du qotidien," *Positif* 308 (October 1986), 21, 21.

52. Garrett Stewart, *Between Film and Screen: Modernism's Photo Synthesis* (Chicago: University of Chicago Press, 1999), 17.

53. Ibid., 10.

54. Michel de Certeau, "History and Mysticism," trans. Arthur Goldhammer, in *Histories: French Constructions of the Past*, ed. Jacques Revel and Lynn Hunt (New York: New Press, 1995), 441.

55. Michel de Certeau, *The Mystic Fable: Volume One, the Sixteenth and Seventeenth Centuries*, trans. Michael B. Smith (Chicago: University of Chicago Press, 1992), 14.

56. Ibid.

57. Serge Daney, *La Rampe: Cahiers critique 1970–1982* (Paris: Gallimard, 1996), 91–92.

58. Ibid., 92.

59. Deleuze and Guattari, *Thousand Plateaus*, 115. Deleuze and Guattari suggest that the portrait functions in a similar way to the landscape and still life because the latter two also "facialize." They write, "Even a use-object may come to be facialized: you might say that a house, utensil, or object, an article of clothing, etc., is *watching me*, not because it resembles a face, but because it is taken up in the white wall/black hole process, because it connects to the abstract machine of facialization. The close-up in film pertains as much to a knife, cup, clock, or kettle as to a face or facial element, for example, Griffith's 'the kettle is watching me'" (175).

60. Michel de Certeau, *The Writing of History*, trans. Tom Conley (New York: Columbia University Press, 1988), 231, 235.

61. Michel Chion, *The Voice in Cinema*, ed. and trans. Claudia Gorbman (New York: Columbia University Press, 1999), 21, 23.

62. Ibid., 24.

63. Deleuze, *Cinema 2: The Time-Image*, 268.

64. D. N. Rodowick, *The Crisis of Political Modernism: Criticism and Ideology in Contemporary Film Theory* (Berkeley: University of California Press, 1995), 1–35.

65. Alain Philippon, "L'Enfance de l'art," *Cahiers du Cinéma* 387 (September 1986), 6.

66. Bryson, *Looking at the Overlooked*, 71.

67. Ramasse, "Entretien avec Alain Cavalier," 23.

68. De Certeau, *Mystic Fable*, 10.

69. Philippon, "L'Enfance de l'art," 5.

70. Dalle Vacche, *Cinema and Painting*, 223.

71. Bryson, *Looking at the Overlooked*, 136–178.

72. Ibid., 162.

73. Ibid., 174.

74. Dalle Vacche emphasizes the function of the discourse of hysteria in isolating and othering the members of the convent. She notes, for example, the parallels between early studies of hysteria at Salpêtrière, a hospital for women, and the doctor's presumptive hysteria diagnosis within the convent. She also points out that Bernini's statue of Teresa of Avila once served as a model of hysterical physiognomy, equating the exuberance of mysticism with the symptom of mental disease (*Cinema and Painting*, 222).

75. In her biography of Thérèse Martin, Furlong sketches the family background underlying the decision to join a religious order: "Priesthood apart, for [Thérèse], as for most young women of the middle class in nineteenth-century France, the choice was between marriage and the convent. . . . Thérèse had had the chance to observe the first of these alternatives. Her mother, Zélie Martin, had borne nine children within thirteen years, nearly all of them suffering a very sickly infancy. Four of them died within the first few years of life. In the later years of her childbearing, Mme Martin was afflicted with breast cancer, and in addition to the exhaustion of her illness, and her grief at the loss of her children, she had the added stress of running her lace-making business." Monica Furlong, *Thérèse of Lisieux* (London: Virago Press, 1987), 5–6.

76. Ibid., 224.

77. See Georges Bataille, *The Accursed Share*, in Georges Bataille, *Oeuvres complètes*, vol. 1 (Paris: Gallimard, 1970).

78. Marc Chevrie, "Quoi? La grâce," *Cahiers du Cinéma* 383–384 (May 1986), 24.

79. De Certeau, "Mysticism," 24.

80. Chevrie, "Quoi? La grâce," 23.

81. De Certeau, *Mystic Fable*, 195. De Certeau stresses the importance of the *Moradas*, which "are for *mystics* what Aristotle's *Logic* is for traditional philosophy" (195).

82. Ramasse, "Entretien avec Alain Cavalier," 28.

83. Ibid.

84. Meyer Schapiro, "The Still Life as a Personal Object: A Note on Heidegger and van Gogh," *Theory and Philosophy of Art: Style, Artist, and Society* (New York: George Braziller, 1998), 135.

85. Fredric Jameson, *Postmodernism, or, The Cultural Logic of Late Capitalism* (Durham, NC: Duke University Press, 1991), 12.

86. Hal Foster, *The Return of the Real* (Cambridge, MA: MIT Press, 1996), 128–136.

87. Jacques Derrida, *The Truth in Painting*, trans. Geoff Bennington and Ian McLeod (Chicago: University of Chicago Press, 1987), 259. See also Schapiro, "Still Life as a Personal Object," 139.

88. Derrida, *Truth in Painting*, 265.

89. Michael P. Steinberg, "The Collector as Allegorist: Goods, Gods, and the Objects of History," in *Walter Benjamin and the Demands of History*, ed. Michael P. Steinberg (Ithaca, NY: Cornell University Press, 1996), 100.

90. Ibid.

91. Schapiro, "Still Life as a Personal Object," 139.

92. Derrida, *Truth in Painting*, 262.

93. Ibid., 273, 306, 364; Schapiro, "Still Life as a Personal Object," 138.

94. See Schapiro, "The Apples of Cézanne."

95. Gilles Deleuze, "Having an Idea in Cinema (On the Cinema of Straub-Huillet)," in *Deleuze and Guattari: New Mappings in Politics, Philosophy, and Culture*, ed. Eleanor Kaufman and Kevin Jon Heller (Minneapolis: University of Minnesota Press, 1998), 19.

96. Quoted in Derrida, *Truth in Painting*, 381.

97. Ramasse, "Entretien avec Alain Cavalier," 24.

98. Ibid., 25.

99. Ibid., 26. At this moment in the interview Cavalier talks about his own connection to worn shoes. He says that these transitions are "like when a pair of shoes wears out. I find that it's terrible to abandon a pair of shoes: it's like an image of our aging, of things that tire out and end through death. So when I exchange my shoes, I always go to the same spot; I take a pair of new shoes, and I leave the old" (26). In a sense this personal anecdote parallels one of the film's major concerns: returning to the same spots, the places with long and accumulating histories, in order to "leave the old" behind.

100. De Certeau, *Mystic Fable*, 293.

101. Davies's earlier trilogy (1974–1983) also contribute to this ongoing semi-autobiographical exploration of the same time and place. For a detailed discussion of the autobiographical elements of the films, see Michael Koresky, *Terence Davies* (Urbana: University of Illinois Press, 2014).

102. John Caughie, "Halfway to Paradise," *Sight and Sound* 2.1 (May 1992), 11–13.

103. Geoff Eley, "The Family Is a Dangerous Place: Memory, Gender, and the Image of the Working Class," in *Revisioning History: Film and the Construction of a New Past*, ed. Robert Rosenstone (Princeton, NJ: Princeton University Press, 1995), 22, 17, 25.

104. Andrew Higson, "Critical Theory and 'British Cinema,'" *Screen* 24.4–5 (July–October 1983), 80.

105. See Christopher Williams, "The Social Art Cinema: A Moment in the History of British Film and Television Culture," in *Cinema: The Beginnings and the Future*, ed. Christopher Williams (London: University of Westminster Press, 1996).

106. Martin Hunt, "The Poetry of the Ordinary: Terence Davies and the Social Art Film," *Screen* 40.1 (1999), 4.

107. Ibid.

108. Brian Baxter, "Location Report: *Distant Voices, Still Lives*," *Films and Filming* 400 (January 1988), 14.

109. Armond White, "Remembrance of Songs Past," *Film Comment* (May–June 1993), 12.

110. John Wrathall, "Picture This," *City Limits* 367 (1988), 17.

111. Pat Kirkham and Mike O'Shaughnessy, "Designing Desire," *Sight and Sound* 2.1 (May 1992), 13.

112. Tony Williams, "The Masochistic Fix: Gender Oppression in the Films of Terence Davies," in *Fires Were Started: British Cinema and Thatcherism*, ed. Lester Friedman (Minneapolis: University of Minnesota Press, 1993), 65.

113. Paul Duane, "Review of *The Long Day Closes*," *Film Ireland* 30 (July–August 1992), 26; Fredric Jameson, *The Seeds of Time* (New York: Columbia University Press, 1994), 64. In the most schizophrenic formulation, Derek Malcolm describes it as a "musical version of *Coronation Street* directed by Robert Bresson" with "additional dialogue by Sigmund Freud and Tommy Handley." See Malcolm, "Review of *The Long Day Closes*," *The Guardian* (October 13, 1988), 21.

114. Rosalind Galt, *Pretty: Film and the Decorative Image* (New York: Columbia University Press, 2011), 300.

115. Eley, "Family Is a Dangerous Place," 18.

116. Quoted in Harlan Kennedy, "Familiar Haunts," *Film Comment* 24.5 (1988), 17.

117. Eley, "Family Is a Dangerous Place," 18–19.

118. See Carolyn Kay Steedman, *Landscape for a Good Woman: A Story of Two Lives* (New Brunswick, NJ: Rutgers University Press, 1994), 15.

119. See "Radio Interview for BBC Radio 4 *Woman's Hour* ('Permissive or Civilised'?)," April 9, 1970. Accessed online at http://www.margaretthatcher.org/document/101845.

120. Phil Powrie, "On the Threshold between Past and Present: 'Alternative' Heritage," in *British Cinema Past and Present*, ed. Justine Ashby and Andrew Higson (London: Routledge, 2000), 325.

121. C. Williams, "Social Art Cinema," 193.

122. Ibid., 199.

123. Ibid., 200. For further discussion of Daney, see chapter 4 in this book.

124. Raymond Durgnat, "Review of *The Long Day Closes*," *Sight and Sound* 2.2 (June 1992), 44.

125. Caughie, "Halfway to Paradise," 12.

126. Ibid., 13.

127. Ibid., 11–12.

128. Quoted in Caughie, "Halfway to Paradise," 11.

129. Ibid., 13.

130. Ibid.

131. T. Williams, "Masochistic Fix," 241.

132. Thomas Elsaesser, "Games of Love and Death, or an Englishman's Guide to the Galaxy," *Monthly Film Bulletin* 55 (October 1988), 291.

133. Kirkham and O'Shaughnessy, "Designing Desire," 14.

134. Terence Davies, *A Modest Pageant* (London: Faber and Faber, 1992), 103.

135. John Caughie, "The Way Home," *Sight and Sound* 1.7 (November 1991), 26.

136. Ibid., 27.

137. T. Williams, "Masochistic Fix," 237.

138. Carolyn Kay Steedman, "Class of Heroes," *New Statesman and Society* (April 14, 1989), 27.

139. Walter Benjamin, *Selected Writings, Volume 4: 1938–1940*, trans. Edmund Jephcott and others, ed. Howard Eiland and Michael W. Jennings (Cambridge, MA: Belknap Press of Harvard University Press, 2003), 402.

Chapter 6

1. John Berger, *Keeping a Rendezvous* (New York: Vintage, 1991), 16.

2. See Andrew Higson, "Re-presenting the National Past: Nostalgia and Pastiche in the Heritage Film," in *Fires Were Started: British Cinema and Thatcherism*, ed. Lester Friedman (Minneapolis: University of Minnesota Press, 1993).

3. Harlan Kennedy provides a rundown of many previous screen adaptations of *The Tempest*, with an emphasis on the play's adaptability to a variety of times, spaces, genres, and

social concerns: from soldiers returning home to "New Women" in *Yellow Sky*, to attempts to conquer the final frontier in the science fictional *The Forbidden Planet*. See Kennedy, "Prospero's Flicks," *Film Comment* 28.1 (1992), 45–49. On inscription systems or discourse networks, see Friedrich Kittler, *Discourse Networks 1800/1900*, trans. Michael Metteer, with Chris Cullens (Stanford, CA: Stanford University Press, 1990).

4. All quotations of *The Tempest* are taken from *The Riverside Shakespeare*, ed. G. Blakemore Evans (Wilmington, MA: Houghton Mifflin, 1974).

5. Homi K. Bhabha, "Signs Taken for Wonders," in *Race, Writing and Difference*, ed. Henry Louis Gates Jr. (Chicago: University of Chicago Press, 1985), 171.

6. Ibid., 163.

7. Marlene Rodgers, "Prospero's Books—Word and Spectacle: An Interview with Peter Greenaway," *Film Quarterly* 45.2 (1991), 15.

8. Marcia Pally, "Cinema as a Total Art Form: An Interview with Peter Greenaway," *Cineaste* 18.3 (1991), 6.

9. Peter Greenaway, *Prospero's Books: A Film of Shakespeare's "The Tempest"* (New York: Four Walls Eight Windows, 1991), 40.

10. Pally, "Cinema as a Total Art Form," 8.

11. Jonathan Romney, "Prospero's Books," *Sight and Sound* 1.5 (September 1991), 45.

12. Roland Barthes, *S/Z*, trans. Richard Miller (New York: Hill and Wang, 1974), 9.

13. Ibid.

14. Friedrich Nietzsche, "On Truth and Falsity in Their Ultramoral Sense," trans. Maximilian A. Mügge, in *The Collected Works of Friedrich Nietzsche*, ed. Oscar Levy (New York: Russell and Russell, 1964), 179.

15. Ibid., 180.

16. Greenaway, *Prospero's Books*, 21.

17. Paul de Man, *Allegories of Reading* (New Haven, CT: Yale University Press, 1979), 77.

18. Ibid., 76.

19. Maurice Yacowar, "Negotiating Culture: Greenaway's *Tempest*," *Queen's Quarterly* 99.3 (Fall 1992), 690.

20. Greenaway, *Prospero's Books*, 17.

21. Ibid., 24.

22. Ibid.

23. Pally, "Cinema as a Total Art Form," 10.

24. The specific instrument used in the making of the film, the Quantel Paintbox, was a digital "canvas," paintbrush, and palette (whose over three hundred colors appear in the *Book of Colours*), which allows the director to create images on a monitor before reshooting them and combining them with filmed images. Greenaway has suggested that the "paintbox" allows the director to be simultaneously a painter working on a "unique" image, and a film-maker with "realistic," indexical, "authentic" pictures also at his or her disposal.

25. Romney, "Prospero's Books," 45.

26. See Michel Foucault, *The Order of Things: An Archaeology of the Human Sciences* (New York: Vintage, 1994), xv.

27. Walter Benjamin, *Illuminations*, trans. Harry Zohn, ed. Hannah Arendt (New York: Schocken Books, 1968), 79.

28. Rey Chow, *Primitive Passions: Visuality, Ethnography, and Contemporary Chinese Cinema* (New York: Columbia University Press, 1995), 185.

29. Greenaway, *Prospero's Books*, 20. Caliban represents, in a sense, the "Frankensteinian tendency" that Noël Burch sees underlying the attempt to give motion to Marey's and Muybridge's serial photographs. See Burch, *Life to Those Shadows* (London: British Film Institute, 1990), 13.

30. H. R. Coursen, *Watching Shakespeare on Television* (Cranbury, NJ: Associated University Presses, 1993), 167–168.

31. James Lastra discusses the relationship between the uncanny photographic image and narrative in the context of early cinema. See "From the Captured Moment to the Cinematic Image: A Transformation in Pictorial Order," in *The Image in Dispute: Art and Cinema in the Age of Photography*, ed. Dudley Andrew (Austin: University of Texas Press, 1997.

32. See Svetlana Alpers, *Rembrandt's Enterprise: The Studio and the Market* (Chicago: University of Chicago Press, 1988), 81. Rembrandt's painting depicts the dissection of a cadaver with a throng of medical students gathered round, staring not at the cadaver's flayed arm, but instead at Vesalius's text propped up across the operating theater. The lecturer, Dr. Tulp, demonstrates a grasping gesture, as though wielding a paintbrush or pen, performing the physiological process that activates the anatomical features exhibited on the table and in the text.

33. Bridget Elliott and Anthony Purdy, *Peter Greenaway: Architecture and Allegory* (West Sussex: Academy Editions, 1997), 47–50. See also Georges Bataille, *Oeuvres complètes*, vol. 1 (Paris: Gallimard, 1970), 205, 239–240.

34. Michael Fried, *Realism, Writing, Disfiguration* (Chicago: University of Chicago Press, 1997), 53. See also 21–22.

35. Elisabeth Geake, "The New Tricks of the Trade," *New Scientist* (September 28, 1991), 51.

36. Ibid., 65.

37. C. David Bertolini, "The Post-Mortem Image: Peter Greenaway's Documentary *Death in the Seine* and Writing the History of a Corpse," *Studies in Documentary Film* 1.3 (2007), 279.

38. Greenaway, *Prospero's Books*, 43.

39. Gilles Deleuze, *Cinema 1: The Movement-Image*, trans. Hugh Tomlinson and Barbara Habberjam (Minneapolis: University of Minnesota Press, 1986), 109.

40. See Gilles Deleuze and Félix Guattari, *A Thousand Plateaus: Capitalism and Schizophrenia*, trans. Brian Massumi (Minneapolis: University of Minnesota Press, 1987), 3–4.

41. Higson, "Re-presenting the National Past," 116.

42. Building on Deleuze's observation that Prospero is the exemplary mannerist hero, Amy Lawrence provides an excellent, detailed discussion of the mannerist and baroque characteristics of the film. See Lawrence, *The Films of Peter Greenaway* (Cambridge: Cambridge University Press, 1997), 161–164. See also Omar Calabrese, *Neo-Baroque: A Sign of the Times*, trans. Charles Lambert (Princeton, NJ: Princeton University Press, 1992); Cristina Degli-Esposti Reinert, "Neo-Baroque Imaging in Peter Greenaway's Cinema," in *Peter Greenaway's Postmodern/Poststructuralist Cinema*, ed. Paula Willoquet-Maricondi and Mary Alemany-Galway (Lanham, MD: Scarecrow Press, 2008), 51–78; Seung-hoon Jeong, "Systems on the Verge of Becoming Birds: Peter Greenaway's Early Experimental Films," *New Review of Film and Television Studies* 9.2 (June 2011), 171; Walter Moser, "'Puissance baroque' dans les nouveaux médias: À propos de *Prospero's Books* de Peter Greenaway,"

Cinémas 10.2-3 (2000), 39–63; Timothy Murray, *Digital Baroque: New Media Art and Cinematic Folds* (Minneapolis: University of Minnesota Press, 2008), 111–136.

43. Simon Field, "The Troublesome Cases," *Afterimage* 12 (Autumn 1985), 4; Michel Ciment, "Entretien avec Peter Greenaway," *Positif* 636 (February 2014), 26.

44. Walter Benjamin, *The Origin of German Tragic Drama*, trans. John Osborne (London: Verso, 1998), 140.

45. Gilles Deleuze, *The Fold: Leibniz and the Baroque*, trans. Tom Conley (Minneapolis: University of Minnesota Press, 1993), 3.

46. Ibid., 17.

47. Greenaway's repeated use of counting systems as a structural principle in his intermedial films recalls James Elkins's discussion of the "common origins of pictures, writing, and notation." Elkins's analysis of the "ontological instability of the mark" also begins to deconstruct the constituent elements of pictures just as Greenaway's films deconstruct words and cinematic images. See Elkins, *On Pictures and the Words That Fail Them* (Cambridge: Cambridge University Press, 1998), 163–187, 43–44.

48. In *The Fold* Deleuze defines the "monad" as the unit that is specific and individual, yet whole, that "conveys the entire world, but does not express it *without expressing more clearly a small region of the world, a 'subdivision' a borough of the city, a finite sequence*" (25). See also chapter 2 in this book.

49. Ibid., 31.

50. W. J. T. Mitchell, *Picture Theory: Essays on Verbal and Visual Representation* (Chicago: University of Chicago Press, 1994), 152.

51. The film alludes only in passing to explicitly colonial situations, most notably in the *Book of Utopias*, with its depiction of the Virginia colonies, the ultimate goal of the colonists whose account of a shipwreck in Bermuda influenced Shakespeare's writing of *The Tempest*. But as in Derek Jarman's adaptation of the play, the colonial situation becomes an allegory for power relations in Britain itself, especially the effective colonization of the past by nationalist politics and the heritage industry.

52. Fredric Jameson, *Signatures of the Visible* (New York: Routledge, 1992), 1. Stanley Cavell makes a similar argument for the equation of cinema and pornography when he writes, "The ontological conditions of the motion picture reveal it as inherently pornographic (though not of course inveterately so)." See Cavell, *The World Viewed* (New York: Viking, 1971), 45.

53. Martin Jay links Jameson's book with a tendency he sees underlying French literary theory in the twentieth century, a tendency he labels the "denigration of vision." See Jay, *Downcast Eyes: The Denigration of Vision in Twentieth Century French Thought* (Berkeley: University of California Press, 1993), 589.

54. Coursen, *Watching Shakespeare*, 163.

55. Keith Gumery, "A Real Lack of Costumes: Some Thoughts on the Unclothed Figure in the Films of Peter Greenaway," *Velvet Light Trap* 49 (Spring 2002), 79.

56. Derek Jarman's 1979 version of *The Tempest*, in which Caliban is played by Jack Birkett, a blind actor, also foregrounds issues of visuality through this casting decision, which situates Caliban's alterity in his bodily difference, but also in his status as an outsider to a system based on visual signification. The setting of the film—a ruined manor house— also overlays the play's colonial concerns onto contemporary Britain, discovering within a British context a persistent problem: an aversion to difference in all its manifestations. Greenaway's more pan-European perspective searches for an alternative to this problematic

history by displacing Englishness and embracing a more postmodern political entity; in contrast, in Jarman's *Tempest*, a film draped in all the trappings of traditional English culture, the play's "island" of decaying Englishness contains a microcosm of forces poised to destabilize that identity from the inside.

57. Brigitte Peucker, *Incorporating Images: Film and the Rival Arts* (Princeton, NJ: Princeton University Press, 1995), 5–6.

58. Barthes, *S/Z*, 229–230.

59. Ibid., 230.

60. Peucker, *Incorporating Images*, 6.

61. Barthes, *S/Z*, 28.

62. Peucker, *Incorporating Images*, 4.

63. Mitchell, *Picture Theory*, 163.

64. Among the properties preserved by the National Trust, for example, an extraordinary number are advertised as sites with a "literary connection," including the birthplaces or residences of Thomas Carlyle, Samuel Taylor Coleridge, Thomas Hardy, Henry James, Rudyard Kipling, Beatrix Potter, George Bernard Shaw, Alfred Tennyson, William Makepeace Thackeray, H. G. Wells, Virginia Woolf, and William Wordsworth. Among the sites with a connection to film or television, the vast majority served as locations for literary adaptations of the heritage variety. For a discussion of the National Trust, see Robert Hewison, *The Heritage Industry* (London: Methuen, 1987), 54–73.

65. Coursen, *Watching Shakespeare*, 171, 168.

66. For an introduction to the recent explosion of popular, increasingly commercial, "big-time" Shakespeare, see Michael D. Bristol, *Big-Time Shakespeare* (New York: Routledge, 1996).

67. For background on the role of Shakespeare's legacy in British cultural politics, see Alan Sinfield, "Royal Shakespeare: Theater and the Making of Ideology." The specifically commercial and nationalistic invocations of Shakespeare in contemporary culture signal the difference between recent mobilizations of the Bard and what George Bernard Shaw called "Bardolotry," a quasi-religious phenomenon with a longer history.

68. Stuart Hall, *The Hard Road to Renewal* (London: Verso, 1988), 2.

69. Deleuze, *Fold*, 67. Deleuze quotes the latter description of Prospero from Tibor Klaniczay, collected in *Renaissance, Maniérisme, Baroque* (Paris: Vrin, 1972), 221.

70. For a discussion of the heritage phenomenon and its socioeconomic context, see chapter 1.

71. From a dialogue with Stuart Hall, quoted in James Clifford, *Routes: Travel and Translation in the Late Twentieth Century* (Cambridge, MA: Harvard University Press, 1997), 44.

72. Ibid., 15.

73. Clifford Coonan, "Greenaway Announces the Death of Cinema—and Blames the Remote-Control Zapper," *Independent*, October 10, 2007. See also Paolo Cherchi Usai, *The Death of Cinema: History, Cultural Memory, and the Digital Dark Age* (London: British Film Institute, 2001).

Chapter 7

1. Vitaly Komar and Alex Melamid's "People's Choice," which was designed to determine the most popular painting styles in various countries (with the aid of market research

firms) and to produce "most wanted" paintings, attests to the popularity of landscape art in a number of European countries, as that genre appears throughout the ranks of most wanted art.

2. Susan Hayward, "Beyond the Gaze and into Femme-Filmécriture: Agnès Varda's *Sans toit ni loi* (1985)," in *French Film: Texts and Contexts*, ed. Susan Hayward and Ginette Vincendeau (London: Routledge, 2000), 291.

3. The number of selections devoted to the land in Pierre Nora's *Lieux de mémoire* series is remarkable in itself, as that collection includes essays on subjects ranging from generic geopolitical entities (the region and the *département*, for example) to specific locations (Paris, Lascaux, the Eiffel Tower, etc.) to "the local" in general, to "the land" even more generally, to the landscape as a form of representation with implications for how the French see their national past.

4. Rob Edelman, "Travelling a Different Route: An Interview with Agnès Varda," *Cineaste* 15.1 (1986), 20.

5. Studies of Asian cinema and American independent cinema have begun to emphasize the role of landscape in those cinematic traditions. See Linda C. Ehrlich and David Desser, eds., *Cinematic Landscapes: Observations on the Visual Arts and Cinema of China and Japan* (Austin: University of Texas Press, 1994); and Scott MacDonald, *The Garden in the Machine: A Field Guide to Independent Films about Place* (Berkeley: University of California Press, 2001).

6. Jacques Derrida, *The Truth in Painting*, trans. Geoff Bennington and Ian McLeod (Chicago: University of Chicago Press, 1987), 53–82.

7. Pasolini writes that the "second film" emerges in those moments when the "'insistent pauses' of the framing and of the rhythms of the editing"—in short, directorial and stylistic interventions—allow the director's vision to depart from that of the protagonist and shirk the obligations of narrative. See Pasolini, "The Cinema of Poetry," trans. Ben Lawton and Louise K. Barnett, in *Heretical Empiricism*, ed. Louise K. Barnett (Bloomington: Indiana University Press, 1988), 184.

8. André Bazin, *What Is Cinema?*, vol. 2, ed. and trans. Hugh Gray (Berkeley: University of California Press, 1967), 35.

9. Bazin writes, for example, in his study of the "evolution of the language of cinema," "By 1939 the cinema had arrived at what geographers call the equilibrium-profile of a river. By this is meant that ideal mathematical curve which results from the requisite amount of erosion. Having reached this equilibrium-profile, the river flows effortlessly from its source to its mouth without further deepening of its bed. But if any geological movement occurs which raises the erosion level and modifies the height of the source, the water sets to work again, seeps into the surrounding land, goes deeper, burrowing and digging. Sometimes when it is a chalk bed, a new pattern is dug across the plain, almost invisible but found to be complex and winding, if one follows the flow of the water." Or, "in defense of mixed cinema," "Like those rivers which have finally hollowed out their beds and have only the strength left to carry their waters to the sea, without adding one single grain of sand to their banks, the cinema approaches its equilibrium-profile. . . . There remains for it only to irrigate its banks, to insinuate itself between the arts among which it has so swiftly carved out its valleys, subtly to invest them, to infiltrate the subsoil, in order to excavate invisible galleries." Ibid., 31, 74.

10. André Bazin, "The Beauty of a Western," in *Cahiers du Cinéma: The 1950s*, ed. Jim Hillier (Cambridge, MA: Harvard University Press, 1985), 167.

11. Gilles Deleuze, *Cinema 1: The Movement-Image*, trans. Hugh Tomlinson and Barbara Habberjam (Minneapolis: University of Minnesota Press, 1986), 141.

12. Leo Marx, *The Machine in the Garden: Technology and the Pastoral Ideal in America* (Oxford: Oxford University Press, 1964).

13. Denis Cosgrove, *Social Formation and Symbolic Landscape* (Madison: University of Wisconsin Press, 1998), 19.

14. Svetlana Alpers, *The Art of Describing: Dutch Art in the Seventeenth Century* (Chicago: University of Chicago Press, 1984), 145.

15. Ibid.

16. W. J. T. Mitchell, "Imperial Landscape," in *Landscape and Power*, ed. W. J. T. Mitchell (Chicago: University of Chicago Press, 1994), 5.

17. Qtd. in Susan Buck-Morss, *The Origin of Negative Dialectics: Theodor F. Adorno, Walter Benjamin, and the Frankfurt Institute* (New York: Free Press, 1977), 54–55.

18. Derek Jarman, *Modern Nature* (Woodstock, NY: Overlook Press, 1994), 8.

19. Ibid., 3.

20. Ibid., 8.

21. Daniel O'Quinn, "Gardening, History, and the Escape from Time: Derek Jarman's *Modern Nature*," *October* 89 (Summer 1999), 115, 114.

22. Ibid., 115–116.

23. Ibid., 116.

24. These allegories of modern nature have also been crucial for visual artists interested in the border between nature and history and the space of landscape. In the 1977 *documenta 6* exhibition, the artists associated with Haus-Rucker-Co erected a massive installation consisting of two wooden structures designed to frame expanses of the countryside near Kassel, Germany. While one frame presented a picturesque landscape consonant with the area's name Schöne Aussicht (or "beautiful view"), the smaller second frame, placed farther forward, encapsulated a view of urban sprawl and smokestacks at work. The installation juxtaposed the phantasmatic natural beauty so often depicted in landscape art and, hidden at first sight, its disavowed industrial other. Giuseppe Penone's performance and installation entitled *It Will Continue to Grow Except at This Point* (1968–1978) began with the artist grasping a sapling in the woods outside Turin, then attaching an iron cast of his hand at precisely the spot where he had first intervened. Over the succeeding ten years, the metallic hand, grafted onto the living tree, began to evoke the confrontations inherent in the landscape genre, while the tree itself registered a scar, the momentarily stunted growth, the marks of interference, the gap where human action had pried apart the natural world. And in perhaps the most suggestive recent instance of art that collects and analyzes the ruins scattered across the countryside, the Scottish artist Andy Goldsworthy gathered the stones of a dilapidated sheepfold from England's Lake District and reconstructed that fold on its historical site. Conceived within a Cumbria County Council project designed to return sheepfolds to sites where the remains of such structures endured, *Jack's Fold* (1993) attempted to historicize one of the most touristed landscapes in the world by recovering the tenuous traces of farm labor that continue to dot a region known primarily through poetry and traveler's tales. Evocative initially of the pastoral life of the shepherd, these structures are significant less for the rural existence they evoke than the relationship to the land they signify only through an absence: the sheepfolds are revenants from an age largely foreign to the current economy centered on tour groups, hospitality, and the aura of England's romantic literary heritage.

25. Jacques Sallois, "Introduction," in *Paysages photographies: La Mission photographique de la DATAR*, ed. DATAR (Paris: Hazan, 1989), 12.

26. Ibid.

27. Roger Brunet, "Réévaluation des paysages," in DATAR, *Paysages photographies*, 51.

28. Ibid., 55.

29. Ibid.

30. Ibid., 57.

31. Ibid., 61. Nicole Starosielski's *The Undersea Network* (Durham, NC: Duke University Press, 2015) examines the impact of more contemporary infrastructural projects, especially undersea cables, on the landscape, often with an eye to the sort of juxtapositions that appealed to the DATAR photographers.

32. See Arjun Appadurai, "Disjuncture and Difference in the Global Cultural Economy," in *Modernity at Large: Cultural Dimensions of Globalization* (Minneapolis: University of Minnesota Press, 1996).

33. Lynn A. Higgins, "Pagnol and the Paradoxes of Frenchness," in *Identity Papers: Contested Nationhood in Twentieth-Century France*, ed. Steven Ungar and Tom Conley (Minneapolis: University of Minnesota Press, 1996), 104.

34. Barbara Quart, "Agnès Varda: A Conversation," *Film Quarterly* 40.2 (Winter 1986–1987), 6.

35. Agnès Varda, "Propos sur le cinéma recueillis par Mireille Amiel," trans. Sandy Flitterman-Lewis, *Cinéma 75* 204 (1975), 47–48.

36. Hayward, "Beyond the Gaze and into Femme-Filmécriture," 286.

37. Alison Smith, "Strategies of Representation in *Sans toit ni loi*," *Nottingham French Studies* 35.2 (Autumn 1996), 94.

38. Pier-Paolo Pasolini makes a similar observation in his meditation on the Zapruder film in "Observations on the Long Take," trans. Norman MacAfee and Craig Owens, *October* 13 (Summer 1980): 3–6.

39. Claire Johnston, "Women's Cinema as Counter-Cinema," in *Feminist Film Theory: A Reader*, ed. Sue Thornham (New York: New York University Press, 2009), 36.

40. Hayward, "Beyond the Gaze and into Femme-Filmécriture," 286.

41. Ibid., 288.

42. Susan Hayward, "A History of French Cinema: 1895–1991: Pioneering film-makers (Guy, Dulac, Varda) and Their Heritage," *Paragraph* 15 (1992), 34.

43. Sandy Flitterman-Lewis, *To Desire Differently: Feminism and the French Cinema* (Urbana: University of Illinois Press, 1990), 304–305.

44. Agnès Varda, "Agnès Varda de 5 à 7," *Cinématographe* 114 (December 1985), 19.

45. Quoted in Flitterman-Lewis, *To Desire Differently*, 286.

46. Ibid.

47. Georges Durand, "La Vigne and le vin," in *Les Lieux de mémoire*, vol. 3, no. 2, ed. Pierre Nora (Paris: Éditions Gallimard, 1992), 786, 796, 803.

48. Walter Benjamin, *The Origin of German Tragic Drama*, trans. John Osborne (London: Verso, 1998), 176.

49. Mireille Rosello, "Agnès Varda's *Les Glaneurs et la glaneuse*: Portrait of the Artist as an Old Lady," *Studies in French Cinema* 1.1 (2001), 35.

50. Ibid., 31.

51. Giorgio Agamben, *Potentialities: Collected Essays in Philosophy*, ed. and trans. Daniel Heller-Roazen (Stanford: Stanford University Press, 1999), 243.

52. Ibid., 266.

53. Ibid., 270.

Conclusion

1. See Daney's interview with Régis Debray, *Itinéraires d'un ciné-fils*, first broadcast in May of 1992 on the French television series *Océaniques*.

2. Giorgio Agamben, *The Coming Community*, trans. Michael Hardt (Minneapolis: University of Minnesota Press, 1993), 37. For a detailed account of the cultural allusions layered onto the blue screen in Jarman's film, see Justin Remes, *Motion[less] Pictures: The Cinema of Stasis* (New York: Columbia University Press, 2015), 111–136.

3. Gaston Bachelard, *L'Air et les songes* (Paris: Corti, 1965), 194.

4. Ibid.

{ INDEX }